MW00452150

We Sagebrush Folks

Discard

Annie Pike Greenwood

Must Have Books
503 Deerfield Place
Victoria, BC
V9B 6G5
Canada

ISBN: 9781773238197

Copyright 2021 – Must Have Books

All rights reserved in accordance with international law. No part of this
book may be reproduced or transmitted in any form or by any means,
electronic or mechanical, including photocopying, recording, or by any
information storage or retrieval system, except in the case of excerpts by a
reviewer who may quote brief passages in an article or review, without written permission from the
publisher.

This book is dedicated to all children everywhere gratitude for my beloved four

Walter

Charles

Rhoda

Joe

Some names in this book are fictitious. North has sometimes been called south, and south, north. Measles have been called mumps, and mumps the bots. Or at least there have been similar unimportant substitutions paralleling these, which, perhaps, after all are not to be found in the book. Such modifications are for the bewilderment of the folks they will bewilder. But the face of Truth shines free of covering for those who have eyes that yet see.

I have written only the truth. Everything in this book happened either to me, myself, or to someone else living in that country of the last frontier in the United States.

A. P. G.

I. WILDERNESS

I suppose, to be just, I should have laid the whole thing at Daisy's door. I never knew her, yet probably but for her I should never have been a farmer's wife. Even a cow may influence the lives of others, and that long after her death.

I shall say right here, while there is a good chance, that nothing on earth could have induced Annie Pike to marry a farmer. I was not crazy enough for that. Rather would I have married a burglar, or a gambler, or a saloon-keeper—people whom my Boston school-ma'ams (who taught me in the Western mission school) assured me were lost, an expression so vague as to be terrifying.

My childhood was spent in Utah, where I was born, my Gentile father having been Medical Superintendent of the Territorial Insane Asylum; and I recall the cold revulsion with which, seated, as I often was, in our fringed-top phaëton, I observed the jangling, rattling, bumping farm wagons that came into town from Provo Bench, dark genii of dust rising like evil spirits from the hoofs of the great, discouraged-looking farm horses.

With indifference I watched each farmer tie his team to one of the hitching-racks standing before every store in town, next to the unpaved sidewalk, beside the water shining and trickling through our Main Street, just as it shone and trickled through all the streets of Provo, invited from the mountain streams rising in the nearby cañons to water the home gardens and lawns and provide culinary water for all except a very few citizens, among them Dr. Pike, who had the water from three artesian wells piped through his twenty-room mansion.

The farmer's wife was particularly the object of my contempt as I watched her lower herself over one of the wide-rimmed wheels—grasping the iron rod that fenced the end of the high seat, then the green-painted side-board of the wagon-bed, passing, as she did so, one red, raw, coarse hand over the other. Her foot, encased in its heavy, hideous shoe, hovered for safe purchase over the hub of the wheel. The things she wore were of different style-periods—to my superior taste, ugly in the extreme.

I regarded this woman with scornful pity, never suspecting that her condition should be altered. I myself was of finer clay, not by the Grace of God, but by the Divine Right of Kings. I took for granted that farming and laboring people were to serve such as I. This grotesque woman was born into the world my natural serf. The cosmic intention was clear, in having given me a quick brain and little hands and feet, while she had bunching muscles and a great, awkward frame of large and knobby bones.

Celestial Taurus, the starry bull, is said to affect the destiny of mortals born in April; but, probably because I was born in November, it was the cow Daisy who changed my astrological future, with results which could not have been surpassed had the Pleiades and Hyades, led by the mighty Aldebaran, marched in the procession of my years.

They had named her Daisy probably because of the current popular song,

Daisy! Daisy! give me your answer, do!...

ending with the fatuous prophecy that she would look sweet (in those burlesque long bloomers they used to wear)

...on the seat
Of a bicycle built for two.

Or it may have been because that was the era introducing the new expression, "*It's a*

daisy" to express utter approbation.

Howsomever, as we say in the sagebrush, Daisy did look sweet on that handkerchief of land which Charley's father purchased on the outskirts of Columbus, Ohio, the visible hope of a farm which never materialized; for Daisy put an end to everything by eating something that indigested in one of her seven stomachs...or is it five?...and dying before the last of them got a chance to see what it could do. If it had ever reached the last of her stomachs, there might have been some chance for her. And then this story of a sagebrush farm woman might never have been written.

The Greenwoods of Columbus, Ohio, also had a fringed-top phaëton, and at the very time I was sitting in the Pikes' fringed-top phaëton in Utah and regarding contemptuously the farmer's wife, Charley, my future husband, was riding from his city home, out to that handkerchief of land on the outskirts of Columbus, to feed Daisy handfuls of hay and to stroke her neck. And at the same time that I was scorning the farmer and his life, Charley was yearning to be a farmer and to live that life. Daisy's untoward death only increased that yearning. Most men long for the soil. Adam, I am sure, regretted the lost Garden of Eden, but I suspect that Eve fed him the apple in order to get off the farm.

My husband Charley's great-grandfather was a German baron...though the name was not Münchausen. The Elector of Brandenburg distinguished one of Charley's ancestors by giving him his Junker title and something like a hundred and sixty acres of German estate, together with a possible army of one general, one captain, one sergeant, and two privates, the usual dominion and fighting-force of barons of that day. But what they lacked in territory and armament, they more than made up in Junker pride, which, once met, can never be forgotten.

The boy Charley looked like his good old German grandmother, who had run away to America with a man beneath her station but with plenty of money, and whose English vocabulary consisted almost entirely of the word *orange*, which she pronounced *o-ornge*. She was a wonderful, psychic old lady, who was sent for, far and wide, because she could take the fire out of burns, and heal them instantly, by saying a few words. This gift descends from the first daughter to the first son to the first daughter, and so forth, generation after generation. Little Charley, who for some reason she always called "Johnny," was her favorite, though not the first son of her daughter's family. He looked like that *Grossmutter* and should have been named Karl; but because of his handsome face and figure and noble manners, and because of his misleading surname, he was often referred to as "Prince Charley."

When I married Prince Charley, or the Baron Karl, and made my home with him in three different states, I had not the faintest idea that the cow Daisy was browsing around in the Elysian fields of his subconscious mind. I did not even suspect that the ghost of a cow was trampling all over our dining-room table, out there in Kansas, where my brother-in-law Fred was describing, with his forefinger, the boundaries of the farm in Idaho to which he wanted Charley to go. I suppose if I had been clairvoyant I should have seen Daisy, but probably I should have considered it a warning that I had overpaid the milkman that morning, a thing I was likely to do, all arithmetic being transcendental to me.

When Charley actually announced his decision to give up a perfectly good salary from the million-dollar sugar-factory in Garden City, Kansas, to go to a perfectly unknown, sight unseen, undeveloped wilderness farm in Idaho, I almost went on a hunger-strike, through horror. I loved the pretty house I was having such fun furnishing, one of my passions being interior decorating, inherited, no doubt, from my ancestors who interior-decorated Windsor Castle, and painted pictures on the side.

But Charley brought home a certain magazine published for city farmers, who love to make fortunes on the imaginary acres in their heads. Only the one-in-a-thousand who succeeds ever gets written up in this really most attractive weekly. The issue that decided me not to stand in Charley's way to success sported a crowing chanticleer in full color on the cover. Inside, Charley showed me, there was an article about a man who made enough to buy a farm from six hens and a

rooster in only two years; and if the eggs from those hens and their offspring had been lying end to end, they would have been lying end to end, and the man who wrote that article would have been lying from end to end.

The last thing in the world I wanted to do was to go on a farm. It was an utter absurdity even to think of such a thing. When I married, all I knew of housework was what I had learned from looking in the dumb-waiter that brought all our food to our dining-room in what the *Salt Lake Tribune* called our "luxurious apartment" at the Insane Asylum, during my father's years of service as resident medical superintendent. After we returned to our twenty-room home on half a city square, I concluded my education by learning to make salad-dressing. The gap between bothered me not at all.

Charley taught me to fry a steak, and he thought he was teaching me to fry fish; and so I regarded it, as I admiringly watched him take those little fish and fry and fry and fry them. They tasted a good bit like a piece of balsa-wood, but I was filled with wonder that Charley could cook them, and I did not then know that fish should be cooked only about seven minutes.

I wanted to surprise him by cooking the next meal myself, and I did. I decided to cook a quart of rice as a side-dish. When Charley came from his work, I had everything in our apartment but the bathtub filled with the cooked rice, and it was still boiling over on the gas-stove. It was in Los Angeles, where delicatessen stores were handy. A flustered bride and her man ate their dinner out of cartons that night.

So out there in Kansas, where we had gone from California by way of Colorado, Charley was preparing to go on the farm in Idaho. When I married him, several wealthy girls had coveted him; and therefore I must play the noble part of being a real helpmate—where-thou-goest-I-will-go kind...so that he would not have to stay at work with the million-dollar sugar-factory until some day his salary would be only a thousand a month, and he would say, bitterly, to me, "If you had been willing to go, by now I could have been independent on the farm!"

Charley considered that there were probably no cows, nor horses, nor wagons, nor buggies, nor anything else for a farm in Idaho, so he set out to do his buying right in Kansas. First he bought a team of horses and a buggy horse named Buttons. I liked that name. It was so crazy, suggesting anything on earth but a horse. Probably nowhere else in the world could he have bought a horse named Buttons. That much was fairly certain. But its value to our future farm was debatable.

The next thing Charley did was to buy a second-hand narrow-gage buggy and a second-hand narrow-gage wagon, never dreaming that in the Far West nothing is ever used but wide-gaged vehicles. The consequence was that when we reached Idaho, we were forced to ride the road with two wheels always down in a rut and two cocked up on the high middle ridge.

The land was Fred's. It was a sort of partnership agreement, we to own the farm ultimately. I was to stay in Kansas with my two little ones—Walter, five, and Charles, seventeen months—until a house was built on the farm, Fred taking a carpenter along to do the job. These two were to meet Charley when he passed through Colorado Springs with the freight cars in which would be our household goods, our horses, a cow, a calf, the buggy and wagon, and a dog.

All the Kansas farmers assured Charley that he could not well farm without a good big dog, which is indeed a fact. Charley had heard that splendid dogs were being killed every day at the dog-pound, masters not appearing to claim them. He took Walter with him to the pound, and such a massacre had just taken place in the presence of the other dogs, who were shivering and crouching against the high wire netting of the inclosure.

One little fellow was particularly terrified, shaking all over and crying like a baby. The hearts of both Walter and Charley yearned with pity over the little mongrel, Charley sickening at the reek and sight of the blood-soaked ground. I saw them stop Buttons before our pretty bungalow and ran out to the buggy with little Charles. There on the seat was the little homeless tike whom I christened, at once, Tylo, having just finished the reading of Maeterlinck 痴 *Blue Bird* 預 t that time we were all going around wearing enameled bluebird pins.

7

ANNIE
PIKE

You could never make me believe that Tylo did not realize what had happened to him. He fairly worshiped Charley and continually proved his gratitude in every way possible. One of the ways was by grabbing Fred's ankle between his teeth when my brother-in-law attempted to enter one of Charley's freight cars, unannounced, at Colorado Springs. Charley considered that act a striking evidence of intelligence on the part of Tylo, but Fred was not so much impressed. I think Fred expected a good deal when he thought Tylo should discriminate between a thief and a banker. I am not casting any reflections on bankers—they are like Christians, all right if they are all right; but the name means nothing, except, in these latter days, to damn them rather than to accredit them. Of course, Fred could hardly be blamed for his depreciation of Tylo, because it was Fred's ankle that Tylo had tattooed.

WHEN THE HOUSE was ready, Charley wrote us to come. He did not write of his wearing experiences, such as trying to take his cargo of freight by night along the bank of the Jerome Canal, in danger of its waters, with the calf falling out of the wagon every little way and Charley getting down from his driver's seat to boost it back into the wagon. He met us at Minidoka; and he was no longer Prince Charley, nor was he the Baron Karl, but a red-leather-necked farmer who looked so much a stranger to me that for the first two or three minutes my heart quailed.

The train stopped at Milner solely to allow us to leave it, Charley's patient team of work horses, harnessed to the narrow-gage wagon, having been left standing at the hitching-rack beside the ugly dark-red station at Milner, a tiny town breathing its last gasp. The *raison d'être* of Milner had been the building of a dam for diverting the waters of the Snake River into canals that should slake the thirst of the fertile volcanic-ash desert, before the flowing of the man-made streams the property of others than farmers—first the long-vanished Shoshones; next the trappers; following them the cattlemen and the sheep-men, disputing the land and murdering each other, but finally grumblingly sharing their public domain. And now, at last, sheep-men and cattlemen were viewing the canals with dismay and were preparing to join forces against the interloping farmers, that hated class who would most surely drive these magnates farther and farther into the desert, nibbling away a little land here, a little land there, and fencing it against the flocks and herds.

Past four empty stores our wagon rattled; past the bank, run by Gundelfinger; past the general store run by Longenberger and Belmont; past the general store run by Jake Solomon, the only Jew in that part of the country, whose store sold everything from saddles to cheese. The town was a cluster of houses, almost all of them empty.

In front of the long gray porch of Jake Solomon's store Charley drew rein and went in for supplies. I was surprised at this, for we had spent much time listing and ordering all kinds of staple groceries from a big mail-order house, and we expected them to last us for a year, as Charley, until I came, was to have boarded with a family named Curry, living on the desert farm nearest to the uncleared eighty acres on which Fred was having his carpenter build us a house. We had exhausted our ready funds in making that big grocery order and buying the cow and calf, the team, Buttons, buggy and wagon, harnesses, and the many other things that the Kansas farmers either thought necessary out in Idaho or saw a chance of getting rid of for good money. Boys will be boys, and farmers will be farmers, and business men will be business men, and all dishonest mortals everywhere will be dishonest mortals anywhere.

I learned later that we could get only bacon, flour, sugar, and such staples at Jake's, there being no green groceries whatever to be had in Milner. This appeared to me an act of God to help me market my garden stuff. Experience, however, taught me not to bring anything to town, as it only wilted on the counters, the farmers who were then living in the wilds, themselves raising no gardens, preferring to feed out of cans (so easy to cook, you know), even including canned milk (no

cow to bother with, you see). They were city farmers. Miles away were a few scattered Mormons, provident and wise, trusting the Lord and the work of their own hands about equally, which is no sacrilege against the Maker, since it relieves Him of a lot of odd jobs that a man ought to do for himself.

To entertain me, as we rode along, having stowed his armful of groceries in the wagon at our feet, Charley began to relate an episode concerning Jake Solomon's store which gave me an insight into those canned farmers from the cities who were soon to leave us for their sedentary occupations. Speculative city farmers they were, though, for that matter, as agricultural economics stand today, all farmers are speculators—the most reckless gamblers in the world, with all the cards stacked against them. Not long after we arrived in Idaho, every one of those pseudo-agriculturists near Milner was gone, but before they left, they all helped to pay for the saddle Ikey Solomon had sold to one of them.

Ikey had been left alone, for the first time, in charge of the Solomon store, while Jake and his wife went to Twin Falls to buy an order of goods from a wholesale house located there. At that time there were near Milner, living in tents scattered more or less closely together, over five thousand men engaged in building the dam to make a reservoir that would keep water flowing through Jerome Canal, which they were also digging and blasting. There was a constant rushing trade at Jake's store, more than Ikey could handle alone successfully. But Jake's unmarried daughter had gone on a visit, and he did not like to trust strangers to help Ikey, who was naturally elated by the confidence reposed in him to manage things with the old folks away.

At the end of the month, when father Solomon made out the bills, as was his custom, a fine saddle was itemized by Ikey as sold on account, but there was no trace of the debtor's name. Jake blew up. It was not alone a personal matter. The Hebrew race had been disgraced. Ikey pleaded hard.

"I tell you what, Father," he beseeched, using all the hands he had and rolling his dark eyes, in his agony of spirit; "I tell you what, Father; you let me make out all the bills, and I promise you I'll get the money for that saddle. I'll charge it on every account. The man that owes for it will come in and pay, and we can explain to the others, when they kick, that it was just a mistake!"

The result was that all those careless first settlers around Milner paid, individually, for that saddle. That characteristic which had made possible their leap before they looked, into an occupation of which they were in perfect ignorance, together with the fact that they were well supplied with money, made them accept their totalled bills with childish confidence.

I confess to a thrill of adventure as we rode along, in constant danger, as I was, of spilling from my high seat with every motion of the wagon. Certainly I was an anachorism: my hat, a fine white straw, with a single red rose and dark-green foliage, a Paris model; my suit, of mixed blue-green-brown wool, straight from Best and Company, New York; my very beautiful little shoes, evidence of one of the foolish passions of my life; my gloves, covering carefully manicured hands. I was sitting on that high seat of my husband's farm wagon for the first time I had ever sat on the seat of any farm wagon. And around me stretched a wilderness which was still haunted by the spirits of the Indians, whose eyes beheld it exactly as I was seeing it, except for the insignificant interruptions of man around Milner.

The horses' hoofs began the hollow *clomp-clomp-clomp* across the long cable bridge that spanned the Snake, the rough brown planks appearing to rise before the feet of the animals at every step. At our right, interrupted by boiling mists, over Milner Dam hung a sheet of silver water, dropping into the river-bed, where it raged among the huge, rounded, cream-colored boulders. Some distance beyond the other side of the bridge the fearful, rushing waters sank into gigantic black-lava cañon walls, which dropped, precipitously, from the level sagebrush land.

We started up a steep grade, and Charley explained, "At the top you will see the beginning of Jerome Canal, which irrigates our farm."

A moment later I was gazing into the dark depths of the placid water, so quiet that it appeared to be standing still, only a faint ripple here and there betraying that it was really moving

10

on, out into the desert.

"It's deep," said Charley. "After it leaves the spillway, the roar of it can be heard for miles. You can hear it all the time on our ranch. Now for the country God forgot."

The great farm horses from Kansas, one bay and one gray, Nell and Jim by name, were urged along at a brisk pace. We were traveling parallel with the Jerome Canal, hidden from us by the high bank which had been dug and blasted from its bed. There was nothing but sagebrush so far as eye could see, probably not interrupted for the Minidoka Mountains at our backs, though so blue they looked that the pastel green of the sage must have been screened in some tenderer atmosphere. Mountains that I learned so to love! As I craned about to behold you from my wagon seat, I did not know how your beauty would hearten me, day after day, for tasks too heavy and circumstances too painful.

As we rode along, we passed the wreck of an old steam-shovel, lying among the boulders. It had settled there two years before, when it had blown up, killing two men. Skeletons of steers and sheep lay among the pale gray-green brush—bleached bones of slaughtered animals, marking the sites where the laborers had camped. Piles of twisted wire from bales of hay told of the hundreds of horses that had been fed there. Huge piles of empty tin cans, with ends gaping in ragged edges, were rusted by the rains and sunk into the buffalo-grass, those eager little soldiers marching in where space had been cleared of brush for the cook-tents.

The road widened, separating into many lanes, evidently used during the building of Jerome Canal by teamsters driving simultaneously. And on these roads, and among the debris, clumps of sagebrush, and boulders, everywhere there leaped countless jack-rabbits, perpetual animation, giving a jocund air to the monotonous scene. This vision, full in reality of prophetic menace, was to me, in my ignorance, a source of delight, the words of Milton singing through my brain:

And young and old come forth to play
On a sunshine holyday.

Great bands of sheep had browsed here, testified by tufts of white wool caught in the scraggy fingers of the sage, thus giving the landscape the appearance of a Southern cotton-field. The wilderness bore evidence that it had been desecrated by man; his justification was not yet apparent.

Miles and miles of wilderness, and not a sign of habitation: no tree, no green, only the gray of pungent sagebrush. And, everywhere, leaping jack-rabbits. Strange that I should have felt so elated? I was going to live on land untrod by the foot of white woman in all history! I was going to make my home where there had never been a civilized home before! I was to be a living link between the last frontier and civilization! I was a pioneer!

The road left the bank of the unseen Jerome Canal just where it begins to roar over the not far distant spillway. I did not know then, as I heard its lusty voice for the first time, that for all the golden years of my youth, day and night, indoors and outdoors, I should have the rush of that man-made river in my ears, becoming an integral part of my outer and my inner life, so that the very memory of that swelling roar evokes the sight of the lovely, serene valley that lay below our house on the bluff, or the still, clear, bright, sunny air, or the black clouds rolling up from the southwest for a storm, or the intimate smell of rain and the secretive pattering of the preluding drops, or any of the thousands of magic remembrances that charm in and of themselves, even were there no dearer human associations.

A GROUP of bushy-topped young aspen poplars, the green, gray-backed leaves trembling in the slight breeze, seemed to spring out of nothingness to our left, surrounding a comparatively new, plain, gray, box-shaped frame house, without porch, a stone for the step in front of the door. This house presumably consisted of two small rooms. Charley stopped before the little gate, hung between reaches of barbed wire fastened with staples to cedar posts, which smell so sweet in rain, the dark-red, stringy bark still on them. The grateful sweating horses snorted and sighed hugely with relief, settling into their harness with a creak of leather bands and straps.

11

Without preparing me, "Oh, Jeff!" called Charley, "Oh, Tony!"

We had evidently been expected, for immediately a flock of white chickens blew toward us like a cloud, obscuring the approach of two men and a little girl. The chunky man came first, beaming broadly. He had beautiful brown eyes, perfect teeth, regular features, and a rose and tan complexion. This was Tony. Jeff was tall and thin, and when he smiled, he revealed a row of bad teeth. Jeff's little Susie stood back, with an air of hostile withdrawal, yet regarding us with sullen and inquisitive suspicion. Her long, shaggy bangs hung down into her eyes like those of a Shetland pony, and those inimical eyes of hers were as blue as cornflowers, and as cold as icebergs.

The little girl had been dressed in her best for this meeting, a red and gray figured percale. Immaculate were Tony and Jeff in work shirts and overalls. I did not know then that the shirts were washed and ironed by the men, and that their midweek donning was entirely in my honor. I saw at once that Jeff, lanky, nondescript of nose, and colored like Indian pottery, was, for all that, a personality; while poor Tony, a little too plump but handsome as a god, was just another man, in no wise significant.

"Meet the Missus!" introduced my young husband, the first time I ever heard that expression, so familiar everywhere now. I do not mean that Charley introduced this vernacular into the language, but that out in the brush he had picked it up from some one. It made me feel very strange, as though I should have been fat, forty, beamingly complacent, with broad fingers holding onto the infant Charles, then close in my arms.

The men seemed extraordinarily glad to see me. More admiration than I deserved glowed in their eyes, although I was not unused to that glowing, finding it a rather delightful emphasis to my sex. But my thoughts kept turning to Susie. What could be the matter with that pitiful little creature? To be so filled with hate for every one that it brims over in cornflower eyes! If I had only known then the psychology that I know now, I might so have helped Susie. I might have helped her to help herself. The psychology of mind and behavior should be taught to children as soon as they can talk. That would abolish most of the tragedies of life; for mistakes mean failure, and if we knew what we do with every act and thought, few would dare to violate the psychological laws that mean successful living or failure.

The horses bent their heads to the rising road. On the top of a bluff I could see my future home—dark-green shingles with black roof, a frowning porch with white toothpick pillars under the southeast corner of the upper story. I never got over the ugliness of that dugout porch, which gave the house a glowering, sullen face. The dark-green upper story looked too heavy to be resting on those slender sticks of wood which supported it, appearing to keep it from sinking down onto the porch floor. I am not fond of any kind of front porch, and this front porch threw the whole house out of balance.

For years I planned how that porch might be included as a part of the living-room. I have a passion for remodeling almost everything I see. Many a chance moment I spent blue-printing our house in my mind. But it was, after all, rather a wonderful house for that wilderness, well-built, comfortable, though it had for foundation only some lava-rock boulders at the corners and also at far intervals along the sides. Some years later Charley banked it with dirt, but until that time you could see under the entire structure.

We did not go at once to our home, Charley announcing that we were expected for supper at the Currys' rented farm, where the three men had been boarding. Fred and the carpenter had gone to Twin Falls on business, but I should have them in the morning for breakfast; and it would be my job to board them from that time forth until the house was complete, only two rooms downstairs being finished.

As we approached the Curry home through the dusk, we could see pale yellow light shining in its windows, and Charley made a remark which I was to hear several times within a short period, but of whose significance I had no suspicion. "Mrs. Curry is so glad that another woman is coming to live out here," said my husband.

The home in which the Currys lived consisted of two big rooms, with partitions in each to

12

make bedrooms as well as a kitchen and a living-dining-room. From the outside it looked as though two small houses had been pushed together, one painted gray, the other unpainted and weathered dull brown; though I could not see these details that night as we approached, after my clumsy clambering over a wheel into Charley's waiting arms. It was so very, very quiet out there. Stars were pricking the dark sky, and there was the feel of a new-born world in the delicious cool air. I always feel night through the pores of my entire body. It intoxicates me.

There was a platform at the back of the unpainted house, but Charley led me to the side door of the painted section, where there was a block of stone for a step—a little too low, for you had to lift your foot high on to the door-sill. As I did so, the light from a glass lamp fell through the open doorway on my beautiful little new shoes. I noticed that, but without pride or interest, for Charley was introducing me the next moment to the Currys.

Mrs. Curry, a patient, pleasant-voiced blonde, was dressed in one of those flowing atrocities which used to be called Mother Hubbards, gathered to a yoke and effecting a most slovenly appearance. I thought they had been obsolete long since. I never wore one myself, and nothing could have induced me to do so. Indeed, I was always amazed that Mother Hubbard's dog could have fixed his mind on a bone, no matter how hungry he may have been, if she wore that sort of garment. There was a reason in the case of Mrs. Curry, however. That she was pregnant was unmistakable.

There were three children, a little girl with dreamy eyes, rosy cheeks, and tight braids, and two older boys, without identity in a shadowy corner. Curry himself was dark, lantern-jawed, shifty-eyed. I knew he could not be trusted, but he always amused me. We have to value people for what is precious in them. He had a sense of humor and was good company. The first words he said to me were, "I'm so glad another woman has come." Mrs. Curry had not heard him. As she put supper on the table, she said in her gentle, musical voice, "I'm so glad another woman has come."

We had fried potatoes, fried sow-belly, boiled navy beans, and canned sliced pineapple. A curious intuition made me pause as I ate the pineapple. I will not say that the pineapple was trying to tell me something. But certainly there was a message in the air that was endeavoring to reach me with regard to that pineapple. I felt a little bewildered, but forced my mind away from it.

Later I learned that the frontiers have been pushed onward with this diet of fried potatoes, sow-belly, and boiled beans. Add bread to these, and coffee with canned milk, and you have the typical meal of the cowboy, the sheep-herder, and the first settler. Indians of today also use this menu. I have an Apache Indian friend who complains to me indignantly, his handsome face stern, "Wherever I go and they have sow-belly, they always give me the tits. I don't like 'em settin' there on my plate!"

I was not accustomed to fried potatoes, boiled beans, and sowbelly, being first-generation American from English roast-beef-and-Yorkshire-pudding ancestry. My maternal grandmother had never done any manual labor in her life. She was a musician, a singer, and we had servants in my own mother's house, where she saw to it that they set before us the kind of table called "groaning" by every well-regulated village paper in the United States. We lived in a village, but only in such respects as a groaning table did we live like villagers.

I am sure our table groaned groan after groan, and not just on holidays twice a year, as in modern degenerate homes, where only collapsible cats and dogs can find room to be pets. Our table groaned every day in the year, loaded, as it was, with roasted beef, or roasted turkey, or roasted what-not; several kinds of vegetables, cooked perfectly; hot bread of some sort, usually biscuits; several kinds of jelly and several kinds of pickle; for dessert, pies and pudding and what-not—a sweet what-not this time; and the festive note of bushy celery, standing straight up in those adorable fluted glass celery-holders (I love antiques), the tops of the celery blossoming in such a bouquet of ivory leaves that guests, with napkins in necks or on laps, had to dodge around it to see each other. Ordinary flowers can never express the holiday spirit of a bouquet of celery.

So I was greatly amused at my sitting there, attempting to eat fried potatoes—which Charley loves, that being the German of it, and which, at my mother's table, I had eaten very

infrequently, that being the English of it. More amused was I at the boiled beans. I hated boiled beans, and never, never ate them. I should have been most amused at the sow-belly, but I had never seen it before and did not know what I was eating. I wondered, though. I wondered what the buttons were on my meat. I did not know that my salt pork had been a mother. My feelings were spared what my Apache friend has to bear. Even had I known, my reaction would have been different. Horrified blushes would have flooded me from my beautiful little shoes to my fluffy blonde hair, probably hennaing it slightly. In *my* childhood such salt pork would never have been allowed to come to the table without brassières.

I was conscious that I was sitting before the humblest table at which I had ever eaten. I felt that supercilious content with myself which afflicts snooty people before they realize that everything is just whirling electrons, and that Mrs. Curry's whirling electrons are just as aristocratic as Mrs. Greenwood's whirling electrons, even though Mrs. Greenwood was born in the midst of the whirling electrons whose illusion is so much different from the illusion of the electrons composing Goose Creek, where Mrs. Curry was born.

Charley's middle name is Pliers—he could always fix anything with them; and my middle name is Scribbling. I could never fix anything with that, or with anything else—if I cannot mend a thing with gum or a hair-pin, I give up. As I sat there, my *cacoëthes-scribendi* personality was recording my impressions to be placed in a book some day—and here they are, but with another interpretation.

When the meal was ended, Mrs. Curry washed the dishes in an old tin dish-pan, and I dried them for her. I marveled why she was using only an inch or so of dish-water. I did not then know that all water for the house must be carried uphill from the canal below. That was something I should learn very soon, for our house was in the same position on that same long hill which human beings were attempting to farm.

There were two glass lamps, one tiny and squat, the other having a stem. The wicks were very small, as the less wick, the less kerosene used. And I might say here that kerosene is always "coal-oil" on the farm. We were using the smaller lamp in the unpainted house with the rough-plank platform; placed on a shelf, it cast a murky shadow over the dish-pan sitting on the still warm stove, before which Mrs. Curry washed the dishes, a trick that I there learned and afterward practised, the dish-water thus being kept warm while you wash.

In the room we had left, Charley and Sam Curry were talking crops—the Baron Karl talking crops with a mere tenant farmer. For the Currys were renting this ranch from the Endicotts, whose home was in Burley. Endicott, a lawyer, had begun speculative agriculture at the same time that all the other city farm-gamblers had taken their little fliers by settling in the sagebrush country. Endicott was not foolish enough to throw up his law practice. But his wife, a strong character and ambitious, with a fiery streak in her, took the children, a hired hand, and a hired girl and went out to live in the brush on the farm that the Currys now rented.

The little city family on the Endicott ranch were at the mercy of the cattle and sheep barons, who had been waging bitter feuds against each other but now united against their new menace, the farmer. The brothers Shoddy, a name thus corrupted by the farmers, grazed their cattle over four states, rounding them up only to brand them and ship them, and, after branding them, turning them out to increase and to feed at the expense of the Government. Thus great fortunes were made.

No bankers hounded these cattlemen and sheepmen at harvest-time. Where there is comparatively little expense and certain profit, there is no need for mortgages. Sheepmen might be slightly affected by the law of supply and demand, but when the market was low, the cattlemen simply left their herds on the range, still feeding at the expense of the Government, with little or no supervision. No need of warehouse to carry the crop through the winter. And when the cattleman or sheepman needed hay, there was always the bone-head farmer. The banks in Idaho were owned by the sheepmen and cattlemen, and the mortgage was always due when they needed the hay. And there would have been no mortgage had they not always depressed the market below the cost of

raising. Yes, farmers are bone-heads about selling things below the cost of production. Some day they will learn. But, even then, what can they do about it?

At the time Mrs. Endicott was directing that farm, the sheepmen and cattlemen had been so long at the game of sucking their fortunes out of the Government that they had come to believe that the West belonged to them and every farmer was an interloper. To dispute this the price was your life. Ordinarily no fences would have been necessary around these widely separated sagebrush farms, but nothing was safe from the depredations of Shoddy's cattle.

The hired man on the Endicott farm confessed his inability to keep the cattle from trampling and devouring the crops. Mrs. Endicott accepted the challenge. Seizing the hired man's hunting rifle and running swiftly into the fields, she, who had never fired a shot in her life, pressed the trigger to scare Shoddy's cattle—and scared one to death. In court the Shoddys proved that there was a shot in the steer, but you know what wealth will do in an American court. Probably the steer had swallowed that bullet sometime. No doubt, if they had made a search, they might have found in him some Indian arrow-heads, or maybe a spear-head. He may have collected such things.

The hired man took the blame, and there was nothing that jury could do about it. *Confessio facta in judicio omni probatione major est*, as the lawyers say: a confession made in court is of greater effect than any proof. The hired man did not put it that way. He claimed to be guilty of the shot, not of speaking in a dead language. They could not jail him for that, anyhow. But they did jail him for shooting the steer, which he had not done, the steer undoubtedly having swallowed the bullet. One thing is sure. That hired man certainly fixed things for himself so that, like the hired man the poet tells about, his home was where, when he went there, they had to take him in. That was Endicott's.

Thus was concluded a dream of independence on the farm. In *Lord Jim* Conrad says that it is not good for a man to know that he cannot make his dreams come true. It may not be good for some things, but it is the incentive that forces the reform of all injustice. Some day some one with the power, who has had his farm dream fail, is going to start things moving toward justice for the farmer. But it will never be Congress, left to itself. Perhaps a gadfly, that will sting the politicians into action. Perhaps...lawmakers of another kind...representatives of industries...ah, but I, too, am dreaming, and if I do not look out, I shall be told to pack up my troubles in my old kit-bag and beat it for Italy or Russia.

How foolish it is to go wandering into the realm of politics and economics along with all the other daffy people of the world when I might sit, in memory, in that humble rented farm home of the Currys, with its bare, unpainted pine-lumber floor, its curtainless window—there was but one in that front room—and the glass lamp with the stem casting mellow light from its position on the old-fashioned organ. Sam Curry and his wife are singing to us. I cannot get over feeling touched by the thought of that rascal standing there and singing with his patient wife,

Some day I know you'll forget me;
It has to come true they say,
But I'll not forget you, my darling,
Though you may be far away.

The impression I had then of their relationship was confirmed in the years I passed near them. Sam thought his wife was wonderful, and he looked at you with proudly challenging eyes whatever she did or said. Mrs. Curry worshiped him, and to her he was the most witty and charming person in the world. Even when she had to go to live in the chicken-house, when the Aspers began buying the farm on time, Mrs. Curry never lost her equanimity or her love for Sam. And that is the only kind of marriage that is worth having.

NEVER were nights so sweet as those nights in Idaho. The air seemed to caress you; millions and millions of stars glowed in such a depth of the heavens as I have never seen elsewhere. Every sense was awakened, and soothed. Such was my first Idaho night as we rode through the calm on that high wagon-seat from the Currys' to our own place. Such was the last night I ever spent there. Such were nearly all the nights I saw and heard and breathed there.

15

Fragrant shavings still lay in curls on the floor of the new house. Charley had been plowing, and there had been not a moment to make things ready for my coming. He and I together made the beds, and then we all crawled into them and slept—such sleep-such sleep as might have been envied us. One of the things that no money can buy—such sleep.

Heroically I forced myself out of bed at the ungodly hour of six in the morning when I heard Charley moving around. He would have prepared his own breakfast before going to the field, but there were Fred and the carpenter; moreover, whenever I thought of those wealthy girls who had wanted the Baron, I gritted my teeth and went after things with all my might. It should never be said that I was not as good a wife to him as they might have been. Besides, it was a kind of lark to farm. I didn't mind it at all.

Fred and the carpenter were glad to see me. Men always look forward to a change of cooks. And Fred had brought with him a beautiful pure-bred golden collie. There was the most kindly indifference between the little scrub mongrel Tylo and the pure-bred collie Tag. She did not belong on the farm. At night, when the coyotes were *yip-yip-yipping* and wailing their insane cries from the nearby desertland, Tag would spring up from the porch floor where she liked to lie, and with bristling and quivering she would call back her horrified answers to whatever evil thing it was that she recognized in their voices. When she did this, she was oblivious to even my presence, and she loved me; but at my touch close against me would press her shuddering body. Oh beautiful Tag! Something in me responded to you! In my sweetest memories of that sagebrush farm, there you always stand, faithful, your trusting eyes meeting mine.

We had nothing to feed her. She had been used to fresh meat, bought especially for her from the butcher by Fred's children. She hated jack-rabbit and Mollie Cottontail and never touched them. She would not even chase them. Salt pork was the same. There was nothing for her but bread. She used to look at the bread and then at me, with pitiable starvation in her lovely eyes. She could not understand why we were doing that thing to her.

I began to learn to cook with nothing. One of the last things I said to Charley that first night on our farm, just before we fell asleep, was prompted by the sudden vision of a circle of pineapple with a hole in it. "Oh, yes!" I murmured, "Where are all the things we ordered to cook with?"

And then Charley told me the devastating facts. He had hauled all those boxes in the wagon with the calf that kept falling out and having to be boosted in, and they were stacked in the unpainted Curry kitchen. It was too much for Mrs. Curry to see all those supplies stacked up there, and she with nothing to use. She could do with so little, too. For a wash-boiler she had an oblong kerosene can with one side cut away. She it was who taught me to use a baking-powder can for a chopping-knife. She taught me, also, to "taste things up" when they seemed flat. And when I helped her, she taught me to make jelly out of stewed dried-apple juice, baking the pulp in crusts for pie.

I cannot blame her for what she did. A first she begged Charley for a little bacon. That was the beginning of the end. Box after box was emptied. But the Currys were fed, for once. Charley said the children were fairly demented about pineapple. They thought it grew on bushes, with holes in the middle of the fruit, as canned. There was one long orgy of feeding, and the .end had come with my coming—not only the end of the feeding, but the end of the feed. That summer we lived on Mollie Cottontails fried and jack-rabbit cooked in a crock in the oven, with little biscuits placed on the top about ten minutes before serving.

A clean kitchen one moment, and bits of sagebrush and dirt from the door to the woodbox the next. Bleeding scratches on my arms and hands. The smell of sagebrush so constantly throughout the house that we can no longer smell it. Cooking with sagebrush. Breaking scraggy, scratching sagebrush over my knee, and having it lance my arms with its claws.

The first year nobody forgot to chop sagebrush for me, for I had three men waiting on me, while I waited on them. This was after Fred and the carpenter had gone, and Tony and Jeff were helping Charley fence the ranch. To keep the rabbits out, the men said; but from what happened to the crop, I think the men just fenced the rabbits in.

16

Until each of my children grew to be six years old, one after another filled me with fear of the canal below the house. But I never suspected the sagebrush. The fertility of land in southern Idaho is judged by the height of the sagebrush growing on it. Our land was good, but to the far east was better land, with sagebrush high as my head. It was there that Charley always went for our fuel, taking a hay-rack to bring it home. Baby Charles and little Walter loved to go on these trips.

Walter always stood on the hay-rack, ready to stack the sagebrush as it was thrown up to him. Charley chopped industriously, the trunks of the sagebrush like young trees, little Charles, in his scarlet coat, darting hither and yon as they worked.

Then it happened. One day, when the last brush was stacked on the rack and Charley was about to climb onto the load, where Walter already awaited him, there was no little red-coated baby. Not anywhere was he to be seen, although Charley climbed high on the load and looked all around, as far as eye could see. And then he began calling...calling...calling....Suddenly Walter burst into heart-racking sobs.

Down from the load Charley lowered himself. Then he began circling the wagon, ever a little wider and a little wider. It seemed appalling that a baby could be swallowed up like that, but there was not a sign of little Charles. It was growing dark, and unless they could find him soon, the cowardly coyote would make him prey. That skulking wild dog-wolf would not fear to attack a baby.

And then Charley saw the little red coat gleaming in patches through the thick, tall, dark-gray brush....Charles! They did not tell me at once; they were too shaken by the experience. Even when I knew, the canal was still my greatest fear.

I LOVED IDAHO. I loved the vast, unspoiled wilderness, the fabulous sunsets, lakes of gold, and the dreamy, purple mountains that appeared in the sky along their rims; and when these gradually dimmed and vanished, a million stars in the dark-blue sky—a million stars, seen at a breath.

It was not all beautiful. Idaho's wild winds raged for days at a time, lifting the earth in great clouds of dust. Fields were literally transferred by the power of those winds, some of the land having to be sown over again. On everything within the house lay a thick gray powder, like that on a moth's wings exaggerated ten thousand times. Hair was transformed to dun color, eyebrows shelved with it, skin thickly coated, eyes red and smarting, teeth gritty.

The soul of the desert, I used to think that wind, making its last protest against being tamed. Through my kitchen window I could see an enormous cloud of dust pass, two pairs of horses' ears just pointing above it. Somewhere in that cloud I knew was Charley, engaged in leveling a field. When he came in for supper, he was masked in dark-gray powder, the ash of ancient volcanoes, one of whose craters was visible from my kitchen door. At Charley's request, I brushed him down with a broom outside the house. Then basin after basin finally made him recognizable.

I pitied him that summer. He was not used to farm work, and he was so exhausted at the end of the day that right after the evening meal he would fall asleep in painful and grotesque postures in the chair we had bought for our pretty bungalow because it would be so comfortable for him. Jeff and Tony were helping to fence the ranch, and so they ate two meals with us and always spent the evening with me, while Charley slept in his chair near us. They afforded a fascinating new entertainment for me, with their wild tales of this wild country.

New entertainment, in that the tales were about Idaho. But out in Kansas, Buffalo Jones had told me many a story as we sat by the base-burner in the Keep home, where Charley and I then roomed. And I remember Buffalo Jones said to me, "You ought to meet Zane Gray. He likes to write, too. I am taking him to the 101 Ranch to pick up some stories. No, he hasn't had anything published yet, but he keeps on trying." It was Buffalo Jones who killed thousands of buffalo; who founded Garden City, Kansas; who finally lassoed lions in Africa, before the motion-picture camera.

17

Our two new friends were pathetically appreciative of my cooking. "The womern what hooks up 'ith me," said Tony, "kin be either chuffy er skinny, but she gotta make spud salad like this here o' yourn, Mrs. Greenwood."

They brought Jeff's little gramophone, with its wax records, and there is no way of estimating the abundance of cheer that happy little instrument brought to our lonely farm-house. Things that I hear I somehow feel that I am also seeing and smelling and tasting and absorbing through my skin. Such were the songs that the swiftly whirling cylinders brought me. One was "The Button-hole Finisher," ending with the words, "I'm a nice Yiddisher boy!" And there was "Good morning, Judge," a narrative, with song, which showed us a tipsy Irishwoman brought into court before a judge she had known since he was "nothin' but a pup," as she said; she sang some rollicking come-all-ye's, among which was one beginning,

> As I went out one marnin',
> Down by the river side,
> I met a young maiden,
> And coal black was her eye.

And there was "Below the Mason-Dixon Line." And Ward, of Ward and James, reciting, very well, a scene from *Macbeth*. Shakespeare on a pioneer sagebrush farm! I sang with the gramophone, and I danced with it, habits which I have never relinquished; for even now I sing with the grand-opera stars, and the famed symphony orchestras play for me to dance. When I have reached the stage where I can no longer dance and sing, I shall have to have a certificate from some one proving I am really I.

Susie always came with the men, and she was always freshly scrubbed, but still with her scraggy long bangs in her eyes. I took a few hair-pins and pinned them back. She was really pretty, except for that cold hostility, repellent seen in any eyes, but so sad in the eyes of a child. Wistfully she stared at the light-blue dresses I wore mornings and the white for afternoons. "My Mama didn't never wear no pretty dresses like you," she said. "She didn't wear nothin' but black, all the time."

Poor child! Poor young mother! No wonder there was a divorce. Clothes affect the attitude of every one around you, and besides, with you yourself, though you may not know this truth, clothes are ingrowing. Folks must dress attractively, or dreadful material and psychological things happen to them. *Psyche* means soul, and to me it means something more than your little peanut soul that you bother God about saving for only God knows what. *Psyche* means all you are, away down under, even where you know nothing about yourself. If you dress in black all the time while you are the young mother of a little child, you blacken that child's world, its memories of you, and cast a shadow before its future. You give yourself black dreams by night and black dreams by day. It is true that clothes are only whirling electrons and that color is illusion. But an illusion can be the truest fact there is. Whence color? Not by reason of light waves—there is no color in them, or of them. Whence color? All color is psychic...soul...the *Ding-am-sich* of everything.

One morning, before the fencing had been completed, I was astonished by the sound of trampling feet just outside my kitchen door. I fairly bolted forth in my amazement, and there before me I saw the rhythmically moving backs of a herd of cattle being driven directly over Charley's wheat-field, whose light-green blades were just piercing the rich dark soil. Two stubbly-bearded men on horseback, wearing sheepskin jackets, were urging on the animals, although the mist of green on the face of the field was apparent to any eye.

I cried out, rather excitedly, and my voice can be heard always, "Please! Please! don't drive your cattle over that field! Can't you see the young crop growing?"

The response came with a leer and a sneer: "Your man hain't no call to fence this here land in. This here's been a right-a-way ever sence I come to this here country! A right-a-way's a right-a-way. The law's on our side. Your man kin go straight t' hell. We're comin' through here now, an', what's more, we're allus comin' through here, an' you kin tell 'im fer us it won't do 'im no damned good t' fence this in, 'cuz if he does, we'll cut the wires. You farmers is a damn sight too smart about takin' up land that belongs, by rights, to the cattlemen."

His companion had continued to drive the cattle over our crop, and the speaker spurred his horse to catch up with them. I saw the man who had talked with me ride on ahead and deliberately gather in our cow, which Charley had staked along the upper-canal bank. And was I mad? I have one of those even dispositions that is like dynamite when it gets set off.

I ran to the barn, where I knew Charley had gone to feed the horses. He had just caught sight of the invaders and was standing outside the little shed-barn, staring in amazement. As I ran toward him, I called, "Charley! They've taken Jersey from the canal-bank, and they're driving her out to the desert!"

Where Old Buttons was, I cannot remember. Charley mounted Old Nell, one of the great, lumbering farm horses from Kansas, and off they went to the rescue of Jersey. Out in the northern desert where some day the gasoline Split-the-Wind would importantly chug across the landscape, there he found Jersey, cut her from the herd, and told the herdsmen what he thought of them. It was not any better than what they thought of him. It is a waste of time to tell folks what you think of them. They know already, and if they don't know, it is because they don't care. Too much talk in the world, I say.

For Time is the answer to all things. Either you get what you want in the course of time, or you do not, and getting what you want usually means plugging away at the job and hanging on through thick and through thin, through scorn and through praise. The cattlemen could be on the job of herding only a part of the year, while the farmer was there all the time.

There was no road beside our farm when the herdsmen drove over our crops, for there was no *beside*—nothing but sagebrush desert, with a Mormon farm in the far distance, recognizable by its clump of well-grown trees, and the Endicott farm in the near distance. At first, for some time the cattle-herders cut our fences with wire-clippers, which they carried for the purpose; but after awhile there were too many acres fenced in, and, besides, there came to be a well-marked road, running north and south, out to the desert. But our troubles were never done, so far as they were concerned, for year after year the cattle broke our fences and feasted at our stacks of hay.

THE MAIL! That first summer we had no mail except when Jeff and Tony went to the desolate town of Milner and brought it back to us. I could see them coming up the road on Jeff's wagon, Tony beside Jeff, and little Susie standing between his knees, as Walter had stood at my knees when we drove from Milner for the first time. I knew it meant mail, and my heart danced joyfully. I would run to the kitchen door and "Hoo-hoo, Charley!" so you could hear it over the eighty acres. If he could come,' he would hurry to the house.

At that time our only driveway was straight past the toothpick-pillared porch. We were so lonely we had to have folks come directly to us. I might say here that Jeff's wagon was practically the only vehicle that made use of this road. There was no one else to come. Even the various kinds of farm agents had not yet discovered us. As the years went by, these would swarm about us like bees at the smell of honey. They would put us on their regular routes, and we would receive them in our home as guests.

I could hear Jeff's "Whoa!" and Tony calling to Susie to come down on the side of the wagon where he was standing, instead of attempting to descend alone on the other side, as she always did, in the kind of hating-the-whole-world way poor little Susie had. Can you blame her? There is not a much wickeder thing that can happen to a child than to be deserted by its mother. The outrage is not comparable with being deserted by its father. That may never affect the child. But to be torn from the breast from which it drank its life, in such confidence of continued and unselfish love, does something to a child which will affect every human relationship it has so long as it lives.

The bright light in their eyes was for me, as they came trooping up on the toothpick-pillared porch. Susie came first, not because she wanted to, but because Tony thrust her before him as he came. Jeff had been left to bring the mail, but both men were bearing goodies for me, a box of candy from Tony and a box of sweet cherries from Jeff. I am about equally fond of chocolate creams and sweet cherries, so the gifts were much appreciated. Both of them seemed anachoristic as you saw the miles and miles of sagebrush desert through our open front door.

19

For several days after their trip to Milner our house would be littered with papers and letters, purposely so, that we might read again what Cousin Joe said, or my sister Florence, or Charley's sister Margaret, or my sister Hattie, or Charley's sister Laura, or my brother Bert, or Charley's brother Ed, or my father. My mother had died when I was a little girl—my wise, delightful, laughing mother. I remembered her. How could a child forget so much love and laughter?

Rob, Hattie's husband, sent us Eastern papers, which he, in turn, received from his brother. For years he sent these papers to us, and in the course of time they came to be shared by the whole district, children coming miles for them when they were expected to have arrived and been read by the Greenwoods.

I was the only one who cared for the *New York Times Book Review* section, and you cannot know how much I cared. You see, I was transplanted there on that farm by Charley and Fred and the man who wrote about the eggs that, laid end to end, had bought a farm or something, but inside me I had always been a writer. I had sung before I could write, and I remember as one remembers first love that moment when I knew I had been born to write. I was reading aloud the first story I ever read, out of my little brown *Appleton's First Reader*, and an ecstasy suddenly shook my heart. I looked up as though at the call of a vision, and I exclaimed aloud, to myself—there was no one near—"I can do that! I can write like that!" And I had never written a line, so how could I know?

Yes, I was a born writer, but I could not write. I used to wonder as I pored over the *Times Book Review* whether I should ever write a book that would be reviewed there. And well might I have wondered, and wondered with justifiable apprehension. I could not write, though I thought I could. I was not depending on the opinion of any one as to whether I could be successful in that field. Many born writers fail because they never really learn to write. And some, alas! succeed for the same reason. But all of them must write just the same, no matter what the outcome. They cannot stop, any more than they can stop breathing, until they die. If you do not write in that passion, you are not a born writer, but you may be very successful at writing just the same.

The farm made me write. I was too lazy, had I been in the midst of luxury, to persist, although I should have continued to be tortured by the urge to write. Now my torture consisted in not being able to write. There was so little time for that.

There was excuse for my not being able to do on that farm all that was forced upon me by circumstances. I had been an invalid child, psychic, somnambulistic, and I had suffered through childhood so that I was not expected to live. I had suffered as a young girl, and I made no complaint, not through bravery, but because I took for granted that everybody else felt as I did. I had no self-pity, but I look back with deep, impersonal pity now at that young girl, suffering uncomplainingly, with no one who had sensitiveness to help her bear her pain. Ah, well! who suffers in youth reaps the power to understand in age.

I was an extremely good housekeeper that first summer. That, or my cooking, or possibly just that I was the only woman they ever saw, led Jeff and Tony, separately, to confide solemnly to Charley, "If I could get a woman just like your wife, I would marry tomorrow."

Charley told me, with that air of sanctification which bespeaks the sense of proprietorship a man feels when his wife is praised by other men. As for me, I was slightly chilled by the word "tomorrow." Why not today?

I did manage well that summer, for my duties were only slightly increased over those I had handled in our bungalow. That was not farming. It would be farming when I should rise at four to work in the garden and continue working all day, without let or stop, until ten at night—or possibly, with luck, until nine, with a precious, precious hour after nine to sit at my old typewriter and write the tiredness out of my aching back and my cracked-heeled, burning feet.

When we really farmed, I did not know how to manage. I took too much on myself, as I have done in every occupation I ever followed. Had I not astounding vitality, I should have killed myself many times over. Mrs. Asper managed well. She planned everything, and she put everybody

to work. The supreme art of managing is to keep other people working and leave yourself free to think and plan. Mrs. Curry taught me brave adaptability, but Mrs. Asper was an example to me of good management—an example by which I did not profit then, but which some day I hope to use.

It would have been a matter of good sense for me to have saved myself. After there were farms around us, and the farmers used to flow to our living-room to hear Charley talk (he is an excellent talker), rain pouring outside, instead of allowing them to "settle the Government," as they called their informal conventions, I should have appeared among them with scrubbing-brushes and soap and rags and set them to work, for that was something they could do; for so far as settling the Government is concerned, it looks as though God Almighty would have to dip his sponge in the Milky Way and wipe us out and begin again. The way things look to me, I have a good mind to stop this writing right now and go out and begin building an ark with grocery boxes I can get free from Tom the grocer, in our neighborhood. I have two cats with which to start the animals. And it looks like rain.

That first summer we went to Lateral Eight to a dance in the Riverside school-house. It turned out to be a most solemn occasion. A handful of young people in new Twin Falls clothes moved solemnly about. I felt entirely out of place. Not because I was not dressed as well, for I was even better dressed, my New York clothes, ordered in Kansas, as I always bought, bearing very well the comparison. But I did not belong among those sad-faced young dancers. I love so to dance that I cannot help smiling. And I cannot help smiling most of the time. To be truthful, R.L.S.'s little jingle should be revised, and then it might apply to those dancers:

> *The world is so full of the changing of things,*
> *I'm sure we should all feel as upset as kings.*

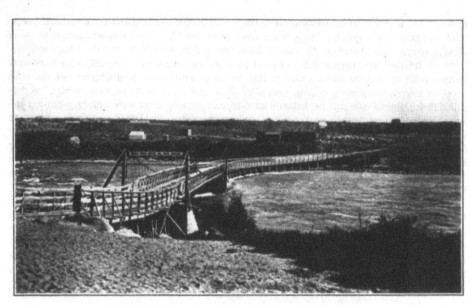

THE OLD WOODEN BRIDGE AT MILNER

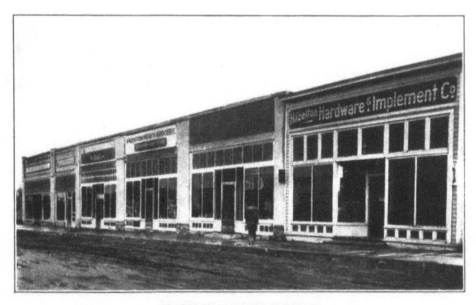

HAZELTON MAIN STREET

Jeff and Tony and little Susie went in Jeff's wagon, and Charley and Walter and little

22

Charles and I went in our narrow-gage buggy, riding high on one side, either Charley's or mine, because the ruts were broad-gaged, Old Buttons jogging along, the harness making that *soo-soo-soo* sound that harnesses make when horses jog. I had such good babies. Night or day they never cried, and always they gazed around, too busy taking everything in to want to be the center of interest. At the school-house Charles had slept on a desk, and Walter had sat near him, serious, as always, yet with a mine of humor within him, which of course we did not then know.

Jeff took the lead there, his wagon bumping and rattling ahead, and going home he did likewise. Suddenly one of our front buggy-wheels struck a big piece of broken lava so forcibly that my sleeping baby was thrown from my arms, out into the brush. There followed not the faintest cry, and my heart stood still at the implication. My baby must have struck his head on a piece of the lava that lies about in that region. He must be dead. I sat there stupefied, unable to utter a sound, trying to realize the horrifying calamity that had befallen me in that second of time after the buggy had struck the boulder. This was how such tragedies came to people. Unsuspecting, they go out for pleasure, and come home to mourn.

Hearing Charley's shout as we struck the boulder, Jeff drew rein and called back, "What's the trouble?" He did not wait for a reply, but was down over the side of his wagon before Charley could get out of the buggy. I was too stunned to follow their conversation, but I could hear them scraping through the brush, looking for little Charles. In a moment they would bring my dead baby to me. I would have to carry him thus all the way home. I was turned to stone. A few seconds, and Jeff laid him in my arms, perfectly well, perfectly sound asleep.

HOW WE SLEPT that night, after our ride through the brush to the school-house, dancing, and riding back again through the brush! In the night, while we were asleep, the canal overflowed its banks, making a lake of the coulée below our house, and a very deep lake it was, formed of the V-shaped coulée. This was a strip of land very difficult to farm; hence Charley had decided that it was just the place to stake out Jersey. In the night, at the back of my dreaming unconsciousness, I thought I heard a cow bawling. But a cow bawling meant nothing to me at that stage of my life. There comes a time on the farm when you develop antennae of sensitiveness all over your body. You feel that things are wrong out at the barn, or the chicken-house, or what-not, and to hear a cow bawling even in the back of your dreams will bring you stark awake with the swiftness of light reporting a long-dead star—a dart, and you would be running down the hill to that cow, clothes or no clothes.

It was too bad that poor Kansas Jersey had been forced by fate into the hands of city farmers. Of course you know what happened. It haunted me. I thought I should have saved that cow's life, though probably my idea of saving a cow's life at that time might have been to float the ironing-board out to her so that she could cling to it with her hoofs. One thing I did. I vowed that no cow ever again should lose her life on that farm if it were in my power to save her.

I was put to the test late that summer, when Ray McKaig was proselyting for members to support the Non-Partisan League. His very lovely wife, Leah, came with him, and I was rejoiced at seeing another woman. She said her feet were hot and tired. Had she paid me this call in the city, I should have let it go simply with expressing my sympathy. But we did things differently in the sagebrush. I expressed the sympathy, and then I went and got a foot-tub, and a really-truly Kansas towel, instead of the beet-seed sacks the men used, and a bar of toilet soap, and she drew off her shoes and stockings and sat there bathing her poor feet while we talked. She and Ray had tried farming in North Dakota. She had been a teacher of English, and he was a young minister when he met her. They had not been able to bear, without protest, the wrongs of agriculture. So they had given up the farm.

We sat there talking together while she bathed her feet. I was so happy in being with another woman that the new cow had a hard time making herself heard, although she was bawling at the top of her voice, and her long, hairy, lugubrious face was almost pressed against the window-pane. Suddenly I remembered my vow, which I considered as sacredly given as that old one of Hippocrates, sworn to so solemnly by my father when he began his practice of medicine. Here was

a cow in distress, for some reason. Perhaps I could save her life.

I told Mrs. McKaig the tragedy of our first cow's Ophelian death, though not with flowers in her hair, and asked her to excuse me while I investigated the cause of Jersey II's woes. She said she would put on her shoes and stockings and help me. One look at that cow was enough. I had seen her before, when Charley had treated her for bloat. I could well see that unless extreme remedies were given, and that at once, even slinging her up to the hay-derrick could not save her. I had heard the farmers say to Charley that when a cow is sick and lies down, if you can only keep her on her feet she will not die. So they make a sling, wrap it around the sick cow, and string her up to the derrick, just high enough for her hoofs to touch the ground. If she dies, it means you did not get her up there soon enough. Medical science does so much experimenting with animals for the sake of humanity....I pass on this slinging-up business to physicians, who could maybe save many a life by slinging up all the sick folks so they would have to stand. I leave the details to the doctors, whether they sling the sick people up to the chandeliers or have hay-derricks in all the city streets.

I knew I could not make a sling for a sick cow, for I never had seen one, and had even neglected to find out whether they are made of rope or of canvas. Besides, I have done a lot of things on the farm beyond my strength or understanding, but it seemed to me that stringing up a cow to a hay-derrick was a pretty ambitious project for a woman of one hundred and twelve, or so, pounds. It might leave me strung up on one end of the rope and Jersey on the other end, and what a sight that would be for a husband when he came home from electioneering around the country—his cow made well by slinging up, and his wife half dead from the same cause.

I was determined to use every means short of slinging that cow up to the hay-derrick. A gag, I knew, was the first requisite. I had not noticed how Charley made his, nor how he made it stay in the cow's mouth, so I had to go at the business by the trial-and-error method, the way marriages are made. I took the butcher knife and whittled a stick. Then I tied a rag to each end. With the gag and a big pail I went out to the cow.

This Jersey was of the dehorned variety. I could not imagine how I was to keep the gag in her mouth. If I tied the rag around her neck, she would hunch about until the gag would be out of her mouth. You can't tie anything to a cow's horns when they have been burnt out with acid at the time they started to grow. As I looked at that long, insistent face, I saw there was absolutely nothing to which to tie the rag strings of that gag except her ears.

She did not like this. She probably remembered her dehorning experience when a calf, and perhaps had the idea that I was trying to de-ear her. I managed, by stretching on tiptoe and almost hanging my weight on her ears, to accomplish my design. But I know now that the cow and the giraffe must have belonged to the same species when our old buggy horse Buttons was a little *Eohippus*.

You see, when a cow has eaten alfalfa, she bloats. It would seem more sensible to me to bloat on dried hay and a drink of water, the thing that happens when as a child you eat dried apples and then drink and drink. But cows are far from sensible, though I think they are like a great many people whose stupidity passes for good horse-sense. It should be called cow-sense.

After a cow has bloated, you save her life by three means, besides stringing up in a sling to the hay-derrick. First, you must hurry to apply a gag, to hold her mouth open so she can belch up the gas, because no gas, no bloat; in fact, if you had some means of degassing a cow at once, you could deflate her like a balloon. The next thing to do is to throw cold water on her flanks. This condenses the gas, I suppose, so that she is not so inflated, but I cannot see how that alone would be of much use, for to stand throwing bucket after bucket of cold water on a cow's flanks for days and days, just to keep her alive, is one of the few useful things I refuse to do. The third treatment for a bloated cow is to walk her up and down. This moves the gas around in her seven stomachs...or is it five?...and, the gag being properly placed, she then explodes at the mouth, a very interesting performance if it might somehow be used as power to light a house, or something.

I have omitted one method of saving the cow from death by bloating, but that method I

24

should fear to attempt, not being very sure of a cow's anatomy. If worse comes to worst, you take a sharp knife and stick the cow in one of her stomachs. You cannot just go at it blindly, even if Nature has arranged the cow for hoarding stomachs. Now, when a human being gets gas on the stomach, he goes to the kitchen for a teaspoonful of baking-soda. I suppose the reason soda is not used with cows is because it would take a bucketful. And, too, I have an idea that some one would have to hold the silly thing's nose while the soda and water was being poured down her throat, and did you ever try holding anybody's nose when the whole face was just one big nose?

A cow may be silly, but after I got that gag in Jersey's mouth by tying the rags to her ears, she learned how to twitch them off, and I spent every few minutes putting them on again. The cow was so interested in getting rid of the rags that she stopped bellowing, so that if bellowing had been what was the matter with her, I should have had her cured. But her sides were still inflated, and though I do not know whether politicians are right in saying that it is dangerous to have an inflated dollar, what I do know is that an inflated cow is cause for thought.

In one of the moments when the rags were staying on her ears, I led Jersey down to the canal, forcing her out into the stream as far as possible without being obliged to go along with her. She stood quietly enough, the rags on her ears acting as a "county irritant," as a doctor from Burley once expressed it when he rubbed the chest of one of our children with some kind of peppy salve. I began throwing pailful after pailful of cold water on her flanks.

When I had reached my limit of endurance on this fire-brigade business, I led Jersey from the ditch, lovingly and patiently replacing the rags on her ears and the gag in her mouth, and saying a few bad words in an amateurish sort of way. I thought, as I did so, that an hour more of that cow would take all the amateur out of my profanity. Besides, the cow was holding back her gas on purpose. I was beginning to feel sure of that. Just stubborn. She had not belched a belch.

Mrs. McKaig now came out of the house, and together we paced the driveway, the cow between us, looking as though she were laughing, by reason of the gag in her mouth. I felt very solemn, and I managed to inspire Mrs. McKaig with the same emotion. Charley and I could not afford another cow. This was no joke, unless the cow was of the contrary opinion, as I was beginning to believe.

But no! This cow was in the last stages of bloat; I was now sure of that. She should be stuck. I wondered, if she got down, whether I should be able to stick her with the butcher knife, and how far back her five stomachs...or is it seven?...run. Just when I was getting to the desperate point of attempting this sort of tapping act, in through the gateway came Old Buttons with the buggy in which Ray McKaig and Charley were still talking politics.

Upon my explanation, the cow was led to the barn without a word, this being out of respect for Mrs. McKaig, as I afterward surmised. What took place between the two men in the barn, I do not know. But I can tell you that I was hopping mad when Jersey's calf was born the next week. Maybe I was dumb about mixing up the cultivator with the spring-tooth harrow, but I do think the Baron should have told me a few little things like that. I know he did not feel too modest about the matter, and if such had been his affliction, he might at least have explained, under cover of darkness if necessary, that Jersey was in a delicate condition, the way the newspapers always blush in print.

I HAD READ so much about germs and bacteria and what-not that I spent my life making things antiputrefactive—I think that word sounds more terrible than "antiseptic." There was a set of shelves in the little entryway to my kitchen on that sagebrush farm. On these I placed a glass for each member of the family, including Jeff and Tony, for they were boarding with us while putting up the fence. In my neatest script I wrote the name of each person, pasting it on one of those glasses. On the shelf below I put a towel apiece, to match the glasses. The water-bottle hung near, in the shade, exposed to the breeze. I had filled it, and kept on filling it, with boiled water.

That water was the most evil-tasting stuff I ever put in my mouth. It was perfectly cold, perfectly safe to drink, and perfectly flat. Charley had warned me that men and hogs and horses and cows were likely to use the lower canal, where we got our drinking-water, for their wallowing and

25

bathing. I do not go around smelling folks, like a dog, but it was not necessary in the case of the farmer. I was not afraid he had been bathing in the canal. Maybe it was the flavor of the animals we missed. I think now that it is a mistake to remove all the bugs and microscopical fish and flora and fauna, though fauns are not frequently found in drinking-water in Idaho. Better enjoy your drink of water, and maybe have a sick spell once in awhile, than to have to slosh it down and close your eyes to keep from tasting it.

There was a north canal, not used by any farm-house, and in this my whole tribe of children learned to swim and dive and float. It was there that the men took their baths. Our men, I mean. I, too, enjoyed its silky, steel-cool waters, the native willows dipping their fingers in its current. I loved it. The boys and men, being the privileged Lords of Creation, with nothing obscene about their noble bodies, were allowed to get into the water without cloth wrapped around them. But Rhoda and I had to wear bathing-suits. Of course, Rhoda was not on the farm that first year, but this book will sprint back and forth like an old woman maundering over her knitting. Or is it bridge these days? I have an idea old women have no memories any more.

I am sure that Tony bathed as often as the others, but he had a faculty for looking slouchy. Jeff, on the other hand, was immaculate. And the thing that marked him out for me was that he read good books, enjoyed them, understood them. In spite of what he had said to Charley about being willing to marry me, I was not his heart's inspiration. When he brought our mail, he always sat quietly in a corner to read a handful of letters. I could not help seeing one day that they were addressed to him in what appeared to be a feminine hand. This was confirmed by his voluntary statement, "You don't know what these letters have meant to me this summer, Mrs. Greenwood."

I knew that Jeff was divorced, his wife having run away with another man, taking her baby boy and leaving poor stricken Susie behind. The young wife had fled from those black dresses, the monotony of the farm kitchen, the odor of manure, to more black dresses, more monotony, more smell of manure. But the illusion of sex is one thing that man will never overcome. For that matter, if the illusion called *color* is a psychic fact, and not a material one, why may not the illusion of *sex* be a psychic fact, and not a material one? Perhaps the reason it fails so often to mean permanent happiness is because we regard it as material and treat it so, and the soul, the *psyche*, is thereby lost to us. Marriage need not, of itself, spell disillusionment.

That first summer began my love for Idaho above all other states I have known. Perhaps it was because I sat up in the clouds, like the God Doré drew for the big rose-colored *Paradise Lost* we had in the home of my childhood. There is something about mere altitude that clarifies the vision. It was a lovely valley, the blue Minidoka Mountains to the south, the white Sawtooth Mountains to the north, the black, sprawling buttes to the west, and, so often, the thrilling mirages of cañons to the east, where ordinarily we could see no mountains. And there was in my mind the constant sense of a limitless sky, over the surface of which the changing clouds floated.

One day I brought a bug, which I had preserved in a tumbler, for Jeff to see. "You were telling us about wood-ticks, and I think I have one here," I said.

One glance, and Jeff responded, "That's not a wood-tick, that's a bedbug."

I had been taught that only slattern housekeepers ever had bedbugs, and here was I, at the business of farm housekeeping not a month, with bedbugs to show that I had failed.

Jeff saw my evident distress and offered this comfort: "They're right in the wood here. You can't help it."

I had a sneaking suspicion that if they were in the wood, some woman was to blame for getting them there. I am a pretty omnivorous reader, and I had never read anywhere that bedbugs haunt lumber-yards with the idea of being made up into houses.

When Charley and I were alone, I said to him, "Were you troubled with bedbugs when you slept at Curry's?"

"I should say we were," he answered. "We were eaten alive. We simply could not stand it. As soon as the floor was laid in this house, we brought our bedding right over here. It was ghastly."

I did not say a word, I was so appalled. I have changed greatly in the course of my life. I

used to feel, when a catastrophe such as that had struck a family, that the guilty persons whose intentions had been innocent enough should be saved the punishment that knowledge of their crime would cause them. Now I spare no one. It saves me from burying all those hideous thoughts within myself. If any one should be forced to share them, it is the persons who caused them.

I imagined I could exterminate the bedbugs by catching them one at a time. Night after night I got out of bed to kill the dreadful beasts as they crawled up the walls or, worse still, bit the children. I never had a full night's sleep while that scourge lasted. I kept them down, it is true, by this means, but they continued to appear. I hate to admit that through my inefficiency I suffered the torture of sleepless nights on account of those bedbugs for four years. And every day I took all bedding off the beds, turned the mattresses over, and searched. Certainly I found bedbugs. The house was overrun with them. But one day I traced a bedbug to its lair.

Upstairs in the unfinished room was a bed with coil springs. Millions of eggs were in these coils, and bedbugs of every age, from little Willie in a bib to Grandpa with a cane. I stared, chilling all down my spine, the saliva beginning to run in my mouth. The latter function meant how much I was going to enjoy what I was about to do. Gasoline. Cans of gasoline. And I poured it in the baseboard cracks. We saw not another of those devilish insects until Hi Hepgard lost his farm and brought all his things to store in our upstairs. But that was years afterwards, and I was not long having them then. I had learned where to look for the racketeers.

We had other pests. Folks might have bedbugs in the cities, but they could never have packrats and mice with donkey ears and hairy tails. I do not know that this is anything to brag about. We should never have had them either had not the man who built the chimney accidentally left a brick out.

Those mice were the strangest-looking creatures. Twice as big as a city mouse, and with long, hairy tails and ears like a donkey's or a rabbit's. They chewed the fronts from my best dresses before I even knew about them. We slept so well in those days. No worries—we were on the road to fortune, and nothing could stop us. Charley had no parade of debts then, and I did not lie awake wondering what was to become of my children. So the mice could eat the fronts of my silk dresses and I not know until I took them from the nails. It was a good little house, but I should so have appreciated even one clothes-closet. I suppose even a clothes-closet could not have kept out those donkey-mice.

The mice did not wake us, but the packrats did. They evidently had not learned that the Greenwoods had come until after the mice read it in the paper. But we knew they had come without having to read it anywhere. They lived between the ceiling and the floor of the unfinished upstairs, and they were night-lifers, like the people of New York City, as I have been told. But their night life was not a matter of theaters, cabarets, speak-easies, dances, or city whatnots. They were evidently college rats, training for the packrat Olympics, for they woke us up running, hurdling, pole-vaulting—I am sure it was pole-vaulting—in fact, everything but rowing was practised, and maybe they were planning that. Sometimes there would be a fight, and from the sound I am sure they were using boxing-gloves. We could always hear the squealing of the one getting licked.

We did have wood-ticks, too, in spite of having more than our share of bedbugs. The wood-ticks did not claim to have come in the lumber. They were content to be brought in on the hairy leg of a piece of sagebrush. I had to look the children over daily, and frequently I found a wood-tick, swelled blue, all Greenwoods having nothing but blue blood. On common folks, of course, they would swell red. Still, I suppose there are scientists who would contend that the peculiar gray-blue was intended as camouflage while the wood-tick was living on the sagebrush. Nature is not so clever. Otherwise she would have taught the wood-tick to turn pink on baby Charles.

August brought the flies. I had no screens except at the doors, so all summer long the windows were tight shut, except at night: Now I think of it, there were two windows in the bedroom with screens. But I needed all the windows so I could open them. I needed especially to have the dining-room windows open. It was years later that I bought mosquito-netting and tacked it

in place myself, even in the upstairs windows, because some one always had to sleep there.

When I went on the farm, the Government was just the Government to me. It had never done anything conspicuously good or specifically bad for me. At the time of the Spanish-American War I jilted two young men because they would not volunteer on account of the Government already having its quota. And I nearly married two others because they paraded up and down the main streets of my home town, with other willing college fellows, banners—star-spangled banners—flying. Of course, the Government did have its quota, and I might have been arrested for bigamy, there being a prejudice against anything but progressive polyandry in the United States. It was glorious while it lasted, and no damage done, for none of the fellows went to war, and I did not marry any of them. So that was all the Government meant to me.

Something about farming makes you want to "settle the Government," as the farmers say. You see, the Government allows the city man to go right on living as though he were able to do so, but the Government is the friend and helper of the farmer. The Government sent us hard-working farm women the plans for making homemade screens. Market our crops for us? Heavens, no! Why, woman, that's socialism! Well, what is socialism? Is it anything that will help the farmer and feed the starving poor in the cities? Don't talk that way, some one might call you a communist! Let's talk about flies.

There were plenty of flies to talk about, swarming around that dark-green farm-house. Every morning, as soon as he was up, Charley went out with a gasoline torch and burned flies on the outside walls and under the eaves. Inside, by noon the ceilings would be black. It cost me an hour of my life every summer day, all the years that I lived on that farm, to drive out the flies so that the men could eat in peace.

I was not a good housekeeper, therefore I could not demand that the manure at the barn be hauled daily to the fields. But it would seem good business to me that this should be done.

Think of guarding the health of those who eat in the house. And the poor overworked farm woman—can't we say a word here for the overworked farm woman, wasting an hour of her busy life every day chasing flies through the rooms with a dish-towel?

AT FOUR O'CLOCK of one morning in August, that first summer, I was awakened by the sound of some one tapping on the glass of the half-lowered window in which there was no screen. It was twilight in the room. I slipped into a kimona and went to the window.

Sam Curry was there. "Kin yuh come over to my place, Mrs. Greenwood? The woman's sick."

Even then I did not suspect why she was sick. I have always been unsuspecting—a polite way of saying *dumb*—and so it took me by surprise when I saw that unmistakable look on Mrs. Curry's face and observed that she was preparing her bed. She had no white sheets, just some double gray cotton blankets, evidently bought for the occasion. I knew, instinctively, that she had nothing to which to change while those blankets might be washed. I knew that there was no thought of washing them for months and months. And knowing this, I was haunted by the specter septicemia.

All I had read of the horrors of childbirth on the farms came back to me. I was the antiputrefactive woman, and here was a dreadful example of what I had learned meant certain death. I looked around the tiny partitioned bedroom. On an unpainted old kitchen chair lay two folded diapers and two little slips, all made from flour-sacks. It was a large layette considering that it took four flour-sacks, and some time is needed to use four sacks of flour. There were no little wool shirts and no little wool bands.

I have never been able to do much with my arms in the way of extraordinary feats, as they are very small. All my strength seems concentrated in my legs. I used to be able to run with the wind and to dance all night. When I saw that layette, I made up my mind that I could beat the stork. Without a word, I flew, on my light feet, from the Curry farm to the Greenwood farm. In an instant I had the little shirts and bands Walter and Charles had worn. I had planned to keep them always. It hurt my heart to part with them. But that was momentary. It would have hurt my heart all my life if

28

I had not parted with them.

I laid them, with some little dresses and petticoats and socks, on the kitchen chair beside the cheap iron bed with its sheets of dark-gray blankets. Mrs. Curry was now sitting on the side of the bed. For nightgowns she had made two more Mother Hubbards of colored percale, suitable for her to use as dresses when the lying-in period was concluded. She looked to be in much pain and was moaning a little, and I wondered why the doctor was not on hand. Just because a woman has had two babies does not mean she is an expert in obstetrics, any more than having a large family of children means being able to rear them wisely. Such ability and training are not inherent in motherhood. I knew a woman in Kansas who said to a little girl who did not want her to hold her baby brother, "Why, my dear, I would not hurt your little brother. I know how to take care of children. Why, I've had nine children, and I've buried seven."

Mrs. Curry was in a state too anxious to be impressed by my contributions to her layette. Sam was wandering restlessly about, or standing still, looking thoughtfully into space, listening to his wife's moans. He loved her, but he was not worried. I never saw a farm man worried over the confinement of his wife. It may be because birth is an everyday happening on the farm. Even death seems little to impress them. Death is also the farmer's partner.

But I was not used to either death or childbirth. I went out on the rough plank platform, weathered gray, and looked down the road in the direction I expected the doctor to make his appearance. It was down the road to where Hazelton would be founded before another year, the whole town of Milner, such as it was, bank and stores, picking up and locating there. Sam Curry had hurried out and stood beside me. He looked as though he feared I had intentions of escaping.

I turned to him, a sudden suspicion assailing me. "Have you been for the doctor?"

He shifted, uneasily. "Why, I thought me and you could look after her. Me and her mother done it before."

Imagine comparing my inexperience with his mother's years of midwifery! I turned on him, and I am sure there was that look in my eyes which always appalled my children, though I myself was unconscious of it. For one thing, I am told that at such times my eyes turn from green to dark blue, as my father's used to do. "You go for a doctor," I commanded. "You'd better hurry."

I could see that he was still of a mind to dawdle around until I should forget, but I kept looking at him and in that manner looked him out to the barn shed, whence in a few minutes I heard him canter forth, and I watched him take the road to where Hazelton was to be. I went back into the house and waited, sitting gingerly on the edge of a chair in the front room, facing the open bedroom door. I could see Mrs. Curry, and I was almost as anxious as she was, though not in her pain. What if the baby should come before the doctor arrived? I went out and pushed some sagebrush into the stove and filled the kettle and the dish-pan with water. I had brought an old sheet along with me when I brought the baby clothes. I remembered my father's expressions of disgust for folks who had babies with not even a piece of clean rag in the house. I had seen no white rags of any kind near the bed.

The doctor came. He looked crosser than a she-bear with cubs teased by hunters. I do not think he ever saw me. I was just something with skirts on there in the house. I was already prejudiced against him, for I had heard he was a homeopath, and my father was an allopath, and I had heard my father express his scorn of the illegitimate children born to Father Hippocrates. "Six months, and you're graduated!" I have heard him fairly snort.

This homeop was not responsible for practising. He did not want to practise. He had given up practising. He had a fine big ranch, with a great many sheep on it, and he was generally engaged in the obstetrics of lambing. It always made him mad to be called as a physician, but what were those sagebrush farmers to do, with no cars to speed to Twin Falls, and this sheepman known to be some kind of doctor? He had to come, that's all. Whether he had ever made a vow to Hippocrates or not.

He made an examination and grunted that the baby was not yet due. Then he turned to me and, without looking at me, snarled, "Get me some breakfast!"

I thought that was too funny. No man had ever spoken to me in that way before in my

29

life. I thought that if he would only look up and see what a wonderful creature I was, and see also, as he must, that I had only dropped in and was not really affiliated with the Currys in any way, he would have been ashamed of ordering me around. I was entirely mistaken. I learned that out in the brush folks are not greatly impressed by either looks or breeding. They are not greatly impressed by anything but how much money you got for that hog. How can you blame them? The farmer gives his very life, and the lives of his family, to raise a hog. The hog means reality to him.

The doctor himself washed the baby in olive-oil. I learned later to appreciate that doctor. He was not so bad—just eccentric. The next morning I hurried over to the Curry place. I found nothing bigger than a wash-basin in which to bathe the baby, but I made a good job of it. I am really not a sentimental woman, but I break down once in awhile. When I had that baby all clean, I hugged it gently to my breast. Something happened to me. I had received my initiation as a sagebrush woman. Until I die, I can never get away from that fact—there are great reaches of sagebrush in me.

II. EDUCATION

The man who sold Charley our rabbit-proof fence convinced Charley of its merit, but he had failed to convince the rabbits. It was the end of our first summer, and all we had to show for Charley's unaccustomed labor were a few undug potatoes, probably enough for our winter's supply. Charley had some good cabbage in his kitchen-garden to store for our table. I was still a city woman. It had not occurred to me to raise the vegetable garden myself. I had raised flowers in Kansas, but I had an idea that the vegetable garden was man's work.

The thing you learn on the farm is that the cultivating of crops and the butchering is man's work, while everything, including cultivating the crops, is woman's work, except the butchering. I have a suspicion that the only reason butchering is not included is because men enjoy doing it. Great day! Two or three men together, doing the butchering. Men love farming, and one of the reasons is that the normal human being is gregarious. Almost every operation on the farm that is considered man's work requires at some stage a number of men to prosecute it. There is fun in working together, joshing and laughing, but it is a pleasure that the sagebrush women knew very little about.

Mrs. Hubert and Mrs. Hatch were good pals and managed to help each other with their work, living only about a mile apart. And Mrs. Asper had a sister about five miles away and several other relations who used to help her. She was my nearest neighbor. We might have helped each other, but she had no need of me, having so many relations; there was no reason for exchange in our case.

Mrs. Asper did not come until the second year. But when I came, the Huberts were already there, unknown to me, several miles from our ranch; and Mrs. Hatch came at the end of that first summer. She was an extraordinarily capable woman, with a sharp tongue. Extraordinarily capable people usually balance the scales by being extraordinarily uncharitable toward those who are not so efficient. Every virtue has its vice on the other side of the shield.

Charley had really worked—worked to the limit of his strength, and the rabbits had eaten his labor. A mere blush of green showed where his crops had been. I had worked harder than I had ever done in my life, but I have to smile now when I look back on that first summer and meditate on what I considered work then. I did not know that three miles away Jonathan Bradstick's wife had that summer ridden a two-way plow, one baby about to be born, another clinging to her lap. They lived in a little tar-paper shack. I never saw her that she did not have a smile on her face. I saw her for the first time at the end of the summer.

The summer was ended; we had no crops to sell; we were neck-high in debt at the grocery-store; we had no money. Then something occurred which looked to Charley as though sent straight from God, or wherever things are sent from to men who do not take much stock in the kind of Creator, if any, that the churches bother about their little peanut souls. I was not a churcher, but I had a churcher's untrusting faith in God—the kind of faith that prays and prays and is never sure a prayer is answered until it is answered. And that is not faith. Charley bothered God not at all. Our temperaments were very different in one thing: he had never given any thought to God in his life, whereas I was obsessed with the thought. I was always wondering what it is all about, and who did it, and a great deal of the time my wondering about who did it was so I could place the blame. I had yet to learn gratitude for small favors, and that is the beginning of faith.

What was like a special dispensation to Charley was to me a bolt of lightning out of a clear summer sky. I was enjoying farming. I had taken on my shoulders none of the worries that were harassing Charley. They simply had not sunk in. I hate debt with an overwhelming hate. I shall never be able to branch out into business, because I will not go into debt sufficiently to demonstrate my right to credit. I believe, too, they use arithmetic in business, and that counts me out. As yet, I was not conscious of our grocery debt.

I was soon to have my come-uppances, as we say in the brush. Nemesis was about to catch up with me. One day Charley Willey came to the house, met my Charley outside, and strolled with him to the shed barn, where my Charley was about to milk. I saw them, casually, through the window. After you have been on a farm for a few years, you do not see any one casually through the window; you see them with absorbing interest, noting the new shoes, or the old hat, or the sentiment telegraphed by the movement of the body. I knew a farm woman before I went on the farm, and I used to condemn, with conscious superiority, what I thought her extreme curiosity. I did not then know that you can have such a hunger for your humankind that you learn to know every wagon as it goes by on the road below by the dog trotting underneath, the dog being the easiest point of identification of the person seated in the front of the wagon.

Charley Willey, who was a trustee of the district school, and the other two trustees, at their meeting the night before, had decided to ask me to teach the school the coming school-year, which was to begin not three weeks away. The contracted teacher had broken her contract and was not coming. The procedure of the trustees in their effort to acquire my services ran true to rural form, though I did not then know this, and I was much surprised that they had not come directly to me. Farmers never ask a farmer's wife whether she will do what they want. They always ask her *husband*, and husband, of course, is obsolete as a word, the reference always being to her *man*. There are no verbal *wives* either. Each is referred to as *the woman*. Adam, who was the first agriculturist, began it. You will remember that he answered the accusations of the Lord by saying, "*The* woman whom thou gavest to be with me, she gave me of the tree, and I did eat." (The big coward! And that's the kind of first Pa all of us had!)

It was a good thing the trustees did go to Charley first, for had they consulted me, I would have answered most decidedly in the negative. The one man I would never have married was a farmer, and the one thing I would never have been was a teacher. It is a mistake to object to any shift of fate. Today I know that among my richest experiences are those acquired through being a farmer's wife and through being a teacher. Perhaps, too, there was a place for a laughing, foolish woman, who had a passion for writing, in both the fields of agriculture and education. Those who easily conform, who have no decision as to what life should give themselves and others, are not the ones to discover and fight injustices perpetrated by men, or women, who know they can wrong their fellowman because they have the undisputed power. A teacher who does exactly what she is told, either by trustees or by a course of study, whether she believes what is to be done is right or wrong, is the teacher who in the school-room insists upon implicit obedience, whether she is right or wrong. No human being can be positive he is right until he listens patiently and tolerantly to the other fellow's side. And that goes in every walk of life.

Charley must have cogitated how he was to approach me, although he was never notably tactful where I was concerned. Few husbands are. It is the wives who have to exercise this gift, generally because the money is where they can get at it only in that manner. It is a gift which passes down from mother to first, second, and third daughter, and to as many more daughters as there are, and from them down to other daughters. It was a worse affliction in the Victorian era, but it has certainly not passed away, in spite of woman's thinking she is a free human being because she has the right to vote wrong, as I did in the last election. (I think. We'll see what that admirable man in the White House does about agriculture.)

"Well..." began Charley, taking a scalded cheese-cloth square and straining the milk into a Kansas crock—an office that he almost always performed for me, "Well...Mama, we can pay our

debts at the grocery-store now."

"You've sold something!" I exclaimed joyfully, getting ready to execute an impromptu dance, a thing I was always glad to do.

It must have given Charley a pain to see my lack of realization of our situation. But then, there was my side of it, too. I had felt shuddering horror at the very thought of a farm, and the persuasion of Charley, together with that wonderful chanticleer weekly, had put me there, in spite of every instinct I experienced that I, of all women, should never go on a farm. I had been taught to believe, by Charley particularly, that a fortune was just waiting for us to come and pick it out of the soil.

"I have not only sold nothing," said Charley, placing the milkrag in a tin of cold water, "but I have nothing to sell. Use your eyes. Does that look like a crop out there? The rabbits got it all. I have about five dollars worth of potatoes. That's my crop."

I am pretty silly at times, but sometimes I have to stop to think a little, so I was silent for one thousandth of a second, a long season for me. I did not even have time to formulate my question as to what magic means he could employ to pay our bills.

"It's just this way," said Charley, beginning to wash his hands in the granite wash-basin which sat on the home-carpentered wash-stand some farmer in Kansas had sold the Baron. "Charley Willey says that the trustees want you to teach the school this year. The teacher they had failed them."

"How do they know I can teach?" I demanded, my green eyes, I am sure, turning to that black-blue they do when I am powerfully moved. At least I felt black-blue at his words.

"Oh, Jeff and Tony have told them how much education you have."

"But I never tell any one how much education I have, for I have had just enough education to know how little I have."

"You speak good English, don't you?"

"Only when I feel like it....But arithmetic! I can't do arithmetic! Why, when I was working...or looking like I was working...for my Bachelor of Letters, I failed in both geometry and algebra, and if it hadn't been for Leo Bird, I could not have graduated. And the worst of it was, I didn't care. Leo was the one determined that I should get through. And it was just a chance. I just happened to know how to answer the things that were asked me in my special examination. And, Charley, you don't know this, but Malcolm Little was on the faculty then...he was working his way through by teaching Spanish...you know his folks lived in Mexico...and when my name came up for discussion, as to whether I was to graduate, some one said, 'Has she passed in mathematics?' And Professor Tanner said, 'Yes,' and Charley...Charley, that whole faculty burst out laughing!"

"But they said you had the best graduating thesis; they told you so."

I wished that in a moment of vainglorious bragging I had never told *him* so. I had never been impressed, myself, by that judgment. You see, I had cribbed a little here and there, and I was not much impressed with the stuff myself. I could write just as good if I had not been too lazy.

Charley was continuing to speak across the chasm of my bleak despair, for I could see that I was going to have to do what he wanted. Those wealthy girls who had wanted him would have done it, and so I...

"I can help you with the arithmetic, and you know you can do the rest. I'll hitch up Old Buttons, and you can go over to Charley Willey's and sign the contract before it gets away from us; and you can bring back the school-books you will be using...Charley has the school supplies at his house...and when you look over the books, it will not seem so bad."

It took courage. I said no more; changed my dress, dressed my two little fellows to go with me; and there I was with the reins in my hands, driving Old Buttons out through the sagebrush, baby Charles sitting between me and the five-year-old Walter. I had never driven a horse before, but I knew I could. My father's horses were famous throughout Utah. He had the best money could buy, several buggy horses—for his practice, I think I am safe in saying, was the largest in number of cases, and the widest in point of territory to be covered, of any doctor the West

ever knew. He had also his saddle horse and a saddle horse for my sister Florence, who looked so pretty on her side-saddle in her long-skirted riding-habit. For me there was a gentle, beautiful little Indian pony. My father was unofficial physician to the Ute Indians, who used to travel, by ponies, all the way from the reservation to get his services, just as later they traveled all the way from the Navajo reservation for the same purpose.

My father never charged the Indians for treating them. Indians, almost without exception—I never knew an exception—are grateful. Such cannot be said of white men, who are, almost without exception, ungrateful. My father had healed a squaw, and one day her man came leading gentle little Lady, named because she was a lady in actions, though I cannot today understand why some one did not give her an Indian name. I used to ride the streets of Provo on my Indian pony like a wild thing, my long light hair streaming out behind. I rode without saddle or blanket, and because of Victorian taboo I stuck on sideways, slipping off only rarely, never fearing and never being injured.

I have always loved horses, and what we love we do not fear. Old Buttons took us safely through the sagebrush to Charley Willey's home beside the spillway where the Jerome Canal begins to voice the protest of its father, the Snake River, at being forced by man into the degradation of common labor. There were lovely big trees around the Willey farm-house, so I knew the place must be that of a first settler. I signed the contract, feeling as though I were sentencing myself to the tortures of death after a bad life, and then, with a stack of books and my babies, back Old Buttons took me through the gray brush, which, not so many years later, I was to see change into green alfalfa-fields.

I sat up nights poring over those books, so terrified I could scarcely see the print. In imagination I saw school-benches filled with children over whom I had no control because they had discovered how little I knew. I could not sleep for thinking of the disgrace I was about to experience. No one will ever know what I suffered at the thought of that school. I could not be a typical teacher. I knew I would have to smile and laugh, and I could not punish children as I knew children were punished in school. I have always felt about the four walls of a school-room, and the hideous formality and repression of it, as Longfellow felt when he wrote in his diary, "Air! Air! Give me air! Give me freedom!"

MY HEART BLED that whole long year because of my separation from my baby, for I knew he missed me. All through the day, at intervals, the little fellow would go to the front door and, turning appealingly to his father, speak almost the only word he could yet say, "Mama!...Mama!" Charley would reply, "Not yet, son. Not time yet to go for Mama." The baby would then content himself as best he could—there was never any crying of my children for what they could not have. That separation from Charles has made me abnormally sensitive to anything that may happen adversely to him, a feeling which was to be deepened by another separation from him, to take place years later.

The horses could not be spared the first day of school. I dressed in my prettiest frock, to fortify myself, and walked the distance with Walter, for he was to go to school, at the age of five, to his mother. He was large for his age, much more advanced mentally than the average five-year-old, yet none of us suspected that deep within him was such a fund of humor and tragic understanding. How dare we deal inconsiderately with little children, when within them lies such character as we are not wise enough to penetrate?

I stopped at the home of one of the trustees on my way. I thought he would walk with me to the school-house, if he had not already gone before, to open it. This trustee had been a Methodist or a Baptist preacher—I have forgotten which, and he was generally spoken of by the farmers as "Revener Klyte." My knock was answered by his wife, gray-haired, a fine woman. I knew so many splendid women in that sagebrush country. The men took the women there, but it was really the women who bore the burden of the change.

Revener Klyte and I had never seen each other before. He was not dressed in overalls, but wore a suit such as any man might wear. On him it declared, "I am sanctified!" I do not know why

34

a preacher's clothes should hang in those holy, straight lines, somehow like a Gothic cathedral. Especially is it strange that this should be so in Dissenters. Revener Klyte is not the only preacher I have seen whose clothes hung in those churchly lines on his prayerful figure.

He handed me the key but made no move to go with me. I was to open the school-house and take possession all by myself, a perfectly normal proceeding, but horrifying to me. I was about to be gobbled up by a school-house when I wanted only to have my baby in my arms.

It was normal to expect me to go alone, but what I found in that school-house would be considered normal only in a district perfectly indifferent to its school-children and without respect for its teachers. I learned later that until the year before, the teacher had held school in Charley Willey's home, there being then only three or four pupils.

Now there were about eighteen, clustered about the unpainted wooden steps, which were just pushed before the door. I was amazed to see tall, robust young men, up to nineteen years old, and little children, not more than four. I was mystified about the young men, supposing instantly that they had brought the children. One look at the little ones convinced me that I was supposed to care for the babies, or what was I being paid for?

Before I forget, I should say right here that I tried teaching eight grades and first-year high school just one month. I love children and young people. But I also believed I was being paid to teach the grades efficiently; it seemed to me a crime to waste the time of those farm children, who so much needed education, by taking care of the babies. It meant that I had to prepare enormous amounts of busy work for those little folks, a proceeding which would have delighted me had I not also been conscientious about preparing myself to teach the other children.

Teaching first-year high school along with the other grades, with fifteen minutes for each class, could be only a farce. I went to the parents and told them so. They were reasonable. When the question came up in the big district school meeting, with everybody present, a year later, these parents remembered what I had told them and made brief speeches against saddling the teachers with this absurdity. Farmers and their wives can see things like that. It was not practical, nor was it practicable. There was a high school at Hazelton, six miles away. What is six miles to a youth if he really wants to learn something?

I hesitated over that last sentence, almost concluding it with the word *education*, but today

Education's so full of a number of things,
It doesn't mean much but a dangling of strings.

If you think that opinion harsh, just remember that I am nobody, and be comforted. But I want to add—and please do not disturb your family with a backward flip-flop if you happen to be a professor—colleges are places where young people waste their lives trying to learn how to live. I say this who studied in three colleges. But, of course, they were the exceptions that prove the rule. Doubt: Are young people going to college to learn how to live, or just to pick up a smattering of stuff that will make them feel at ease? I give it up. Silly women like me are prone to dive beyond their depth, and they never can swim.

Here I have been keeping you wondering what atrocity awaited the opening of that unpainted, undovetailed, weathered school-house. Allowing the usual number of sense-organs to each person, about thirty-six eyes gimleted me as I turned the key. It felt that way to me. I can be as brave as a lion because, like the lion, I never realize my danger until it is over. A great many people get praise for that kind of unconscious courage when it is just plain dumbness. I was not brave as I turned that key. I wanted to kneel down before those staring human beings and say, "Have mercy on me! I never could do arithmetic. I would not be perpetrating this deceit of my own free will."

The key was turned, the sullen, unpainted plank door swung open, and there met my eyes the most terrifically disorderly *dump*—that's what the sagebrush farmers call any house with which they are disgusted. It was a dump if there ever was one. I do not know the origin of that expressive word, but I suspect some farmer adopted it to describe a house so disorderly that it looks as though

everybody in it had just dumped things anywhere, including everything from clothing to garbage.

There was no clothing in that dump, but everything else possible in a school-room had been dumped there. I could not help feeling a little indignant that the trustees had *dared* to send me to such a place. All along the way of my years in the sagebrush country I was always being astounded that certain people should dare to do certain things to me. *I...I...I!* How it takes the *I* out of you to be sat upon by the folks all around you. But they did not sit upon me any more than I deserved. I was a bumptious human being who for years retained that Divine-Right-of-Kings opinion that I was God's little pet lamb.

The children all trooped in with me, the babies toddling ahead like little chicks, the young men lingering at the door like self-conscious young roosters. All of them were staring at that big room because I was staring. Perhaps they were wondering why I looked so horrified. You would have thought they had never set eyes on that room before.

Light glimmered dimly through windows which must never have been washed since they were placed in their frames. These windows ran along one side of the building only. The floor was covered with litter: books, prone, with widespread backs, pages flat on the dirty floor; old overshoes, ragged and covered with dried mud; little and big wads of paper; blackboard erasers. In the front of the room was a tiny, rickety table, evidently Teacher's desk. And back of Teacher's desk, on the wall, was tacked a black-painted rag, which here and there hung in strips. This black rag was spattered with white and yellow and a sticky-looking red substance.

I forgot I was Teacher. I said, *"Who threw a fit here?"*

At this unexpected question from Teacher, who should, I am sure, have at least worded her inquiry in a more educated way, a good many of my future pupils began to snicker. The babies just toddled about, one of them picking up a dried-muddied overshoe to bring me like a faithful little dog. The young roosters at the door pushed each other off the steps in an agonized appreciation of my vernacular. Of course, at this day I would never say such a thing as I said before those young, learning ears. What I would say now is, *"What the hell...?"* I think everyone understands what that means.

Seeing my puzzled look, as my eyes again rested on the besmeared black rag, a red-headed girl with nervous eyes began to volunteer, "Them things on the blackboard is what us childern throwed at Old Shavvy last year..."

But this was the young roosters' story. They came into the room by one impulse, and somehow, with their sudden entrance, I felt in them that they did not think the new Teacher was so bad. All young folks are willing to give us grown folks the benefit of a doubt. We usually ball things up by some word or act that makes us fall so far in their estimation that they can no longer respect or like us. Then we say we never saw such badly behaved young folks.

Just as Elida, for that proved to be her name, had reached the word *year*, the story was continued by Homer, her brother, with the same beautiful hue of hair. "Them spots was made when we throwed our lunches at Old Shavvy and told 'im t' git!" All the young fellows were grinning, and watching me with intent, serious eyes, to see whether I could stand the test. "The white and yeller is hard-boiled eggs. The colored, sticky stuff is jam. If yuh go up closeter, yuh'll see the bread on the floor."

I could see it from where I stood, after my attention had been directed. I wanted to laugh, and I didn't know why. My imagination was springing ahead of my information. I felt the boys relax a little. They could sense that unteacherly levity in me. "Who is Shavvy, and why were you so cruel to him?" I asked. I had not even smiled, but the boys knew.

"He was our teacher last year," said Bernard, a big, husky, handsome, curly-haired fellow. "Name's Shavock...we call 'im Old Shavvy."

"Was he old?"

"Yes. He musta been all of forty."

"Did he fight back?" I couldn't see myself refusing to answer with a few refreshments.

"Him?" Bernard's voice was scornful. "Naw! He didn't do nothin' but stand up a-front o'

36

the blackboard 'ith his hands a-front of his face."

"You're pretty big...what's your name?..."

"Bernard."

"Bernard. Maybe he knew he couldn't fight you."

All voices broke in at once, and from the medley I gleaned that Shavvy weighed over a hundred and eighty pounds and that he was just a-skeered of the big boys.

"We told him t' git," declared Homer, with some delight, "and you shoulda seen 'im git! He went down the road to where he was boardin', and he never come back."

I smiled at them. "You're a pretty tough lot, aren't you?"

They squirmed uneasily at that. They were not sure of me now. Maybe I was just Teacher, after all.

"Come on," I said. "Everybody help me. You pick up, and I'll sweep. And can't somebody get on a horse and go for something to clean those windows with?"

William, tow-headed and faithfully dumb, swelled with importance as he hurried to say, "I'll go, Teacher. I on'y live about two miles away. I gotta horse in the shed."

"All right." I had seen the stub of a broom leaning in a corner by the ragged black-cloth blackboard. I was about to move toward it when I noticed all but one or two of the big boys moving toward the door. "Aren't you boys going to help us?"

"Can't," said one of the big fellows. "Have to work. We can't start t' school till November. We can't go none after February. Time fer spring plowin'."

"So that's why you're still in school!"

"Not me," said an attractive-looking lad of about nineteen. "I come to high school."

"Here?" I was surprised.

"Yes. You kin teach me, can't you?"

"I might be able to teach you some things." In my usual manner I was ready to bite off more than I could chew, as our tobacco-chewing ancestors have given us the expression. I did not want to teach, but I was beginning to see the possibilities of working with these young people. Of my own free will I would have taken babies and all, even as God does; but before I was through, I found I could not do it, being, much to my surprise, only mortal.

The other young fellows looked a little crestfallen at what they had just heard. And one of them hastened to say, "We taken the eighth grade over three years now. Dad says it couldn't do us no harm, and we might learn somethin'."

That struck me as tragic. Marking time—being young, filled with fire and life, and compelled to mark time in a school-room. I had lived in a little town, and I knew what that feeling of being young and alive and yet compelled to mark time meant. I thought the thing out later, and when the boys did start to school in November, I had arranged with their parents that they might remain until the end of April, when the first county examinations took place. "You've just *got* to graduate from the eighth grade," I told them. "Then maybe some of you can go to high school at Hazelton."

I had never cleaned anything in my life as dirty as that filthy school-room. After I had swept, we took the bucket William had brought, and Homer went on horseback for some water. With this, using my broom, I scrubbed the floor. A few days later I had little white sash curtains at the clean windows. The sills were too shallow, and it would be too cold in that school-house, to have flowers. As yet I had no flowers in my own windows.

I STUDIED HARD every day to fit myself for teaching those children. I have never been a typically good student, although I have never stopped studying, and it is today my great joy to be learning something new all the time. I was a student who registered for too many courses and got what I could in class recitation, though oftener than not I was bored almost to death by the slowness which is a necessary concomitant of this drudgery-learning which palsies the whole educational system. Sometime there will be a laboratory method in all classes, so that the student completing the experiment, be it with words or with geological formations, may go on as fast as his brain will

let him. The horrible waste of young life in class-rooms has always appalled me.

Besides registering for too much and then getting what I could in classes, I spent the rest of my time studying all the other subjects for which I had not registered. My curiosity with regard to this world, human laws and natural laws, is insatiable. I shall never stop studying until I stop existence.

That does not mean I am the child prodigy of learning. I know so little! Oh, I know so little! But thank God I do not know everything, for think of the wonderful good time I have ahead of me, just finding out, and learning!

Too much about *me*. This is not my biography. I would try to be a skilful analyst of the interior of *me* if I were writing my autobiography. A man's inner life is his biography, all the outer life being but accidental circumstance. Of course, one must tell both, but the details of the outer life only to show what the inner has done with it.

I studied as I had never studied before. I did not want to fail those children in any way. I would be the best teacher that a person such as I could be. I stung the board of trustees for a few supplies so that the children could do some work with their hands. The trustees were pretty sour about my high-handedness in doing this, but I did not care. I knew if I asked them, they would say no. What I did say was that I would like to get a few supplies, and their permission probably meant a dozen pencils for ten cents and some chalk for the ragged blackboard. I stung them for three dollars' worth of colored paper, raffia, paints, and what-not—educational such like. Every child should be taught to do as many things as possible with his hands. It was a woman who wrote these wise words: "By training the hand to trace out Nature's action, we train the unconscious mind to act spontaneously in accordance with Natural Law; and the unconscious mind, so trained, is the best teacher of the conscious mind."

At the time I had not read this that Mary Everest Boole wrote. I knew it only with my feelings. Besides, how was I to teach eight grades, with fifteen-minute recitations, and keep those children busy without busying their hands? There was not enough for their heads to do. I could not give them enough, and give it right, to occupy their time. I would not leave them to suffer unoccupied. All there is to serene happiness is to be absorbingly occupied.

These farm children had never made anything in their lives wherein beauty was considered a necessary part of use. This is a lesson which cannot be taught farm children in words. They are not word-minded. They are inarticulate. But I could teach them through their hands. They could feel beauty. And man is mostly feeling. Says Walt Whitman, "What is humanity in its faith, love, heroism, or even morals, but *emotion?*"

How could I study as I should, and plan basket-making and colored paper-weaving and such like, with things not going on right at home? We had hired a girl named Blanche to take my place in doing the household tasks. She was far from fair, as her name implies, being burnt brick-red. Her grin was wide, and it showed a mouthful of dirty, perfect teeth. Great shoulders and breasts and hips added to the lust of eyes which sought every worthwhile man, as her hands reached out for him. Her first challenge to every possible man was, "I'll wrastle yuh, 'n' I kin lick yuh," accompanied by a hearty laugh and a display of dirty, perfect teeth. To get her hands on a man...to get a man's hands on her...she knew men.

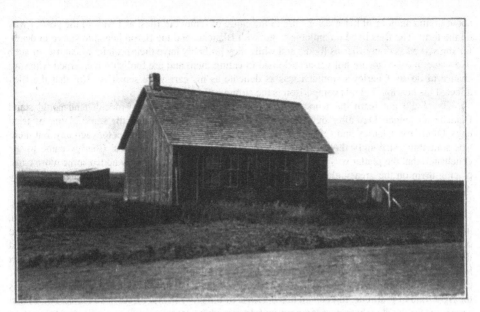

MY FIRST SCHOOL, "PLEASANT VIEW"

THE NEW "GREENWOOD" SCHOOL, CHURCH, AND GRANGE HALL

The only cooking she seemed able to do was frying eggs. She was not conscientious

about giving an hour of her precious life to the cause of removing flies, as I was all the years I was on the farm. The flies lived on amiable terms with Blanche, and the Baron began to starve to death, for she served as many flies as foods, and while they probably have their protein, or caloric, or such like value, most of us are not yet accustomed to eating them and are foolishly concerned when we chance to do so. Charley's stomach was as delicate as his ears were sensitive. Not that the flies affected his hearing, but this comparison is the strongest I can make.

I did not learn the worst of this until the day when Charley decided he could stand Blanche no longer. Day after day Blanche served what appeared to be the same platter of fried eggs. Of course, Charley and Jeff and Tony ate nearly all the eggs on the platter each day, but there was something strikingly the same about that platter, a slovenly sameness. Charley came to the conclusion that the platter was never washed, that each day Blanche simply added some more eggs, placing them on the greasy plate along with any cold eggs that might have been left from the day before.

One day a fly got tangled up in the river of grease that flowed around the islands of eggs. Unable to ford the stream, the poor creature died. Charley beheld the sad demise, but with cold, unpitying heart. Then his nefarious plot against the beauteous Blanche was hatched. He would find out whether that platter was ever washed. I can imagine how criminal he looked as he perpetrated the dastardly deed. No one saw him lift an egg and gently bury the poor fly under that *ovum mausoleum*. No, he did not lay a wreath on the tomb of the Unknown Fly. *Shocked?* Look a little closer. Do you think that wreath means anything to a single unknown soldier? Do you think that is the right kind of gratitude, to keep up this pretense of the glory of war? Let's take the cost of all that ceremony for the slaughtered anonymous and do something loving with it that will start preventing *War*. Let's deflate this buncombe with which we show off before each other.

So there was the dead, we might say the martyred, fly, buried under the monument of an egg; and there was the gentle Blanche, entirely unsuspicious because occupied in the art of attempting to manhandle Jeff and Tony at the same time...or should I say womanhandle, which is more deadly to the male...and Kipling did not say that.

The next day, on came the platter of eggs, swimming in grease, accompanied by the great-bosomed, great-hipped Blanche, who could shift the plate about with one hand and with the other run her fingers through Tony's hair, immediately afterward running her fingers—the same fingers—down Jeff's neck, which is supposed to give a delightful thrill, and maybe it does. The Baron sits up with every fastidious nerve quivering toward those eggs. Yes, that must be the very egg! Its countenance is recognizable. Surreptitiously he lifts the egg, and damnable evidence! there is the very fly. Or, if not the very fly, damnable evidence just the same.

A very silent Baron sat and pretended to eat. At the end of the meal he made out a check for Blanche—we had begun banking the school money and paying on our grocery-bill at the same time. Blanche was mad. Blanche was very mad. She gathered up her belongings, and out of the house she bounced. Charley washed the dinner dishes, not forgetting the platter, Tag gratefully receiving the mausoleum of the Unknown Fly.

Charley had to go on with the farm work, so I tried doing as much as possible of the housework, along with the school work. Saturday meant cleaning the house thoroughly, baking bread, and doing innumerable household tasks. On Sunday Charley helped me with the washing, heating the water out-of-doors in a galvanized tub over a fire of sagebrush, built in a little rock enclosure on which the tub was set.

On that first Saturday after Blanche left, I cleaned the downstairs rooms, which were the kitchen, the dining-room, and my bedroom—mine and the Baron's and the two babies'. I heaved a sigh of relief as I fished my lovely white comb from among the embroidery I had been doing. Little Charles had originally hidden it there, in the basket among my fancywork, but with no intention of deceiving any one. The first I knew of it was when I was eating breakfast, and Blanche came flying into the room with streaming, disheveled hair. She never combed her hair until after breakfast.

"Mrs. Greenwood," she said, emphatically, "I can't find that there white comb of yourn

nowheres. I put it right back on the dresser when I used it, and it's gone."

Like an idiot, I murmured, "You wanted...to comb...your hair..."

"I always put it right back there when I git through with it."

I volunteered no solution, though I might have offered a clue, remembering, as I did, that little Charles had picked up my comb after I had used it, standing on tiptoe to drag it down. I had meant to take it from him. Now I was glad. I knew he would tell me where he had put it.

I shall never be a good Christian because I cannot stand anyone using my toilet articles other than me, myself. There are none I love enough to have them comb their hair with my comb. I realize just as much as you do how very selfish this is. I am willing to buy another comb for any one, but the test of my friendship would be that. Don't ask to borrow my comb unless it is the last remedy that will save your life. And then I will throw in my toothbrush, too.

Blanche went off grumbling to herself that now she would have to use the men's comb, for, of course, every farm-house has a men's comb, near to the wash-stand. This custom filled me with about as much horror as must have flooded the mind of the inquisitive lady who saw all her husband's other wives with their heads cut off—or were they hanging? Mrs. Bluebeard had nothing on me when it came to having the blood freeze in her veins. That happened to me as I saw man after man run the same comb through his hair. It was not just because I was the antiputrefactive woman that I felt so outraged at the sight. Some instinct in me was violated. Probably a snooty one, bred in me by generation after generation of parasitic ancestors. I can reason this out, but please don't ask to borrow my comb, just the same.

My idea was that if I took the comb away from the home-cobbled wash-stand, every farmer would appear on the scene with his own individual pocket-comb. I recognized that he must comb his hair, for the farmer is a whale of a fellow, in the sense that his manner of washing his face is to throw water almost over his back. And then, there was usually dust, and perhaps dried alfalfa-leaves, in his hair.

Of course, I did not effect a reform in this matter, as I did not effect the dozens of other reforms I tried to nuisance onto the sagebrush farmers. These reform-leaders give me a pain in the neck—and I was the painingest ever. But I had a heart. Even if Charley had not, of himself, hunted up the men's comb, I would have restored it after watching a patient farmer trying to slick down his wet hair with the back of his hand. It was the first time I ever noticed the Mormon, Eb Hall, who afterward became my good friend. The test of the strength of your friendship is how much injury you are willing to forgive. Years and years after I saw him patiently trying to slick down his hair with the back of his hand, Eb rocked so hard in my beloved little chair in which I nursed all my babies, (I being the kind of woman who would fight like a tiger rather than allow any bottle to take my place—to miss seeing those trusting eyes looking up at you while your babe drinks his life from your breast...how could any real woman miss that experience without the deepest regret?) that he broke off both rockers, as you shall hear in its proper place, yet still remained my friend.

If I had been shocked by Blanche's use of my comb, I had a greater shock in store for me concerning that fair maiden—one of the greatest of my life. Everything clean below and bread baking in the oven, I went upstairs. Charley had installed a trap-door to keep the flies from coming downstairs, and the heat of summer and the cold of winter from doing the same. I pushed this up and stepped over beside the bed in which Blanche had slept.

Even before I reached it, I had caught the frightful odor which pervaded everything. It so nauseated me that I nearly fainted. "Something has died up here," I thought; "a cat, or something maybe a skunk..."And then I found them.

I did not find a lot of dead cats and skunks, though I should much have preferred finding a nice, orderly stack of decaying animals of those species rather than what I did find. I had sedulously saved every coffee can we had emptied that summer, and there were many, for while I cannot drink anything but water or milk, on account of being easily intoxicated by coffee, Jeff and Tony and Charley were great coffee-drinkers. The Baron, being more or less German, had been reared on it, and his mother had been nipped in the bud by me when I saw her feeding my delighted

41

infant, Walter, buttered toast soaked in strong coffee. She was a wonderful woman just the same. Different nationalities have different customs.

But now for Blanche. I hesitate to tell you because I fear that, even at this late date, some of that ghastly asphyxiation may pour out from the pages I am writing, so vividly do I recall that disgusting experience. Coffee cans were ranged beside Blanche's bed, and hidden behind other coffee cans, and in corners, and tucked about among the unfinished ledges made by beams. These cans were filled with what I shall refer to politely as *ordure*, though there is no politeness of any kind told in any etiquette book that has anything to do with that gross situation.

We had one of those hideous, necessary little houses which spot the back yards of rural communities, village or farm, and which we idealists try to ignore in our phantasmal dreams of what life ought to be instead of what life is. These little houses always stick up like the proverbial sore thumb, and it is a tribute to the delicacy of the human heart that during their greatest reign, when there was one in the back yard of even the most pretentious mansion, dainty ladies still died of love for faithless swains. What has one of those little houses to do with love? This: it is a great balancer when we are likely to die of biological tortures to remember that we are but animals, like all the rest of the pathetic creation. Let us crack no foul jokes about this, but let us remain sane.

Well, there was a job for God's little pet lamb! To my credit let it be said I never once considered shifting that unpleasant task onto any one else. Fairly trembling in every Divine-Right-of-Kings limb, I brought upstairs a slop-pail. In this I carefully deposited those filthy cans, as many as the pail would hold, making trip after trip out to the little necessary house which Blanche had been too lazy to use. We had intended those cans to hold the lard from the two hogs we were fattening.

When the job was done, I stood for a moment in the far back yard, contemplating the dark-green house with the toothpick-pillared porch. It ought to be burned to the ground to purify it after what had occurred there. I knew that I should never be rid of the horror of that upstairs in any other way. I never was rid of it, but I did not burn down the house, because as yet it did not belong to Charley and me, although we were still perfectly certain that some day it would.

I was sure a dreadful fate must befall so offensive a creature as Blanche. I considered none of her virtues, though now, even in the face of a crime so nasty, I think there should be an attorney for the other side. Blanche was a far superior farm woman for out-of-door work than I could ever be. She had already plowed, sowed, cultivated, irrigated, and helped harvest crops. And I can imagine how she enjoyed working with the men. Well, maybe the rest of us women would enjoy working with *some* men. She had undoubtedly ridden the spring-tooth harrow, a machine for which I had a good deal of respect, since it seemed to get the best of every man who rode it. The disk, too, she must have ridden. And pitching hay was old stuff for Blanche.

Now let us consider the plaintiff. One incident will be enough to throw the case out of court if we try it on grounds of farm efficiency and not of decency. We cannot condemn all people and all things for lacking decency, or half the people and half the functions of the world would be abolished. Personally, I think this should be done. But we cannot accept the opinion of one impractical woman against half the world.

When I drove Old Buttons back from Charley Willey's house by the spillway, I had not wanted to cause the men any extra trouble on my account, so I attempted to unharness the horse myself, a thing I had never before done in all my life. What I did was to unfasten every strap of that harness, literally taking the whole thing apart, turning it into a heap of short and long straps, so that before it could be used again, some expert had to match the straps, put them together where they belonged, and make the harness all over. Blanche would never have been guilty of such an act—causing the men to damn their souls with swear-words, and all that. So now, I as the plaintiff say that Blanche's crime may be overlooked, though it cannot be oversmelled.

Blanche did not come to a bad end. Life is not like that. She married a wealthy cattleman. Maybe he was like her, and maybe not. Maybe he was just lonely. And maybe he felt in her that superabundance of physical vigor which attracts us all. And maybe his blood ran away with him at

42

the touch of her large, red, lecherous hands. There are times in all of our lives when we are such sad weaklings. And, on the other hand, he might be just such another as Blanche—hands on every woman he met who attracted him...there are such men. *Huh! You're tellin' me?*

IT WAS HARD after Blanche left, carrying on with both household duties and school. Charley did all he could, but with a family of six, counting in Jeff and Tony, and four of them adult and two of them babies, it was really two women's jobs. For one week the school slowed down so that the work there was comparatively easy. It was spud-picking time, when all the farmers in the district, and all the farmers' wives, and all the farmers' children of sufficient years to be able to bend over and pick up a potato, were busy picking up potatoes. The school might well have closed, but there were three or four pupils whose parents had raised only potatoes enough for the family. They dropped out, singly, for a day at a time.

It was spud-picking time on our farm. Besides the three men of our household, there was a crew of three more. And this is the time to tell of my beloved Limpy, who was eaten by cannibals, though he was not a missionary and never went to the Fiji Islands or anywhere. We loved each other deeply, and I cannot think of his soft brown eyes without a little sadness. Of course, I realize that if he had lived, by this time he would not only have been a great-great-great-great-great-grandfather, but he would also have been long dead. That is the only consolation I have for his having been eaten by cannibals. I shall see him come bouncing toward me down some heaven-road, bleating his constant love for me.

Charley found him lying beside the brown tobacco-weeds on the road from the school-house, as he drove back from getting me, four of us in the buggy, little red-coated Charles seated between me and Charley, and Walter at our feet. Something white lay at the side of the road. Drawing rein on Old Buttons, who was an angular brown horse, if you would like to know, Charley picked up a little lamb, one of whose hind legs was broken. We knew how it must have been done, for every day, and several times a day, great bands of sheep went past our farm, spilling through the wire fence in driblets of white roly-poly wool and flooding back into the road again. There were usually two men on horseback at the head of the band, immediately following the sheep-wagon, in which the men slept at night. The cooking was done outside. This sheep-wagon had a wide box built on each side, and a deeper one at the front, directly back of the driver's seat. The lids of these boxes were hinged, and cooking utensils and all necessary things for camping were kept in them. The tops at night, covered with thin mattresses, or just blankets, were the bunks. Over the wagon was a rounded canvas cover.

At the end of the band of sheep were two more men with empty oblong kerosene cans, such as Mrs. Curry used for a wash-boiler, one side cut away. But not so beneficent was the use of the two kerosene cans in the hands of the two sheep-herders in the rear of the flock. The road was long and wearying for the little lambs, trying, as they did, to keep up with their mothers all the way out to the unfenced desert. The bleating of ewes and their little ones could be heard for over a mile as they were forced on their way.

It was too much for the babies. They could not keep up. A group of tiny fellows always lagged behind, having struggled almost beyond endurance. Their mothers had to go on, and it was their affectionate, anxious cries, back and forth, that made the medley of sound, somewhat like the plaintive notes of a thousand differently keyed clarionets, all playing at the same time, and none of them in harmony. The backs of cream-colored wool, spotted occasionally with the dull black of the odd ones, ran like the slowly rippling stream of a canal after a spring rain, when the ivory-hued clay is washed down from the farms into the water. As a few of the tired lambs straggled back, the sheep-herders would throw the empty kerosene cans at them, to scare them onward. Such a can had caught Limpy, and there he lay, no doubt mourning for his mother, gone, so unaccountably, far beyond his sight and hearing.

I held the lamb's leg while Charley put a shingle splint on it and wrapped it around with cloth. It was a very capable job, but not quite perfect, and the name I gave him while he still wore

43

the bandages continued to be appropriate. God takes especial care of all things that have not the brains to care for themselves. Brains? No, I cannot call it that, since man, who is most divorced from God of all his created animate things, has shown such a brainless exhibition as the World War.

Not being very bright, for sheep are not, God supplied a time-sense to make up to Limpy for that lack. My lamb knew that the woman who fed him from the bottle would be coming home about half past four in the afternoon. He knew that she would be walking then, because all the horses were in use. He knew he could see her if he went down to the corner where the new school-house was being built—the lure held out to get me to teach...I could teach there, but a few steps from home...not in my time to happen. Every day, just as I reached the Jerome Canal bridge, I could hear the bleating of Limpy, and down the road he would come bouncing to me; and it was not just that I was the bottle-lady—he loved me. Everywhere on the farm he followed me, even as poor Peewee, the chick of later date, used to follow me. I was their mother. And why not? Animals seem to me just human beings in another form, and I have seen many human beings who seemed to me just animals in another form.

No one knew what I thought of Limpy, and no one knew what he thought of me. The men were so busy that they never saw us together. About the only time they ever saw my actions toward my pet was when I forced him out-of-doors, for he would follow any one into the house, and that so quickly that the screen door could not slam between him and the place he loved to be. We had to have fresh meat, a thing almost impossible to get, and very expensive. You can't just go egging and salt-porking—sow-bellying—men all through a week of spud-picking. Jeff and Tony would have remained no matter what we gave them. And there is where I came in: they were hungry for women folks. But the crew of three had plenty of women folks of their own, and although they might be on thin fare at home, they were not willing to pick spuds for you on the same feed.

One night little Charles lifted his plate from his high-chair tray and held it out to his father. He had eaten one decotchment, as the sagebrush farmers say, and had learned that he must look out for himself. For sometimes, in our hurry, we forgot the baby until we could hear his plaintive voice complaining, "I ain't got nothin' t' bite!" Then we all came to the rescue.

His father did not notice the lifted tray, so out sang little Charles, "Gi'me some more Limpy, please!"

Then I knew. I knew that the baby had witnessed the slaughter. I knew that I...*I*...had cooked my beloved Limpy for those horrible cannibals to eat, myself an unconscious accessory before the fact. To feed spud-pickers. I am not a crying woman. I have shed tears only a few times in my life, and then it was because I was so gol-awful mad that I could think of nothing to say. When I knew I had been among those atrocious spud-picking cannibals to eat my poor child Limpy, I said nothing, but my appetite was gone. From that day to this, I never said a word about Limpy to Charley. The Baron was doing the best he could. He had worked hard, and had seen the rabbits harvest all his crop except those few potatoes. I should have been a sillier woman than I am had I complained.

But every day, when I reached Jerome Canal bridge and could hear the roar, close at hand, of that beautiful dark-blue man-made river, I thought I could see, far up the road, just turning the school-house corner, the little ghostly form of my Limpy, bouncing down the road to me. (Well, Limpy, I know you will never forget me, and I expect to see you bouncing toward me, and bleating your love, on that heaven-road, as I have told the folks who are reading this book.)

SPUD-PICKING TIME over, and the children all back in school. Not only the children who were there before, but the big young men, who looked as though they could take a cow by the horns and throw it over the fence. They crowded themselves into the largest of the seats, dispossessing some smaller, slightly disgruntled boys; and there they were, stuck in those seats so tightly I did not see how they were going to be able to leave them behind when they were ready to go home. The seats were nailed to the floor, so it looked to me as though they might even carry the old school-house along with them.

"My goodness, boys," I said in my most unteacherly manner, I was so dismayed, "I don't

know how you ever got into those seats, and I don't see how you will ever get out of them. Haven't you some old tables at home, and a chair for each of you, that you could bring to school?"

A grin covered every manly face. "That's one o' the things we driv Old Shavvy out fer. We ast him could we bring a table, 'n he says if we was boun' t' come, we gotta take what the rest taken. Sure we kin bring a table and chairs. You got a table, ain't yuh, Bernard?"

There was dignity about that table at the back of the room, and I really enjoyed watching those young men, bent seriously over their books and writing away, I hope, with a certain amount of enjoyment. Yes, they did like to write. I taught them that right where they were they had most wonderful things to write about. Bernard, I remember, took delight in writing a description of that old plank school-house: "The cracks between the boards," he wrote, "are so big that a cow could put her head through them." So, you see, with a little encouragement, we had a humorist, right there in the brush.

My heart was lacerated by the sight of the sore hands of the children who had been spud-picking for a week. At the look on my face, Harry, my fussy pupil, explained, "The kids all gits sore hands pickin' up spuds."

"Don't your hands hurt?" I asked yellow-haired Emily Streeter.

Bernard made answer for her, "Sure, they hurt. My little sister cried nearly every night of spud-pickin' with hers."

Faithful William expatiated, "It don't make no mind about my hands. What gits me is the bendin' over all day, and maybe night."

"Yes," Elida hastened to say, "it gits me, too, that night work, 'ithout no supper, ner nothin'. On Wednesday, you know it sprinkled a few drops, 'n Ma 'n Pa, 'n us kids picked up spuds, 'ithout no supper, till 'leven o'clock at night. My! Mrs. Greenwood, I was 'bout dead. *My* little sister cried the last hour."

"How much money will you children get for your part of the work?"

"Money!" Homer was amused. "*We* don't git no money. You can't hardly make nothin' outen nothin', farmin', Pa says. He used to be a bricklayer. He says he wisht he's back on the job."

"Pa says we has t' be a-workin' anyways," further explained William. "Pa says we's lucky t' sell our spuds a-tall this year. Las' year we couldn't git nothin', so we dug what we needed ourselves,'n fer seed, 'n let the rest freeze in the ground."

"We can't sell nothin' but the great big spuds, nohow," added Bernard.

I came in with my foolish, inexperienced opinion—I was still a city woman: "I should think the poor people in the cities would be glad to get the smaller potatoes."

Children are so sensitive. They feel what they cannot express. They liked me, and now I had committed a piece of ignorance which made them ashamed for me. They saw, suddenly, that Teacher might know a lot about the unimportant subject of English, but she had failed in the important business of farming. They liked me so well that at once every face was averted, eyes looking away from me, in order to save me embarrassment. Instantly I knew this.

"I read in a paper my brother-in-law Rob sent me that potatoes are listed to cost $4.00 a hundredweight at Chicago, the crop beginning to arrive there now."

They all looked at me with interest. I had redeemed myself. That sounded like intelligence. Nothing sounds so dumb to farmers as the ideas about farm conditions expressed by city men. City men just do not know. You have to know the inside of things before you can know what remedy to advise. You cannot teach folks how to swim if you have never been in water. It may be that a remedy is a theory, but it must be based upon experience with the thing to be cured.

"We sold our spuds fer forty-five cents a hundred-pound sack," contributed Bernard. "But they won't take nothin' but the big potatoes fer that. Can't never sell none but the big spuds."

I looked at those childish hands, scoured raw by the constant handling of dirty, rough potatoes. I thought of the little backs, bent painfully for seven days and nights, and longer if there were more potatoes. I thought, too, of the lordly men who came riding out among us in their cars, smoking their expensive cigars, and not a car among us, and the cheapest tobacco for our men. I thought of how they come out and say, "I'll give you forty-five cents for your potatoes, and you'll

take it, or be damned." I thought of how the price was set in order to give the middleman the greatest profit, and was in no wise related to the cost of production—the cost of the seed, the plowing, planting, irrigating, cultivating, harvesting, with every member of the family giving work that ought to have a monetary value, but which has none. Does not the cost of the water have to be paid out of the price given for the potatoes? And the taxes? And the payment on land?

I wondered what they would think of me at Longenberger and Belmont's if I walked into their store and said, "That pink percale over there on the third shelf. I'll give you ten cents a yard for it, and not a cent more, and nobody else will, either, for we have combined to keep the price there."

Then Henry Belmont would say, in horror, "But, Mrs. Greenwood, that is the very highest grade of percale. It cost us, wholesale, ten cents. We have to make a little profit, in order to pay taxes, and the upkeep of the building, and the clerks who work for us, and me, and Mr. Longenberger, and Bertha. If we sold you that at *your* price, we would be idiots!"

"Then you'll have to go out of business," I would say in my snippy, middleman way, "for none of us will buy anything from you except at our own price."

Henry Belmont would try to go on with his business, in spite of what I said, hoping that by laying in a large stock of percale, pink in color, he could make a profit. But in the meantime all the people banded with me had decided that they were not wearing pink percale this year, and that would leave Henry with the goods on his hands. Now he looks around to see how the farmer is handling such a situation.

Well, he finds this: When the middleman will not give the farmer enough for his crop, he buys a lot of hogs, and hens, and cattle, and feeds his crop to them. Government agricultural experts call that turning the crop into meat, selling the crop on the hoof, though personally I have never yet seen a hen with a hoof. But that has nothing to do with the question, so I will not report this zoological fact to Uncle Sam.

So, what does Henry do? He gets all the women of the family together and says to them, "Girls, you turn this pink percale into dresses and sunbonnets, and I am sure we can sell them to the farmers."

Pretty soon, all the windows of Longenberger and Belmont blossom with an array of lovely pink dresses and bonnets. The farmers and their wives come to buy, but what they say is not, "How much do those things cost?" but, "I'll give you ten cents for that bonnet, and thirty-five cents for that there dress, and if that don't suit ye, they kin rot on the shelf fer all we keer. We got a dozen other places where they's sellin' to us at our own price."

Then what happens? I hope you will agree that this is quite a drammer, though Shakespeare and Eugene O'Neill missed the plot. It could be worked up good, if they tried. Well, this is what happens. Henry Belmont cannot sell a thing, and the taxes keep right on having to be paid; the building has to have new shingles; Bertha and Mr. Longenberger and Henry are all going without any pay, eating a little out of the store to keep alive, but the clerks are hollering for their pay, and they don't mean *maybe*! The family car is sold, and the family home will have to go, too.

So what happens then? Well, Henry and a few other merchants who have had to fail on account of selling to the farmers at their own price, or refusing to sell, all of them write letters to the Congressmen they cast their votes for at election-time. With what result? One of the Congressmen raises the tariff on pink percale, so that none can be shipped to where Henry is at a lower price than the cost Henry has figured on *his* percale. How does that help Henry, when the price that makes it impossible for him to realize expenses is set by the *farmers* and has nothing whatever to do with the foreign merchant? It just means that neither the foreigner nor the hometown man can sell pink percale at a profit.

Another Congressman puts through a law to inflate the dollar. But what's that to Henry when he cannot get hold of even a flat dollar? They can puff the dollar up until it bursts, but it just doesn't mean a thing to Henry, because no one will buy from him with flat dollars or puffed dollars except at a price below the cost of production.

46

Then another Congressman passes a law to fix the price of percale so that it will be fixed. There is no other true reason, for this does not change the situation at all. Either the farmers will not buy at the Government price, or they will secretly force the price down where they want it. And the answer is: Has the Government done away with kidnapping? And did it do away with bootlegging? And how about racketeering? You can never *law* anything *in* or *out* of existence.

Good old Government! Means well, but all the politicians have their hands in their own pockets, in order to put there what they can grab from the Government. No! Not all! There are still men among them who will not sell themselves for anything, and there is a man in the White House whose integrity is undoubted. In the course of our brief United States history we have had several nincompoops in the Presidential chair. Getting elected to a job does not give a man the capacity to fill it.

Congressmen mean well, and Presidents mean well, but the last and most favorite answer to Henry Belmont and the other suffering merchants is:

"Dear Henry, *et al.:* We have made a law to let you have all the credit you need to carry on your business at present. But, of course, you must pay us back soon, and with interest."

Henry is desperate; so, like the farmers, he allows good old Grandma Government to pay the mortgages on the store building and his home. He gets hope of buying another car. And good old Grandma Government lends him money to buy more goods. He has CREDIT! Now his business can get out of the hole.

What happens? The farmers still hang together, setting their own prices, and Henry not only cannot make expenses, but he cannot get an edge with which to pay back good old Grandma Government. He is in the hole worse than ever. AND HE SEES IT.

There he is different from the farmer. The farmer always suspected there was something crooked in the deal he gets, but he has not thought it out, and he is too short-sighted and too weak to hang on with other farmers until he forces the middleman to accept his terms.

No, he can never do it alone. What's a Government for but to help its weaker citizens out of the clutches of predatory interests? S-s-s-sh, woman! that sounds like socialism, or communism, or something. It is! It is! It is *something* the farm woman who writes this gave the golden years of her life, her health, the well-being and education of her children, to learn. Not voluntarily. No farmer's wife does these things because she wants to do them. Yes! I am shouting it now! I have found out SOMETHING, and it is in this book.

GRACIOUS! but I'm hoarse. And what good will it do? I did not shout these things to those pitiable farm children. I was still a city woman, just stirring in my sleep. What was it all about? I did not yet know. The nightmare that I, myself, was doomed to be that tired, round-shouldered, red-handed, ridiculously dressed farm woman whom I had seen clambering over the wagon-wheel at Provo, while I sat in our fringed-top phaeton, conscious of the fact that I was her superior by the Divine Right of Kings—God's little pet lamb—the nightmare of seeing myself gradually become that woman had not yet troubled my dreams.

It turned bitter cold. Before the winter was over, the thermometer had dropped to forty below zero. We had to heat the open-work school-house with brush. And that sagebrush must be grubbed and dried by the children and me, for we had begged for the job of being janitors. I had not then been made aware that we should have to supply our own sagebrush fuel, or the plan that had given us this responsibility might have fallen through.

On the very first day of school I had discovered that my children knew nothing of music, even in some primitive form. With three exceptions, the only instrument they had ever heard was the harmonica. The only singing they had ever heard was that of their own families and of the cowboys. Nearly all of them had heard a harmonica, but not nearly all of them had heard a cowboy sing, for most of their parents were too poor to have hired hands, and the cowboys were working for the wealthy cattlemen.

When I told the children, that first day, to sing with me "America," I was horrified to hear the sound they made. In every school there are monotonists, children without ear for music, blind in

47

their music sense. There were, of course, some of these in that old school-house, as was to be expected. But what was the matter with the rest of them? They must have tried to sing at some time. I decided that the trouble lay in the fact that they, and their parents before them, had never really heard any music—or should I say, never heard any real music?

I hatched the plan then to have the children help me to do the janitor work, which, I learned, was worth five dollars a month. With this we could begin making payments on a school Victrola, the advertisements of which had so fascinated me. I could take some of my school pay to start things, and I would buy a number of the best records obtainable. While my pupils were learning, they should learn right.

Then Revener Klyte told me we were expected to grub all the sagebrush with which we heated the school-house. I was so anxious to get that phonograph in the school-room that I saw the phonograph and not the grubbing. Not many things would be accomplished in this world if we counted the cost rather than considered the desired end. For one thing, half the marriages that are now made would never be made, and there would be very few children born. In fact, there is no more perfect example of keeping the mind on the phonograph and omitting all thought of the sagebrush than the great biological urge.

Again I was hurt when I saw those brave little children trying to help me grub sagebrush with their sore hands. As time passed, of course, their hands healed, but the weather grew increasingly cold and pierced through the cracks in that, poorly constructed building as a knife cuts through bread. The brush was no sooner in the stove than, with a roar, it seemed to have passed up the chimney.

I knew that the district was not poor, receiving, as it did, a comparatively large amount of taxes from the railroad that ran through the southern part. Of course, a new school-house was being built with some of these funds, but the more I thought of how it was being built at the expense of those children, the madder I got. Even if we had not been compelled to take an ax and chop sagebrush from the acres surrounding the school-house, the little children gathering it up and carrying it in, I should still have been indignant. The district could afford coal.

With the determination to pry some coal loose from the trustees, I stopped at the house of the Revener Klyte on my way home from school one night. He was seated, comfortably reading, in his prayerful clothes, close to a little pot-bellied stove in the front room, and I noticed near his feet the hod filled with coal. It gave me courage. As tactfully as is possible for a woman who is not tactful, I made my request for school-house coal.

"Do *you* have coal at your home, Mrs. Greenwood?" he asked, clipping his words carefully. He was looking out of the window, not at me.

"That's different. Mr. Greenwood gets the brush, and can keep putting it into the stove, because he has the time. The children and I have to..."

"Do any of those children have coal on their farms?"

He knew they did not, and it made me boil to have him bait me that way.

"It isn't the same...," I began, when he interrupted again.

"Then," he continued, just as though I had answered his question, "I can't see any reason why the school should have coal. The children are not used to anything but brush. You'll find a lot of things you'll have to get along without here in Idaho."

True, damnably true, but why should he rub it in? And why should he so unctuously enjoy the prospect in a kind of lustful anticipation? He was a former Baptist, or else Methodist, minister, and he was supposed to believe in all that Jesus taught; but he got only so far as "Suffer the little children..," and he believed in letting them suffer.

I went over to Charley Willey's then. I had better sense than to try to carry the question of coal over the head of one of the trustees. Of Mr. Willey I asked only a load of sagebrush occasionally, as we needed it. This he promised me, and it was a source of joy to the whole school when a sagebrush-pile grew beside the open shed barn, where the children kept their horses tied during the day, feeding them every noon the hay brought for that purpose, as soon as they had eaten

48

their lunches.

Among the young men who had come to school after spud-picking was one I had never seen before. He was one of the most mischievous I ever knew, yet possessed of the most gallant manners. Indeed, he was the only one of the children who could be said to have any manners. They were not any of them rude, but they did nothing unless told to do it, though willingly enough then. Keith was different. He thought of pretty things to do. When the county superintendent visited the school, all the other children just stared as she stopped her buggy beside the school-house gate. Keith alone ran out and, with a charming smile, asked to be permitted to tie her horse to a post. Where he got this delightful gift, I cannot imagine. It was far from indigenous to the sagebrush.

Ah!...but the other side of the shield! Keith was a little devil. I mean a big devil. He was about six feet tall, with a laughing eye and a rippling tone to his voice. He set the sagebrush-pile on fire, just to see it burn. It burned beautifully. Teacher watched it, too, when faithful William came running with the dreadful news. Then she sat down to the rickety little table and wrote:

DEAR MR. QUAILPUT: Keith had a little accident today with our newly hauled sagebrush-pile. Would it be possible to allow him time tomorrow (Saturday) to haul another load for us? We have no other fuel.

I signed it, and when Keith came into the school-house with the others, at the summons of the bell, there was still a wicked devil in his eye, slightly subdued by some apprehension in my direction. All eyes were fastened on me with the one question, "*What are you going to do about this?*" Even Keith looked at me, a trifle uneasily. I just stood there, gazing straight ahead, with expressionless face, for a full minute. That was not accidental, nor the result of anger or agitation. I had learned that in the school-room there are no more powerful means of discipline than quietness of manner and well-designed silences. Add to this the power of the human eye, and there is little need for any other medium of control.

But back of the straight, long, calm look you give the erring child, there must be somebody looking who has already inspired the respect of that child. All the looking in the world will not move a child if the one looking is a being whom the child disapproves. He may be held in honor by adults. But children *know*, and it is the children who are right. The child has some of the instincts that belong to other animals, their intuitions, and almost their guidance. We grown folks..."*For a cap and bells our lives we pay...*"

When the room had become so still that we could hear the dogs on the next farm yipping at the heels of some animal, then I spoke, in an exceedingly low voice, looking for the first time at Keith. "You will please remain for a moment after school, Keith."

He was gonna git it! He was gonna git it good! Teacher had never before been so still and so unsmiling. The sense of this well-justified catastrophe pervaded the room during the whole afternoon, making my pupils very quiet. I never had any trouble with discipline. I never thought of it. What I did think about was self-discipline. What am I doing now? How am I looking and speaking? What are my actions conveying? A badly behaved, restless school-room usually means an undisciplined teacher. Pupils are nearly always the reflection of the teacher. I have qualified those last two statements because the day was coming when I should learn that the strictest self-discipline is of no avail where there is conflicting authority. That day was a long way in the future—many, many years away. I shall tell you about it later, here in this book of rambling reminiscences of those golden years which gave me the right to say, "We sagebrush folks."

Keith was free to leap on his horse and dash out of sight, as he did all the other nights. The children, as they marched out, were not any too sure of him, their eyes, still accusing and condemning, fastened upon him, seated there alone at the place he had taken for his own, before the unpainted, home-carpentered kitchen table.

When they were gone, he leaped up lightly and marched to my desk with an uncertain smile on his face. He was feeling a little guilty. He had not wanted to win my bad opinion, although he had so wanted to burn that sagebrush-pile. Most of us would really prefer to do right, but temptation clouds our better impulses and makes us blind to everything except that which we

desire. If temptation be removed, or rejected, or satiated through gratification, we still feel that scrap of God in each of us which makes us wonder at our former weakness. This, so analyzed, is what we call *remorse*.

Because I did not answer his smile, Keith hung his head. Had I tried force on that great six-footer, he would have laughed and left me. And he would have been right. Physical force is almost never right in the school-room. It is a pitiable thing when exhibited by a woman. And generally reprehensible in a man. The exceptions prove the rule, but they require the finest judgment to estimate their justification. In any case, however justifiable, it is an involuntary admission of pedagogical inadequacy. Sometimes to do without violence requires more wit than any of us possess, and that proves we are by so much the imperfect teachers.

I handed Keith the note I had written, and I said, "Read this, Keith, and if you feel like doing so, I should like you to deliver it to your father."

He stood reading, then thrust the note hurriedly into the pocket of his tan flannel shirt, and answered, as he rushed away, "All right!" Almost immediately I saw his horse dash by the row of windows, and I knew Keith was riding home, as he always did, like a demon shot from hell.

It may be that Keith never showed his father that note, simply fulfilling himself the obligation indicated there, for his father was most indulgent with him, as I afterward learned. On the other hand, he might have showed it to his father, and his father might have ordered him to replace the brush-pile. That is where my sex-appeal would have come in. Yes, I had sex-appeal. All women have sex-appeal for some men, just as all men have sex-appeal for some women. It is a good thing that none of us are delegated judges as to which these shall be.

What a dull, unattractive, hideously colorless world this would be without sex-appeal! Still...let's keep our heads sufficiently not to go and throw ourselves into the river because we cannot marry the one we want. There are plenty of useful, worthwhile things that need doing in this old world which awaits remaking at our hands. Also, there is the comforting thought that we never marry the ones we thought we were marrying. Each of us marries a total stranger. The sort of adjustment we make proves how big we are.

YOU ARE probably filled with suspense as to the manner of my charming Canby Quailput, Keith's big, stalwart, virile father, who impressed you as though he were a stallion pawing the earth. And speaking of pawing, perhaps you remember how I said of the man Blanche married that he might possibly have belonged to the genus *man-goes-about-pawing-women*. Only I did not put it in those words. Canby Quailput...I'll tell the story.

One night Jeff, Tony, and little Susie came in Jeff's wagon to tell us there was to be a dance in the hall over Gundelfinger's bank at Milner. It was probably the last chance we should have to dance there, as the town was soon to pick itself up bodily and move to the new site, Hazelton, where a grain-elevator was to be erected.

I was delighted at the thought of that dance. I was never so tired that I could not dance all night long. That night the men and Susie went in their wagon, this time following our buggy across the wilderness through the dimming light, over the miles of snow, down the grade from Jerome Canal to the big bridge over the turbulent Snake. Night has now fallen completely, so that as we take the snowy, packed road on the other side, we can see the lights in the hall over Gundy's bank and, drawing nearer, hear the orchestra playing,

Ev'rybody's doin' it, doin' it, doin' it!
Ev'rybody's doin' it, doin' it, doin' it!
See that ragtime couple over there,
Watch them throw their shoulders in the air,
Snap their fingers, honey, I declare,
It's a bear, it's a bear, it's a be-e-ear!"

In a moment, before we could get out of the blankets in which we were wrapped for the six-mile ride, the orchestra would probably begin playing "The Bunny Hug." I hasten, with eager anticipation. I love...I love...I love to dance! I shall never get enough dancing before I die.

50

We park baby Charles on the long bench which runs around the entire hall, my coat over him and Charley's coat under him. Walter is set down beside him, and from that instant his eyes never desert the drumsticks and the drum until we leave the dance and steer him reluctantly down the bleak outdoor stairway, his head turned backward to watch as long as possible what he was seeing for the first time in his life, a drummer snaring away on his little drum, *tur-r-r-rump! tur-r-r-rump! tur-r-r-rump! r-r-rump, r-r-rump, r-r-rump!*

I love drums. They get into my blood. I am as fascinated as five-year-old Walter, sitting there oblivious to the hallful of whirling dancers, staring at the drummer. I dance with Charley and Tony and Jeff, all three men looking very strange to me in their town clothes, I have grown so used to seeing them only in work shirts and overalls. Susie sits beside Walter, watching the dancers, her head turning from side to side as she follows each couple out of her range of vision. Strangely enough, these two children have never once given any sign that they are conscious of each other's existence.

As Jeff takes me to my seat, some one looms up before me like a war tank, though more shapely. It is Keith's hearty, so-masculine father, Canby Quailput, and he has come to ask me for this dance. To be taken in his arms is like being swept up by a hurricane. My feet scarcely touch the floor. The crowd parts for us, and well enough that it does, otherwise we would part it, leaving swaths of dancers lying prone on either side of our path.

We matched about as famously as a Spitz dog and an elephant, for size, although he was a good dancer. I had the amazed feeling that I was two-stepping with a graceful mountain. As the music gave those premonitory notes which are always recognized by dancers at the coming end, Canby Quailput looked down at me and drew my eyes up to his by reason of the curiosity I felt regarding this unknown, rather terrific he-man from the big open spaces—he was not a pinched, parsimonious farmer, but a wealthy cattleman. Then he said, with an exaggeration of the lilt in Keith's voice, "You're a cute little thing, aren't you?" And with that, just as the music ceased, he lifted me to his breast and gave me a big hug.

Had I been fifty then, I might have considered it a compliment, but I was not fifty. I felt indignation as big as Canby Quailput himself, but what was I to do? Remember, this was before Keith had set the sagebrush-pile on fire. I never was a gold-digger. I think, though, that was the opportunity to be a coal-digger, by working Quailput for some school-house fuel. Foolishly, I put the moment to no use, except to be disgusted. But there was Keith. I was Teacher. I had to ignore that hug for the sake of my pupil.

As soon as he had lifted me to my seat, he sought a nearby open window and, leaning out over the sill, drew great draughts from a flask, which he then returned to his hip pocket. This fact makes me a little doubtful as to whether it was my sex-appeal that provided the new brush-pile. Perhaps, after all, I was blotted out of his memory by the Demon Rum.

We left the dance-hall long after Quailput vanished somewhere. I am not sure that dancing with me made him leave, but he exited about that time. I was not sorry. One hug, such as that, is sufficient.

That dance was practically the last time Tony and Jeff and Susie and the Greenwoods were ever together in one group. The two men moved entirely out of the district, taking Susie with them. She had just begun her pathetic entrance into school. Jeff had found a cape for her somewhere, and a little close bonnet. I shall never forget the look of hope on that child's face when I gave her a little desk of her own, and she sat down in the midst of other little girls. Her own little books, too. She had never owned anything personal, nor had she ever associated with other little girls, or any other children, except for the silent, thoughtful Walter, who had evidently found nothing in her to interest him, lonely though he naturally was. I think, from the new look of contentment on her face, that she was happy for the first time since her mother had deserted her.

When Susie came with the men to say good-by, it was the last time I ever saw her. It was the last time I ever saw Jeff. Tony I was to see later, when he would tell me some strange stories. As far as Jeff was concerned, his strange story had already begun with those letters which had meant

51

so much to him that summer, as he had related to me. But Jeff told me nothing more, and when I learned the truth concerning those letters, I did not wonder that he was reticent with Charley and me as to where he was bound, and why. These things I shall tell you in the course of this somewhat disjointed narrative, which is really not intended as a narrative at all, being simply a cross-section of the life we sagebrush folks lived there in southern Idaho.

THAT WAS NOT the last of Keith's tricks, when he burned the sagebrush-pile. The second prank included Homer, who worshiped him and went about with him everywhere. For their practical joke they chose a day when the thermometer was in the region of forty below zero. I have an idea that the choice of day was purely accidental, though the forty below was an incident propitious to their impulsive plan.

We went to school earlier than usual that day, Walter and I, in the buggy behind Old Buttons, Charley driving, delighted little Charles tucked in the seat between his father and me. It was so cold that Charley had fastened a brown Army blanket from the dashboard to the hood, having cut a little hole in front of his eyes so that he could see the road. He had to see to drive, but I snuggled back, with my arm around little Charles, and Walter leaning against my knee. I needed no sight of eyes to be able to see that country as it lay, dazzling white, from horizon to horizon, a page of loneliness in the book of my life.

I must here make a confession which really belongs in the autobiography I shall never write. It belongs there because it is strictly about me and my writing. Whatever curse the passion for writing has been to me—and it has been that—it has also been the means of keeping me sane. As I look back over those years, I can say truthfully, considering everything (that which I tell you and that which I will not tell you in this book), that only my passion for writing kept me out of the insane asylum or my grave.

I think I recognized the beginning of something that might overwhelm me when I stood, as I did many times, on the toothpick-pillared porch, looking across the white valley under the radiant light of an incandescent moon in frosted glass—such a flood of light as one might read by. I used to look across the unblotted snow, with no mark of any kind except two white haystacks which the rabbits had undermined until they looked like huge mushrooms. These were on a scrap of land which Sam Curry was farming on his own, in addition to the Endicott acres.

I could see the road below, and the sight I saw will never again be duplicated—a river of rabbits, running from west to east, the closely packed little animals moving like rippling water, on their way somewhere. And near at hand, because we were the invaders of the wilderness and not they, the sharp, staccato barks of the desert dogs, coyotes, and their long, maniacal wails. The sight, the sound, they struck a chill to my heart.

As I sat forcing myself to study after school, when I was already tired beyond my strength, I often lifted my eyes from my books, and there through the window, across the dazzling, alabaster snow, the cold, white Minidokas stood, monumental, veined with blue, a faint pinkish light illuminating them from the setting sun. I forgot the page I had been studying, and a chill struck to my heart.

Something was happening to me and mine, and I did not know what. I could not penetrate the future. I had not come because I had wanted to come, but here I was. What could we do about this casting of our lives out here in the wilderness if the farm failed? And it might fail. I had not the comfort of Charley's confidence. Why should it succeed? What could we give the world that it needed, and, even so, how could we get it to the consumers, and at what price?

Just the impractical, sometimes despairing thoughts of a foolish woman, brought on by the sight of that lonely, never-ending snow, stretching across the wilderness. A way out? I must write one. Yes, I must write one! I never did. A farm is no part-time job. Neither is writing, if it is done right. Those who have time for part-time jobs have no real jobs at all. After that first winter, when the snow chilled my heart with its terrible loneliness, I was able to go on, love for that wilderness land of Idaho growing in my heart, but never enough to blind me to a yearning for some way out—never enough to make me willing to go down, with my family, a sacrifice.

52

Very cleverly I start to tell you something interesting, and then switch off on myself and my own feelings, as our boresome acquaintances buttonhole us on the street, while we stand, first on one foot and then on the other, eager to be off. But we must listen to a tale of woe: how every member of the family has something the matter with his internals, from gallstones to cancer, until you have the impression of a great mass of diseased intestines, livers, kidneys, lungs, hearts, and duodenums—I forget what a duodenum is, but it sounds bad. I am not heartless, just so pitying that this sort of thing, given wholesale, makes me sick. I suspect that folks who go around demanding sympathy are just plain selfish, particularly when you only saw them that night at a lecture and unfortunately got introduced.

Please accept this as my crawling, humble apology for forcing on you the feelings I had out of seeing snow, and we shall get back to the day Homer and Keith played their practical joke. Charley stopped the horse in front of the funny little despondent gate in front of the ugly, weathered school-house and removed the Army blanket. The brilliant white of snow was blinding. Weeds along the way were little silver trees, sparkling with diamonds, and there were diamonds, diamonds everywhere, laid out for exhibition on the white plush of snow in Winter's vast show-case.

I knew the children were in the school-house, faithful William—pale-blue eyes, conscientious, dull face—and fussy Harry—little brown eyes, agitated face, yet not less dull—being the self-appointed fire-builders, who never failed me. We see such unattractive children, ignored by everyone while they are young, and they almost invariably turn into our solid citizens, with ordinary, standard, good homes, all cut from the same pattern, good, ordinary women for wives, and children of their own having every opportunity but that of genius, a questionable blessing.

The door bursts open. Out puffs a volume of black smoke and, fleeing from it, fussy Harry and faithful William with, close on their heels, all the rest of the school-children, excepting only Homer and Keith. I did not notice this exception at the time, remembering it later. I jumped to the conclusion that the school-house was on fire. Charley told Walter and little Charles to stay in the buggy. He had already tied Buttons to the gate-post. The two of us entered the smoky school-room.

The stove door had been left open—a big, pot-bellied stove—and from its mouth the smoke was pouring. Charley closed the stove door quickly and then went out into the snowy yard, followed by me. My brain had imagined no reason for the smoke, but Charley's mind was quicker than that in my head.

"One of you boys get up on the roof and look down the chimney."

"I'll go, Mr. Greenwood." It was faithful William, and he was climbing from window to eaves in no time, while I then observed that Homer and Keith had joined us but had not been eager to offer, like William, although they were gazing upward, watching his progress with curiously half-smiling, expectant faces.

William was now just two legs, waving and dangling out of the chimney-top, struggling, I would say, with some unseen impediment. Out he comes, triumphantly waving a piece of clothing. "Here's suthin', Mr. Greenwood," he calls, "and this ain't all," and he tosses a man's coat to Charley, who immediately begins to prowl the pockets, rewarded by nothing. "Here 'tis," calls William again, and down comes the vest belonging to the coat. Charley fingers in the pockets of this and, as William drops beside us, draws forth a receipt for a bill of goods, made out to Homer J. Stillton.

A cry from Elida Stillton: "That's Pa's vest and coat, Homer Stillton! You're gonna git it...you're gonna git it good!"

We all turned back to the school-house. Charley stuffed more stubborn brush into the pot-bellied stove and left us. The same sense of impending justice hung over the school all day. I said not a word, cruelly conscious that both culprits would rather have had me speak, and be over it, than to keep that silence, for they felt certain that act would not be overlooked. Only a lazy teacher overlooks anything, although she may decide to ignore some things until she knows better what to

do. Besides, I had taken possession of the Homer J. Stillton vest and coat, and Homer had to get them back before the righteous Elida made her father enhance their value by means of his imagination, if these pieces of clothing continued absent.

Just before closing-time the inevitable words came: "I would like to speak to Homer and Keith right after school."

Again I kept the boys waiting, purposely, while I put work for the morrow on the ragged blackboard.

Then I turned to the boys, who were fidgeting near my desk with grave faces. "Here's your father's coat and vest, Homer," I said. That was all. I never stuffed a chimney to smoke out anybody, but I think I should like to do it, given the right people.

Both boys drew breath and looked up brightly. And both said something like the following: "We never done that fer devilment ag'in you, Mrs. Greenwood. You come earlier'n you always do. We thought we could do it 'fore you come. We jest done it t' smoke out Bill 'n Hairy...they always throws fits over nothin', 'n..."

"Forgiven this time, boys,...but no more of it, please. You see, that caused us all inconvenience. Anybody can play a practical joke. It doesn't take brains to plan them. Hurry, Homer, put those things back before your father finds out."

That was the last of such jokes. It is true that I would like to stuff chimneys and smoke certain people out. But I do not do it. I manage to restrain myself that much. I suppose it may end in my doing worse. I hate practical joking.

AN ADVERTISEMENT I saw in the Boston *Journal of Education* offered a box of tooth paste to each school writing to the address given. It does no harm to say that it was Colgate's. I sent for it, and prepared my children for instructions in its use by telling them all to bring their toothbrushes on a certain day. I took along a gray granite washbasin, a tumbler, and my own toothbrush.

Standing before the class, I commanded all toothbrushes to be lifted as mine, and was rewarded by the appearance of an appallingly black toothbrush, with an ancient, yellow, bone handle, clutched in the fingers of the yellow-haired Emily.

"Toothbrushes," I reminded my pupils gently, still conscious of that alarming black brush.

"Ain't none of us got none," from Bernard. "Tole Dad, 'n he says we gotta do as he done...did...do without none. He says he's kep' his teeth chawin' tobacco."

You can't pass open judgment on the habits of parents. I thought for a second. "When you go home, I want you to take a salt sack....How many of you can get a salt sack for your own?" (All hands up.) "Boil it every day for a few minutes, and you may take this sack, put on it the paste I shall now distribute, and rub your teeth with it at least once a day."

Emily was bursting to tell me: "I got a toothbrush." (She waved the black-stubbled brush.) "Ma found it in the yard of the farm we jest rented. Someun musta scrubbed their teeth there before we come. Ma was cleanin' the stove with it, 'n I says you says I gotta have it fer m' teeth, 'n..."

Her little sister Eda broke in, "She says we kin both use it...it's mine, too!"

"I tell you what you do," I said to the two little girls. "That's not the kind of brush I meant, so you give it back to your mother. Besides, it will be much more fun to rub your teeth the way the other children do."

How proud they were of those individual tubes! (A big fat one for Teacher!) It was with some consternation that I saw them go, a tube gripped lovingly in each hand. I was afraid they might end by eating the contents for its flavor. They had so few treats.

The phonograph fund was not growing fast enough to make music accessible to these pupils in the weathered old school-house. We had to have money. I could give a little, but we needed more than I could give. I could lend more, but who was to pay me back? The boys and I consulted together. The result was a platform in front of the ragged blackboard, made from lumber borrowed from Mr. Parish, whose little daughter Florence and son Hector were in my school. The

54

boys also made a scarecrow under my instructions, building it of straw and placing on its head a battered hat, contributed by Mike Gogenslide by request. Mike was not insulted when the boys told him they wanted the worst hat in the district and that he was wearing it. They said the teacher wanted it. Off came the hat. Mike always liked me, in a perfectly silent way; I could feel it. He replaced the battered hat with one which made the boys sorry the scarecrow had not been built with two heads. They told me about it, showing, always, a fund of exceptional humor.

Around the neck of the scarecrow were two strings, one tied to a pencil, one to a subscription paper; and a legend, in large letters, was blazoned on his breast:

HELP ME TO HELP THE SCHOOL TO GET A PHONOGRAPH

Keith stuck an old pipe in our scarecrow's mouth, watching with dancing eyes the horrified reaction of the other pupils, whose gaze turned at once to see what Teacher would think of this last prank. The hygiene book said terrible things about tobacco, and Teacher was compelled to teach it, as teachers are compelled to teach it throughout this good old United States now; and the result now, as then, is that the men go right on smoking, and also the women, if they care to do so.

Education does not form peoples' habits. How blind we are when we expect such a thing! All that education worthy of the name can do is to help people to find out what they want to know—what is necessary for their well-being that they cannot get otherwise. Habits are made through admiration of an example. We should have learned that through the failure of the Eighteenth Amendment. We shall fail as badly with repeal unless we have enough splendid men and women to set the right example, whatever that may be.

I knew my boys were already smoking and chewing. The older ones, I mean. They had been doing it for years. Their fathers had set the example. I was only a woman. My opinion carried weight, but boys need men to follow. And there was no fine, un-smoking, un-chewing male to change a habit fastened upon those boys like riveted iron. No matter what I felt about it, there was nothing I could do except say, "Boys, scientists have discovered these facts with regard to tobacco." That's all. My example meant nothing.

We had our little entertainment, the first ever given in the district—"The first time we ever come t'gither under one roof," as the enthusiastic Eb Hall, my future Mormon friend, expressed it. None of his children were in my school, all being too young.

I trained the children for exhibition by means of class work, which was a logical thing to do, for no class has any right to existence unless it leads to some form of activity connected with the child's actual life. I invited the Milner school to be present, and they came in a delighted body. After the program we staged a potato-passing contest which filled the old school-house with shouts of laughter. There was my school and Milner's school, with its teacher and one trustee, keeper of the livery-stable. The two schools faced each other, a bushel basket at each end of the facing rows, and from the full basket to the other went the potatoes, each school trying to fill its end basket first.

The parents were excited spectators. "Go it, Florence!...Look out, Bill!...Homer! Homer! quick! quick!...Mary Jones, there....Here, that ain't no fair!...Good fer Milner!...By jiminy, Milner gotcha that time!...Bernard! Bernard!...Look what you doin', Hairy!...Hurrah for Milner!" Faces, young and old, flushing with excitement, and the great requisite of all enjoyment, complete forgetfulness of self. Had they paid twenty-five dollars a seat; had it been in Soldiers' Field; had it been a contest between famous teams, no greater pleasure could have been experienced. It was the first sport these children had ever known, their proud parents watching and urging them on.

The same lanterns that had lighted their evening milking now hung on nails around the bare board walls. The women had brought pumpkin pies, some cheap brand of coffee, sandwiches of pork. Charley had provided our gasoline stove for making the coffee.

Before the lunch came the program, and it was a moment of heart-bursting emotion for those parents when their children stood on that unpainted plank platform and spoke or sang. They themselves had never done anything of the kind, nor had they ever seen anything like it done. These children, who had just been bossed about, scolded for not watering the hogs right, cautioned about shutting the barn door tight on Fanny because we don't want her calf to come while she's out in the

storm, told not to forget to close the outdoor cellar against freezing—these children were doing things their parents knew they could not possibly do themselves. Pride! Pride made up of smiles, and very close to tears—pride in offspring.

Everybody munching pie or sandwiches and drinking steaming coffee. Teacher flitting here and there, using her big chance to get acquainted with parents and put in a word now and then that will make things smoother for a misunderstood child. Eph Parish making shushings to everyone by hammering on a desk with a knife.

"Hey! *Folks*! Eb Hall here was jes' a-sayin' that we-uns has never been under one roof t'gither before. I move you Mrs. Greenwood organize us into a Lit'ry Society, so's we kin have this here doin's come often. They used to have lit'ry societies out east in Nebrasky, where I come from, when I was a kid. All in favor say '*I*!'"

There was a shout. He forgot to put the "No." I formed the organization then. Guy Raine, husband of a woman who could play the harmonica like a man, was elected president, and his son Arthur, secretary. I went Eph Parish one better. I who was not even a Christian, but with the untrusting faith in God of a Christian—I organized the first Sunday-school the district ever had. In doing this I know I exhibited only the ever-ready impulse of humanity to seek safety in conventional forms. I felt it would mean more social life. And when the phonograph came...

All the farmers had signed the paper, promising the payment of substantial sums, so I knew I was safe in sending enough of my own earnings to get the phonograph at once. When it arrived, the farmers and their families came for miles around, driving through the bitter, biting cold in wagons bedded with straw, old quilts drawn over the family, the driver muffled to the eyes.

I had sent for the best of records, but along with them some childish game records, such as "Round and Round the Village" and "Here We Go Round the Mulberry Bush," songs passed down through generations of children, beginning with whom nobody knows. Caruso, Melba, the great symphony orchestras, all performed for us sagebrush folks, there in the little old school-house.

There is a painting called "The Power of Music"...a sophisticated group, faces expressing every degree of tragedy and resignation, a red-haired, scarlet-gowned woman the dramatic center. It moves me deeply, that picture. In my mind, never yet painted, is another even more striking, entitled the same: in the rough, brown-planked school-house, sitting two to a seat, a baby on each desk, my work-worn, shabby farmers and their wives; children standing in aisles; the big boys lounging against the walls; every face intent; not a sound except the music from that morning-glory horn. These farm people had felt so much; had suffered so much in silence; had suppressed so much of joyous desire; had been so isolated from the world—this music, austere, classical, though it was, voiced the emotions of their hearts. For the ordinary city man the trashy, popular tunes—he has never lived with hunger, cold, pain, and death. It takes deep hearts to love deep music.

One incident of the school-house night entertainment with our scarecrow I forgot to tell you. It was while the potato race was in progress that I could see Charley and a rangy, overalled man, bulbous of eyes, in earnest conversation. This man was called "Sul" Smith, because he had two of the balkiest horses in the district, and balky horses were said by our sagebrush farmers to *sul*. I suspect the original word was *sullen*, corrupted into *sulling*, mistaken then for the conjugation is *sulling*, from some city man's use of is *sullen*, hence the verb to *sul*. Very expressive, I think, and worthy a place in the language. Sul Smith had a brother-in-law called "Sticky-fingered" Scott, a name requiring no analysis. The two families were what the sagebrush folks called "campers," people who came from other states in covered wagons—the last, somewhat ignoble covered-wagon trekkers toward the last Western frontier. They camped somewhere on the sagebrush land, making their living as they could from the farmers, not less poor than they, except for a few potatoes and some garden truck. Hay for horses they begged or worked out with odd jobs.

Charley told me afterward that this man, Sul Smith, was saying, "I hearn tell you wuz kindly a lawyer, Greenwood."

"Well...if you don't care what you say," Charley told him.

56

"This here's it. I'd be proud fer to hev yuh tell me what fer t' do in a case like this-a-here. They's some good jobs a-workin' with the road crew that's jes' come in, 'n I kin git one effen I kin git muh papers."

"Your papers! What papers? I hadn't heard of any papers," Charley queried in surprise.

"Yes, a feller hez t' hev papers t' git work with the road crew. Carl Berger got his papers, 'n they give 'im a job to oncet. Now, Greenwood, you bein' kindly a lawyer feller, kin yuh let me in on the how of gittin' muh papers so I kin kindly git some o' this-here road work. I gotta wife, 'n three kids, 'n muh sister's fam'ly..."

Charley was an accomplished mimic, so I could see every expression of Sul Smith's face written on Charley's face and hear every expression of Sul's voice in Charley's voice. Charley told me it flashed on him what Sul meant. "Why, man," said Charley, "you must mean your citizenship papers!"

Sul looked delighted. "By golly, that's it! It's muh citizens papers! How'd yuh know? I guess they wuz right about yuh be'n' kindly a lawyer. Carl Berger says them very words—he says he done got his citizens papers."

"How long is it since you came to this country?" asked Charley, in some wonder, Covered-wagon campers are not generally immigrants also.

"I been in these here parts dost onta six months, er so be."

"But, Sul, you speak English like a native. Are you from England?"

"No, I hain't never ben t' no England. Do uh hev t' be frum England t' git muh citizens papers?"

A suspicion struck Charley. "Where were you born, Sul?"

"I wuz born in Oklyhomy, in the town uv..."

"Why, man, you're already a citizen of the United States!"

"I be?" He looked dazed, then a broad smile spread over his sun-browned face. "By God! now, ain't that lucky?" he exclaimed.

The remark I make here is that if I had read this story or heard it over the radio, I should have had hard work to believe it. But it is true.

This is a good place to state, I think, that every one of those hard-pressed farmers paid what he promised on the school Victrola. Everyone in the district loved its music except the Revener Klyte. He attended our Sunday-school, but no one suggested his name as superintendent, although everyone did look up to him with more respect than the other farmers could command because of his holy clothes and manners. He was entirely absorbed in himself and his own opinions, an affliction common to men who often hear themselves speak in public before a lamblike audience; they grow to feel their hearers subservient to them, and that superiority-complex at-tack becomes chronic and spreads to the entire group of reasoning faculties, so that such a man finally includes among his inferiors the public at large. That is one of the reasons for the general unpopularity of preachers and public speakers of every sort. *Windy* is the word generally applied to them, and windy they are, for words without deeds are as the wind, which bloweth where it listeth, and no man careth.

While the early group of Sunday-schoolers were waiting for the rest of the farm wagons to come through the frosty morning air over the squeaking snow, I tried to make it happier for them by playing the phonograph against the first, important roarings of the sagebrush fire in the big, pot-bellied stove:

Joy to the world! the Lord is come:
Let earth receive her King;
Let every heart prepare Him room,
And heaven and nature sing.

The farmers and their wives forgot that their feet were still cold in their big, heavy overshoes. Little children turned toward the music, drinking it in, as it were, with wide eyes and open mouths, little, rough, red hands held to the comforting heat of the black, ugly stove. Only one

person in the room was not enjoying it. He was trying to set a better example than had been given by Teacher. The Revener Klyte was reading his Bible intently, sitting in one of the little fellows' desks, up in front. I knew he was praying to the Lord not to count him as one who was enjoying the ungodly music of a machine on the Sabbath Day.

I admit to prejudice concerning Revener Klyte. I think it is because I felt his aura of holier-than-thou, and not only that, but his aura of knowinger-than-thou. I can stand an insult to my morals better than one to my intelligence, because morals have shifting standards, and mine may be the right one after all; but intelligence is intelligence, and I always felt that the Revener Klyte had not a very high opinion of my ability. So you see my wounded conceit cannot give you a fair picture of the Revener Klyte.

He certainly was a great help in making a go of the Literary Society. He did the best he could for us, which is all any one could do, trying to teach two women, his wife and his sister-in-law, to play the violin—fiddle, I mean—when his own qualifications were...well...woman! remember your wounded conceit! It was not wounded conceit that made me scream inside while they played a trio, "Silver Threads among the Gold," which sounded more like "Sniveling Heads amid the Cold," or something like that.

The cow-rangers were the best of all at those Literarys in the old school-house. Standing before the tattered old blackboard, arms draped around each other's neck, eyes never lifting from the floor, they sang the songs you now hear over radio, only better, and many songs that you have never heard. I can see them now....Later I copied the words while Steve Drake sang them for me in our living-room at the farm-house; there is a version slightly different, but I like this one because I got it myself in the brush:

> *The road that leads to the fair, mystic regions*
> *Is narrow and dim, so they say,*
> *While the road that leads down to perdition*
> *Is posted and blazed all the way.*
>
> *I oft-times have wondered how many*
> *Would perish on that great, final day?*
> *While we all may be rich, and have plenty,*
> *Who will find the dim, narrow way?*

APRIL examinations, and would my big fellows get through? I know they had enjoyed school with me, but that was not enough. *They had to graduate!* I had begged one month from the plowing to get them through, and they *must not fail.*

When they handed their papers to me, I found them very creditable, except for one factor: those boys had actually forgotten the existence of commas. I could see how it had occurred. When they had read the questions, which came from the county superintendent at Rupert, and had seen that they could answer them, their enthusiasm was so great that they had just rushed on and on, unconscious of such punctuations. Imagine an airplane running a race through the heavens and having to stop to acknowledge a lot of comma clouds!

I knew it was likely to prove fatal if I sent those commaless papers back to Rupert to be judged, even though every question was answered correctly. I now make confession of the crime of my life, which, until now written, has never been revealed to any one: sitting there at my desk, startled by shadows and creaking of boards, I deliberately sprinkled bootleg commas over their manuscripts.

Oh, the joy of handing those certificates to boys who had rushed across the wilderness on horseback, through the spring twilight after a long day's work, to receive them! I shall just have to be content with a lower place in heaven, for I will not pray forgiveness for those commas which I do not regret having dishonestly sprinkled over those examination papers.

Before the boys...young men...left to work again, all my school wrote letters of appreciation of that Victrola to Thomas Edison on his birthday, and his reply is reproduced here.

Cable Address "Edison, New York"

From the Laboratory
of
Thomas A. Edison,
Orange, N.J. Feb. 19, 1914.

Miss Annie Pike Greenwood,
Milner,
Idaho.

Dear Miss Greenwood:-

 Allow me to acknowledge the receipt
of your favor of the 6th instant and also of the letters
of your young pupils containing birthday greetings. I
want to thank you and them for your congratulations and
good wishes as well as for your kind remembrance of the
occasion.

 Yours very truly,

 Thos A Edison

I wrote an account of how I had used the Victrola, which was published in the *Journal of*

Education. The Victor Company republished this in an attractive booklet, "The Victor in the Rural School."

Dr. Albert E. Winship, editor of the *Journal of Education*, was to speak at a joint institute of several Idaho counties, and since the meeting was at Twin Falls, he had the train stop to let him off at Milner. From the station he went directly to the livery-stable, run by the trustee who had visited my school on the entertainment night, a red-haired, brown-eyed man of about forty. Dr. Winship told him he wanted to be taken out into the country. The man shook his head emphatically.

"No," was the uncompromising answer. "These here roads is snow on top and deep mud underneath. I wouldn't take the horses across these here roads for nobody. Might's well kill the horses 'n be done with it. I wouldn't take the horses out this kinda weather fer God Almighty Hisself!"

Dr. Winship wrote all this incident, and it was printed in the *Journal of Education* just after my first article was published in the *Atlantic Monthly*. He was turning away, disappointed, with the words, "I am so sorry. I had the train stop for me just on purpose to go out and visit Mrs. Greenwood's school."

He said the man became galvanized. "Who did you say?...Mrs. *Who* did you say?"

"I wanted to go out and see Mrs. Greenwood's school," answered Dr. Winship, hopefully.

The man grunted, disgustedly, and began throwing the harness on his horses. "Why in hell didn't yuh say so in the first place? I'd go anywheres fer that woman!"

Such is the potency of a little human kindness, the like of which I had exercised that night of the entertainment, taking a moment, flitting, as I was, hither and yon, to say a smiling word to the red-haired trustee from Milner.

We held closing-day exercises in the new school-house, which I was supposed to have occupied. Men were hammering in the adjoining room, and the farmers, wives, and children were seated on planks laid on kegs of nails. But we were there at last, speaking, singing, though with no platform.

I told no one what I am telling you now. A few days before, I had received a letter, not preserved, containing practically these contents;

"I am naming the new school-house and the new school-house district after you because I have long admired your work. It will be known as the Greenwood School-house, and that in the Greenwood District."

After a few more kindly words, it was signed Ida M. Sullivan, one of the real names I am giving in this book. She was the county superintendent of schools. The sagebrush farmers have never known why the region where their farms are located is called Greenwood. They probably imagine it came about because the Greenwood farm is just up the hill from the Greenwood School—not logical, because the Endicott farm was as near.

Several efforts were made by incoming farmer's wives, the men being indifferent, to change the name of the district back to Pleasant View, or forward to Buckeye, or What-not, though not many supported the latter, if any. I kept my mouth shut, a strange matter for me. The name could not be changed, as they imagined, by general vote, or even by secret propaganda, the actual device they employed. It was a school district. Only another superintendent can change it. But look what happened to Hoover Dam!

So, until some one changes the name of the Greenwood District to something else, I am going to be glad within myself that those wonderful acres of land, extending on the north to the little Hootin' Nanny gasoline railroad, and on the south to the great River Snake, and on the east to the outskirts of Hazelton, and on the west out into the wilderness yet unconquered—that all this wonderful country is named after me. The honor cannot last long. The name will be changed, blotted out, and I long forgotten. But now...there it is.

Dr. Winship wrote me, "I have spoken of your work from the platform of every state in the Union."

I tell you these laudatory things to balance the rest of this book, which is an account of

60

the downfall of a self-opinionated woman—incidentally, but still mostly of my beloved sagebrush folks.

III. BIRTH

Farming is giving birth. That is why nearly all men yearn for the soil. In spite of pain, giving birth is the most ecstatic experience possible to a normal human being. Man unconsciously envies woman this privilege. His surrogate is cultivation of the soil. He thrills for the earth at the receipt of the seeds. He feels her gestation, with anticipatory bliss, anxious fear, faithful preoccupation. The harvest is for him the birth.

Birth is a continual process on the farm. The land is for borning; the animals are vessels of reproduction; the woman steadily, even as the seasons, births forth the farm family until all its members are in being. The crops are of short duration; animal life ceases to have conscious continuity; only the woman gives that which never ceases—joy in springtime, companion in summer, fellow-worker in autumn, comforter in winter.

Birth is something which city folks connect with the word *control*. Not to control it is accident, mistake. We sagebrush women bore our babies regularly, every two years, sometimes at shorter intervals. Always a number of us were pregnant; always some of us were nursing our young. Only the sterile among us were simply housekeepers.

Out of birth came nearly all the troubles and delights of us sagebrush women. The joys were without dramatics. If you had a good man, it was happiness, no matter what the pinch of poverty. Among the children there were no neurotic twists to result in tragic maladjustments. No child was so long the baby that it formed complexes of jealousy and hatred when the next baby appeared. The children helped to rear each other; all helped to make the family living; all were responsible. No idleness. No money spent foolishly.

My children! I feel the hair damp on their heads from swimming in one of the canals. I smell the sweet drying alfalfa in their clothes. I see their bright eyes and their sunburnt skins. I all but taste them.

And we loved things together, my children and I. Pretty, the magpie, with intelligent, very blue eyes, hiding the bits of cottage cheese I gave him, in the binder, the spring-tooth harrow, and other farm machinery, and coming back avariciously for more. Outside my window he practised talking as he heard us talk. Joe had found him out in the sagebrush desert and brought him back buttoned in his shirt as he drove home the wandering cows.

The kitten, Clara, with the largest purple eyes I ever saw in an animal, sickening unto death because of the mistaken kindness of the children in feeding her all the little, naked sparrows she would eat, gathered from the rafters of the granary. Walter brought Clara home from Hazelton, where some farmer had dropped her. He carried her buttoned in his shirt.

Always I had a hospital of birds and beasts, brought by the pitying children from the fields. A family of baby pheasants whose mother was killed by the binder. A cat who had lost a leg, cut off by some farm machine. The stray dog that I did not like; he had a sneaky air, and I let him die of pneumonia, attempting to save the poor creature when too late, only to regret it all my life and be haunted by that pitiable hound as though I were a murderer. I had finally taken him into the house, out of the winter, making him a padded coat and rising in the night to give him warm milk. But it was too late. Forgive me, poor dog!

Tag, the pure-bred collie, added to the birthing on the farm every season—litters of

beautiful puppies which could not be told from pedigreed animals except that there was always one little mongrel beast among them to shame the others with the blot on their escutcheon.

The cows always went dry some time near the end of February, calves being upon the verge of birth. There would be no milk to feed our pets, and they must be given away. Skeezicks, the mottled, clownish dog who was the family skeleton among three snow-white collies. Walter comes home from the field where he has been plowing. Skeezicks was the only pet dog he ever had. Whistling here, whistling there...my heart vibrating. At last, to me, "Where's Skeezicks?"

"The cows are not giving any milk...your father gave all Tag's pups to the Montgomerys when they came today. Mr. Montgomery wants them for his sheep..."

"But Skeezicks was *my* dog. I could have fed him part of my meals..."

"Yes, I know..."

I see him sitting on the front porch with the toothpick pillars, looking down at the ground. He sits there a long, long time, looking down at the ground. That end of the porch is where Skeezicks always came scrabbling out to greet his master, wild with joy, wagging his body with his tail. Walter will not cry. He is not that kind. His tears flow inwardly. He just sits looking at the ground.

It was that way on the farm. Every time the cows were about to give birth to calves, the farm pets had to be given away. Human beings went without milk and butter and cream. Two months before the vegetable garden gave forth the first delicate tip of lettuce, all the canned stuff, put up by me the previous summer, and all the cellared stuff, stowed away by the same hands, all had been eaten. We never sat down to the table alone, except occasionally for breakfast, or when we were going to a movie, or to a rabbit-drive, or such, when likely every one else in the community was rushing to be gone in the same direction. I was glad to have the farmers drop in and stay for meals. I could seldom see the women, and people have great interest for me.

I remember only one occasion when I felt rebellious. I had been on my feet all day since four in the morning. It was nine at night. The last dish was washed, and the bread mixed for the morrow's baking. I untied my apron strings with a sigh of relief. Bed was not enough. It never was. I was too tired to go to sleep. I would sit down to my faithful old typewriter, which Charley had bought me the second Christmas after our marriage because I wanted one above everything else. I would sit there, and gradually the ache would go out of my back, my feet would stop throbbing, I would no longer feel so tired I wanted to lie down and die. I would be writing, surrounded by an envelope of farmer-manufactured tobacco smoke, being cured as a ham or a bacon is cured in an old-fashioned smokehouse, my nerves lulled by the talk of farmers settling the Government, talk which I heard only as a murmur less insistent than the sound of Jerome Canal, always in my ears.

Walter

Charles

Rhoda, seeing her first lawn

Joe, on our first corn shock

SAGEBRUSH CHILDREN

There was a knock on our front door. An old man, a former minister. Selling Bibles. We needed no Bibles, but "Come in," Charley is telling him.

"We're traveling. We have our own car, sleeping in it. But we'd like supper."

Then I hear Charley say, in the warm hospitality of his heart, "Come in. Bring your wife in. My wife will fix you something to eat."

Well, his wife did fix them something to eat. There was scarcely a thing left over. She had to go down cellar on knees so tired they trembled; pare potatoes with hands that ached from toil; fry them; fry eggs; warm some left-over biscuits; open a jar of pickles, a jar of peas, and a jar of peaches; set table; and look as though she liked it. And she was ready to drop tears of tired rage on the frying eggs. She was wondering how it would feel to ride all day in the lovely open air, for it was early spring, and then stop comfortably at some farm-house and have the drudge there cook a meal for one.

The good old couple came in and ate, and poor lonesome Charley, who could not stand a word about religion, listened to the old fellow drone on in uninspired numbers. It was a strange thing that their religion never once took me into account. Was I tired? Should they have come to me to cook for them? Is it always Christian to ask some one to cook for you just because you are hungry? They said they had a cooking outfit with them but thought it would be easier to stop at a farm-house by the way. Yes, it was easier on them. But was it easier on me? What is it Shylock says? "Oh, these Christians!" And was I mad at Charley!

I did not write that night. If you must have the truth, had I answered the door, and had they said, "Could you give us a meal?" I would have invited them in. I think I resented not being allowed to be a heroine of my own free choice. But is there anything so very heroic about choosing one's own sacrifice?

We had five dogs, fourteen cats, and my magpie Pretty. They all ate out of the same pans, together, taking sly slaps at each other if their mother did not catch them at it and make them ashamed. I was their mother, of course. They understood me, and I understood them. The one language understood by all creation is *Love. Lady*, says Ruskin, means "bread-giver." Cats and dogs do not like bread, will not eat it if they can get anything else. These dogs, cats, and the bird thought I was their *mother* because I shamed them when they spatted at each other; because I said loving words to them and looked loving thoughts toward them; because I set out what they liked for food, the big pans of separated milk. The lion and the lamb shall lie down together, and a human mother shall feed them.

I did not mind so much the lack of vegetables and fruits and milk and cream and butter during the very early spring, almost into summer, excepting for two things. Nearly always the pork became rancid, and the potatoes had by that time developed every disease to which potatoes are heir. The pork was well enough for some months; and when put in our cellar, which was just a square hole outdoors, roofed over and with steps, the potatoes looked perfect. Charley dipped his crop in a formaldehyde solution, and our potatoes showed less disease than was general in that part of the country. But by February the black rot had put in its appearance.

I could scarcely bring myself to touch those black-rotted, stinking potatoes. I must struggle up the outdoor cellar steps, a heavy pail full of potatoes in my hand, and pare all of them in order to get enough for dinner. After they were cooked, I could still detect the odor, and I could not eat them myself. In the springtime, before the garden came, I slowly starved. But that made the raising of my garden more of a passion with me than ever, if that were possible. For growing things from the soil is for me a bliss which I cannot adequately explain. Birth. The glory of helping the earth give forth. The glory of watching the miracle of growth, lettuce seed always producing lettuce, and kernels of corn, always corn. How could anything but man come from that norm which was meant to be man? *Who or what* meant these things so to be? What is the *meaning* back of it all? And how can we doubt that there is a meaning?

BIRTH meant to the older women of our sagebrush community what some day it would mean to us younger mothers. They had long passed the physical operation of birth, and theirs were now the ineradicable results. Sometimes it meant for them a harvest of pain. For it was their

65

harvest-time, and when they should have been feeling the joy and the peace and the plenty of harvest, they were suffering the tragedy of things gone wrong with their fields, the grain laid low with the scourge of rust, and no more time for growing.

The father of a sagebrush family is its god or its demon. There is no escape for the wife and children. In *The Doctor* Balzac wrote, "Anything may happen on these isolated farms." He meant the farms of France, but no European, nor any Eastern American farm, can compare in its state of isolation with those sagebrush farms of ours, green gems set in the midst of long stretches of desert land.

There are more city women in insane asylums than there are farm women. Statistics tell us that, and we must believe statistics, because men devote their lives to compiling them, and because the figures are all put down there in print. Figures always seem to me as convincing as God. Besides, we all believe what we see in print. "I saw it in an article the other day" is proof convincing enough to clinch any argument. In the case of insane farm women, we need not refer to any article, or even to be overcome by the arithmetic of the statistics (which I always am), for it is a fact that there are more city women than farm women in insane asylums. I was personally acquainted with this truth in one mental hospital, having lived in this asylum for years—in "luxurious apartments," according to the Salt *Lake Tribune*—when my father was medical superintendent of the institution. In that asylum there were more city women than farm women.

The reason mentally deranged farm women are not in the insane asylums is because they are still on the farms. I do not write this to make you smile. The sanest women I know live on farms. But the life, in the end, gets a good many of them—that terrible forced labor, too much to do, and too little time to do it in, and no rest, and no money. So long as a woman can work, no matter how her mind may fail, she is still kept on the farm, a cog in the machine, growing crazier and crazier, until she dies of it, or until she suddenly kills her children and herself. More farm women than city women kill themselves and their children. You read of such cases so frequently that it seems strange to me if this explanation never occurred to you. No need for statistics to prove it.

I was recovering from the birth of one of my babies when the first insane woman of our sagebrush community was removed to the State Institution at Blackfoot. I had been too overwhelmed with work to get acquainted with her, and I never knew certainly the cause of her mental lapse.

The second woman to go insane lived not far from our farm. Her name we will call Mrs. Goodinch. One day, when her entire family of children and her husband were trailing her as she worked out-of-doors—chopping sagebrush, among other things—suddenly she seized a hen and chopped its head off. Then another, and another, and another. She was very agile, and she had no difficulty in capturing the silly fowls. All around on the ground were bloody, flapping, headless chickens.

Her children stood aghast. But her husband was yelling and cussing and hopping in and out among the flopping chickens, all of them together like corn popping in a skillet. He dared not go near her, for she was larger and stronger than he, having done most of the work on the place herself, and there was that bloody ax, brandished in her big, muscular, rough, raw hands.

When the last chicken was done to death, she turned her frenzied face toward her children, pointing with her left hand to her husband and exclaiming, "Go get the old man and hold him while I chop his head off!" And she would have done it, without their help if necessary, but he was through the barbed-wire fence and down the road before she could move in his direction.

He was stumbling down the road, mouth sagging in terror, eyes bulging, when he met two of our good sagebrush women, driving their buggy toward him. At sight of his frantic excitement they stopped, and he related his tale of horror, climaxing it with, "And all them there chickens with their heads chopped offen um!"

Thinking they might pacify Mrs. Goodinch, the women drove on, out to the rented farm where the Goodinch family existed miserably; and as they went, they decided that seeing the old

66

man sitting around all winter, with no food and no shoes for the children, probably had something to do with the matter. They met Mrs. Good-inch. She had left behind her ax and her children.

"Goin't' Burley t' git a job," she told the women.

She was dissuaded from walking the twelve miles to Burley. Instead of that trip, a few days later she was taken to the insane asylum at Blackfoot. I cannot see why. The chickens had nothing to eat. There was no more wheat. It was best to chop their heads off at once. Maybe the old man needed a good beheading. Certainly the family needed someone to go to Burley and get a job. I think her actions were very sane, though too rebellious for a farm woman. Maybe rebellion in a farm woman constitutes insanity.

"Anything may happen on these isolated farms." There was another woman who lost her mind but was never taken to an institution for mental disorder. She had borne six sons. One after another she had seen them unmercifully beaten by their father until they ran away from home, writing no word as to their whereabouts for fear he would have the sheriff bring them back. It was the last son that did for her. When she witnessed his brutal beating, she suddenly lost her mind. But she was not violent. She laughed all the time. She had not laughed since she was married. But from the moment she heard the piteous cries of her young son, she began to laugh, and she never ceased. The boy ran away, and she never knew it. She was spared the agony of thinking of those six sons she had borne, out in the world, God knew where. She just laughed all the time.

Her man had money. He had wrung it out of the unpaid labor of his sons and his wife. Why he should have wasted any of it on her, I am sure I cannot imagine. Some twist in his nature compelled him to take her here and there to specialists, always with the same result. She just kept on laughing.

One case came nearer to me. I could not visit my friend Mrs. Howe, though I heard she was ill. I could not walk. I had phlebitis after Joe's birth. The day finally came when I could go with Miss Butterworth and Mrs. Jean in our two-seated vehicle known as a Mormon white-top—I suppose because all the Mormons had them, and the top was covered with white canvas. Ours still had U.S. MAIL in big letters on it. I don't know what its history had been. Charley bought it second-hand, giving what was left of our narrow-gage buggy to some one more needy than we were. After the white-top came the cart, and after that our second-hand Ford which we called Sagebrush Liz.

We took with us to my friend's home as many dainty edibles as possible. "These things ought to last Mrs. Howe a long time," said Miss Butterworth, "but they won't. That tribe will clean them up within a half hour after we leave."

"That tribe" were my friend's children. And I knew what Miss Butterworth said was true. But they might be excused a little, for they lived on boiled potatoes, lard gravy, and corn syrup with their bread.

When Mrs. Howe had come to Idaho, she was beautiful, with dark eyes, rosy cheeks, and a great rope of chestnut hair wound in a coronet around her head. But she was not well, and never had been. At her home in Galesburg she had been able to get along, but her husband had thrown up his good job and put their savings into sagebrush land, persuaded by speculators to that madness.

She had come to a shack in the wilderness, tar-paper covered, like so many other shacks, cold in winter, broiling in summer. There were no conveniences. But these were only material hardships. The thing that killed Sally Howe was seeing the gradual degeneration of her family. They had come with books, and one of the most modern of phonographs, and good furniture. She lived to see them existing in a state lower than the farm animals, because when a human being no longer aspires, but simply lives to eat and sleep, he is lower than the beasts whose habits are the same as his. The father, too, had the beating habit. A whole family can sink into debasement under the hands of a father who lays violent hands upon them.

One day, as I sat by the window unable to walk, I had asked Tom Howe about her condition. "She just lies in bed," he had said. "She used to be the kindest woman. But now when I try to wait on her, she says, 'Don't come near me, Tom Howe, or I'll scratch your eyes out!'"

And Emily Howe, eighteen, the eldest girl in the family of five, told me, "We surely thought Ma was dying yesterday. She told Frank to tell us all to come to her bedside. We did, and Pa was even shaking. He thought the way we did, that it was her last words. We stood in a line by her bed, not saying a word, and hardly breathing. She started looking at Pa, and she went down the row, slowly. Then she said, 'You're a fine-looking bunch!' And then she turned her face to the wall."

I could picture it, all of them standing there, slovenly, sunburnt, and she had been so immaculate and dainty. She had no desire to get out of that bed. Of course, she was really ill, too, and nothing was being done to make her better. There was no money to pay doctors. She was a farm woman, and she would have to live or die as nature saw fit.

Mrs. Jean was one of the best managers in our district. She and I were probably the frailest of all the sagebrush women. She had the advantage of me in many ways. Her people had all been farmers as far back as anything was known of them, down in South Carolina. She knew how to do everything and do it well, but she did not do it all herself—she set others to work. I admired her greatly. She saw to it that her children had musical education, taking them to Twin Falls herself, in the car she and Dan managed to get—a good one, at that.

But Dan was a very good husband and father. He was called among us "the workin'est fool ever." That meant he worked whenever possible and did not spend three months of every winter just sitting around settling the Government. When the other men started settling the Government, Dan always allowed he would be "gougin' along."

It was Mrs. Jean who organized the first women's club in our sagebrush community, the Ladies Fancywork Improvement Club, as the women called it; and it was a decided credit to her, for those women often did things for the members of the community much more important than mere fancywork. It was they who had planned this ministration to Mrs. Howe, Miss Butterworth and Mrs. Jean being the acting members of the committee. I was included in the visit because I was a friend of Mrs. Jean, and also because they were borrowing our white-top; very courteously they asked me if I would like to go with them.

We were taking some delicious eatables with us, for not only was Mrs. Jean proficient in cooking, but Miss Butterworth had taken prizes at the Fair for her butter and other things. She was pretty, gray-haired, and had given her life to her brother's motherless children. She often wore dainty lavender clothes, and she had a sense of humor and was "plunk and chuffy," as Tony Work would have said—Tony, so long gone from our neighborhood.

I was shocked when I saw Mrs. Howe. That glorious hair was a solid, dingy, repulsive mat on her head. It could not have been washed or combed for months. We women dared not cut it off, for we had not the right, but that is what would have to be done with it. As Miss Butterworth turned back the covers to bathe her, there scurried across the grimy undersheet literally scores of big dark-red bedbugs. They had been feeding on the helpless sick woman. Miss Butterworth had brought a box of insect powder, which she instantly puffed over the vile vermin.

Somewhere we found two clean sheets. We placed Mrs. Howe in a big chair while the bed linen was changed. I had been shocked by the condition of her hair; I had been shocked by those scurrying bedbugs; what next I saw shocked me more than the other two put together. Under the hips of the suffering, sick woman a hole had been rotted entirely through the mattress by the uncontrollable flow of the excrement from her body, for her bowels and bladder were paralyzed.

We twisted the mattress around so that the uncomfortable hole would be at the foot of the bed on the other side. And while Mrs. Jean and I were so engaged, Miss Butterworth puffed the insect powder over every inch of the bed-frame and the mattress that she could reach. It would mean temporary relief for the sick woman, but the house was alive with the verminous pests.

We used a bread-board for a tray, and I fed my poor friend with a spoon while the other two women made her bed. Fresh raspberries with thick cream; little, browned, oven-fragrant rolls; Miss Butterworth's prize butter; white slices of roasted chicken; delicate custard; and many other things we had brought, with thought of tempting her appetite and in the vain hope that some of the

good things might be saved for her. They were a selfish family, the five of them all grown, Harold, fifteen, being the youngest. Perhaps we might have done friendly things for them also. They had been rendered dependent and spineless by a father who had the beating habit. In a family with a beating father the children usually lose all power of independent, elevating action. *Thou shalt not lay violent hands upon the body of another human being!*

My friend had almost totally lost her mind. I could see that easily, for though I was a little girl when I had lived among the insane, I had forgotten nothing. She stared at my face for a while, eating of the fresh, luscious raspberries I gave her, and then I saw that she was making efforts to speak to me. At last I made out what she was saying: "Rhoda...Joe...Rhoda...Joe..." Tears sprang to my eyes.

The Ladies Fancywork Improvement Club wrote to the Red Cross, and soon my friend was in a sanitarium where she could be given proper care. She recovered enough to enjoy sitting there, clean, well-fed, but she yearned not at all for the tar-paper shack, her five children, or her husband. One of them had been kinder to her than the others—Pete, we called him. He went to see her. And there she died. She had enough physical disabilities of which to die. But I believe she might have survived them all had there been hope in her life. She had reached the bottom from which there is no climbing up. She died as the result of the births she had accomplished: she died because of what her children had been compelled to endure and because of what they had become by reason of it. Birthing for her had been a bitter tragedy.

AMONG the sagebrush friends I most enjoyed was an elderly woman who seemed to know how to meet life with such sanity that I asked her one day how she had managed to rear her large family and keep so well-balanced. This was her reply: "I thought I'd go insane when I was younger, but, instead, I lost the hearing in my right ear. You know, I am stone deaf in that ear. When that first happened, I thought I had another grief added to my other troubles, but I found out it was just a blessing in disguise, sent by the Lord. My man, Fraser, has always had the bad habit of reviewing all his troubles just before he falls asleep. He goes to bed, and then he begins to cuss. Everything he doesn't like, he cusses. He cusses the weather, and he cusses his bad health, and he cusses his horses, and he cusses the plowing, or he cusses the price of wheat, but most of all, he cusses our boys. I could lie there, kept sleepless by him, and stand all his cussing till he got to the boys. I just couldn't stand that, and I thought I'd go crazy. They were good boys, and they worked hard, but he was never satisfied. But after I went deaf, when he began cussing the boys, I just turned over on my good ear, and I couldn't hear him any more. I simply went to sleep. So you see, my dear, my deaf ear is my greatest blessing."

Birth was not meant to be harvest-time with the younger women, the women of my generation. Ours was the birthing-time, the bringing-forth time. Our sorrows were the pangs and troubles of the now-birthing time. So it befell with Mary Carbine. She had eloped with Mordrum Carbine, of whom her parents disapproved. They were farming people of Iowa, having prosperous land and a good home. Mary had known what was best in agricultural life in America. She was to know what was worst.

Mordrum Carbine brought his Mary to our sagebrush wilderness. He established her in the center of his dreams of affluence and in the reality of a little tar-paper shack. Her babies came often, one pushing another out of its mother's arms. Few other young girls could have stood such frequent, unremitting birthing, but Mary Carbine was a magnificent creature, tall, statuesque, beautiful. She took her fate silently, with a quiet that was not joy. I felt that as I used to watch her suckle whichever child was of that age.

She would have been a gorgeous creature dressed in fashionable apparel. With the outdated clothes in which she had fled with Mordrum, and which had never been replaced, she was a noble figure. With no self-consciousness whatever, she would sit, broodingly, feeding her infant, a white-marble shoulder and firm round breast bared, sights to blind with their beauty. The other farm women who nursed their young, with equal unconsciousness of the nude, were not built as was she. Her regular features, bowed above her babe, were crowned with a heavy weight of shining, waving

hair.

I felt she was not happy. She was trapped. She knew she could turn to no one. The deed that had ostracized her from her kin and thrust her into the hard wilderness was her own. She would bear because she was responsible, and because there was no way out. Once I heard her speak to Mordrum. Her voice was low, but I read in it all her disillusionment.

A friend of my own little family was Aunty Sother, or so we called her, an auburn-haired, sunny, capable middle-aged woman, who had cared for Rhoda in our own home when I lay in the hospital after Joe was born. Mordrum Carbine went for her on his horse. His wife, he said, had given birth to another baby two weeks before, he being the only person present to deliver her and care for her afterward. He was the kind of man who read everything and who therefore felt himself competent to do anything.

This confidence does not usually come from reading. There was Segmetter. He had helped with our potato-digging. As I called the men to dinner, he was sitting in a low rocking-chair, *squeak-squawking, squeak-squawking* back and forth on a loose board in the floor, his partly bald head burnt the color of his featureless face.

Of course, I supposed he would get up and come to the table with the other men, but he did not. He simply hitched the rocking-chair to the end of the table, saying, "I'll eat in this. Feels good after workin'." His chin was not much above the level of the cloth, both soiled, gray-shirted elbows elevated at a sharp angle in order to cut his meat. Old Man Babcock had heard about the Carbine baby, and he was telling about Mordrum going to get Aunty Sother.

"I heered she's pretty low," said Ves Appleby, wiping his mouth with his bandana handkerchief. He had just sucked a cup of coffee through his walrus moustache.

Peter Siggins, who flowed over his belt in blue-shirted rolls of fat, remarked, "Mord took keer of her, hisself. He was sure goin' hell-bent-fer-breakfast to git Mrs. Sother when I come along by there today."

Segmetter was putting potatoes in his mouth very cleverly with the blade of his knife. He spoke through them: "Me, I taken keer of my womern with all our kids, en I didn't hev no trouble only with the least one of my kids. I thought fer a little 'at it was all up with the womern en the kid, too. He come backside fust."

They continued talking obstetrics, which gradually led into the animal field, the undesirability of bull calves being discussed, and the low price given for them by the Hazelton butcher, the town of Milner having picked up bodily, and moved to a new location and a new name. This led one of the men to tell how his sister-in-law insisted on her children calling the bull he owned "the gentleman cow." While they laughed with great guffaws, instantly relapsing into their food again, Eg Hammick reached across the table for his third piece of raisin pie and remarked, "Mord's womern shore musta been tooken bad fer him to go clean over nearly to Milner t' git Mrs. Sother."

I did not listen to the rest of their talk. I was thinking of beautiful, young Mary Carbine. Even after the men had gone back to the field, and I was eating in the midst of the plates they had wiped with bits of bread in preparation for their pie, I still thought of Mary, and I pushed aside the book I had intended reading, as I always read in every fraction of time I could call my own.

When I had first come on the farm, I had supplied pie dishes and linen napkins, but after the meal I always found the napkins had been "trodden under foot of men." Those farmers were used to their bandanas or the sides of their hands. And they preferred their dinner plates for pie, the pies being placed on the table segmented, so that they might help themselves to as many pieces as they desired. I was a good pie-maker. I had learned from Hib, the master baker who had come to farm on shares with Charley; they had divided the profits at the end of the year, which were nothing divided by two.

It was Swinburne I had opened to read. I got no farther than

From too much love of living
From hope and fear set free,

70

We thank with brief thanksgiving
Whatever gods may be,
That no life lives forever;
That dead men rise up never;
That even the weariest river
Winds somewhere safe to sea.

That afternoon Aunty Sother stopped in on her way back from Mordrum Carbine's. She would not stay there. This was her story:

"When we reached the shack, Mordrum threw open the door. The five little children were huddled about, their faces dirty, their hair uncombed. The one-roomed shack was filthy. Mary Carbine had been sick before this last baby. She could hardly drag around.

"But what made me stop in my tracks was the terrible, unmistakable odor of septicemia. I took care of lots of women with their babies before I came here, and I knew what that meant. So I turned to Mordrum Carbine, and I said, 'I can't take this case,' I said. 'You'll have to get some one else,' I said. 'Your wife has blood-poisoning, and she looks to me like it was pretty bad,' I said. 'You'd better go to Twin Falls as quick as you know how, and get a good doctor and a trained nurse, or you'd better take her right there to the hospital,' I said.

"I didn't care what he was thinking," Aunty Sother continued. "The men get a craze for coming out to these sagebrush farms, and nothing will do till they drag their women away from the city, to live out here without anything. I know Mrs. Carbine was a farm girl, but I know her folks, and they have money. I couldn't help thinking how it would kill her mother to see what Mordrum Carbine has done to her.

"Angus would be just as inconsiderate with me and Bernice. It changes men to get out here. The life is good for them, they farm as they want to, but, maybe you don't know it, they talk most of their time away. The other day Angus came in and asked Bernice and me if we would help him with a little hoeing in the onion-field. We went out. Pretty soon Ben Temple come along on his wagon. Angus stopped his horses by the fence, and for over a solid hour, Mrs. Greenwood, those two men talked."

"They were settling the Government," I interjected, somewhat flippantly, I am afraid.

"Well," she smiled, "whatever it was, I said to Bernice, 'Don't do any more. We worked hard all day yesterday for him, and I'm tired. We'll just lie down here in the shade of this shed, and we'll watch, and when he goes back to work, we'll go back to work.' And we did. After about an hour he noticed that we were not working, and he took a tumble, and started in himself, for he could see that we had our eye on him."

Two years after these words were spoken, Bernice was made the victim of our sagebrush agriculture. She married a farmer to get away from drudgery on her own father's acres. And she went to worse, for she became the slave of that farmer's exacting old mother, who hated the girl because Bernice had been educated. I am not writing fiction. The rewards and the punishments cannot here be bestowed according to the agreeable stories you read in some of the magazines. What I write is the true stories of lives lived.

Mordrum Carbine went for no doctor, and Mary Carbine did die. In all her superb beauty she lay here in that squalid tar-paper shack, dead of her romance. To me there was in her death little of the consolation of resignation Swinburne suggested that day I sat facing the dirty dishes of the farmers in the field. She would not have cared to live forever, but she had children. Well, she could rest at last, and maybe that was what the poet meant, for

...even the weariest river
Winds somewhere safe to sea.

They were beautiful children. I kept one of the little girls until word could come to send them all back to Mary's folks. I would have adopted the little girl if they had not wanted her so much. I have always wanted to adopt some children. I am sure that motherless children need me even more than my own do. And what are motherless children for but to be adopted? And what are

childless homes for but to do the adopting? Or, so much more fortunate, the homes where there are already children? It is an indictment of all women that there are little children in public institutions. Their pitiable, wistful eyes reproach me night and day. These children might turn out bad? They would for you if you are the kind of women who expects them to do it. You did not mean it. You had not thought. For the ones that might turn out bad are the ones that need you most of all. They need love, and more love, and nothing asked in return, not even love. For only women with great hearts, who can love without demanding return, forgiving everything, have any right to the blessing of being allowed to adopt children.

Mordrum Carbine did not come to a bad end. You will have to forget the Pollyanna love-magazines and get down to life. All true values are eternal and cannot be measured in simply material ways. He married two other women after Mary, the second being thrown from a horse and breaking her neck. And he earned a little cash in nickels and pennies from the farmers, preaching a cast-iron creed each Sunday....Jesus forgive him, for he knew not what he did.

I was well acquainted with Mordrum. He used to drop in to see Charley and end by talking to me. He had a dabchick mind, surprisingly agile, diving into deep water with ease, and just when you expected it to bring up some pearl of great price, lo and behold! a little, unimportant fish. But such as he was, the sagebrush farm people willingly gave him their Sabbath nickels and pennies, because there was no one else in the vicinity claiming to bring them the sacred wahoo, which their souls were eager to acclaim the burning bush.

PREGNANCY is a natural state for a woman whose condition is natural. But it is not desirable for a sagebrush school-teacher. My pupils never suspected those five months during which I carried another body within my own, growing daily, demanding more of me daily. I was slim of figure and appeared only to put on a little more flesh. I taught eight grades; conscientiously studied and prepared the class plans for them all; kept house for the family, for Charley was now busy with the spring plowing; and I walked to and from the school-house, for all our horses were needed for farm work. I was tired, always tired, ghastly tired.

The food! We were living on potatoes, salt pork, cabbage, and apples. I wanted other food, but there was none, so I made no complaint. I wanted desperately to rest, but there was no hope of it, so I said nothing.

And I was sick with anxiety about the little ones left at home, for Walter was caring for the baby. One day I felt sudden panic and went swiftly to the open door of the school-house. In the midst of the recitations I walked rapidly to that door, trying to pierce the distance between the school-house and our farm with my eyes. Something was wrong. I totally forgot the school-children, could not recall what we were discussing, and abruptly dismissed them. Then I locked the school-house door, after shooing the last child away, and started breathlessly for home. I knew it was my children.

There they stood, in the cold blue sunshine of early spring, five-year-old Walter looking anxious, and baby Charles, his red coat removed that the sun might reach him better, dripping and shivering. The baby had fallen into the canal.

Charley was over the hill, plowing, and the children were out of his sight at the house. We always thought Walter practically grown after Charles was born. He had such a serious face and never by any chance did anything that required a rebuke. He was most dependable. But he was a little child, just the same. And he had the thoughts of a little child.

He had been engaged in digging wells with a spoon, and every little while he would send little Charles to the canal for a canful of water. So intent was he on his digging that it was some time before it occurred to him that Charles should be back. Running down the hill, there he saw floating on the top of the swiftly flowing stream little red-coated Charles, who was grasping with his baby fists the grass on the banks. As the grass gave way under one and then another hand, he would reach for a firmer hold. He had been doing this for some time, and his endurance was about ended. Walter had come just in time. He pulled the little fellow out and led him, shivering, up the hill, the red coat running a stream of water as he walked.

72

Walter knew that he must get the baby dried and warm. It was as cold within the house as without, so he decided he must build a fire. He crowded sagebrush into the kitchen range, standing on a chair to do so. It would not catch the flame from a match, as it was very damp. He remembered how his father overcame this difficulty, and dragging the kerosene can over to the range and onto a chair, from that vantage-point he poured the oil down among the brush. Then he tried matches again. Only a miracle kept the brush from igniting, for he tried them over and over again.

Something had to be done quickly. He removed the soggy coat from the baby and coaxed the good little thing out into the pale sunshine; and there Charles stood, blue, teeth chattering, when I arrived. Within the hour death had stalked these infants three times—the canal, the kerosene, exposure. But no harm came of it.

We had a large amount of hay that second summer, but hay was only five dollars a ton, less than it cost to raise it. And there was no market for any other crop. So Charley decided to do what the Government agricultural men were preaching just then: if he could not sell his crops from the fields, he would sell them on the hoof. He bought one hundred little pigs and planted two fields for them, one of peas, the other of mangelwurzels. Each, in turn, was to be fenced for hog-corrals, alternating with the alfalfa-fields.

There is nothing more contrary than a hog. It seems to study what you want it to do so that it can do the opposite. All day long it will hunt for weak places in a fence, and it does not matter whether you mean to keep it out or to keep it in, the place where you do not want it is the place where it wants to be. And always it looks at you with the vicious little blue eyes of a thoroughly bad man. The hog is the only animal with eyes like a human being's.

Continually, Charley had to get off his plow and herd the hundred hogs back into the field from which they had forced their way. He could get nothing done. So he set six-year-old Walter at the task.

The child was unable to control the crafty herd, though he spent the day at it. I could not bear to see Walter's anxiety, for the strain of responsibility on a little child's face cast a shadow which does not belong there. Pregnant as I was, I left my housework every time I heard his voice shouting the hogs back where they belonged. I knew he could not get them back alone. They were almost as big as he and would race around him as though he were not there.

I ran through tall alfalfa, stumbling over the ridged irrigation ditches, falling often, so exhausted by the running and so jarred by the falls that I could not rise for some time, lying there in the mud and water until I could drag myself to my feet. At such times the child within me seemed very heavy.

I was determined to go to the hospital at Twin Falls to be confined. I had seen enough of that surly sheep-doctor, and there was no other physician in that part of the country. Besides, there was something seriously wrong with me. I suffered eclampsia after the birth of Walter, almost losing my life, and my arms were acting in the same way as they had before he came. They were even worse, for they were not only without sense of touch, but they were filled with unbearable pain.

One evening I was walking the floor in terrible agony, cradling one arm on the other in an effort to ease them. I wore, having removed my daytime clothes, a long, flowing blue-green kimona, covered with golden butterflies. I had made it myself, before coming to Idaho, and it had a way of bringing the best out of my blue-green eyes and my fluffy light-brown hair. But as I paced the floor, I had no thought of how I looked. A woman in the last months of pregnancy does not expect to present a beautiful sight.

The children were asleep. Early September had brought a cool night, and it was already dark. Through the kitchen door I heard Charley's footsteps with a different, quicker spring to them. His eyes were bright as he came into the room.

"You don't mind if I go over to the Mormon dance at Lateral Eight with the Currys, do

73

you? I knew you wouldn't want to go."

What could I say to that eager voice? I am afraid I lied, though I did not mean it for a lie. I said I did not mind, and I did. I minded being left all alone in that quiet farm-house when I was in such pain. I minded being the one left behind because I was the one to bear a child, and I loved to dance. I walked the floor, still cradling my aching arms, crying to myself, for no one could hear me but myself, and no one ever knew it until this moment.

Yes, Charley had failed me. He had no business to leave me there alone under such circumstances. But he would never have done it had I not failed him in some way first. We women build the foundation for men's treatment of us. Some of our men need more love than we give them, and some of them need a right good beheading every once in a while. Many a woman wrongs her husband with too little affection. And many a woman wrongs her man with too much patience. But if there need be one wrong or the other, let it be that of too much patience. For sometimes the long road of all-kindness conquers at last.

I had uremic poisoning. I had suffered from it ever since my eleventh year, when I contracted a severe case of measles which crippled my kidneys so that the uric-acid crystals were returned to the blood-stream. I was drowsy nearly all the time. I grew tired so soon. I never knew vigorous health. But this state had been mine so long that I imagined everyone felt the same way; so I neither questioned it nor complained, and thus was my danger the greater. I lived constantly with death at my elbow.

It was likely to get me this time. But I went on, trying to be a normal creature, a farm woman, a super-human, believing that all I did was no more than I should do. The week before Rhoda was born I cooked for fifteen men who had come to help stack hay. And in the intervals of serving them I would creep into my bedroom to sink for a moment across my bed. I was so tired. Through the bedroom window I could see the mare and the cow, turned out to pasture for weeks because they were going to have young.

The day came when I was packing my trunk to leave for Twin Falls. I had been cleaning the house, so as to leave it decent for the little family, and I had washed. The last piece of my ironing lay across the ironing-board, and my trunk stood open to receive it. The little baby things were lying in one of the top compartments. I thought I would feed my thirty-two chicks for the last time. They were to be fall fries.

I had the wire chicken-house near the canal. Nine o'clock, and still light, with the long twilight of a hill-top that looks afar at mountains across a vast sweep of valley. I had set Charley's supper for him, as he had been late in the fields, and he had just started eating it.

I was crouched among the restless little fluff-balls, sprinkling wheat from a can, when the bag that acts as a cushion for the head of the child broke, the water flowing downhill. This should not have occurred for another week, nor until after labor. I had been working too hard. With a feeling of dazed incredulity, I stood up and turned back to the house. No chance of getting to the hospital. More than dismay, disappointment, made my heart heavy for the moment. But I walked into the living-room, where Charley sat eating and looking over an old paper, and said, "The baby is coming. You'd better go for the doctor."

He looked at my face, and knew. In a few moments I heard the Mormon white-top rattle past the front of the house, where we then had a driveway. By this time labor had set in, and it was not coming gradually, but with violence whose power made me realize that my time was not far off. I went into the bedroom, carrying my baby's little clothes, made of cloth purchased from the same baby bazaar that had provided the material for the other children's baby clothes. The school money had come in handy there, and I had sewed them myself. I had to buy little shirts and bands to take the place of those given to the Curry baby.

Clean sheets I put on the bed, and water on the range, first filling the fire-box with sagebrush and lighting it. I set about these things restlessly because the pains were absorbing my attention. I gave no thought to the possibility of my baby being born with no help at hand. I waste very little time on possible difficulties.

74

But I was not alone, after all. The rushing sound of wheels grating on the gravel of the driveway came to a stop at the porch with the toothpick pillars. Feet on the porch boards, the door-screen closing after three figures, blurred in the deepening darkness for I had carried the glass lamp to the bedroom. The sheep-doctor and "another woman" to care for me. The woman was Mrs. Rush, dark, beautiful, miscast, mismarried, repressed, quiet, with speaking, somber eyes. What she hid within her was expressed by her one child of a previous marriage, who had been in my school, a brilliant, gifted, singing, dancing little nymph, who afterwards made her fortune in vaudeville. Which sounds like fiction, but is fact. But that never did heal her mother's life. It would always be too late for her. She was the kind of woman who never recovers from her mistakes.

Together we hastily undressed me and slipped my white lawns-dale gown over my head. It was pretty, with dainty lace and embroidery. My other-days lingerie had not yet passed away, to be replaced by the cheap, coarse materials that for years, until too late, disguised from me the fact that my arms and shoulders were...But no one cared about them, so why should I?

The doctor had left his ewes, which were doing some out-of-season lambing, and he was not very happy about leaving them. His attitude expressed the outrage of one who considered that I might have planned better. I was perfectly heartless. The only thing that concerned me was the bringing of that child into the world, and I was the helpless agent of powerful Nature, robbed of the right to will.

Rhoda was born. "A girl," announced the sheep-doctor, in a grudging voice. I was too tired to care what sort of voice he used. I had not expected him to break down and cry with joy. A little girl! I was glad, but so tired. She had come, and now I could rest.

As part of his treatment the doctor used a catheter. From that moment there was a terrible pain in the back of my head. It never ceased, day or night. It was unbearable torture. Unbearable, therefore I need not bear it. It is only the little things that can hurt us. It is only the little things we have to bear. When an injury is great enough, Nature supplies her own anæsthesia. I lapsed into unconsciousness after a week of suffering.

The fourteenth day of my lying there thus, my young husband demanded of the sheep-doctor, "What shall I do with her? She is getting no better. Shall I take her to the hospital at Twin Falls?"

"Foolish expense," muttered the sheep-doctor, who was really not a bad-natured man, but an eccentric. "Foolish expense. If she's going to get well, she'll get well right here. If she's going to die, you'll have all that useless expense."

For years I held that against the sheep-doctor. I thought he was heartless. But as it turned out, he was right. The doctor into whose hands I fell at the hospital was far less competent than my sheep-doctor, even though he was of the school of medicine practised by my father, the allopath, and the sheep-doctor the despised homeopath. For when the hospital doctor had not guessed right after several tries, he said I was just having an attack of hysteria. He thought he could bring me out of it the way he had cured another woman patient. When she had failed to respond to his treatment, he had turned down the covers and spanked her, and she had been so mad she cried, and was well at once.

That was a far crueler implication than any made by the sheep-doctor. After all, the hospital doctor did not cure me. He had no hand in my cure whatever. He did not even know what was the matter with me. But the manner of getting to that hospital was interesting, had I known anything about it.

There was but one motor-car within a radius of seven miles. This Charley hired, wrapping me in blankets and holding me on the seat with his arms as we crossed the six miles of, as yet, sagebrush desert. He had telegraphed ahead to have the train stop at Milner, with a cot provided for my use in the baggage-car. There I lay, unconscious of the *trap-trap-trap* and the rushing sound beneath me, as well as the swaying of my bed with the motion of the train.

The hospital doctor experimented on me. They tell me I stared at the nurse and the doctor,

but I saw neither of them. The doctor was wrong. I was not suffering from hysteria. I was insane. I was living in a land of unreality with whose difficulties I had no power to cope. And that constitutes one form of insanity.

I do not know why having been insane should brand a person. My own condition has diverged widely from true sanity four times in my life, and looking back I cannot see a time except the present when I was entirely sane. Even in this present I am living, there are one or two subjects which throw me out of balance. I àm generally so sane that I can recognize these facts.

Everybody is insane. Those people who exhibit bovine calm under all circumstances are among the most insane. For quick emotional reaction, under control, is a sign of sanity. And no person is sane who has not an active sense of humor. No person can become much less than normal for any length of time who has an active sense of humor. It is probably the most precious attribute possible.

The hospital room was not my environment. I had none. I was simply something which was required to stare at an imaginary bright light in one corner, near the ceiling. I was not allowed to take my eyes from it. Torture. And a truck kept backing up to wherever this was that I was imprisoned. My one impulse was to escape to it.

November rain was the sound of that truck. The sweet November rain in Idaho, fragrant, musical, soaking the ground in preparation for winter, running in streams from eaves—intoxicating delight of calm, delicately gray November days. The melancholy days are not for Idaho, nor her November days the saddest of the year, for those rains are cheering, and the ugly, windy, violent weather of spring is here rebuked with a gentler spring, preceding winter. In Idaho, if summer comes, spring cannot be far behind, for the spring of November follows the heat of August and September and the faint chill of October, to shower everything with warm, abundant rains.

I was lost in that terrible world of unreality, where a torturing light must be watched through an eternity marked only by the backing up of a truck and its driving away, continually, continually, hopelessly. That ignorant doctor, under the cloak of his diploma, tried everything on me. Filled my system with medicines that were unnecessary, plastered a blister on the back of my neck. "And if that doesn't bring her out of it," he informed my anxious young husband, "I'll turn down the covers and spank her, and she'll come to." I am sorry that it was not necessary, for I hope that he might have been right, because I have the further hope that I should have bitten him until his glacial blood ran in streams. Further to console my poor Charley this doctor informed him, "I might as well tell you that it is very doubtful whether your wife will live, and if she does, I must warn you that her mind will be a perfect blank." That was a sweet thing to tell a young man who had three perfectly new children on his hands.

The doctor had just taken the blister off my neck and was exercising in some gymnasium in preparation for his next indoor sport, when I disappointed him by falling out of bed. I struck my head on the iron framework of the bedstead and immediately came to my senses as much as I had ever known them. I heard a cry, "Oh, Mrs. Greenwood, what are you doing?" and I looked up and saw my pretty young nurse for the first time.

PRAYER is a strange thing. So is a tree. One no stranger than the other. One as natural as the other. Nobody had to train the heart of man to pray. In prayer there is a force to move the universe out of its orbit. All the sagebrush farming people met at the school-house and prayed for me. They were told I was dying. Probably I was. But their prayers pushed me out of that bed; their prayers crashed my poor little head against that iron framework.

Slowly I grew well enough to be taken back to the farm. I have a very dear cousin, much older than I, whom I have always called Cousin Joe; my Joe is named for him, as Rhoda was named for his wife, my Cousin Rhoda. When Cousin Joe heard that I was able to leave the hospital, he sent me a check for seventy-five dollars "to take a trip somewhere." How could I go away somewhere and leave that forlorn little family of mine any longer? I sent for a second-hand, reconditioned phonograph and a great pile of the very best records. And thus my sagebrush children, in the heart of a wilderness, the last frontier of the United States, heard the greatest singers

76

of that day, symphony orchestras of four hundred men, famed violinists, and works of the genius composers. That was unparalleled among pioneers. And it will never happen again. Now there is no longer any frontier, and the radio has come, with its necessary commercial announcements and its instrumentations which often sound as though a cat were chasing a mouse through a litter of pans, crashing them to the floor. The baby bawls, a pig squeals, and a man sings that his heart is practically beyond repair, or the Punk Sisters do close harmony which makes everything sound alike, and that is Music. That is the heritage of childhood that will be passed down to another generation. And because this requires no attention, but insists only upon being heard, children everywhere do not listen to what is really worth concentration.

I was so weak I could not even read, so I did much thinking with my perfectly blank mind. We go on thinking, just the same, sane or insane, the only difference being that insane thinking concerns itself with unreality. I was sane enough to be thinking of nothing but reality. I sat by the living-room window, staring idly out at the fields.

"I was just wondering," I said to my young husband, "how you got along without me when it came time for you to cook for thrashers."

"I didn't have any grain to thrash. The rabbits got it all. I fed alfalfa, mangelwurzels, and peas to the hogs and then fattened them on wheat."

"You've sold the hogs, Charley! And we've got our start?"

"Start! Yes...a start backward! By the time the hogs were fat, the market price had dropped to four cents a pound."

"Couldn't you have kept them until the market went up?"

He answered me emphatically: "Every day you keep a hog after it is fat, you are losing money. The packers simply depress the market whenever they want to, and use some current event to make it seem plausible."

"The market price of pork dropped," I murmured, trying to realize our calamity with my perfectly blank mind.

"Dropped!" repeated Charley, "it dropped to forty cents a pound, made into bacon! As soon as they had robbed me of my hogs at four cents a pound, I went to Longenberger's and asked the price of bacon. It was forty cents a pound."

I turned my face away from him as far as possible, to hide the tears which had welled into my eyes. I was very weak, you see. And then there was my perfectly blank mind. I was trying with it to reason out what was the matter with farming.

I kept right on thinking about it, and a year from that time, when most of our eighty acres was ready to cut for hay, I had a brilliant plan. "Don't you sell your hay until you can get a good price," I advised my husband.

The hay had cost Charley eight dollars and fifty cents a ton to raise. The sheepmen were offering the farmers six dollars. Charley's hay was mortgaged to the bank, as was the hay of all other farmers in the district.

"You hold your hay for a better price," I told him. "The sheepmen have to have your hay, and if you do not sell hastily, they will pay you a price that will give you a fair profit."

Charley laughed scornfully. "When a man has a red-hot iron in his hand, he cannot wait for it to cool to set it down. All the hay in this country is mortgaged to the banks. The banks are owned and controlled by the sheepmen, as is also the government of the State of Idaho. The banks demand their money on the first of November. The sheepmen meet each year and decide what price they will pay for hay in order to make their profit. No consideration is given to what it cost the farmer to raise that hay. The president of the Idaho Woolgrowers Association told the convention, "'We sheepmen have thousands of dollars tied up in our investment; the farmer has nothing but a pitchfork and an irrigation shovel.'"

When I heard that statement, I wondered if mine was the only mind that should have been condemned as blank. Yes, the sheepmen's president was right. We had invested a pitchfork and shovel—and our lives. We had condemned ourselves to unremitting labor in the sagebrush wilderness for this reward.

When Rhoda was born, four new members appeared in four other farm families in the Greenwood District. Also, the World War broke over in Europe. One year later the children of Europe were still butchering each other, hoping daily to have some of the Big Bugs tell them that it was time to stop mutilating and murdering each other because another group of Graybeards had been forced to cough up a piece of land.

Also, besides the forced human abattoiring, there were the important schemes that I kept thinking up to make the sheepmen pay us a living wage. But I suppose the president of the Woolgrowers Association would have said that we farm people had to be using our time anyway, so it could not be considered as invested. It had never occurred to him that I might have preferred using mine to hang by my toes from the bell-less belfry on the school-house roof, or in sliding on my ear down the hill beside our farm. "Only that time should be counted which you are free to use as you choose," says Charles Lamb. Time may be said to be yours when you get paid for its use, or when you have the right to decide what you will do with it, or both. Especially both. Under any other condition time enslaves us, and we are no longer free, but bond. The sheepmen were stealing our lives from us. They were glorified porch-climbers, while the farmers slept, robbing them of the coin of their lives.

I grew tired of thinking. Besides, the every-two-years baby crop was now due again for me. The fields of motherhood were always fertile fields. We women who had borne our young when the World War broke were ready to bear again, now that the warships were leaving America's harbors with her sons aboard, singing "Over There," so gentle a song of hate in the mouths of boys sent forth to murder their fellow-men, and to be murdered.

This time I went to a hotel in Twin Falls to wait, with Rhoda, for Joe's birth. No, this meant no happy prosperity, but another mortgage plastered on. Rhoda was barely able to say a word or two, a thoughtful, solemn, pretty child, with great quantities of hair and lovely pink-and-white china skin.

One day I began having labor pains. After some hours I telephoned for a car to take me to the hospital. Within fifteen minutes the baby was born, Rhoda standing beside my bed, gripping my hand tightly and weeping loudly in terror. I ignored the intimate event occurring to murmur soothing words to my baby girl. There had not been time to lift her to the bed beside me.

Charley came next day and took Rhoda back with him to the farm, where Aunty Sother was caring for my family. Ten days, and I was to return with my new-born baby boy. On the tenth day I awoke so happily. Going home! Little orchard trees, not yet in bearing, but trees just the same, and my passion, trees. Perfume of the hay-fields, and the way they rolled up and then down, toward the Sawtooth Mountains, toward the black volcanic cone. Valley to the south, beginning to have little farms where was wilderness when I had come. And the blue, the serenely blue Minidokas. Skies, skies of every kind: the beauty of piled-up clouds, rippling clouds; sunsets over the black buttes, which lie prone, as though they were sleeping mourners, their cloaks drawn over them; sunsets seen through delicately penciled trees that ran a single lovely line, like a Japanese print, on the boundary of Endicott's far eastern field. And the swelling roar, always the swelling roar of the great, gorgeous Jerome Canal, a man-made river which steals the children of man and laughs at his grief.

So happy! Today I go back to the farm to my little ones. And to Charley, who had come in his blue serge suit of other days, looking like the handsome Charley of other days. So tired I was of work shirts and overalls. The blue serge suit brought back the lilacs of romance, the gentle sweetness of new love.

For a while I would not have to work. Aunty Sother was there. And Hib, the master baker, was there. Hib would bake wonderful bread and cake and pies. There would be collie pups running about. The cow I liked would come bawling up to the kitchen door for me to stroke her neck. Sometime she would likely begin purring, and what a purring there would be! A full, cow-sized purring.

"All night," I say, casually, to the head nurse, who has come to help me dress, "all night I had such a cramp in my leg."

She became suddenly rigid as iron, a look of alarm on her face. Then she said, "I'll have to telephone the doctor. Perhaps you can't go back now."

Can't go back now? Can't go back now? No, I couldn't go back. First one leg, and then the other. Phlebitis. My legs elevated on a sloping board, on hinges, made by a grateful carpenter who had spent a year under the care of these nurses. He had fallen down a grain-elevator shaft and broken nearly every bone in his body. When he recovered, out of gratitude he had made these hinged boards for phlebitis patients. There were two men in the building with phlebitis, after operations. Seven weeks I lay there in one position, my legs stretched on that board, feet far above my head; ichthyol at five dollars an ounce used as an ointment; removed every day; hot-water bottles. Another mortgage.

I did not like my nurse but was too timid to protest. She used to rip the bandages from the ichthyol, almost tearing my flesh away. I yearned for my pretty, curly-haired nurse who had been with me when I was insane, after Rhoda's birth. But shortly after that time she had gone up the cañon of the Snake and, seated with her back against some native willows, had drunk poison. Her trousseau had been ready, and she was so blithely happy. Then the man told her he had been engaged to another girl in another city when he had engaged himself to her, and that the other girl would not let him off. He was married the next day. And that afternoon my pretty nurse took poison. The Boy Scouts found her, just as pretty as ever, sitting there dead. That poor, miserable weakling of a man could get two women desperate about him. That poor fellow did not need love. The women needed love. But what he needed was a right good beheading.

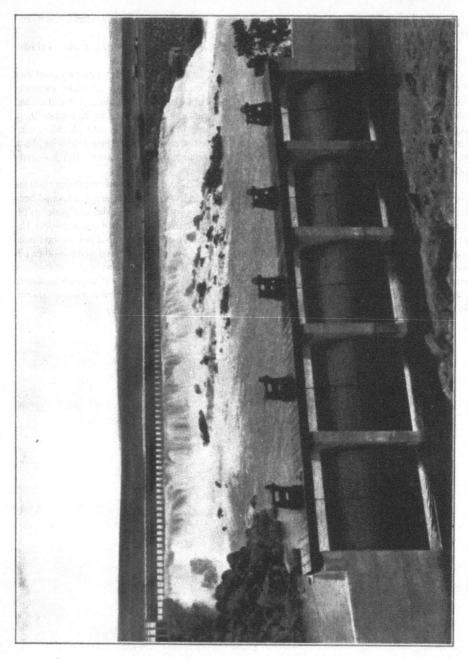

THE MILNER DAM, DIVERTING THE WATER OF THE SNAKE TO THE DESERT

The biological urge is far more powerful in women than in men. And the ravages of repression are proportionately greater. No men ever endure the torture that love-starved women

suffer, pretending, as they are forced to do, that no terrible hunger gnaws at every act of their lives and at every thought. And no children to partly compensate. For the man and the woman are one, and one without the other is a cripple. So is the woman more a cripple, for the woman is more than the man. Her nature is driven by two powers. Fatherhood is acquired by propinquity. No woman can escape her motherhood. She is born a mother when her babe is born. It is to her either blessing or a curse. Birth!

PHLEBITIS! Seven weeks with both legs elevated on a sloping board, high above my head, and covered with ichthyol at five dollars an ounce. More mortgages on farm and stock. Seven weeks of lying in one position. Magazines. Books. Nauseated at the sight of print, I who had been a reading drunkard.

Homesick! White collie dogs prancing around. Sound of galloping hoof-beats on the hard roads that wound through the farm. Smell of alfalfa, drying in the sun. Blue sky, so much blue sky, heaped-up white clouds, purple Minidokas, white Sawtooth Range, black buttes, red sunsets drowned in sky lakes of golden liquid. My children...my children...my children....The lonely hospital. So much silence. Four square walls. Softly padding feet of nurses in the hall. Homesick!

Charley, in the blue serge suit I loved, came and took me home. Phlebitis! I could not walk a step for months. Just sitting there by the window. Two babies. Snow across the fields in an unbroken sweep. Silence. No women. Miles away the women, all overburdened with work. Watching from the window the two little boys, trailing their father through the deep snow as he cares for the hogs and horses and cows. Following him back to the house from the shed barn, steam from the warm milk in the pail rising on the icy air. Walter and Charles bundled in dark plaid mackinaws, caps pulled over ears, high overshoes, Brownie and Blackie, the two most faithful, most stupid dogs in the world, following the little boys. The colt Bony, short for Bonaparte, with his magnificent head set upon ridiculously short legs.

Squeak, squeak, squeak, their feet on the hard-beaten snow outside. *Yawp! Yawp! Yawp!* Brownie and Blackie barking importantly as Eb Hall goes rattling by on the road of ice, his spotted dog, tongue lolling, trotting wearily, as though a part of the mechanism that makes the wheels go around.

I can hear them stamping the snow from their feet, the swish of the broom to remove what cannot be stamped off. In they come, bringing a gush of crisp, cold air with them. The spotted dog did not go by, as I had imagined. It is Eb Hall. And it is Hib, our good friend through all the years, always with us at Christmas, ringing the Santa Claus sleigh-bells that so excite little Charles, philosophizing real words of wisdom from a life that has been given so many sordid knocks ever since childhood. A poor little lad, weeping into his pillow because his mother and father were divorced. God pity people who know not what they do to the innocent when they marry...and divorce.

Eb Hall is also a good friend of mine, a Mormon. He comes sympathetically into the room where he knows I sit all day, mending, looking out at the snow, caring for the two babies. Eb Hall is a Mormon who lives his religion, and a member of any church who really lives the best part of that church is a good man or woman. Eb helps his wife with her house-cleaning and her canning. That is not the habit of farmers in general, although I have seen Mrs. Jean's husband sitting with a pan on his knees, patiently paring peaches while she canned them. And he "the workin'est fool" on the farm, too.

Eb just missed being handsome by reason of the odd placement of his eyes, almost too close together. Sometimes Nature likes to play a joke on us. We have always believed eyes too close together mean dishonesty. There never was a more honest man than Eb Hall. Nor one with a heart more tender. Now he was saying to me, "What you need to cure your legs is fer to get some sheepmanure, an' put it in water as hot as you can bear, and keep your legs in it. Ain't nothin' more better than sheepmanure fer curin' lameness. Now, fer bringin' out the measles when they have went in on a child, you jest give it a tea made outen chickenmanure. It sure brings out the measles."

Perhaps the reason my bad legs have never been entirely cured is because I did not soak

them in what the Arkansawyers would have called a "decotchment" of sheepmanure and water. Two years before, when Jack Overdonk, a bank cashier from Chicago, had come to farm his acres next to ours on the north, he had told us about being cured of white swelling by poultices of fresh cowmanure, while on his uncle's farm when he was a boy. Some people are so stubborn about taking advice. They pick and choose, and go on suffering, as they deserve. I admit that I am one of them. I have had measles twice, but even to ward them off, or, rather, to bring them out, I will not drink chickenmanure tea. Just a little idiosyncracy of mine, I suppose. Announce it over the radio, and we shall all be falling over each other to drink it at the soda-fountains. Of course, the best way to get it started would be to have Congress pass a law against it.

I sat there at the window, gazing sometimes at the long, almost limitless reaches of snow, sometimes at the yawning sock I was mending—later Miss Butterworth taught me how to patch them; sometimes I would look at the babe in the clothes-basket beside me, sometimes to see that Rhoda was not attempting to cut off her tongue in an effort to find new uses for my scissors, patient Tag having moved out of her vicinity with an unsightly cropped spot in her beautiful tan coat. Farmers come and go, speaking to me and then forgetting me in their talk; filling the room with smoke from their pipes; squirting brown, evil-smelling juice into the coalhod, among the lumps of coal; mud from their boots sizzling as it bakes on the sides of the base-burner. They are settling the Government.

Dialects from many sections sound in my ears—Oklahoma, Iowa, South Carolina, Canada, Texas, the Arkansawyers not yet among us. And we have our good German neighbor, Old Man Burkhausen, who brings the *Vaterland* over to read scraps from it to me. Burkhausen is an expert gardener, and he and I both have a passion for growing things. In the summer we stand together in my garden, talking old-world wisdom regarding the raising of plants.

There never was such a community of farmers in the world's history. And what am I doing here among them, a laughing, dancing woman who had never prepared to cook; who was ignorant of motherhood; who could do very little that was useful...what am I doing here? I loved those people. I still love them.

There is a knock at the door. Eb Hall and Hib cease their little argument about what is the matter with the Government, and Charley opens to Grant Parish's father. He is asking for turpentine for a sick horse, and Charley is replying that he has none. "Come in, Parish," Charley is saying. "Just sit down. I haven't any turpentine, but here's a doctor book. I'll see whether anything else would do."

"Some says to use turpentine," says Eb Hall, "and some says to use ferhyldemay. Now, fer me, I uses turpentine, but on the South Side a feller told me that ferhyldemay is the dope to use to cure a horse when it has spasdemic fits."

Eph Parish answers him, settling into a chair, squirting a stream of brown liquid into the coalhod, sizzling the bottom of one huge boot on the side of the base-burner. He had brown eyes and must have been a good-looking young fellow, but, seeing the deep creases in his face and the restlessness of his glance, I remembered his wife's blessing of a "deef" ear.

"Ain't no one can't tell me how to cure nothin'," he said. "I ain't had but this one horse tooken bad in two years. I uses turpentine with the others. I'd a-ben proud fer t' git some ferhyldemay, but I couldn't git none. I taken the last I had and put it on my wheat. That there county agent done tole me how much ferhyldemay to use on my wheat, but I didn't take no stock in what he said, not in a pig's ear, I didn't. I thought I'd try that ferhyldemay stunt, fer you know I got plumb ruint by smut the year before—not a pokeful of good wheat. So I taken that there ferhyldemay, an' 'steada the full amount the county agent said, I jest tuck halfen it. When I done it, I didn't think it wouldn't do no good. An' that there grain was plumb et up with smut. I think it was becuz I never planted it at the right time-a the moon. I allus plant my spuds 'n beets in the dark-a the moon, 'n things what grows above the ground in the light-a the moon. I remember the year I was keerful to plant my wheat in the light-a the moon. I hed the best crop I ever raised. Thet's the year I got my seed from you, Charley. I didn't hev a mite-a smut."

"Nothing here," comments Charley, closing the doctor book. Then he resumes the subject just concluded by Parish. "I treated that grain I sold you with formaldehyde."

The obvious implication made Parish lose interest in the subject at once. "I tell you, Charley, we done a bad job when we put Mrs. Sprague on the School Board. We don't want no woman there. What we want's three men."

Feet stamping on the front porch as these words were being spoken. *Rat-a-tat-tat* on the door. "Come in, Ben! Come in, Ben!" Charley likes Ben Temple, and his voice has a particular warmth for this friend. Ben is like me and Tag—a sort of misfit. He sings cowboy songs with a charm unknown to the present-day radio singers, his laugh is delightful, and he laughs a great deal.

"Well, Mrs. Greenwood," says he, "I see you're still here." Then he laughs, for he means that I am here because there is no possibility of my being anywhere else, since I cannot walk. I smile at his joke. And then Parish speaks again.

I was jest tellin' Charley we done a bad job when we put a woman on the School Board. We oughta of hed three men."

"Well, 'n maybe you ain't so far wrong, at that," agrees Ben, tamping down the tobacco in his pipe and tucking the red can in his hip pocket. "Look at her a-buyin' them there books fer the kids 'ith fairy-tales in 'em. Us let's talk about this 'ithout no bull-con. My ole woman says t' me, she says, 'Jes' listen t' thet there youngun a-readin' thet there trash thet don't mean nothin',' says she. Benny, the least one-a my boys was a-readin'. What we want is fac's in the schools, not a batch-a fool things thet unsettles the kids' heads. Fairy-tales didn't never milk no cows."

Feet again on the front porch. I am used to this. Hib is hungry. So are the little boys. So Hib leaves and goes to the kitchen, just as Charley opens the door to Stillton, called Still, a very suggestive name in prohibition days, but nothing he could ever say or do would be even exhilarating. Charley gives a chair to Still, who sloughs his sheepskin coat and wipes the icicles from his moustache with a bandana handkerchief. This seems to remind Ben of his blue bandana, upon which he at once blows his nose loudly, returning the handkerchief to his hip pocket. It has left his nose blue. That is the way with new blue bandanas. I have warned Charley to buy nothing but the red. I hate either kind, and washing them is to me a grievance and a humiliation of the flesh, crumpled and stiff with mucus as they come to the tub. I always shrink from them as I do from the stinking potatoes with the black rot. I am no angel.

Charley's mind has not quit the School Board question. "But we ought to have at least one member of the Board who can read and write...oh, they can sign their names, I suppose. But Abe, by his own confession, never got beyond the third grade of a country school in Texas. And Brad was raised in the wilds of Canada, where he had no education at all."

Still has now thrust his pipe-stem under the thatched roof of his upper lip, and he mumbles decisively, "I ain't got no predjesty ag'in' no one. I ain't got no cause to grum, fer I ain't got no kids to school. But they's sech a thing as too damn much ejecation. Now, that ole hen wants to spend the district's money on sech things as fairy-tales...says the kids learns faster a-readin' stuff they wanta read. Wants two teachers fer sixty kids. She can't tell me nothin' 'bout it. I never went to no two teachers. An' I reckon I've did jest as well as them there kids will with two teachers to learn them fairy-tales."

Charley speaks: "Eight grades is a handful for one teacher. My wife could give them only ten minutes apiece for each class."

"Sure!" exclaims Parish. "'Cuz why fer? Cuz they's learnin' 'em ever'thing on earth—makin' baskets, and learnin' 'em fairy-tales, 'n askin' the kids sech fool questions ez, 'Who's Gov'ner, 'n Pres'dent?' They'll know 'thout no teacher learnin' 'em when they's growed up. Besides, they'll be diff'rent then. 'N who written *Uncle Tom's Cabin*? I ain't never knowed, 'n don't care effen I never know, 'n not knowin' about *Uncle Tom's Cabin* ain't never pervented me from puttin' in a crop right. What was good enough fer us is good enough fer our kids. We don't want no woman on the School Board. Makes me sick t' see women a-pushin' theirselves inta men's jobs the way they's a-doin' these days."

Hib has been making frying noises in the kitchen. I know how deft and expert his fingers are, and my appetite is rising at the thought. There will probably be some of his good apple pie, made with lots of butter circulating in the filling. Here he comes, asking Ben Temple to move so he can get at the table to set it. "Want any help, Hib?" asks Charley.

"Sit still," says Hib. "It's all O.K., Charley. Stay to supper, fellows?"

Strangely enough, all have been fed. We rarely had a meal without some one extra. I liked it. Farms are lonesome places. You either grow to love anybody and everybody who is willing to come in and eat with you and tell you the anecdotes of a lifetime of living without the contamination of reading, or you grow stingy and exclusive and hate any one who looks as though he might linger until mealtime. I knew a few farm women like that. They compelled their families to go without eating so long as any one outside the circle was in the home, and one woman, when forced to serve outsiders, always brought the dessert fruit to the table in the glass jar in which it was canned. At the end of the meal she would flourish this jar swiftly before the dazzled eyes of the eaters, breathlessly chanting, "Anybody want some peaches for dessert? Anybody want some peaches for dessert? Nobody wants peaches for dessert, so I won't open the jar, and it will do for another time"; and she would rush off to the cupboard with the fruit jar, close it securely behind doors, and leave the room before any one could protest. I really believe that same jar of peaches answered for dessert in this fashion every time company dropped in for dinner.

Another knock. We always had conventions in the winter, but it is a stranger who is admitted this time. "Mr. Greenwood? My name is Dearborn. I represent Wetzel and Company of Seattle. If you will give me a few moments of your time, I believe I can supply you with anything in my line at from ten to fifty per cent less than you will have to pay any one else."

The Baron is the heart of hospitality. He turns no one away. Sometimes we were cheated, as when an ingratiating old man stayed with us, sleeping and eating without charge, and next day stole several sacks of oats from the granary. The old scallywag thought I was deaf as well as lame, I suppose, and perhaps blind. I could hear the old rascal shoveling up the grain, for we were nearly out of it, and the shovel hit the planking of the floor, the sound of the scraping as he gathered it into heaps coming plainly into the room where I sat. Then I saw him bring out the sacks on his back, one at a time, and load them into his wagon. I had noticed how good he was to his team. And now I wondered if it was always at the expense of farmers who had not enough oats for their own teams. And I wondered, if I were God, whether I should say to the Recording Angel, "Don't write down the stealings of that old scamp. He's so kind to his horses." Just sitting there all day made me try to solve such problems, while the farmers were doing the big jobs, such as settling the Government.

"Well, come in if you wish," Charley told the salesman, "but I tell you beforehand that I can buy nothing from you."

"Not even tobacco? Farmers buy tobacco when they can't buy anything else. Can you show me the farmer so hard up he can't buy tobacco?"

Charley laughed mirthlessly. "Tobacco is all that keeps me from going crazy on the farm. When I plow, if I can't smoke, I chew. You can't smoke sometimes. When we stack hay, I always chew. The person who condemns a farmer for using tobacco doesn't know what it is to plow acre after acre when you've thought all your thoughts over and over and got sick of them. That's why the farmer spends his time chewing, spitting, and plowing; chewing, spitting, and harrowing; chewing, spitting, and planting; chewing, spitting, and cultivating."

Absently I paraphrased Shylock: "If you see us, do we not spit?"

"Talk about Outdoor Sports!" Charley was continuing. "There's nothing like the American farmer's Great Outdoor Sport—and also Indoor Sport—of chewing and spitting tobacco."

"Yes," the agent laughed, "the family can go without shoes, but the farmer must have his tobacco. Huh! Huh! Huh!"

"And, by God!" exclaimed Charley savagely, "if every farmer had what was coming to him, his family could have shoes, and he could have his tobacco without making it a reproach to

him. He lives without everything that makes life attractive because he raised the bread for the world—penalized for feeding the world. And he has not even the moral right to use tobacco, his only solace.

"I can't blame the farmers for buying tobacco," the Baron continued. "There was Hunt Cleveland...went around all last winter with feet done up in gunny-sacks because he didn't have money for overshoes, but he never quit chewing. If my crop had brought a just price, I could have given you an order. But I had to sell my hay for four dollars a ton. Giving it away! I am plowing it all up, except enough for my own use, and the sheepmen can go to the devil. My clover-seed was blown into Baldy Parson's field. Sugar-beets and barley just made expenses. Potatoes a good price for a change, but crop a failure everywhere. Wheat less than it cost to raise. Farming is the greatest get-poor-quick scheme on earth. If it were only an occasional year...but it's year after year, and it isn't only in the West; the Eastern farmer suffers in the same way...no market when he is ready to sell...yet there is a real demand—which is satisfied at below cost of production."

The Baron was surely wound up, for he did not stop at that. "You can't make me believe there are any hungry people in the world. The middleman tries to make us think that the world does not want our crops. How else can you interpret the fact that we can't get out of the crop as much as we put into it? '*Discourage the farmer, and he will part with his crop for anything I may offer,*' is the slogan of the middleman. And he says to himself, 'The farmer will keep right on plugging away, no matter what we give him...he doesn't know how to do anything else.'"

Another knock came at the door. "Say, Charley, what's the chances of borrying yer clover-seed cleaner?" It was Simon Heminway, with sandy hair and skin the same color.

"Come in, Simon, come in. Sit down a bit. My clover-seed cleaner's been one place and another the last two weeks, and I've got to use it myself tomorrow. You can have it the next day. Sit down a minute. This is Mr. Dearborn. He's taking orders for groceries."

"I seen your outfit in front of Berry's a while back," observed Simon.

"Oh, yes...Berry's! I got out of there while the going was good." The agent snuckled to himself. That's the way he sounded. He snuckled to himself, drawing his chin down into his collar.

"They said they couldn't give me an order," he said, the smile from his snuckling still on his face, "on account of the low price they got for their crop...same old story I meet everywhere. But Berry said he thought he would take some tobacco since I could give him such a good price on it. You should of seen his wife. She says, says she, 'Jed Berry, how can you have the face to order more tobacco when we don't know where the money is coming from to buy the childern's shoes? They went barefoot all summer,' she says, says she, 'and their shoes is all wore out, and they can't go barefoot in this snow,' she says, says she. 'Fifty dollars you spent for tobacco last year,' says she. 'Why, I hain't spent that much on myself all the time I been married,' she says, 'an' you'll not chew and smoke up no fifty dollars this year,' she says, says she. 'Not and stay on the farm with me and the childern,' says she. He never opened his head to her, but as it was getting a bit warm, I hit out before my feathers were singed." He snuckled with rapid snucklings, like a locomotive getting under way, and with each snuck his chin tried to retire down his neck. He had been a farm boy in Nebraska, and got his job as a salesman because he could talk farmer.

"Yeh, that's Old Lady Berry," commented Simon Heminway, drawing forth a new blue bandana, on which he blew his nose lustily. I was fascinated. Two new blue bandanas in one day. The handkerchief was withdrawn from his nose and deposited in his hip pocket, and at the same time he sloughed his sheepskin coat and brought forth from some pocket the inevitable red can and his pipe. I stared at his nose. Yes, it was blue. I must warn Charley again about those dreadful blue bandanas.

Simon was puffing a light in his pipe, and at the same time, though it seems impossible, he was repeating, "Yeh, that's Old Lady Berry. But as I was sayin' to Daisy, you can't hardly blame her much. She owns that farm herself, from her Ma that died on her, and has worked in the field every year, besides doin' the work after them younguns."

"Old Lady Berry!" exclaimed the agent in surprise. "Why, she didn't look a day over

forty."

"She ain't that. She ain't a day over thirty. She wuz married when she wuz sixteen. Her an' her Ma what died on her kep' a eatin' joint up to Shoshone. When her ole womern died on her, the girl up 'n married, 'n taken what cash the hash-joint brung, 'n bought this here farm of hern. She's had t' boss the ranch ever since."

"Lord save me from a bossing woman!" It was the Baron issuing a proclamation. "If my wife tried to boss me, I would take to smoking days and chewing nights, and if this farm ever paid anything, I'd gamble."

Simon blew a cloud of smoke. "It does make a feller sore," he agreed. "As I wuz sayin' t' Daisy, I ain't much on hellin' round, but effen I was hooked up to Ole Lady Babcock, I'd be wusser'n Bab fer cussin'. She plowed nearly all that there eighty acres of theirn...wore a pair of Bab's overalls while she done it; pitched hay, mowed clover, and, as I wuz sayin't' Daisy, done more work than Ole Bab done in all his life. He's kindly a putterin' ole fool. Never could do nothin', but always spent solid hours a-doin' it. One time I was cuttin' through their place to hunt my sorrel mare, 'n I heered the old lady say to Bab—he was a-tryin' t' mend the binder—'Why'n't you put that there nut here?' Ole Bab riz up and yelled, '*You git the hell outen here*!' an' you can take it from me, she *git!*"

The men puffed, meditatively. I could see that on the battleground of each male mind were females being vanquished. "That shore would make me sore," continued Simon, preceding the words with a puff of smoke. "It shore would make me sore if the Missis called me down the way Berry's ole womern done before folks. As I wuz sayin't' Daisy, it may be that Ole Lady Pringle ekals a horse fer work...she boarded her family and the nine road-workers fer weeks...but she works her jaw too much t' suit me. I reckon Bert tries her consid'able. He's a awful dunderhead. But she shore can make the hot cakes. I'd sooner eat a decotchment-a hot cakes after her 'n any womern I know. You bet Bill Sellers's wife don't dast say nothin' to him. Effen she done it, Bill ud offer to knock 'er down. As I wuz sayin' to Daisy, seems hard she has to work like she does, but she ain't never knowed nothin' else. Her pa wuz a good-fer-nothin'. Lived in a shack up Goose Creek, and they'd a-starved t' death savin' it wuz fer her ma's garden 'n chickens 'n the hog the ole womern raised every year. When Bill Sellers's wife married Bill, she didn't ixpect nothin', 'n she got it!" Simon laughed loudly at his own joke, slapping Stillton's knee and leaning forward to inquire with his light-blue eyes of the circle of farmer faces whether they had ever heard the equal of that wit?

Hib had set the steaming dishes on the table; the expectant little boys were struggling up into chairs, eager eyes appraising the feast as they got into position before their plates and cutlery. Charley lifted Rhoda to her high chair. While Hib was giving a general invitation to the visitors to eat, it being declined because all had supped, the Baron supported me, my legs practically useless, to my chair at the table.

My mind was thinking, in the perverse idleness said by some old scribe to be the devil's workshop, that if I was to be chained to my rocking-chair much longer, I too would take to chewing and spitting and cussing, and maybe helling around a little in my imagination; and I would have a few things to tell, inaudible perhaps to any but myself, about what I think of men who boss their women, under the impression that having been born male has somehow constituted them, *ex officio*, little Vice-God Almightys.

THE MEAL is over, and, yes, it ends with some of Hib's delicious apple pie, flaky of crust, with melted butter swimming among the transparent amber slices of apple. I make an island of my section with thick sweet cream. Barbarous and unetiquettical, I suppose. But who cares? I am a wild, bad woman, chained to my chair, my one dissipation that of eating thick cream with my apple pie.

Again I sit in my rocking-chair, the beloved one Charley bought me the Christmas Walter was born. I was going to keep it, as it was then, all my life; but two years after this very night, Eb Hall talked religion to me so hard, emphasizing his words by swaying back and forward so

violently, that suddenly, long legs waving wildly as they described an arc, Eb went completely over, breaking both rockers off squarely at the first joint. I think it is always a great mistake to argue religion so seriously that you break the furniture doing it. Eb was a good man, and I liked him, but I did wish he had been sitting on the red-hot kitchen range instead of my pet rocking-chair.

My chair was as uncrippled as I was crippled when I was helped back by Charley to its lap. On this night I sat beside the sewing-machine, upon which the Baron had placed one of the glass lamps for my convenience. It was the one with the bowl looking like crystal bubbles. I love old-fashioned glass lamps. I never minded the daily chore of filling our three lamps with kerosene, trimming the wicks—job for an expert: lighting, trimming, relighting, squinting each time, until the ecstatic triumph of a perfectly even flame; then washing chimneys and lamps with hot suds, pouring hot water over them, and polishing them until they shone like the fabulous gems in the Sesame cave. In Cabell's *Jurgen*—yes, I read it—he speaks of a part of Heaven which smelled of mignonette, where a starling was singing. I am sure there is a part of Heaven smelling of kerosene where the beautiful glass lamps are burning.

The table is cleared, and the dishes washed. I cannot see him from where I sit, but I know that Hib has safety-pinned a dish-towel in front of his overalls and is smoking his pipe as he washes the dishes, Walter drying them. A few more farmers are added to the convention, Parish leaving, Dan Jean appearing briefly, only to announce that he guesses he'd be gougin' along. Stillton is again reminding the women of their inferiority. He doesn't mind that I am present. Really, he likes me pretty well, which makes me wonder whether to be proud or insulted, considering his views of my sex.

Charles is a little fellow, but one by one he is able to bring me books from the big case, the last relic of our more prosperous days. Gone now the velvet carpet, followed by the grass rug, and now the covering is a linoleum just like a rug, as the advertisement says, and as every woman thinks if she has gone crazy and half blind. Bedroom rug worn out, and gone. Going, going, gone. Almost everything gone now. Painted bare floors...well, Mrs. Curry didn't even have paint on the floor of the chicken-house where she is so cheerfully living.

My dear book friends! What should I do without you? They are piled here on the machine beside the glass lamp. In a moment I shall be far away from these domineering little Vice-God Almightys of the farms. *Paradise Lost*—still a favorite of mine, though not so revered in spots. I often dip, as now, like that dabchick mind of Mordrum Carbine's, but I nearly always bring up a pearl. And can this be one?

...though both
Not equal, as their sex not equal seemed;
For contemplation he, and valor formed;
For softness she, and sweet, attractive grace;
He for God only, she for God in him.

That's not what your wife thought, John, and she ran away from you, so that you wrote a ponderous tome on divorce because of her desertion. I don't know that I blame her. Why should you be hobnobbing with God, while she must be content with you?

The farmer Stillton
And poet Milton
Are brothers under their skins.

Here's my trusty Tennyson, though I do think that consumptive girl might have used an alarm clock instead of bothering anybody to call her, Mother dear, even if she was to be queen of the May—looking so beautiful, as she did, coming down with tuberculosis, and laboring under the delusion, as she later did, that Robin was likely to pine away at her death, and then cribbing that last line from the Bible...

When the wicked cease from troubling and...

Let's get the taste of Johnny's line out of our mouth. What's this of yours?

...this is fixt
As are the roots of earth and base of all;

> *Man for the field and woman for the hearth;*
> *Man for the sword and for the needle she;*
> *Man with the head and woman with the heart;*
> *Man to command and woman to obey;*
> *All else confusion.*

"*Et tu, Brute!*" Well, that teaches me a lesson—to Buy American, or See America First, or something. These Englishmen give me a pain in the neck. I'd hate to be one of their wives, or even two of their wives.

> *My country 'tis of thee,*
> *Sweet land for two or three,*
> *Oh, ting-a-ling!*
> *Land where the farmer bragged*
> *While his poor wife was fagged*
> *And agriculture sagged*
> *Like everything.*

Come here, my dear Holmes, with your gentle humor and your eternal *Rah! Rah!* spirit. I will have American. What is this?

I would have a woman true as death. At the first real lie that works from the heart outward, she should be tenderly chloroformed into a better world.

You don't say! But let the dear men go on lying and lying. Well, Oliver, here is something I would have, too. I would have a man as true as life, for death is false, and at his first lie of any kind, working up from any part of his anatomy, he should be violently beheaded into some celestial garbage-pail. And that, Oliver, is what I think about men lying—and women, too. For a lie is the indication of a leak in the dike. Honesty is not the best policy. Honesty to be honesty cannot be a policy. It is the foundation character. To be strictly honest toward one's fellowman is to be loving and just. There is no true honesty without love and justice.

Chesterfield, de Rochefoucauld, Seldon, Dumas—all farmers, all men who feel their inferiority to some woman or who have been jilted—I will not quote here your bitter words. Sit you down beside Milton, Tennyson, Holmes, all of you here with the rest of these farmers. You need not mind me. I am just a farm woman, crippled on the field of motherhood. I am glad I cannot see your little red tobacco-cans and your bandana hankies, for your bandanas might be new and blue, and when you used them I should be watching to see whether your noses turned blue, and I do not want my attention distracted from what I have to say to you, which is that most gorgeous expression originated in this particular age by the clear sighted young. It is: *Oh, yeah?*

IV. DEATH

Death, of course, is more familiar to farm children than to city children. Always there are farm animals over which hangs sentence of death by violence from the moment they are born. The farm child gets used to feeding an animal so that it may be profitably killed. The farm child gets used to the idea of eating the animal for which he is so carefully providing.

I am no sentimentalist about this state of affairs. I myself would be willing to receive instant, painless death by means of a shot in the head if my every need were gratified up to that moment. That is practically the life of a farm animal. A shot between the eyes, the scalding-tub, the saw and knife, salt and sugar, and on your plate the fragrant ham.

Charley was an expert shot—had received a sharpshooter's medal from the Government, in fact. My surprise was great, therefore, when I heard Eb Hall say to him, very seriously, "If you had aimed at that hog a little to the left or a little to the right, you would have missed it, Charley."

When kindly Eb had gone, carrying with him a pan of good, clean hog liver, which the city man scorns because it is not so fine as calf's liver, I asked, "Did you really nearly miss that hog?"

Charley gave a silent snort with the expression of his face. "That's Eb," he said. "I shot that hog squarely between the eyes."

The scalding-tub. Galvanized, and now black all over its outside with soot from the fire over which the water was heated.

When we went on the farm, we laid our deep-piled velvet carpet on the living-room floor. Good furniture. A big bookcase full of books. Year after year the room changed, until at last there were but a few meager furnishings and linoleum on the floor. Curtains for the windows wore out. There was no money to replace them. The only plenty we had was mortgages.

One habit of my previous life I refused to relinquish—my daily bath. All the years of my farm life I had to bootleg my daily bath because there was no place convenient to take it but the kitchen. So always I must bathe with one eye on the glass in the upper part of the kitchen door. Some telepathic anxiety of mine always set the men on the march for the kitchen to get a drink from the galvanized bucket that sat on the big home-carpentered wash-stand in the corner. Generally I made from three to six electric dashes for the bedroom during the course of a bath. It was my one exciting diversion, substitute for college track racing or contract bridge.

At first I had only a small granite wash-basin, which I repeatedly emptied into a slop-pail and refilled with hot water from a kettle; thus I washed the whole map of my person, a few square inches at a time. Of course, I was not very large, being five feet four inches tall, and weighing one hundred and fifteen pounds, or thereabouts. I was glad I was no larger, for I usually had to carry my bath-water up the hill from the canal.

Next, I experienced the joys of a galvanized wash-tub. I was little and could crouch down in it when I wanted to. Then one hog-killing time the men took my bathtub and used it for scalding the hog. It was returned to me irredeemably sooty. Smut on the kitchen floor, smut on the towel, smut on my body. I was patient throughout those trying years, but after bathing in the hog-scalding tub for some time, I went on the war-path. Hell hath no fury like a patient woman on the war-path. I got my new, clean tub, and hog-killing times, when the men began wandering about in that vague

tub-hunting manner, I trusted them not, but stood guard over my tub until I heard the hog squeal and saw the steam rising from some other receptacle, out by the granary.

Then came the final luxury of a canvas bag and hose, hung from a nail on the kitchen wall—of course, where I could still keep an eye on the glass of the outside door. I could take a good bath in two quarts of water. What that meant when the buckets dragged down your arms and your knees caved in as you lugged them up that hill from the canal! I sprayed all over my body, then scrubbed enthusiastically, then sprayed all soap away. Glorious! And I could almost always make it with not more than two or three men getting drinks.

How much that canvas sack on the wall meant to me! We had a cistern, blasted out the summer before Rhoda was born, but it was either empty, or the pump broken, a great part of the time. Water must be carried from the canal. The little boys took their turns. The Baron brought water. But there was no providing enough without my service. Heaven be thanked for the little canvas bag and the clean, new galvanized tub!...Heaven and the Baron—in justice, Charley provided both.

Cow-killing time was different. The cowhide was valuable with the hair intact. At least, it should have been valuable, but men traveled from farm to farm buying the hides and paid fifty cents apiece for them. Think how many pairs of shoes can be made from one hide. Would you feed a cow, care for it, kill it, skin it, to price the hide at fifty cents? Or something of that kind. I may have included too much in the bill, but I know, and you know, that hide was worth more than fifty cents.

A strange thing always occurred when a calf, cow, or young bull was butchered on the farm. Generally a half-grown bull calf, it would be skinned and hung from the arm of the Mormon hay-derrick, so called because the Mormons were the first to go to the cañons, bring back poles, and construct derricks in this manner. By the time we were in bed, every cow and calf on the ranch would be standing under the naked carcass, neck stretched upward, bellowing and bawling in so loud and continuous a chorus that sleep was impossible. There was something chillingly weird, something uncanny, in the performance.

WHEN WE KILLED A STEER, THE CATTLE BAWLED

A GRAVE IN THE SAGEBRUSH CEMETERY

When Jersey's calf died in the new orchard, she stood over its little body and cried great tears. They rolled out of her big, pathetic eyes, down her long-nosed face. From time to time the

cats died, the dogs were shot, and, very sad to me, my intelligent magpie, Pretty, came to a violent end by hands unknown. He was just learning to talk, and he loved me so much that it seemed like murder to me.

Tag's fate was worst of all. One day I noticed that she persistently scratched herself. Examining her hide, I found it pocketed from tail to ears with great, squirming masses of maggots. I did not realize, the number of those disgusting burrowing larvae, otherwise I would never have tried iodine. That entirely used, I thought of creosote sheep-dip. This, too, proved ineffective. Had I only known a very recent discovery of science, poor Tag need never have died. The maggots would not have injured her. They would soon have made their next metamorphic change and left Tag's tissues clean, so that they would have healed readily.

But this I did not know, and I pictured Tag being eaten alive, down to the bone. Together, Charles and I dug a trench large enough to receive her body. Then, while I held the attention of her big, trusting, soft brown eyes, Walter shot her with his twenty-two. I never think of our sagebrush farm without seeing that noble creature.

DEATH forever hovered over those sagebrush farms. Winding in and out among our farms ran the canals bearing the waters of the Snake. Scarcely a week passed that those waters did not close over some baby face. This was my terrible fear. This was the fear of all us sagebrush women.

Mrs. Jean, running all the way from their farm to ask, "Have you seen Bud? I can't find him." The fear of the canal in her face and voice.

Hen Turner, galloping like mad into our yard, his too large ears pressed out more prominently than usual by his badly adjusted cap: "Come over to Greshams. Little Bill drowned in the canal this morning."

Mrs. Curry: "Did you hear, Mrs. Greenwood? Armstrong's little girl was found two miles down Jerome Canal from their place, caught in the weeds. She had been dead..."

I tied my little Joe to one of the toothpick pillars of the scowling porch with a forty-foot rope. One day he was missing. I could not breathe. The sky curdled and then grew leaden. At last it occurred to me to trace the rope. Our house was without foundation, perched on big lava-rock boulders. Under the flooring, in the very center, there sat Joe like a bright-eyed squirrel.

Missing again. This time the rope there, but no baby. Walter running to tell his father. I searching the place over. It couldn't be...my heart throbbing...it couldn't be...and yet it could be...it had been for other women. Then I saw Charley wading our canal in his high rubber boots and prodding the bottom with a pitchfork.

At the sight, involuntarily, my hands flew to my head, I cried aloud, "My God! My God!" and a feeling of madness fell upon me.

There flashed through my mind the words, "He is down on the school-house steps."

I called, "O Charley!..." but got no further, for he was shouting to young Charles, who suddenly started to run down the hill, "Go to the school-house!" and young Charles was shouting back, "I just thought of that myself!"

Sitting on the school-house steps was baby Joe, a hammer he had found there in his baby hands, *beat-beat-beating* on the rough board which many little feet had worn into depressions. And yet...what modern psychologist says there is no such thing as telepathy? Or...let us not be afraid to know...we must dare to know, the truth, for there is not one world of the living and another world of the dead. There is only life, everywhere in the universe change, but no death, only life. My soul has intimations of more and greater life. What spoke to me, to Charley, to young Charles? We could not all have been impressed at the same time with the same thought from nowhere. There must have been...Why not? A tree growing, in all its beauty, is stranger than that.

And yet it did happen to Joe at last. One night the children came from the hillside below the house, my baby streaming with water. I had intrusted him to their care with infinite cautioning. One moment's forgetfulness, the baby seen floating down the canal. Walter in the water, frantically after him. God spared me the ultimate grief, though why I should be more fortunate than other

women, I cannot imagine. My little Joe was still alive. Beneficent, beautiful waters of the Snake, winding in and out among our farmlands. Sinister, haunted by the little drowned faces of babes.

The Currys had a farm hand and his wife to help them. They were helping the Currys as Daniel Webster helped his brother Zeke—to do nothing. The farm hand's wife had harsh, dull, blonde hair, streaked around her face an ugly dark shade where it was growing out unbleached. The two were city people, and she was about to have a baby.

Three days was fortunately the span of life for that babe. The community rose to the occasion by planning a funeral for the infant. It was to be in the school-house, and the men made a little casket of pine lumber, lining it with batting and satin. We all contributed to buy the materials.

The day of the funeral my sister Florence sent us a box of clothes. It was always an event to get a box of partly worn clothing from some of our relations. In this box was a pretty hat for me, worn only one season by my sister. It was a small, dark-blue silk beaver, with one lovely narrow, flat, blue-green feather on it. I wore it to the funeral.

I sat near Baldy Parsons, who was wearing his store teeth, as we all called artificial teeth, because he expected to join in the hymns, and he could not sing without them. They usually lived in his vest pocket. Church in the school-house, and this funeral, brought them out. Rhoda, my baby, sat on the desk before me, looking about with that solemn, critical gaze which marked her from the first.

My heart was so shaken at sight of the little home-carpentered casket that I could not sing, and I cannot today remember what it was that Baldy Parsons was roaring with such enjoyment. I only knew that there lay a mother's babe, dead, and here was mine, alive, in my arms.

When the services were over, Charley came near, and with him a city man, a handsome man, with dark curling hair, dark eyes, and a dimpled chin. I saw the Baron draw the attention of this attractive stranger to me, and then...that look of swift, glad surprise at sight of me! I had not seen that look of glad surprise at sight of me in the eyes of any man, excepting only Tony and Jeff, in almost two years. I am a vain woman. It brought a wave of nostalgia that shut out my love of the wilderness under the warm, caressing sun, shadows of clouds lying in patches across the sagebrush, or the millions of stars that rush upward into the vast depths of the desert sky, arrested in their motion for the infinitesimal moment of fifty billion centuries. I liked to have men look at me with that glad surprise in their eyes. It awakened in me sparkling pools of laughter, winged feet, and a heavenly abandonment to the innocent moment. Oh, I was not a farm woman—not a real farmer's wife! Just an impostor! It was the dash and verve of my sister's pretty hat that made this man see me as I had been.

But I was a real mother. I gathered my baby to my breast, as Charley and Jack Overdonk, that Chicago dream-farmer who had come to his reality-ranch, moved away. I left the solemn, packed school-house, for I had work to do and could not follow the little corpse to its grave.

Passing through the hall, I overheard subdued conversation between Mrs. Stillton, very fat and very kind in a pale, blonde way, and her friend, Mrs. Baldy Parsons, little, like a tiny bird, her face always working sympathetically while you talked to her.

Said Mrs. Stillton: "Yes, I did go fer t' lay out that baby, but after I seen it, I was a-feared t' tech it....You know..."

She paused significantly.

"What fer wuz the matter, Mrs. Stillton?" Mrs. Baldy's face was agitated, as though ready to draw in whichever direction the answer pointed.

"It was..." Mrs. Stillton raised an overstuffed paw as partition between her and any outside listener.

But I knew already, although the news had not sunk in until that moment. Some there are, cursed before birth, for whom three days are enough of living.

But the syphilitic babe was followed to its first and last resting-place by practically every farm family in the Greenwood District, in their wagons and buggies, none of us having cars at that time. The cemetery was on a baked knob which was dedicated to the purpose of its use because it

was good for nothing, there being no water that could be made to reach its ugly barrenness without too much trouble.

And there they laid the syphilitic babe among the little drowned babes, who made no objection, unless perhaps, at midnight, they may come forth to register wraithy indignation at such contamination. But it may be that the babes have long since deserted that selfish, heartless spot, particularly since around all their graves are the holes of gophers, while over those graves on moonlit nights the coyotes stand and laugh hysterically at what the gophers are busy about down below.

Knowing the direction of my unswerving ambition, and also the circumstances of my life before my marriage, the casual observer might have discovered little joy in my existence on that pioneer sagebrush farm, which demanded unremitting labor from one who had been an invalid child, a delicate young girl, and a prey to uremic poisoning over a lifetime. It is true that I was a miserable housekeeper—negligent of dust and grimy windows and such-like breaches of the code, that most of my work in the house was accomplished by such will as measured in horse-power, or electric watts, might have moved one of the lesser stars out of its course. Yes, my house was far from a model. I might have had it so much better with less effort on my part had I known how to manage as did Mrs. Jean from South Carolina. But, alas, I had not been born of useful female ancestry. My little wrists and ankles betray the fact that I came from a race of parasite women, pampered by their men. So, after all, in a way I can blame the men.

But I had my incidental recreations. When the garden made no demand, I would slip out of the house at four in the morning with my big, clumsy, trusty old typewriter, a load for a man, and going into the orchard, with a few sheets of paper and an old alarm clock to check my leisure before breakfast, I would enter Heaven. Pretty, the magpie, was usually my companion. He would steal my pencils and, in great delight, fly away with them, while I followed with almost a flight paralleling his own. And he was so delighted by his trickery of me, coming back to sit on one of my extended shoe toes and chattering madly—yes, and laughing. "If anything is human, all is human; if anything is divine, all is divine." In Pretty was what is in me.

Besides my vegetable garden, over which my good German neighbor Burkhausen and I used to consult, there was my gift garden of flowers. And perhaps this is the place to tell of my infant career as a writer. Alas! the child died almost aborning. But it was interesting while it lasted.

Clippings sent me from papers and magazines throughout the United States commented on my articles; letters in such abundance that I thought of dying so as not to offend the writers by not answering; letters from the United States, from Europe, from Africa, from our island possessions; letters from all sorts of people—physicians, missionaries, farmers, farmers' wives, a famous head of a famous girls' college, a famous governor of a notable state, a United States Senator who said I inspired him to go to Congress. Beautiful shoes came from New York; dish-mops, very fancy, from Washington; cases of honey from Canada; wonderful flower roots from Illinois, four-o'clocks whose seeds had been in a Maine family for generations; a great box of flowering hedge from New Jersey; and many other things. We had fun while it lasted, except that the letters hurt my conscience. I was especially stricken by the letters from a spinster lady in Brooklyn who wanted to come and live with us.

And there was my really wonderful collection of iris, looking like rare orchids, sent me by one who had gathered their roots for his garden from all over the world. I used to stand and look at them and worship God. Imagine having so much beauty there on that desert farm! Blue, bronze, rose, orchid, ivory, and the variegated, the combinations, the browns and purples, the light, the dark—all lovely.

One man had filled my windows with flowers that bloomed in winter. I had a shelf built midway across two windows, and the two windows, from lower sill to top, bloomed with a chorus of harmonizing color set in green. Those were the windows where I could see only out across the

lonesome snow, with a view of the barn and the granary and the little hideous outhouse which no amount of high dreaming could disguise as anything but sordid, ugly, necessary convenience.

Our dark-green farm-house with its black roof and toothpick-pillared porch stood up in stark ugliness, no pitying tree to veil its face. But I must not be ungrateful. It was a warm house in winter, and only two houses in the entire district were as comfortable, and only one of these more convenient, the only house with a bathtub until you reached Hazelton. But our house was ugly. And it is a weakness of my character that I can forgive almost anything more easily than lack of beauty, just as it is also my weakness to worship brains. But let me balance my defects by confessing here that out of the whole world of women, throughout all time, I envy the career of one only, and that one is Jane Addams of Chicago's Hull House.

Make no mistake about beauty. It is not easy to achieve except as Nature achieves it. And it most certainly does not consist in regularity. He who has instinct for balance in irregularity has instinct to achieve beauty. It is born, and can be imitated, but there is always chance of failure in imitation. Beauty is likely to fail when it becomes standardized.

A house on a hill should be white. It should be nested in greenery. I could not change the dark, dour color of our house, so I went down the hill to the barn corral, where the soil was black with the seepage from well-rotted manure. My gift garden should help me to nest the house in green. With two buckets I carried this soil and put it in a bed dug around the house. It was severe labor. But I could watch my gift garden miraculously change to leaves and blossoms; I could have a hand in creation, as though I were God saying, "Let there be light," and there was light.

All my senses responded to that sagebrush farm. Never a day passed that I was not thrilled with the changing beauty of the vast cloud-filled skies, the purple and gold sunsets, the blue and white mountains, our gray and green valley, our own lovely, undulating farm, with its ivory wheat-fields, its green beet-fields, its purple-blooming alfalfa. I loved to go to sleep to the chorus of the crickets in the grass just outside my window, with its thorough-bass of the frogs down along the canal. The cool, delightful summer nights; the limitless stretches of clean, white winter snow.

I think, though, that my memory of my little children is the sweetest thing I have out of it all. I loved the smell of my baking bread, and I might be called an expert at baking, for Hib, the master baker, had taught me. Twice a week, eight big loaves of bread, a big pan of rolls, another of sweet bread of some sort. Pies and cakes made every day. And, too, I loved to see my golden butter. I churned in various ways for various reasons: from six to twelve pounds in the big churn with the handle like a barrel-organ; a little cream in a fruit jar; or, best of all, I churned by shaking a ten-pound syrup pail while my little children marched behind me, around and around the dining-room table, singing,

> *Count your many blessings,*
> *Name them one by one,*
> *Count your many blessings,*
> *See what God has done!*

Around and around the table we marched, I shaking the bucket, rhythmically, *plunk-plunk-plunk,* Walter following me, Charles following him, then Rhoda, and finally little Joe. My darlings! This is the joy a mother has: forever and ever and ever my little children go marching after me, singing with me,

> *Count your many blessings,*
> *See what God has done!*

I raised a big vegetable garden, probably the largest in the Greenwood District, and it was a distinct success. After the ground was plowed, I did all the work myself—planting, weeding, hoeing, cultivating, thinning, spraying, hand-picking worms, harvesting, cooking, canning. I had a passion for growing things. Memory again gives me that feeling of intoxication always induced in me by the sunshine, the smell of irrigation water, the sight of it crawling slowly down a new-made ditch, and the vision of green things growing. The thrill I feel at seeing things sprout from the seeds I have sown is only surpassed by that I experienced in watching the development of my babies.

96

Chickens I raised. White Plymouth Rocks—hundreds of them. I have voluntarily worked for hours, missing meals, in order to care for hens, eggs, little chickens. I banded their legs in order to keep track of the generations and to detect the best layers. Every spring, when the chicks had reached a good size, I would pen them in the chicken-house and put a numbered aluminum band on a leg of each chick.

One year I went into the chicken-house, luring the entire flock after me by means of sparsely sprinkled grain. I noticed about midway in the door a hole just large enough to drop a chick through. A happy plan presented itself: a chick is banded, and out it goes. This I did until the job was finished. Then I opened the chicken-house door with a feeling of satisfaction, only to confront four stolid, enormous hogs, which were crunching down the last of my banded chicks. Don't tell me hogs are not rightly named.

It was the same with the garden. The horses pounded over it by night, and the cows ate it by day, the hogs working on it by day and by night. I think one of my most earnest grievances against life, fate, the farm, and everybody connected with it was that in spite of going on the war-path, in spite of stratagem and guile, I was never able to obtain the fence for my garden I so desired. My passion for growing things was a great disadvantage. Everybody felt reasonably certain that I would not be able to resist the spring when seed-planting time came round again.

My baked beans, strawberry ice-cream, raisin pie, and potato-cake were famous, particularly among the young people, who had to be watched when my cake or my freezer appeared at any of our "doings," as we called our home-made entertainments. There were other cooks famous for consistently good cooking. Mrs. Epperson was so famous for her cooking that although her man was never known to pay the help he asked, nobody ever refused to go to his rented ranch to put up hay, dig potatoes, or thresh. The men always regarded work done for him as a kind of glorified picnic, without the ants, for he had only a tar-paper shack, so that their eating must be done in the shade of the house, from tables made of lumber set on a sort of trestle. And the food...! Don't you think Heaven will be a disappointing place if they have no cooking there such as Mrs. Epperson's? In my mind I have no doubt that there is eating throughout the universe, whether visible to us now or not.

YES, I COULD COOK, and I was expert gardener and poultry woman, and I could make butter, though not so well as Miss Butterworth, and I was a good mother. But I never ceased to regard threshing as a kind of nightmare which must be endured and lived through until I could get to the other side of it. I had no near friend to help me, as Mrs. Baldy Parsons and Mrs. Stillton helped each other, getting fun out of it. And I had no mother and sisters as had Mrs. Jean. I did the whole thing alone, except for the help of a woman to wait on table. At times I had as many as thirty-two men to feed, some of these being agents, ditch-riders, and so forth, for wherever there was a threshing, all the men in the district gathered like flies around a screen door when a rain-storm is threatening. And it was grand visiting-time for the men, too. They were in a genial mood, and the agents could talk up business to half a dozen at once during the noon-hour or a breakdown of the machinery. For there always was a breakdown, and we sagebrush women must expect to feed the threshing crew several more meals than we had been warned about, while some one dashed to town for broken parts, and the men enjoyed a rest. Leaving out mortgages, farming is the ideal life for a man who does not know where he is going and does not care when he gets there.

We threshed several times each summer. With a crop in which wheat, beans, and oats are ripening at different times, there are at least three threshings. Just before one of these events Charley thrusts his head past the screen door of the kitchen, where I am scalloping the edges of pies with a fork, preparatory to putting them in the oven just hot enough to make you withdraw your bare arm when you have counted ten slowly...it is twenty for bread. "We'll have thrashers day after tomorrow," he says.

I have so much to do with the day's ordinary routine, interrupted continually, as it is, by insistent demands of one sort or another, that not until the dinner dishes are done and I have carried the heavy crocks of milk down into the outdoor dirt cellar, can I give a thought to threshers. Then I

look to see how much bread there is—decide to set sponge and bake on the morrow. That night, when I finally get to bed, it is not to sleep. I had not then learned to take no thought for the morrow, but all night long I lie there planning, cooking five or six, sometimes eight days' meals in my head.

I do all the cooking possible the next day. By putting on the range a gallon of soaked beans, which have turned into a gallon over night from two quarts of dried beans, I can soon have them baked and ready. I use a hotel pressure-canner, my only real convenience and luxury. After the beans have been cooked under pressure, they are ready to go into crocks on the following morning, with slabs of ham laid upon them, to be given the final oven-baking which completed the sum resulting in my famous beans.

The pies I made the day before have been eaten by the six in my family and our several hired hands. So now I make raisin pies, cream pies, fresh-prune pies, apple pies, and Jeff Davis pies, the recipe for the last having been given me by Mrs. Jean. No, my night's sleepless planning has not resulted in *dementia piecox*. The men love pie, lots of pie, and all kinds of pie, and are disappointed when they do not get it. The first two or three years I made one dainty dessert, served threshers with my precious linen napkins at their plates, and did things in style, with flowers as a centerpiece. But the flowers were exasperatingly in the way of the swift passage of dishes, and you could see that the men were wondering how on earth that garden stuff got in one of the vegetable dishes. I would not have been surprised to have had them put gravy on the flowers and eat them. My lovely napkins had no identifying fingerprints in case of murder, but they did have manure sole-marks, and the murder in this case would have been performed, gladly, by me, had any men lingered, to become preys to my wrath, after their dainty dessert. The Baron gave the hint that helped. No napkins; no garden stuff; pie segmented in the tins, as the other women served it; pie, and more pie, and then some more pie.

There must be enough salad-dressing for three quarts of chopped cabbage—I chop it with a baking-powder can. When I have made the dressing according to a recipe of the Boston School of Cookery, I run out across the baked, weedy back yard to my garden and, with a stroke of my butcher knife, secure the largest head of cabbage; but I delay chopping it until the morrow, putting it in a bucket of water, where it may drink and become very crisp. I carry this down the rickety board steps into the dirt cellar. It is always cool there. But after rains the dirt is likely to come sliding in an avalanche down the walls.

While the big white cake, which is to be covered with chocolate frosting, is baking, I dig with a steak fork, relic of pre-farm days, enough potatoes to fill a gallon kettle when pared, and I proceed at once to pare them, for, covered with water, they will not only keep in the cool cellar, but be crisper, and crisp vegetables cook best. You must have plenty of water inside a vegetable, as well as outside it, to have it cook to perfection.

Word is sent by one of the children that everybody is to expect a cold supper on this night preceding threshing day. As for me, there can be no thought of eating. While the others satisfy their hunger, I continue with my preparations. Late that night, having forgotten that I have not yet eaten, I drop into bed, too exhausted not to sleep.

"Pheasant day!" jubilantly announces the fourteen-year-old hunter of the family. Fourteen he is, but he stands five feet seven and a half inches tall and wears a number-eleven shoe. It may appear from this chronicle that one of my children has been given thyroid extract or something, and has suddenly sprung up from infancy to full size. But I am not writing a chronological report, only random impressions of life among us sagebrush folks, and I shall weave the shuttle back and forth, as old women are likely to do.

"There'll be no hunting today," countermands his father. "You are to stay home from school and run errands whenever we need you."

Young Charles looks somewhat crestfallen at not being able to hunt on the first day of the season, especially since during breakfast we could hear the dull percussion of gun after gun, which betrayed that city men were invading our posted farms. The law is that if we farm people post notices that no hunting is allowed on our lands, the public is bound to respect the notices and

commit no trespass. Citizens obeyed that law as they obeyed the Eighteenth Amendment. In hunting season they loaded their cars with bootleg liquor, to serve for refreshment on the way, and with utmost boldness hunted as they would on our posted farms.

Breakfast over, the little daughter Rhoda is set to washing dishes, and the youngest son, Joe, to carrying water from the canal. It is reasonably safe for him to do this because the irrigating season is over, and the water is not as high in the canal as formerly. It is less dangerous for the little fellow to go to the canal for water than to try to draw it from the cistern. The pump is broken, and there is no money for new parts; so it is laid on its side, and all water must be drawn from the inky depths below through an opening large enough for four people to pass through at once. As the cistern is twenty-five feet deep, there is grave danger that a nine-year-old boy may be dragged into that pit of liquid blackness by the heavy weight of the full bucket. I had come upon the two little children, Rhoda and Joe, drawing up water several times that summer, but never without a shock that hurt me in the breast.

The children have now gone to school, and I am preparing the fifteen-pound roast of meat, chopping cabbage, putting the beans in the oven, and keeping myself out of mischief with a few odd tasks like these. I am so absorbed in my work that I am surprised when I see, through the obscuring orchard trees, what appears to be the whirring of a gigantic wing. A puffing monster crawls slowly into sight, moving past the top of my vegetable garden. It is belching smoke, not from its stub nose, but from one horn on its head. Two men ride its back under a horizontal umbrella shelter, and it drags behind it a dormant red dragon with blunt head resembling that of a short-faced horse. The dragon's tail curls over its back after the manner of a scorpion's. After the dragon, at funeral pace, moves the unromantic red tank-wagon, drawn by two discouraged horses. And after this combined imposing spectacle follow the grain-wagons, the buggies, the cars, the saddle-riders, all the crew who are to help with the threshing.

Even as I look, a knock on the front-door screen draws me to the toothpick-pillared porch, where I find the wife of Hen Turner, dark, almost pretty, very taciturn, very clean, her hands already knobby-knuckled from hard work. She has come to help me serve the threshers. There is never a moment of stopping for us two women. We can hear the hum of the machine, and through the living-room window, where the table is set the length of the room, we can see the monster spewing forth the ivory straw, which the sun tips with silver glitterings like Christmas-tree tinsel. A cloud of dust, like smoke, hangs over everything.

We do not talk, we two women. We must rush, *rush*, RUSH! There is no such pressure on the men out-of-doors as there is on the women in the kitchen. Everything must be ready on the very dot of time when the threshing-machine stops with a great silence. Probably the earth would change its orbit, and a few planets crash, if it should ever occur that the threshing meal was not exactly ready when the first tableful of men was ready for it.

As I see them strolling in from the field, during that great silence of the threshing-machine, it is like a command in battle to go over the top. Nerves are stretched taut. I begin adding, in my mind, the different parts of the sum that makes the dinner, peeping into every steaming kettle, prying with a fork, scalding my fingers, burning my arms, turning on the pet-cock in the pressure-canner, looking in the oven at the beans, stirring the gravy, putting hot rolls on plates, seeing that the butter is all right, and a thousand other last-minute tasks.

And we are not fresh for those final Olympic tasks of serving, for while Hen's wife was down at the canal carrying water, or pulling it up out of the cistern, or pumping it, in whichever case the water situation might be, I have been fighting flies. The ceilings of all the rooms have been black with them, although early that morning Charley has made the circuit of the house, burning flies on the shingled walls, under eaves, and in corners. If we have managed to get fly-powder, just before the thresher stops for noon, I puff it into the air from the little can with the tube nose.

I must go out-of-doors with Hen's wife while the flies are dying, or I shall be suffocated. But there is plenty for me to do. I drag a galvanized tub near the cistern, place buckets there, also wash-basins and any pans that can be used. I place a pile of towels beside these. The towels are

made from beet-seed sacks. Bars of laundry soap are scattered about.

Again I am in the house. Talk about the Massacre of the Innocents...millions of dead flies cover everything. I had laid papers over the table, over kettles, over pies, over everything that might be reached by flies or powder. And these I gather, carefully, to burn. I need not detail the course of my fly-collecting. One hole of the kitchen range receives dustpanful after dustpanful of the slaughtered innocents.

And now Hen Turner's wife and I are rushing the steaming food onto the table while the men throw water into their faces. There is always a logical reason for a traditional act. I wonder why all farmers wash by softening the dirt a little with some strong soap, loosening it a little more with water dashed upward in great handfuls, and wiping off the resulting gummy, sweaty mud on the towels. I always washed that mountain of filthy towels in the fatalistic humor that what had to be had to be.

The first tableful are seated, are passing the bread, pickles, preserves, vegetables, meat, everything at the same time, with crosscurrents that manage not to collide, while Hen Turner's wife is pouring coffee for all the coffee-drinkers, and milk for all the milk-drinkers, and water for all the water-drinkers, and coffee, milk, and water for the coffee, milk, and water drinkers, and hot water with a little milk in it for Farmer Stillton. I am already refilling dishes—more hot rolls, more meat, more of everything. The second table is lolling in the shade of the house, listening to the ditch-riders and the agents for This and That Company.

"And I sez t' him, sez I...now, looky-here, Sam Muckleberry, I sez, sez I..."

"What the Goverment oughta do..."

"My idee is that rust on wheat is caused by..."

"And this is the best two-way plow you ever..."

We women carry off the vegetables and meat and set the pie tins, on china plates, all over the table. The men slide their knives under the slices and thus transfer them to their dinner plates, which they have cleaned with crusts of bread, consuming the crusts afterwards. Sometimes they sample every pie; sometimes, like Eb Hall, they fasten affectionate eyes on one certain pie, eating slice after slice. Eb's favorite was raisin; Old Man Babcock's was fresh-prune. Knowing this, I was always careful to see that there was a prune pie in front of Babcock and a raisin pie in front of Eb. I knew those pies would never be allowed to ramble.

Hen's wife apparently lived on nothing; a few bites sufficed, and she was out in the kitchen scraping dishes. I had endured too much to rest so briefly; besides, I had a week's meals, or perhaps more, to work on in just this same frantic manner. I must let down while I could let down. So I always got a book and began reading, this operation usually ending with a scribbling spree. Poor they were, no doubt, but on scraps of paper, on cracker boxes, on fly-leaves, there were written down those verses of mine, born in the midst of the heavy labor of a sagebrush farm.

I am not long at this, but I have rested hard while I was at it. Soon Hen's wife and I are in the midst cleaning up. We scrape, and I put away, and then we wash and wipe, and I sweep, and pretty soon there is calm and order in the farm-house, and the flies are beginning to gather from nowhere for the evening meal.

Hen's wife goes home. I know what I am to serve, unaided, at night. I go to look over the field, and I am smothered by affectionate children and dogs. Shafts of sunlight come down to earth like Jacob's ladder, piercing a black storm-cloud. Red clover grows along the sides of the fields, with leaves that must have been planned to discountenance an atheist.

The best part of threshing is the very tip of the tail of the last day, when you see the monster and its attendant dragon crawling down the road to another farm. You can never know what it is to be really light-hearted and free until you have endured the galley-slavery of a week or two of cooking for threshers. I did not take it hard only because I was formerly a soft city woman. Mrs. Asper, my neighbor at some distance, has complained to me, almost in tears, of having threshers remain when she was so worn out with them she felt she could endure no more. Of course, a woman like Mrs. Epperson, who had cooked for the road-workers weeks on end, would

never turn a hair or lose a wink of sleep. There is genius in cooking for threshers as well as in composing symphonic music.

But I did pretty well, considering everything. I really made a success of it. It was a big job, and I did as well as any of the born farm women. My Waterloo came through another matter, a small one, as is so often the case. When Napoleon fell asleep on his horse at Waterloo, it must have been because he considered the occasion not of sufficient importance to keep him awake.

I WAS NOT DECEIVED concerning my point of failure. It caused me great humiliation. Yet I was nor to blame, for I had wanted to learn to milk a cow. But Charley had said, "No. I don't want you to learn. Then I won't be staying in town and leaving it for you to do. I couldn't trust myself to come home if I knew you could milk. No man could."

It was indeed a very curious matter that nearly all our sagebrush men had some affliction of the wrists, or fingers, or stomach, or what-not, that made it impossible for them to milk, so, of course, their women did the milking. Mrs. Jean was the exception. But then, her husband was the workin'est fool.

Charley was on the board of directors of the Water Company, and there came a time at last when he was forced to stay overnight in Jerome. At that time we had only one fresh cow, but that cow was so freshly fresh that when she was not milked at night, by morning her bag was filled to bursting. So it was at the time I decided I must milk her, since there was not a man on the ranch, our farm hands being in Twin Falls. They had gone that morning, in their fine car, to attend a grand parade of the Benevolent and Protective Order of Elks.

Usually there was a whole family of Russian-Germans thinning our sugar-beets, all barefooted, even to the kind old mother, a great, bulging sack of a woman, tied in the middle with a string which had disappeared in the line of contact between her voluminous breasts and belly. I suppose there are more polite ways of saying this, but in her full-gathered old gray dress she suggested simply the clean, straightforward words I have used, with neither obscene nor sensual associations. This family always came to work in their fine car, and today they were resting between thinnings, having been transported from our fields the night before in the aforesaid fine car. Which makes it pertinent to observe that Charley had crawled to Jerome in our poor, beloved, old second-hand Ford, Sagebrush Liz, the only car we were ever able to afford, and perhaps, in view of our mortgages, we had no right even to her.

Our freshly fresh cow that morning had been bawling at the living-room window, each bawl ending in a cow-sized screech. A cow purring a cow-sized purr might be pleasant enough, but a cow bawling and screeching a cow-sized bawl and screech was simply demoralizing. I did not think the cow was dying of bloat, for her teats were actually dripping milk. When I saw that she could not turn off the taps, I thought even I might milk her.

As I seated myself on a battered galvanized bucket beside her, she turned a suspicious gaze upon me. Nervously apprehensive of that gaze, I began signaling the milk-station by pulling on her teats. When I had seen Charley milking, it looked so simple. Charley signaled with a pull now and then, and the cow obligingly flowed out the milk in a stiff stream. I pictured myself carrying into the house a full milk-pail. I should be so proud to tell the Baron how I had milked.

When that cow stood at the window and bawled and yelled and screeched, the milk was dripping from her teats. Now that I had taken the trouble to sit there on that uncomfortable galvanized bucket, jerking with all my might on teat after teat, not even a drop came out. I consider that one of the miracles. For surely there are miracles of not doing, as well as of doing.

I sat still and looked at the cow and thought, and the cow stood still and looked at me and thought. I don't know what the cow thought, but I suspect it was some of that talk about God that the farmer had said to her at other times—that talk in which there were a lot of "damns." What I was thinking was that I must be on the wrong side of the cow. I had observed every other rule I knew; I had seated myself on the bucket, had spoken tender words of reassurance, had given competent jerks to her teats, and after all nothing had happened, except that the cow had stopped bawling and yelling and screeching and was holding the thought that no milk was in her bag, so

that not by any chance should she once forget and drop a single drop for me. It was undoubtedly because I was on her wrong side.

I had heard Eb Hall say that if you got on the wrong side of the cow, she would not let down her milk. Funny thing about a cow that she has to be so particular about where you sit to milk her.

It is a wonder she has not been driven out of business long ago by some kind of five-and-ten cow that will let you sit anywhere you please and milk her, maybe by telephone. I won't go so far as to say by radio, because I should not blame any cow for holding back her milk while hearing some of the things I have had forced on me over the air.

What should I do? I could try the other side, but I had also overheard the threat that if you get on the wrong side of a cow, she will kick over the milk-pail. When I had milked a bucket full, I did not want to risk that catastrophe. There was no use looking in the dictionary, or the Bible, or the doctor book, to find out which side you should elect to get the right milking side of a cow. Ah, but there was the school-teacher!

Mrs. Quackenbos was a large and ingratiating woman, her education for teaching consisting in being a large and ingratiating woman, and all her pupils learned from her was a large and ingratiating blank. But she did know more than Mrs. Greenwood about certain parts of farming. She had milked cows and knew on which side to sit. I sent a note to her, asking very humbly on which side of a cow you sit to induce her to let her milk down.

My note was read by Mrs. Quackenbos to her roomful of pupils, to be met by a burst of hilarious laughter. Those farm children had not known that there was any one in the world so imbecile as not to have been born with the knowledge of which is the right side of a cow to sit on. Yes, I have avoided saying it, but the technical term is, "the right side of a cow to sit on." And now let grammarians tear their hair in anguish. Lots they know about the right side of a cow to sit on.

A learned youth—learned in the right side of a cow to sit on—came up the hill from the school-house...no, he was not bearing a banner with a strange device, *Excelsior!* though I very nearly stumbled into saying that. He was smothering a well-developed snicker under a solemn, dumb expression. He had come to milk my cow, and he did it. That ornery cow turned her head and took one look at him, and there he was in ragged overalls and an old, ragged coat, a horrible cap forcing his ears forward and out, like Hen Turner's, with freckles as large as pond-lily pads, while I...Yet down came the milk in several steady streams at once, *swish-swish-swish-swish....*

IT IS TRUE that I organized the first Sunday-school in our district, and none of our good sagebrush folks suspected that I was not even a Christian at that time. I was an average deist. I believed there was a God, but I thought he was the old, bearded Jehovah who licked his lips over his successful vengeances, as though it were anything for God to be tickled about that he could lambaste poor ineffectual man. I had no real faith in a loving God. I had no real faith in any kind of God. I was like the average churcher: I believed, feared, hoped, desired, rebelled, complained, but I did not trust. Like Peter of old, who denied his Lord and yet I would found a church in his honor, I founded a Sunday-school.

I trust it did no harm, though there was a period a long time later when it ran true to form and was intolerant of a brother Sunday-school because it was called Mormon. Churches and Sunday-schools *are* powerful influences for good if they are powerful influences for good, but *ex officio* they can be as powerful an influence for intolerance and bigotry.

When one of Jesus' disciples asked his will, he repeated over and over again, "Feed my sheep! Feed my lambs!" and since he always healed the body as well as the soul, I believe he meant it physically as well as spiritually. So long as there is a hungry person in the world, worthy or, *particularly*, unworthy, the Sunday-schools and churches stand arraigned. "Feed my lambs! Feed my black lambs as well as my white lambs! I came not to feed the full, but the empty; not to reward the safe, but to save the sinner from himself."

I founded the Literary Society, and I think it may have saved a few sinners from

themselves, for we often had good, innocent laughter together, and there is more soul-saving in good, innocent laughter laughed together than in all your creeds. For there is brotherly love in generous, understanding laughter. One of my firmest beliefs is in a God with a sense of humor; otherwise He must be inferior to His own creation, and that, of course, is impossible. Oh, my dear, understanding, humorous, loving God!

I am sure those sagebrush folks would have founded all the societies they needed without my help or doubtful leadership. Leaders are a sort of nuisance, anyhow. I am much in doubt as to the good results of most of the world's crusades for which martyrs have died. A man or a woman who acts a true friend to some unfortunate being, right where he or she is by reason of fate, is probably doing all there is to do in this world. Civilization? Let me answer: Civilization is that state which underscores the superfluous. Mercy? Love? These are not the prerogatives of any race, society, or financial condition.

The organization that did the most good in our community was not founded by me, nor was I even a member, though I was asked to join. It was planned and put into operation by Mrs. Dan Jean, and it bore, in the beginning, the unique and quaint name of the Ladies Fancywork Improvement Club. I have told you about this before. I repeat it because it did more practical good than the Sunday-school, the Literary Society, and the Grange, all put together.

There was nothing to say against the Grange. I helped organize that, and I was its first Lecturer. When I heard the title of my office, I sorta hoped it was some kinda talking job in which I could talk all I wanted to and nobody could get away. It turned out to be almost as interesting. I was the Grange entertainment programmer, and, oh, how I love to tell people what they must do! While I was on that job, everybody did something. Those who wouldn't sing, or speak, or play, or stand on their heads, or what-not (it mattered not that they couldn't) either had to provide coffee for the Grange or cake, pie, or sandwiches. Coffee was masculine, the rest feminine. Believe me, folks, there was always something doing while I ran the Grange entertainment program.

Charley gave our Grange the name Frontier. I liked that. But in the voting it ran neck and neck with such original names as Shamrock, Four-Leaf Clover, Buckeye, Pleasant View, and What-not. Well, no; to be truthful, What-not was not advanced, but I am still surprised that it wasn't. There was great electioneering back and forth, Four-Leaf Clover lobbies, and Shamrock lobbies, and Buckeye lobbies, and What-not...I mean, and other lobbies forming in little groups all over the big room, made by folding back the doors between the Upper Grades and the Primary. That ungrateful cow I told you about performed a miracle of *not doing*. When Charley and Jack Overdonk and I secured the name Frontier for our Grange, we performed a miracle of doing.

Of course, the sagebrush folks could not be blamed for opposing the name Frontier, for it meant practically nothing to them, always being pronounced "Front-ear"; and if they had any bewildered idea of why Charley had selected it, their actual response to it was a vague visualization of some repugnant physiognomy with a monstrous ear located in frontal position, probably as nasal substitute—the Last Front-ear.

Jack was the first Master of Frontier Grange, and a handsome figure he made up in front there, after he had arrived around eleven P. M. Jack was still keeping banking hours on the farm, his wife taking up the slack by getting up that much earlier. One or the other of every married couple usually has to dedicate his or her life to taking up the slack left loose by the other partner.

The Baron was Overseer. My mind has always been hazy about the office of Grange Overseer. All I can recognize is that he oversees the backs of people's heads, as he has a position at the back of the room opposite to the Grange Master's position at the front. I have an idea that if the subconscious of the Grange were analyzed, it would be found that the Overseer was originated out of the suspicions of farmers for each other. The Grange Overseer can see whether there are any irrigation spades sticking out of hind pockets, for many a farmer kills his neighbor with a spade each watering season, when the two meet at a head-gate where gunny-sacks are found turning the water where it has no right to be. My attention was often distracted in Sunday-school by my irresistible impulse during hymn-singing to listen with unreligious fascination to the loud

103

bellowings of Old Man Babcock and Baldy Parsons, who were in the habit of stealing our water. Sometimes it seemed to me that even our dear, forgiving Father in Heaven might smile a little sardonically, knowing how the night before the water was diverted with weeds or gunny-sacks.

O can we say we are ready, brother?
Ready for the soul's bright home?
Say, will He find you and me still watching,
Waiting, waiting when the Lord shall come?

I couldn't help wondering if, through force of habit, they would be watching till the Lord's back was turned, in order to stuff gunnysacks in some canal running out of the River of Life.

But Charley did make a very handsome Overseer, standing up there at the back and balancing Jack Overdonk's handsomeness at the front. The Baron was a larger man than Jack, and that is a distinct advantage in the handsomeness of a man. They both had beautiful manners; both were witty; both were city men; both were good mixers; both knew how to turn the farmers around their fingers, and especially the farmers' wives. As far as the two men were concerned in *my* mind, Jack had the advantage of not being my husband. It is only in fiction that a farm woman can glamour her husband with romance when she sees him almost all the time, and during that almost all the time he is wearing overalls and work shirt, with maybe manure under his heels. Besides, she may not have had time to iron his shirt, and she will never think what injury she is doing herself by not dressing her man up for her own eyes.

Then, too, Jack could not be a little cross with me sometimes, for I was not his wife. Nor could he go to sleep in his chair in the evening, with me still awake, a rather dreadful crime in a husband, for he is likely to get in hideous contortions, even if he does not commit the final disillusionment of snoring off key. I think I should not mind snoring in a man if he could train his subconscious to snore something from Grieg, or maybe Bach. But just snorts and whistles grow sort of monotonous through the years of conjugal intimacy.

Jack Overdonk was not my husband, and so it happened that his daily presence at our dinner-table made me glory in the fact that I have a certain aptness and love for cooking. I loved to mix things; loved to read new ways of doing things; loved to see the finished products cooling on the kitchen table or traveling down the men's throats. I was not in love with Jack, but it did sound good to hear Charley tell me, "Jack says your bread tastes like delicious nuts," or, "Jack says he never ate such lemon pie as yours...or your peach pie." And after Jack had eaten his daily dinner with us, he had to go home and eat another dinner which his wife had cooked. And her bread was just as deliciously nutty as mine, and she could make just as good lemon pie and peach pie as I could. But she had the disadvantage of being Jack's wife.

No, I was not in love with Jack, but I was so near it that I trembled on the edge. The worst of it was that I can never have the excuse that I did not know what was happening, for psychologists will please take notice that I am the unhappy victim of split personality, or maybe it is that unpopular creature called Censor, whom I believe Freud discovered, or perhaps it is because on one side of my ancestry they all ran to pirates and on the other side to ministers. Imagine being born of pirate-minister stock!

So when the pirate lass would yipp it up, not caring a damn for any one, filled with laughter and deliberate seduction, there stands the minister's damsel, looking on with critical eyes, and not just saying, "Sinner, repent, or you'll lose your little peanut soul!" but, If you do this thing, you will injure an innocent woman, a woman who will then be finer than you are, and you will unforgivably harm some little children." You might think I could get around the idea of the woman, even if I were given pause by the children, but I never could.

On the other hand, there may have been no real danger to anything but my memory of fickle fancies, for Jack probably thought of me only in the light of dinner, and yet we did have such bubbling, delightful times over those dinners, Jack and Charley and I. Jack's and the Baron's wit sparkled and fenced, as never happened over another farm table in that district, and I supplied plenty of laughter.

Jack was a sort of freak farmer. We never had any one else before or afterward, come into our district to farm who kept banking hours, while imagining that he was farming, and who was so very charming.

OUR LITTLE COMMUNITY continually showed change, though that change crept upon us unaware. The intrepid Mormons had come first, the far-apart groups of well-grown poplar-trees marking where they had settled. Next, lured by wild dreams of pretty farms on which white peacocks ranged, came the speculators who bought land because of Milner Dam. These city settlers enjoyed a brief pioneering vacation and left, after paying for Jake Solomon's saddle. After them came both farm and city folks who had just a little money, or none at all, and who were determined to own their own land. Practically none of them succeeded, the only difference between the city and the rural farmers being that the born farmers are still there, for there was no better place to go, and no money with which to go, but the city farmers have gone back to their bakeries, their streetcars, their bookkeeping, and their other former occupations. There are just enough exceptions to both these statements to prove the rule.

About the time the first middle-class city farmers had their farms painfully extracted from them by means of the Federal Land Bank, the hearty Arkansawyers began to swarm over our district. I have been told that one whole mountain community migrated together, or the pioneers sent for them almost immediately after looking the country over. After a slight period of caution, back there in the mountains where they had all been born, some of the older Arkansawyers farewelled all their intermarried relations, and then these elders, too, joined us, and were they a peppy lot? Lean, active, hard-eyed, straight-thinking, some of them, so I was informed, smoking pipes—I mean the women, for of course there were practically no farmers who were not chimneys except when they were chewing and spitting. I am sorry I did not learn to smoke a pipe where I might have done it as a matter of course, hobnobbing with the older Arkansawyer women. The public exhibitionism of some women's smoking looks to me like an attempt at releasing inhibitions in a very tame way. I am capable of so much more staggering wickedness than that, should I ever start primrosing.

We had become a farming community composed of farm folks from almost every state in the Union and Canada, all speaking our several dialects. My talk sounded more dialecty than any one else's, the Baron adapting himself, good mixer that he always was, so that he talked a conglomerate language which was Ohio-Missouri-Arkansas-South-Carolina-Texas-Georgia-Canada-Russian-German and What-not. Yes, there were What-not dialects, those being the ones that had become badly mixed. This condition of language is already passing, the talk merging into one speech, and that speech being rapidly denatured by the radio. It passes practically unharmed through the rural schools, as the young girl teachers are the product of semi-illiterate farms or villages, with something bewildering added at Albion Normal Training School in order to get a certificate. Albion does not deliberately bewilder. The instruction is no doubt excellent. But the teachers there have yet to learn how easily instruction can slip back into home habits.

One of my most delightful diversions was listening to the tall tales of the Arkansawyers, not tall because unbelievable, but tall because so wildly true. The feuds, with ears chewed off in belligerent encounters, the strange romances held me breathless. Hogan Stinett, keen of features and eye, could fiddle like nobody's business, and Russ, his big, handsome brother, could call off dances with a masterly round of rhymes and rhythm such as have not been captured yet between the covers of books.

Prominade all, an' alleman' left,
And swing that gal in the party blue dress!

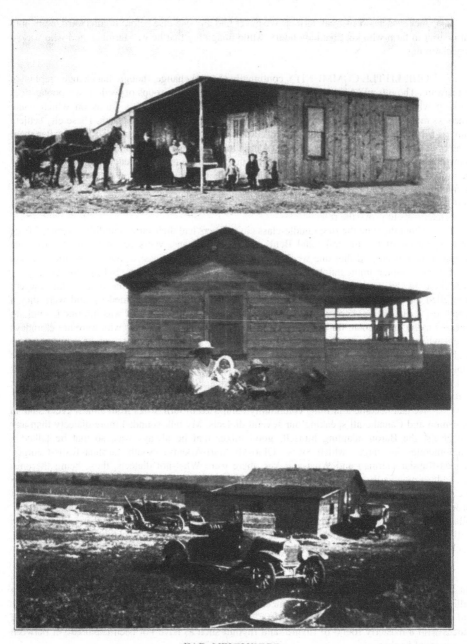

FAR NEIGHBORS

Steve Drake, who would have been more at home on a vaudeville stage than on a farm, though he loved the smell of the desert ranches, Steve sang the cowboy songs in a musical tenor,

with that nasal twang which is part of all good cowboy singing.

I thought one summer just for fun
I'd try cow-punchin', see how 'twas done,
So when the round-up it begun,
I tackled a cattle king....

I sit here, as I dash this off on my little typewriter, singing from memory the cowboy songs Steve sang for me in our ranch living-room.

Josh Wardell, the ditch-rider, was also an artist at singing these songs. Perhaps I am niggardly, but remembering how he and Wendell Boden and Wendell Worthington sang them with Josh in the little old school-house, and knowing, as I do, that the particular songs they sang have not yet been tracked down by the Hounds of Harmony, I feel a kind of triumphant gladness. Ah, well, here I have set them on the scent, for though many of the names of our sagebrush folks in this book are for obvious reasons fictitious, the names just written are real. The last I heard of the two Wendells is that one ran a service-station in Hazelton, where his cowboy songs helped to tame the gasoline pump; the other was on a real cattle-ranch in Canada; and Josh was perhaps the most picturesque citizen of Hazelton, with his fine, bold eyes, his somewhat lank hair, and his high boots. I liked Josh, though he never knew it, and there was little danger that we would ever elope together.

Each family had its stories of other states, through which were woven customs foreign to those which must be acquired in our sage-brush community. And we had our own sagebrush sagas that would be told to the grandchildren of our children. The stills found in the desert and told about in hushed voices; mad coyotes, victims of hydrophobia, who bit horses and cows and men and made them raving mad and frothing at the mouth. Sadie Stillton, called "Blondie" by a designing young man who would have robbed her of her virginity in a vacant shack; but Sadie fought valiantly and preserved it, in order that she might bestow it, willy-nilly, on the married man she loved.

Hazelton was a part of us, and the farmers took sides when Hobart Tanson dug a cesspool and a child fell in it. The child would have perished if some one had not pulled it out just in time. Half of the sagebrush folks blamed Hobart, saying the cesspool was not properly covered; the other half thought the child's mother ought to have been partially on the job. As for Charley and me, we would have defended Hobart on any terms. He was always our most excellent friend.

Then there were those who tried to attack Gundelfinger, the banker. I cannot remember whether he did or did not comb his hair to suit the farmers, but I do know that the ones who had borrowed the most money found the most fault. You see, they felt they had a right to their money's worth if by any chance they should ever be able to pay back what they had borrowed. The Jerome bankers were most hated, however. Our farmers had borrowed more from them.

WHEN THE ASPERS took over the Endicott ranch and began paying real money on it, with a view to owning it eventually, the Currys moved into the chicken-house, which Mrs. Curry, with cheerful adaptability, managed to make into a home. Some of the chickens roosted on the roof, some huddled reproachfully at the door, others watched their chance and crept into the house with the Curry family, but a good many of them accidentally got into the roasting-pan. Who could blame so lovely and patient a person as Mrs. Curry for feeding her family on whatever was clamoring to enter into the family circle, alive or gravied? I think no woman ever had so sweet and kindly a voice as that long-suffering but cheerful mortal, Mrs. Curry.

Sam was born to be an outlaw, but Mrs. Curry managed to keep him from being too much of a hell-of-a-fellow. Of course, his standards remained slightly different from ours, as when one of his sows was run to death in the heat by the Curry children, who were trying to drive it off the crop and into its pen. There is a legend, believed by most farm people, that the reason a hog dies from running in the heat is that the lard in it melts and runs around inside; clogging up its innards. And maybe it is true. Maybe chickenmanure tea will bring out the measles. Maybe the moon does have some interest at planting-time in watching the farmer and getting mad if he does not plant root

crops in its dark and leaf crops in its light. Sounds like I am trying to be funny, but I suspect, if the truth were known, the laugh might be on me—I who imagine myself so rational.

When the sow was run to death, and maybe her lard melted, Sam caught up with her just as she was breathing her last gasp, and with the handy, vicious, long-bladed pocket-knife he always carried, he slashed her throat. She had done all of which she was capable in melting her own lard. No blood ran. Perhaps I am right in surmising that she was already dead when the knife reached her throat. Charley happened along just at that moment. The generous Currys chose the best piece of meat on the sow for the Greenwoods. We were very grateful. But we were eating something else that week. Strange how the Old Testament makes Israelites of us all. "For the blood is the life." The Baron disappeared that meat, but not into his stomach.

About this time, Sam began going around with a bony paw spread protectingly over one of his lantern-jaws. I felt sorry for him. I had always felt sorry for him in one way or another for what I had made him do when I was Teacher. One of his children appeared to be a kleptomaniac. I thought I knew the two reasons. First, he could not see the black rag of a blackboard, he was so short-sighted; and not being able to hold his own with the others, he had to have presents for Teacher. These presents were accessible in the wagon of the Raleigh man, who came around once a year selling us spices and remedies for ourselves, our farm animals, and our chickens.

I was a great hand (as I am still) to read everything I could find on psychology, which at that time was pretty much in its infancy. I found my clue, however, and thought it worth testing. I had the county superintendent force Sam Curry to get glasses for his son Frank. Sam went indignantly to Charley, and Charley came indignantly to me, like the males they were, and I faced husband Charley with large, straight, unflinching eyes, and said:

"I am doing what I believe is right in this case, and...I AM THE TEACHER!"

The way you place the emphasis on these last four words is not to shout them—quite the reverse—but to say them with one long, straight, steady look, and finish the sentence, and end it there without another word, but not to end the look, but to keep right on looking the look until the lookee is looked away by the looker. And the lookee will be looked away by the looker if you are right, especially if you are right, not for yourself, but for some one who is too weak to help himself. You need not be afraid of being murdered. I have never been afraid, nor have I ever been murdered. Of course, if the lookee is your own husband, it is a nice thing to catch him just before he has been looked around the corner of the house, reach up around his neck, and draw his face down for a smiling kiss. But there must be no relenting. You must not mix up this husband-and-wife business with any other business to the detriment of the latter, especially if children would suffer as a result. Remember, when you are caring for the welfare of little children, to say very firmly to those who want to save their purses, or to family dictators: "I AM THE TEACHER!"

I knew Sam could afford the glasses, for he had just sold a suitcase of bootleg white mule. It was the only thing he could raise, so why blame him? And now I want to say right here that as long as the glasses lasted, Frank Curry never stole another thing. A miracle? Yes...to those who do not know the law. A miracle is the result of laws unknown to the beholder.

Sam Curry had a most vile toothache and was going around with one bony paw covering his left lantern-jaw. I felt sorry I had been Teacher to him, and now I felt sorry for his toothache. I liked Sam Curry, and I believe he liked me. He had a sense of humor, and I cannot help loving folks who have real senses of humor.

Sam went to a dentist in Burley and came back with the joyful news that this dentist had offered a bargain of two sets, lowers and uppers, for both Sam and his wife, if they would take the sets at once; and both were to cost the total sum of only fifteen dollars. Of course, Mrs. Curry did not need any other teeth than her own, but it would be only a few years before she would need them, for no farm woman much over thirty can hope to be in possession of her home-grown teeth.

So Mrs. Curry went with Sam in the family wagon, the Curry children, very happy at the adventure, tucked here and there in the straw with which the wagon-box was lined to make it comfortable for riding. And both Currys had all their teeth drawn. If the dentist had offered bargain

sets for the children, no doubt the whole family would have taken to store teeth. Mrs. Curry's teeth fitted reasonably well, but Sam's were continually dropping.

Nearly every one in the community wore store teeth, but a great many had preserved their own by chewing tobacco more than the others chewed tobacco. They told me so, and it seemed to be true. Sam's teeth kept dropping down almost as badly as Old Man Babcock's, the only difference being in the way the two men accepted this inconvenience. Sam bore it with humor, making an asset of it, laughing each time his teeth slipped, and encouraging you to join him in the laugh. Old Man Babcock got mad if you noticed the slip-slopping of his mouth-furniture.

One day Charley had to take some grain to town to the elevator, and Sam asked to go along with him. Just beyond the Jerome Canal bridge they met Old Man Babcock coming back from Hazelton. Once, when Bab had been chasing some horses from his haystack, he had tried to climb through a barbed-wire fence, but got stuck there, caught by the barbs. He was so mad that he had roared and cussed and struggled and jerked until his clothes were in rags. He had not the vestige of a sense of humor, and he could not endure a word of ridicule. He was that type of unfortunate who leaves the tail of his feelings lying around, like a cat's, to be stepped on. Suspicious of everyone's opinion of him was poor old Bab.

Now, good-natured, villainous Sam Curry was possessed of the devil to hail Bab with some facetious remark which no mortal would have noticed except that hot-tempered individual, who probably had something poisonous the matter with all his mutually spiteful endocrine glands. Bab stopped his team. He clambered down, clumsily, over the front wheel on his right and began to run after Charley's wagon. Not understanding the import of this action, Charley reined his horses, and then he could hear Bab yelling at Sam, "You come down offen that seat, you XYZ blankety son of a female dog! Can't no man say nothen like that t' me. I knocked a man down the court-house steps back home fer sayen lessen that t' me, 'n, by God! you come down offen that wagon so's I ken knock yer XYZ blankety teeth down yer throat, you XYZ blankety blank blank blank blank..."

Sam couldn't let that pass. Particularly with a vicious, long-bladed pocket-knife in a handy place. He dropped gracefully over the front wheel, lowering himself without haste, but malignantly, like a vicious baboon. The two men advanced upon each other, yelling threats and insults, Bab's teeth dropping continually, and Sam's teeth dropping continually. It looked like an occasion which might be photographed later as "X marks where the body was found." But Charley was over his wheel like lightning, and advancing upon them with a good-sized mad of his own, he demanded:

"What in hell's the matter with you two fools? You make me so dod-gasted mad I could...Whoa! Stand still, Nell!" The horses had thought his voice meant something urgent to them and had begun to move on.

"He..." stuttered Bab, pointing with a broad, copper-colored thumb at Sam. "He keeps a droppen his teeth at me to make fun of me 'cause I can't help a-droppen mine. Can't no man drop no teeth at me en get away with it. Back home I knocked a man down the court-house steps fer..."

"I can't help a-droppen my teeth down," pleaded Sam, still hoping the fight was not off, his hand on his hip pocket where the long-bladed, vicious pocket-knife lived. "He knows I can't help a-droppen my teeth, en, by God! I'll show the bloody son of a..."

"Now you two fools get the hell away from each other," said my intrepid mate. "Do you hear?" He was not Teacher, but he glared a glare which made the two glarees slink, with what grace or disgrace they might, to their respective wagon-seats. Then Charley mounted his seat, spat tobacco largely over the wheel, and said, "Get up!" The incident was closed.

No, I didn't like him to chew tobacco. He didn't like me to write. Neither of us stopped. We each enjoyed a grievance which came in handy when we wanted to excuse ourselves for any wrong we might do each other, after the manner of nearly all the other married couples who ever lived.

The farmers were always quarreling with one another and having fights, not as enemies, but the sort that brothers fight with each other. I remember the day when Charley, standing shaving

109

in front of the home-made wash-stand in a corner of the kitchen, his face covered with lather, suddenly stopped his razor to exclaim, "What's that?"

Through the two little kitchen windows he could see Sam Curry dogging our horses. Out of the house dashed Charley, taking great strides across the orchard snow, face still lathered, the open old-fashioned razor grasped menacingly in his hand. Sam was ready for him. He had quickly drawn from that handy pocket the long-bladed, vicious pocket-knife, and he was thoughtfully whetting it on the leather of his shoe, his back against a fence post, eyes riveted on that open razor.

So they stood and argued, shouting to be heard on Mars and occasionally flourishing their blades in each other's faces. No two women could have gone that far without a final homicide, yet in a little while back came Charley, the lather dried on his face, to finish his shaving amid mumbled execrations in the direction of Sam Curry. And that night the Currys came over with a birthday cake for the Baron. It was five layers, very white, for the dispossessed hens were not laying, and the cake was a lard-shortened, sweetened biscuit dough, the sugar for which little Janey Curry had borrowed from me that morning. And when I moved the sleeping Curry infant on my bed to a more comfortable position, I found a large bedbug under him. Yet it was a lovely act, that memorable birthday cake, so proudly presented, with such soft, gently-spoken words by Mrs. Curry and such funny grimaces by Sam Curry, coming in back of her with the Curry infant in his arms.

I think Mrs. Curry will make a lovely angel. She never had any decent clothes here on earth, but in Heaven she will have flowing white robes, as good as anybody's. In my Father's plan are many mansions, and Mrs. Curry will be living in one, and she will not have to dignify one of the Lord's chicken-houses with her lovely spirit. There will be no tears or mourning there, nor will there be any bedbugs. If I manage to slip in past Saint Peter, perhaps distracting him with one of my silly grins, I hope Mrs. Curry will be my neighbor and that she will not ever have to borrow heavenly sugar from even me. Yes, I was grateful for those constant boxes of clothes that used to come, only a little worn. But I hope the day will come when I can send boxes. No! That thought is ignoble. May the day come when nobody will have to borrow sugar or have any boxes sent to them!

IN SPITE of Charley's open razor and his frequent scraps with the other farmers, I was a far more discordant member of that farming society. They could understand him. He managed to be like them. They all fought and growled together, and they all came up smiling together. When I did not like things, I withdrew and forgot the offenders, or I was Mrs. Bossy, determined to dictate or not play. I was certainly an objectionable person, as I look back and see myself.

Until the Arkansawyers came, I was the only woman in the Greenwood District who danced. Oh, there were three or four Mormon girls, but they were considered pariahs, anyway. And I was bossy. I thought I knew it all. It would be hard for those sagebrush people to believe me when I say I loved them and today think of them fondly, as being my own in a way that no others can ever be. But I was continually getting in bad with them.

I had been invited as a guest to attend a meeting of the Ladies Fancywork Improvement Club, and there I sat, in the two-room tarpaper shack of Mrs. Throckmorton, yawning over one of the Baron's socks, which yawned back at me with a big hole in the heel.

"You must be sleepy," remarked Mrs. Babcock with surprising penetration.

"I am," I answered. "I went to the Masonic dance in Hazelton last night, and we didn't get home until three this morning."

Beginning on my left with Mrs. Babcock, I felt the women freeze in a solid circle. Lovely Mrs. Landrum Poole, pretty as a pretty picture, leaned forward and fixed her leaf-brown eyes on me. She had Indian blood. "Why, Mrs. Greenwood," and her voice was reproachful, "a nice little woman like you, dance?"

"My father danced until he was fifty and too sick to dance any more." I am afraid my voice was flippant.

"But you would never let your daughter go to a dance," said Mrs. Stillton.

"Let her!...I would take her there, and I should hope to dance as much as she did." The

110

very devil was rising in me.

"Well," said Mrs. Baldy Parsons, her face screwing in a multitude of wrinkles, "my folks wouldn't never allow me to go to no dances. They was Methodists, and they didn't believe in dancen."

"They missed a lot," I remarked, impertinently.

"It's my opinion," said Mrs. Babcock, her thin lips snapping together and her black eyes snapping above them, with, of course, her nose in between not snapping, though I believe it would have snapped had it known how, "It's my opinion that all a married woman dances with a man for is to get some other woman's husband to hug her."

Then I damned myself with this retort: "If that is the way you feel about it, Mrs. Babcock, I think it would be very wrong indeed for you to dance with some other woman's husband."

There was a shocked silence. I do not know how many conventions I shattered by that remark. I do not believe they were quite sure what I had intended to insinuate. But they knew it was something foreign to their standards, and once again, there in the midst of them, I was outcast. So it was again and again; I felt the exclusion of myself from the circle of our sagebrush women by reason of something maverick in my own mind.

But before this awful day of Middle West Methodism and United Brethrenism (our preacher's faith) there had been a time when the Mormons held dances in the school-house; when Mrs. Curry played the organ; when Hogan Stinnett fiddled like nobody's business; when Russ Stinnett, big and handsome, called off the dances:

Prominade all, an' alleman' left,
Swing that gal in the purty blue dress...

Even so, we meant to be very virtuous in our dancing. Our men asserted their authority by trying to catch the younger generation "ragging," a very innocent, rocking-boat sort of dancing, supposed to rival the hoochi-koochi, only worse, being team-work, though, to tell the truth, I think it a cowardly threat to scare people out of wickedness by warning them that the sins they do by two and two they shall pay for one by one. The only way to sin pleasantly is by two and two, and the only decent way to pay is by yourself—not dragging the other fellow in just because he was overpowered by Nature and your blandishments.

So our young folks would dance stiffly for a moment or so and then rocking-boat devilishly a few steps, the hawk eyes of Eb Hall and Charley watching to catch them at it—and hoping they would do it, not consciously, of course, but warming up inside as soon as they saw a chance to stride across the dance-floor and touch, say, Wendell Worthington on the shoulder. "No ragging here," would say Charley, or Eb, very severely.

We always had at least one fight at our dances. Once a jealous husband, just a little drunk, or maybe a little more than that, fought the object of his venom over the top of Rhoda's go-cart, she sleeping peacefully within. I was practically included in the fray in my endeavor to save the child. I dodged in and out amid the pattern of flying fists, pushing the go-cart a little this way and a little that way, the whole dance company gasping in alarm, folks stopping their dancing, but the fiddle still fiddling and the organ still wheezing, the belligerent farmers ever on the point of bestowing upon me the punches intended for each other. It is the only time I was ever really in a fist fight.

Charley and Eb Hall, being floormanagers, and Sam Curry, being husband of the organist, all came rushing importantly, hiding their delight in the affray behind severe countenances. Hogan Stinnett stopped fiddling and hastily put his instrument in its case, his eyes never leaving the fighters. Russ quit calling off the dance, and in the fraction of a moment every man in that hall was mixed up in the fight, Rhoda and I in the center of it. And then, looking like a swarm of bees on an apple-tree bough, such as Abel Asper used to hive, wearing his wife's sunbonnet, the swarm of men moved slowly to the door, taking with them the assailants and leaving Rhoda and me behind, much to my disappointment. I always want to be where the men are, not because I want to be with the men, though I like that, too, but because the men are always seeing something interesting, while the women have to stay where they are and just sit. And I am not the sitting kind.

111

We women were left looking at each other, a great silence settling over the two rooms, Upper Grades and Primary, which had been thrown together. It was like the silence of the threshing-machine when the men come trooping across the fields to dinner. The organ had stopped, and the fiddler was outside, maybe showing the fighters how to chew each other's ears off in the good old Arkansas manner.

I wanted to be out there. Of course, I could imagine it, but you get sort of tired of living so much in your imagination. If you are like me, you enjoy living most of your experience. The mass of men would be out in front of the school-house, the moon shining softly down. The moon shines softly whether it is a fight or a kissing encounter. Old moon has seen worse things than those and shone softly through them all.

All the men would be crowded on one another's backs, breathing into one another's necks, eager for more and more fight. And something like this would be heard:

"You did, too, you blankety blank blank blank, XYZ you!"

"Lemme at him! He can't say nothen like that t' me! I'll make 'im swaller them words, the XYZ blankety blank blank blank!"

"Now, see here, Parley, you gotta quit..."

"Somebody get a-hold of him there..."

I never really want to be a man unless there is a good fight going on. I cannot decide whether I fancy myself in the rôle of peacemaker or of the licker. Of course, I should not care to be the lickee. There is too much fight in me to be a very good alibi-maker. I might crawl off to die, but it is more likely I should just be crawling around to get a better bite out of the other fellow's leg.

The Arkansawyers helped bring more tolerant times to pass. At first our Middle West Methodists and United Brethren were not going to accept the Arkansawyers. And it did take a long time before the first Arkansas woman was allowed to dribble into the Ladies Fancywork Improvement Club.

The Arkansawyers liked house dances. Before our school-house was available, the Mormons had held house dances, even in shacks. Then the beds and stoves were set out in the yard, and you approached your destination through an aisle of furniture. When the Arkansawyers danced in the houses, not so many things had to be set outside, for generally their houses were larger than those first shacks.

The Arkansawyers had come from a country of moonshine whisky. They took their liquor freely and regularly. The only time they paused was when occasionally they might get a spell of religion. But when the intoxication of conversion wore off, they found salvation in moonshine instead.

And they were great sweaters. They were hearty folks. Something about them appealed strongly to me. Yet sometimes at the Arkansawyer dances I crept out under the stars alone and sat down beside a pump or something, slightly intoxicated from breathing my dance-partner's breath, and more than a little asphyxiated by the odor of sweat.

Without exception, the Arkansas women were notable house-keepers, seamstresses, and cooks. As Mrs. Curry had done with the chicken-house on the Endicott place, they also could take any granary or shack and make it into a presentable, attractive habitation. These were our tenant farmers. When I lived there, none of them owned property, nor were they making any effort to own any. And therein they more than probably showed their good sense. They had cars, money enough to be comfortable, no taxes to pay. The load was on the owner of the farm, just as the load was on the would-be owner. The Southern farmers and the Middle Western farmers and the Canadian farmers were all trying to be owners. Taxes and water-payments and help keep them stripped.

THE SCHOOL-HOUSE was the center of our social life always. Not long ago, rummaging in my manuscript trunk, I found a carbon copy of an old letter. I am always amazed when any writing of mine survives the destroying years and my neglect. On the back of this letter, written in pencil, is a list of things I must do: Monday, mend, iron; Tuesday, mop house, make

112

yeast, water-glass eggs, mend; Wednesday, wash and iron, pick over beans, make butter; Thursday, bake bread and cake; Friday, sandwiches and beans; Saturday...

Nothing recorded for Saturday. But make no mistake. It was not a day of rest. I was undoubtedly interrupted in my planning. And make no further mistake of supposing the items jotted were the only tasks I had to do. I recognized by those brief memoranda that I was planning toward something. A recipe for caramel ice-cream on the other half of the back gave me further evidence. And the letter itself provides the full story. Here it is:

Feb. 10, 1921

MY DEAR MRS. FIELD:

I must tell you how pleased the children are with your valentines. I thought Walter might consider himself too mature for lace and hearts. But the child-soul lives in all of us—more than is thought. I know my heart was nearly broken when I was eleven years old and my folks thought me too old for a Christmas doll. Walter worked on his valentines all last evening while his father read *Huckleberry Finn* aloud to us. (Picture me with a mountain of mending.)

Charles took his valentines to school to make, and during recess was the center of a crowd of child-observers. Rhoda enjoyed so much making hers. She thought they were so beautiful that she was in an agony of vacillation as to whether she should give them away or keep them. At last accounts I believe she had decided to divide what she has between others and herself—not to leave herself out entirely is the child of it, too.

Walter is now ready to finish making Joe's valentines. Joe was afraid of spoiling them, as he would probably have done, and therefore he wants Walter to make them for him. On Feb. 14th they will take turns slipping out of the house at one door and running around to the other, to rap and call, "Valentine night!"

We are to have a pie social in the school-house Valentine night, when our pies will be auctioned off to the highest bidders. Very exciting for us old married women to wait, expectantly, for the cowboy or young unmarried farmer who will become a bashful partner in demolishing a pie.

There is also to be a program, the Greenwoods appearing prominently. But then, almost every member of every family in the district will help furnish the entertainment, so the Greenwood efforts sink somewhat into insignificance.

I think we get the best of it right here at home. Charles and Rhoda are learning a dialogue, and Charles eats large bites of innocent biscuit, while Rhoda expostulates with him about consuming such rich fruitcake. The best of all is little Joe, in his long-legged nighties, standing on my kitchen stool and singing,

I dreanth that I was Gran'papa,
An' Gran'papa was me....

We all stand around ready to applaud as he sings, so seriously, delighting his mother with that "dreanth," which she hopes none of the older children will notice and correct. And then the half-wistful smile on his baby face....

"I want some bread," says Joe at dinner.

His father, thinking to teach him a lesson in politeness: "What else should you say?"

"Bread and butter," says Joe.

We thought that spring had come at last, but once again the cold winds blow and the snow falls. We had just heard the first meadow-lark, and it cheered us greatly. Charles, who is making a bird record at school, was delighted.

"And I heard a blackbird the other day," he exulted, "so now I have a blackbird and a meadow-lark for my bird dairy!"

(I smile. Charles, running a bird dairy, Greenwood Bird Butter, $1.00 a pound.)

I am writing today to the University of Idaho for a rooster. If I am successful, I want to send you some eggs. I believe with this new rooster you could use chicks from my eggs to put new blood in your flock next year. They would not be too nearly related.

Our chickens have been the best ever this winter. We have given them almost no attention—a little wheat when the snow covered the ground so that they could not forage for

themselves over the wheat-fields—and they have laid all winter. We could have sold eggs at ninety cents a dozen, but we believe the home table comes first, and while we will not buy anything we cannot, or do not, produce—good reason why!—what we do produce is first of all for ourselves. No oleo on our table, with butter and eggs sold to the grocer.

Our Christmas celebrations at the school-house were notable. Each child drew a name, and they bought simple presents for one another. These were hung on the Christmas tree, and a red and white Santa Claus distributed them. Eb Hall was generally requisitioned for this office. Like most Mormons, he had a glib public tongue, for all Mormons speak publicly, and judging by the length of their services, that, to the speakers, is the most pleasurable manifestation of their religion. Eb was such a fine, good man, I loved to hear his playful remarks as he passed out the gifts.

One year we had a seventeen-year-old Rumanian boy living with us. In the winter we had no need for a farm hand, but the Baron was always picking up people and bringing them home, his heart being easily touched by any need of another. Eli wanted education, and we gave him a home while he attended the rural school at the foot of our hill.

Every day when Eli came home, Charley would ask him what had happened at school. I might explain here that Eli was a substitute for a name to us entirely unpronounceable. "What happened at school today, Eli?" Charley would ask in his friendly way.

Eli would ponder between the first word and his completion of the sentence: "O-o-o-oh...Mr. Mavis, he talk outa de book" (sounded as in *spook*).

Day after day Charley would ask, and day after day Eli's education consisted of the observation that Mr. Mavis "talk outa de book." I think that there was an opportunity for opening the windows of a human soul, and Mr. Mavis failed to take it. I am sure he would have profited as much as Eli would have gained, had he troubled himself to give some personal instruction to that lonely Rumanian lad who had ambition enough to want to learn. But I forget that teachers are teaching for the money there is in it. And Mr. Mavis became so much more successful than we did, investing his salary in a farm that paid him a fortune.

The Christmas Eli was with us, he received the name of a boy to whom to give a present. The first occasion thereafter on which Charley went to town, Eli asked to be taken along, and out of his meager savings he bought the most gorgeous necktie in the stock of Longenberger and Belmont. This he wrapped in tissue-paper and red baby ribbon, according to my instructions as to the universal American custom. And on Christmas Eve there it hung so proudly on the Christmas tree, representing the generosity of Rumania in this land of the free.

There was always great excitement in the school-house on Christmas Eve, and any Christmas Eve might have been taken as representative of how things looked and smelled and sounded. Farm men were standing around the walls, and farm women crowded tightly into the school-children's seats, some wearing cheap new finery, but most of us in our outdated winter hats and dresses and coats. Babies, mostly fat, were hanging onto large bared breasts. Older children scurried, bright-eyed, up and down the aisles. Up in front was the Christmas tree, covered with cheap gifts.

I knew that Eli had his eyes fastened on that Christmas tree with more than joy in his own contribution. He, himself, was to receive his first American present. He would write about it, in his strange language, and send the account back to his parents, and his many brothers and sisters would chatter, telling how our boy got a Christmas-tree gift from an American child. It was...

Every nerve and muscle of the Rumanian lad was alert. The moment his name was called (he had adopted the one given him by Charley), he was out of his seat and down the aisle, his face alight with ecstatic anticipation. The box was so large that the attention of almost the entire assembled farming community followed him to his seat, and even thereafter, as with trembling fingers he untied the string and began casting aside the wrappings, being careful to dispose of them under the seat, so as to cause as little annoyance as possible.

The farm folks continued to look on as Eli continued unwrapping. Paper and string and box, and more paper and string, and more boxes. Some one had evidently hid a precious thing at

the core, a thing which must not risk loss in a smaller package.

At last Eli found it—something hard under his fingers, wrapped like his own gift, and also tied festively with red baby ribbon. Everybody watched intently. Eli laid aside the white tissue-paper. There in his joyously trembling, foreign, light-brown hand it lay...a common black collar button, such as are sent home from the laundry in the neckbands of men's shirts.

There were snickers, and some guffaws, and heads turned back, faces grinning, to answer questions of those too far way to see the prize in Eli's hand. And everyone there realized that a new joke was born, which would decorate many a threshing and haying table.

There was a certain Christmas Eve when little Joe sat, heart throbbing at each name, awaiting the package intended for him. Again farm men stood around the walls, and farm women squeezed into children's desks, fat babies tugging and mumbling restlessly at large bared breasts. Suspense. Eb Hall, in his kindly, playful voice, calling..."Georgie Hunter!...Mamie Stillton!...Alice Stillton!...Janie Curry!...Morgan Downs!...Morgan Downs!..."

Here comes Morgan Downs, running into the other children who are wriggling their way down the aisles, to open presents under the eyes of smiling parents. On and on the list is called by Eb, my heart growing a little tighter as the end appears to draw near, and still nothing for little Joe.

Children unwrapping gifts. More and more children unwrapping gifts. String, paper. Oh, look! Shining eyes, flushed cheeks. Little Joe watching, watching. Little Joe's mother watching, watching. When will Joe's name be called? This time?..."Emma Lou Jean!...Herbert Helms!...Katherine Pool!..." The list is finished. Not one more gift on the tree? Not one. Teacher is announcing that the program is over, and we thank you all for coming out tonight, and the children have done well...at least, we hope the parents will think so.

And no gift for little Joe. He had so carefully wrapped a box of two handkerchiefs for the little girl whose name he had drawn, and having a talent that way, he had drawn a picture on the outside of the wrapper, for little Joe, as his mother had done before him, always felt an urge to draw on any beautifully bare space. The hand-kerchiefs had been carefully selected from his mother's long-treasured store.

Outside the snow lies softly muffling everything, not cold, but intimately loving, under the light of the moon which seems somehow to belong to the Greenwood District; and there are gentle shadows lying in coulées and at the backs of snow-covered clumps of tobacco-weeds. The beaten road of milky glass curves down the hill like a strip of pale opal. The rest of the family talking together and walking together. Joe and his mother a little back of the others, both silent.

Mister comes dashing to meet the family, barking a joyful welcome, reinforced by Tag, plumey tail waving. The family are stamping the snow from their overshoes on the toothpick-pillared porch. Into the living-room, which now has linoleum on the floor, but there is a warm banked fire in the base-burner with its ugly nickel ornamentation, the designs for stoves evidently having been originated for the admiration of just the folks who admire them. Joe sitting down to take off his overshoes. His mother, who has been absent in the bedroom, kneeling beside him with extended hand.

"It's a knife with a chain," she tells him. "You wanted one...Aunt Hattie sent it, and you may have it tonight."

"No!...It's all right...I don't mind..." And that was Joe. And...Oh, God, I thank thee!...that was any of my four brave bairns, for many and many a time in their lives has each of them answered me, "It's all right...I don't mind..."

I am glad to tell you that this was not one of those enormous Calibanic jokes such as sometimes spring from the soil. The child who had drawn Joe's name was down with the measles, and because that child could not attend the Christmas celebration, his parents had never thought of the one for whom he should have bought. Little points of consideration such as that must be bred into folks through generations of good blood. No, I am wrong. I should say that it more often comes so, but Mrs. Curry would have remembered.

Little Charles, long before this time, had suffered a disappointment of a different

kind—that of thwarted artistic ambition, which cannot be answered with, "It's all right...I don't mind..." For we can all do without the material things if we are allowed to express such genius as lies within us.

Charles could draw, too. All my children have the talent for line and color, come down through the ancestry that decorated Windsor Castle and yearned to paint masterpieces on the side. There were a few artists, a few musicians, a few writers, a notable wrestler, mixed up with those pirates and ministers who have always warred within me, and no doubt go on warring within my offspring.

But what Charles loved best to do, and perhaps also his mother, was to speak in public. I had taught him to say,

Here I stand, fat, ragged and dirty...
If you try to kiss me, I'll run like a turkey.

And though he was really neither fat, ragged, nor dirty, standing there in his pale-blue checked rompers, with yellow curling hair and gray eyes and rosy dimpled cheeks, he was certainly kissable.

I well remember the night when he recited his little piece in the Primary Room. Our Literary crowd was not yet large enough to need the two rooms thrown together. Mrs. Benson, whose husband later fought across Rhoda's go-cart in jealous rage of her, recited "Curfew Shall Not Ring Tonight." It was right off the press, so far as that crowd was concerned, and pretty, fair-haired Mrs. Benson "throwed" herself into the part of the sweetheart, or the curfew bell, or something, so that we all sat listening with bulging eyes and open mouths. And such applause as we gave her as she sat down on the front seat, shaking, with beads of perspiration on her somewhat prominent forehead!

Next came a song by Babcock. Yes, actually, some one had persuaded ornery old Bab to sing, and that was one time all his endocrine glands were working harmoniously, the hormones going peacefully about their hormonious occasions. Can it be possible that inhibiting his desire to sing may have been at the bottom of his chronic grouch? He sang about thirteen verses concerning some ram of Derby with such gol-awful long wool....

Oh, the wool upon that ram, sir,...

And then the verses told what happened because of that long wool, ending with,

Now, maybe you don't believe me,
And maybe you think I lie,
But just go down to Derbytown,
And they'll tell you the same as I.

What a send-off we gave him! The young fellows stamped and whistled, and only the women with the bared breasts and the clutching, whimpering, gnawing infants...only those women of us all remained torpid.

Next, Mrs. Raine obliged on the harmonica. She placed a chair up front (there was no platform), and crossing a plump leg over a plump knee, she beat out the time of her tunes on the floor. Few sights were more interesting than that gray-haired farm woman in full swing, *um-huh-huhing* "After the Ball."

Then little yellow-haired Charles recited his:

Here I stand, fat, ragged and dirty...
If you try to kiss me, I'll run like a turkey.

Even Mrs. Raine got no greater applause than my delighted baby.

That was why his heart was so broken at the Christmas celebration following. Excitement. Farmers standing around the walls. Fat babies apparently wreaking cannibalistic intentions on quiescent mothers. Most of the light seeming to shine on the newly erected, rough, unpainted plank platform at the end of the Primary Room, and there on the platform stood smiling, amiable Miss Hartley, pretty and young, whom all the littlest children worshiped. She was their Teacher.

Suddenly baby Charles sensed that here again was opportunity for the artist within him to

116

express that inner soul of harmony, be it painting, writing, music.

> *And that one talent, which is death to hide,*
> *Lodged with me useless...*

I am not sure whether I have Milton's lines as they should be, but I know how that feels, and Charles, remembering his former triumph, also knew.

I was not aware that he had slipped away from me until I saw his aureole of yellow curls turned back, under Miss Hartley's elbow, to show his eager, raised face. I could hear his words as he tried, vainly, to pierce her preoccupation with the program, which was about to begin.

"*I* can speak a piece!" he was saying. "*I* can speak a piece!"

His father, thinking that Charles was bothering Miss Hartley, took great strides down the aisle and, seizing the little fellow from behind, lifted him into the seat beside me. There was a moment of devastating silence, in which a heart was broken. Then the baby pressed his yellow curls within the sympathetic circle of his mother's arm, sobbing over and over again, "I *can*...speak...a piece! I...*can*...speak...a...piece! I *can*...speak...a piece!"

Such little incidents are hard for me to bear. They go on being hard for me to bear every time I think of them. My Charles is a young man now, but I never cease to feel the bitter disappointment of that little fellow, cuddling under my arm and trying to find such consolation as he might in the knowledge that once he had been a success. That experience epitomizes so much of the tragedy I have seen in the lives of others—we will leave me out—and the worst of it is that those words really have no consolation in them, only a sharper defeat: "I *can*...speak...a...piece!...I *can*...speak...a piece!" You can, little fellow? Oh, yes! But it is lodged useless with you, for you may not. Fate has lifted you from behind and placed you where it is impossible.

WE HELD a murder trial in the school-house. There were real murders among the farmers, who sometimes killed each other or the ditch-riders over the water, but the murder of which I speak was imaginary. Yet we had just as enjoyable a time out of it as if it had been a real, sure-enough trial.

I was generally at the bottom of all these imaginary things that happened...or didn't happen...however you wish to state it. This time I supplied the broken-handled butcher knife with which the murder was committed, though, to tell the truth, that knife had been the bane of my existence, being so dull, and so recalcitrant to the grindstone by the granary, that it would not have murdered even a pound of soft butter.

I sacrificed one of my beet-seed towels, and I bled a hen I later stewed, letting the gore fall on towel and knife, while the fowl tried, in realistic victim fashion, to escape my criminal hands. Hen blood looks very interesting if a story is well started that somebody's wife has been murdered with a butcher knife and the gore mopped up with a towel.

Old Man Babcock was chosen to pose as the uxoricide. I chose him. I thought he ought to look guilty enough, since he stole our irrigation water every summer. And don't forget what a hit he always made singing about that Derby ram, for we had insisted on his repeating it at a meeting of the joint Granges and on several other occasions. It may have occurred to whoever seconded my choice that any one who could sing like that could commit murder.

That was one of the most exciting nights we ever had. Farmers came for miles to the trial, and the school-house, Upper Grades and Primary, was packed. They all got so worked up that they left their seats and crowded down to the front, standing on anything and craning around each others' necks in order to see the bloody towel and my mean old broken-handled butcher knife. I enjoyed it all immensely. I have known a great many people who needed a good beheading, and since my hands are tied, as you might say, I have to take it out in imagining murders.

Bab was acquitted, but he had always shown such a bad temper, and the crowd was so worked up, I was afraid they would take him out and string him up to the school-house windmill, just on general principles. Mrs. Babcock was present, or I don't know what might have happened. Folks kept looking at her as though they were trying to believe the sight of her against their very wills. I think most of them went home convinced by the bloody towel and the brokenhandled

117

butcher knife that old Bab had really murdered her and that they had just imagined her ghost.

It was Baldy Parsons who nearly failed my play, which I directed and leading-ladied to get a backdrop and new curtain for the platform. And it was Sam Curry who saved that play the night it was given before Frontier Grange. I did not write the play, although I have written seven very good plays, if any movie magnate should care to inquire about the same. This time I staged William Dean Howells' farce *The Sleeping Car*. I wrote our experience with it to Ellery Sedgwick, editor of the *Atlantic*, and he said that he was going to read the account to the author on his next visit. I never heard how Mr. Howells enjoyed it.

While the thing was happening, it was anything but a source of enjoyment to me, though I can recognize its points at this late date. I had showed the farmers how to build berths, which we covered with green curtains, and the result was supposed to look exactly like the interior of a Pullman sleeper. Since only two or three of us had ever been in a sleeper, this served the purpose very well.

Eb Hall was the Stranger. With money I received for a poem, I had sent away for a black beard for him, expecting, of course, to be reimbursed when the ticket money came in. There was to be another play of one act preceding *The Sleeping Car*, a play which some one else engineered and in which Eb Hall had a small part. If you have read *The Sleeping Car*, you will remember that the high spot in the play is the surprise of seeing a black-bearded visage thrust out from between the curtains of a lower berth just when you are expecting a baby to appear. That ridiculous man Eb Hall became so infatuated with the black beard that in spite of all I could do, he would not remove it for the first play, and in a kind of furious despair I had to witness his entrance as a minor character in that curtain-raiser, wearing the property I had been at such pains to procure for the surprise moment in *The Sleeping Car*.

But that was not all my woe in being director and leading lady of that play, given before Frontier Grange to get money for a curtain and some kind of backdrop, my long-time desires. Baldy Parsons had been stowed in an upper berth, from which he was supposed to poke his head, uttering a groan and the quotation from *Hamlet*, "*O my prophetic soul, my uncle!*"

The moment came, following my efforts to establish some sort of relationship to the bearded stranger, when Baldy was to make his sarcastic remark. Nothing happened. Baldy had fallen asleep, though he had been kind enough to leave his teeth in his mouth, ready for the utterance he was not uttering. I waited, dying in my tracks. At last, because the play depended on that cue, I had decided to make the speech myself, in an assumed voice, hoping some sudden gift of ventriloquism might be visited upon me, as the gift of tongues was bestowed upon the faithful on that historic pentecostal day.

Before I could do more than open my mouth, from the curtained-off side wing came the blast, "No, you can't git no ride on this here Pullman car, you big bum. Now, git right offen here, quick as the Lord'll let you, er I'll da-mighty near break yer ornery neck fer yuh, yuh big bum..."

I had opened my mouth, hoping to ventriloquize a few words, and my mouth remained open in astonishment. I *can* stand perfectly still, but the part I was playing was that of a woman who was never still, either in body or in tongue; yet there I stood, a pillar of salt, not even looking behind me. I recognized in the midst of my horror that Sam Curry had done his best to come to the rescue. He had felt that dreadful pause of Baldy Parsons, and he was vamping a tramp being thrown from a Pullman sleeper, where, I'll venture to say, no tramp in creation ever attempted to be.

Of course, Sam could not keep up that monologue forever, ingenious as he was. He was wearing the barber coat of his former trade, and his face was grease-painted a dark brown. He had wanted to make up with broad red lips and great white eyes, *à la* comic minstrel shows, and only my tears had prevented his wife from this consummation. Now I wondered if he would burst back on the stage, and whether we should have to vamp the rest of a play, or whether I should wake Baldy up, or what to do, when I heard Sam's voice, raised to top notch, suddenly declaiming, apropos of nothing at all except an effort to supply my cue, "*O my prophetic soul, my uncle!*"

The familiar words pierced the consciousness of the sleeping Baldy, and he bellowed an

echo that startled everyone, "O MY PROPHETIC SOUL, MY UNCLE!"

I had undergone such strain that I very nearly shrieked, "*O my prophetic soul, my uncle!*"

I did not really utter a word, though it might have been wise to have ended the play then and there; for I had some female enemies in the audience who were lying in wait for me, and the sooner I made my exit from any activity in the Frontier Grange, the more peaceful it would be for me.

I WAS BORN without a sense of money or of time. Until I married, I was a creature of eternity. I was practical enough to be able to pay back to my dear Cousin Joe the money he voluntarily lent me for my further college education, my father thinking that a Bachelor of Letters from a local educational institution was enough, and adding to this judgment the illogical statement that certain of his other children must have opportunities I wanted, though they did not, because I would learn anywhere. Except for conscientiously paying back that debt, I never thought of money, and I had equally no thought of time, horrifying folks with my last-minute catching of trains and other exhibitions of the sort, through which I passed unharmed in spite of their prophecies.

But I married a man whose father's middle name had been Punctuality, he being connected with a railroad, and my husband had either inherited this attribute in exaggerated form or had been so trained that he spent most of his life fretting while he waited on others. He always feared I would be late, but I never was. I became as sensitive on that score as ever he could be. During my years on the farm I developed a great exasperation over the unpunctuality of farmers in general. They had come into the world timed about an hour too slow. There is time enough for everything that is important enough to do if we put our minds to managing it.

Old Man Babcock was some sort of officer in the Grange while I was Lecturer. I used to hurry down to the school-house, not even waiting for the rest of my family, in order to open Grange at the time voted, for it seemed to me that the sagebrush folks always voted a set time so they could be sure of coming late. Bab also would get there early, on foot if necessary, leaving his wife to drive the team from the seat of the high wagon, bundled, like as not, in one of her husband's overcoats.

Of course, Jack Overdonk should have been there to open Grange, but he never was, still keeping banking hours, night as well as day. I do not mean that bankers would not be on time at Grange. I cannot imagine a successful banker not being punctual. In fact, I am so rabid on the subject of punctuality that I cannot imagine a successful human being who could ignore the exact time when a duty must be performed. But Jack got up in the morning so late that it threw his whole day out of gear, and since he was working only for himself, and there was no one to push him, he stayed out late. Besides, I have a secret suspicion that he never did take any of our sagebrush activities seriously.

Old Man Babcock and I used to build up the school-house fire, which had generally almost died out, and then we would push the benches into place to form the required stations for officers. After that, together, we patrolled the snowy starlit or moonlit road to requisition a quorum of seven with which we could open the Grange meeting. From which you will see that we took our jobs seriously. I am afraid I harbor intolerance for lukewarm people. I believe in doing everything with my whole heart. When I care for my flowers, there is no danger of their dying of drouth, but they may be drowned.

The next time Grange met after the two plays were given, I expected the pleasure of receiving half the money taken in at the door, so that I might buy a new curtain and a backdrop for our platform stage and reimburse myself for incidental things I had bought. I had publicly announced the plans for this project in Grange about six weeks before, and there had been no objections; and all my time possible had been spent on *The Sleeping Car* with that object in view. Everybody knew this. So when the Treasurer was requested to report how much money had been collected in precious nickels and dimes, I listened with pleased anticipation. I had so wanted a decent curtain and something to cover that everlasting row of windows on which we gazed every

time we came to the school-house for any form of entertainment.

To my utter astonishment, Worthy Master Overdonk asked the question, quite superfluous under the circumstances, "What is the pleasure of the Grange as to the disposition of the fund taken in by reason of the two plays?"

There is just a chance that Jack thought it necessary to say this, as a matter of form, but certainly he might have used some intelligent direction later. One of my best dislikers was on her feet at once, and the motion was made and seconded with such lightning rapidity and was acted upon by the Worthy Master in so brief a time, that I believe I cannot be blamed for suspecting that Jack Overdonk was not ignorant of what was to occur that night.

"I move you," said my best disliker, "that the money be used for an oyster supper, to be given at the next Grange meeting."

My second-best disliker seconded the motion. Worthy Master Overdonk, without comment, put the question. I was on my feet at once, my whole being one flame of indignation. I am not tactful under such circumstances. I stated the case, that the idea of giving *The Sleeping Car* was all my own, that I had trained the cast, that I had stated beforehand the reason why the play was to be given, and that there had been no objection. I most decidedly did object to seeing that money eaten in one evening.

When I was through, I looked to Worthy Master Overdonk for support. He had been our intimate companion, Charley's and mine, at every dinner I had cooked during the course of more than three months. I had thought he was my friend, as Eb Hall was my friend, and Ben Temple, and several other men in the district. I failed to take into consideration that Jack's wife was present, and I knew later what she thought of our friendship.

Without a single word in favor of what I had said, the Worthy Master put the question to a vote. And any time you put to a vote whether a big double roomful of farm folks will have a feed or will buy a curtain and backdrop, you may not know what the result will be, but I do. Something to eat! I had been defeated by the united sagebrush stomach. Not that any one there was in the least hungry, but they could not understand my desire, and they could understand the proposition that there be something to eat. *Thou settest a table for mine enemies in my presence, and they eat up the reward of my ambition.*

It was the most natural thing possible on the part of my women dislikers and on the part of the school-house mob. The shock came in realizing that it was also the most natural thing possible on the part of Jack Overdonk. I was so deeply wounded that I could not adjust myself at once to the discovery that he was not the person I had thought him. I should have been as trivial as he, had it been possible for me without pain to accept him at his lack of worth. I had to think him out first. Then I saw plainly the scarlet thread running throughout his life, which had meant disloyalty to others more important than I. Jack Overdonk was incapable of loyalty, absolute, to any one. He was a man who could never reach all of which he appeared capable, because he had not character enough to determine it. Loyalty is not the badge of little men.

But I thanked God for what had happened. I had lost my precious new curtain and the backdrop, but only by such disillusionment as I suffered in learning what Jack Overdonk's handsome face and ready wit really covered could I have been made aware of the danger that threatened me. Not that Jack had any designs upon my virtuous living, nor that I might actually have committed any foolish act; but I might have had something to bury in myself, thoughts, impulses, beyond anything that I have there entombed. There is enough, without adding the folly of fancying Jack Overdonk too much.

If this were my autobiography, a book that I shall never write, I would tell you what I have suffered through a heart too filled with the passion of life and living. And I shall never be burnt out. But I have learned that I was right in suffering rather than in seizing forbidden fruit, for the flame is still burning, purged, ready for a use more necessary. I speak in veiled terms. Only she who has so suffered can read.

I went to Grange the next week, helping Old Man Babcock to round up seven stragglers to form a quorum, acting as though nothing had happened. I did not hate my best disliker, my

second-best disliker, or any of my other dislikers. I am not a hater. I did not even hate Jack Overdonk. But something had happened to me. We did not leave the farm for a long time after that. But my spirit tore loose some of its roots. I think perhaps the tap-root was torn away.

There was oyster stew. And in order to punish the Baron and me and those who supported us, we were given canned cove oysters, while the rest had fresh oysters, ordered especially for the Grange meeting. Charley, who was usually so popular with those very women, was furious at the insult of cove oysters, long-time canned. I did not mind. They came as a kind of anti-climax, an amusing commentary on the sagebrush farm psyche.

I was not beyond their claws. Those women would hurt me again and again, sometimes with justice, sometimes not. But, at least, I understood them, and they never did understand me. And I loved them, and still do love them. I should include Jack Overdonk, but I have too much self-love to do more than scorn a man who had placed so slight a value upon my personality. You see I am not humble.

And so, as an uplifting factor, I had begun to lose out. Uplifters are silly nuisances. I did not consciously pose as one, but I always fancied myself leading the Tenth Crusade. Looking back, I could see that whatever I had accomplished had been sort of sneaked in when the sagebrush family of farmers were not looking. Though, indeed, the first farmers were perhaps more suggestible. I learned the lesson that only an outsider can act as a leader among farmers. Every farmer is suspicious of his neighbor.

I remember the first Fourth of July celebration I ever engineered. The farm folks asked me to do it. I took the job with pleasure, loving to do such work. I know now they gave it to me only because they did not want it themselves. And Mrs. Hubert, an estimable woman, more competent by far than I as a farm woman, firmly believed that I planned every game of that day in order that her little Willie should lose the prizes. She told Mrs. Parish, and Mrs. Parish told Mrs. Babcock, and Mrs. Babcock told Miss Butterworth, and Miss Butterworth told her brother, and her brother told Sam Curry, and Sam Curry told Charley, and the Baron, in that pleasing way husbands sometimes have, told me.

I just exclaimed, "Oh, for heaving's sake, Marier!" or some silly thing like that, and laughed so hard I had to sit right down on the kitchen floor. Charley was disgusted with me. I should have cared a little, at least, with a thing like that going all over the community about me.

That Fourth of July I had a grand time speaking the supposed speech of John Adams. It was misdirected energy, as so much of my energy was misdirected in those days, trying, as I did, to work off some of my superabundant spirits, entirely superfluous in a farm woman. As I stood there declaiming, my good sagebrush farm people stared at me as though hypnotized by a snake. They had not the least idea what I was trying to do. I'll say this for the Baron: that night he said, "You spoke wonderfully, Annie, but there was nobody there who knew it." And he said it in that pleasing way husbands sometimes have, which is more important than any John Adams speech, supposed or real, unless John Adams himself spoke a little speech like that to Abigail.

I was even less successful with "The Star-Spangled Banner," that bloody, *Gottstrafe* hymn of hate for England, which we United Staters have adopted as our national anthem, talking peace one minute, and the next minute screeching about bombs bursting in air and we-hope-they-kill-some-son-of-a-gun. If our united patriotic brains were jumbled together and shaken, there would be a sound like the seeds rattling in a gourd.

I am not making these remarks because of my jealous fury at not being able to sing "The Star-Spangled Banner." Nobody but a colortura soprano can sing "The Star-Spangled Banner," and she does not sing it; she just shows off, while everybody else stands in open-mouthed amazement, some of us thinking what a fine siren she would make on a fire-engine, and some of us wishing she would quit holding onto that note so the bloody war song would end and we could sit down. And only a hundred per cent pickled American could claim that standing up while somebody screeches a song about hatred for another country is any reasonable way of showing love and respect for one's own land. And now just let's see somebody try to intern me for that!

121

Of course, we could not have our Fourth of July celebration without screeching about bombs bursting in air, so I took my stand beside the Curry organ, which Sam Curry and Eb Hall had hauled down on a hay-rack the day before. Mrs. Curry, as usual, was the organist. The grown folks did not know the words, so they just stood and stared. The children and I carried out the patriotic project.

I like to sing, but I am a very low contralto. At least, my voice is. I had forgotten this when I attempted to lead the children. By the time we reached the bombs bursting in air, it was too high for the children, so they had sense enough to stop. That left me making a solo flight. It could not last. Finally, that high screeching note was just in view. I also stopped. I not only stopped, but as Mrs. Curry struck that note, I smiled at the farm people and pointed upward, where they could imagine the note to be. Then I did what in wartime would have caused me to be shot at daybreak, if not before. I burst out laughing. And, believe me, the whole double school-house room rocked with laughter, too. Everybody sat down in that ghastly, unpatriotic manner that proves you do not love your country, but think maybe there are other countries in the world, too, that might be permitted to draw a few breaths.

We had a pie-eating contest. This seems to me to be a thoroughly patriotic American contest, suitable for the Fourth of July. In fact, I think a piece of pie, or an ice-cream cone, would be far more appropriate for the United States emblem than the eagle, and either could stand the light of intelligent analysis better than our use of an old hate-filled war song for our national hymn.

The Baron circulated among the crowd, collecting small change to give the children for prizes. And little Willie didn't get a cent of it because Mrs. Greenwood arranged so he could not. But I told that before. Just as strange as the *strafe* Mrs. Greenwood had on little Willie, whom she did not know from any other of the towheads running about, was the fact that a transplanted city girl won the fifty cents offered for the young person eating the most pie. She was wearing a pretty, eyelet-embroidered white city dress, and she had been with us, she and her family, for only a few months. They remained about as much longer. But that day she won the pie-eating contest.

I think hardly any city person could have resisted entering that contest. The pies were most delectable. Mazie Taylor was so much faster than our born-and-bred farm children that in a second all they could see was the dust of her pie race. Time up! Mazie had won. Looking a little white, she received the fifty cents in view of the marveling farm folks. Mazie had swallowed three pies in about three minutes. Fairly grabbing the prize money, she turned and began running. She managed to reach the corner of the school-yard, and there, in full view of the silent crowd, who had never taken their eyes off her, up came the pie. We won't count her regurgitations, but all three pies came up.

OUR COMMUNITY shifted its population again and again. Charley and I stayed on, sharing with a few Mormons the distinction of being the oldest settlers in that part of Idaho. Our Mormons moved over to the other side of Hazelton, and I was left at the mercy of a strict, non-dancing, rural Mid-Western farming colony, the Arkansawyers not yet having the courage to start something themselves, but, being friendly folks, waiting invitations which failed to be given.

Sunday-school continued to be held in the school-house. There were two attempts to start the dances there again, both strictly nipped in the bud by the reigning Middle Westerners. The Sunday-school passed a resolution that there be no more dances in the school-house because "it is the house of God on the Sabbath." That last expression was incorporated in the resolution.

But, of course, at Grange or Literary or Sunday-school parties the young folks could play games. The games were all alike, except for a slight change of tune and words. The young folks took partners, swung them around, held hands, and sang loudly while they *clumpety-clump-clumped* around in a circle.

> *Chicken in the bread pan, pickin' up dough;*
> *Chicken in the bread pan, pickin' up dough;*
> *Chicken in the bread pan, pickin' up dough;*

Skip to my Lou, my darling!

Little red wagon and a harness, too;
Little red wagon and a harness, too;
Little red wagon and a harness, too;
Skip to my Lou, my darling!

Once Old Lady Babcock, looking like a man dressed in women's clothes, was tramping and stamping around the circle with the young folks, in that violent fashion which these Christian games seemed to find necessary, when her partner lost his grip on her hand, and she went sailing through the air, a hundred and eighty-five pounds, bang against the stove. The stove was not even dented.

I love to dance, but since that exercise was denied me by the prevailing standards, I would have been happy had I been asked to Skip-to-my-Lou, even though I were swung against the stove, or the ceiling, or out of the window. Nothing would have been too extreme for me. But nobody asked me.

Nobody thought about the children, either, so I tried to forget my unpopularity and provide some pleasure for the little ones. I had them stand in a circle, holding hands, and then I turned on the phonograph which I had so long ago secured for the school through the contributions of the farmers. I had chosen the children's-game record:

Here we go 'round the mulberry bush,
Mulberry bush,
Mulberry bush;
Here we go 'round the mulberry bush,
So early in the morning.

There was a sudden cessation of the *thumpety-thump-thumping* feet of the Christian gamesters, and there they all stood, looking reproachfully at me, while one of my best dislikers was *shushing* them and explaining in a piercing voice the quality of my crime. I had turned on the music. That made what they had been doing dancing. So long as they just sang, it was a game, but when I turned on the music, it turned the whole thing into dancing. I turned off the phonograph and went sadly home through the quiet moonlight, feeling very solitary as I took to the icy road. None of the rest of my family had gone with me because it was a Sunday-school party, and no one but me in my family ever went to Sunday-school.

The oyster supper pulled up my tap-root. The spirit of Skip-to-my-Lou alienated me still more. Developments in the Grange practically concluded my social life as a habit. Soon after the oysters Jack Overdonk moved from his farm. His heart never was with us. His heart was never anywhere. After the phonograph episode I no longer attended the Sunday-school parties, robbing my best dislikers of the excitement of my untoward behavior.

I had not been attending Grange for some time because my dues were behind. I never could get used to being in debt. I cannot bear to owe for anything. So it is not likely I shall ever be a successful business woman, for in business credit is money. And you cannot establish credit unless you owe somebody sometime, and then pay promptly, and then borrow again, keeping that up until they trust you so much you could skip out owing them if you wanted to, and you cannot, because your credit is good, and good credit is money, and nobody skips out and leaves money. And I think that is a pretty clear-headed business statement from a woman who has no business brains.

At my last attendance of the Grange it proved to be initiation night. I had always experienced it as an occasion of great dignity. I am hard to shock, but I was shocked that night. I practically knew the ritual by heart. We were never supposed to inject foreign matter into an initiation. Yet such things took place that night as filled me with horror. Today they fill me with smiles. And thus, if we but wait patiently, doth life strike the balance.

The candidates were blindfolded, and before my fascinated eyes I saw the Grange

members stretch a string in front of the unsuspecting initiates. It was just high enough to trip them, and it did. They were caught just in time, amid roars of laughter. I was roaring, but not with laughter. My roaring was silent.

Next, a girl was stationed beside each man and a man beside each woman. Candidates again blindfolded. A man stepped forward and kissed the men, and a woman kissed the women. The bandages were again removed. Laughter and shrieks. Terrible excitement at the thought that possibly the candidates had been kissed by a member of the opposite sex.

By this time Mrs. Smarty Know-It-All, who was also called Greenwood, for short, was seething as the volcanic cone which could be seen from her kitchen door must once have done. And then something happened to make her bomb go bursting in air with *Gottstrafe* explosion. As the candidates marched around the room, big, handsome Russ Stinett leaned forward and asked of one of them the password, which was obligingly given, the candidate not knowing that he had committed the unforgivable sin, not mentioned in the Scriptures. But Russ knew.

Said Worthy Master: "Is there any one present who knows any reason why this candidate should not be admitted a member of Frontier Grange?"

Russ stood up. "Yes, Worthy Master, I do. He gave me the password."

A shout of laughter rocked the building. As it was dying away, I stood on my feet, and I kept standing there until you could hear yourself breathe, it was so quiet. I knew my best dislikers were steeling themselves for whatever crime I was about to commit. I stood there glaring at them all for a full minute. They might steal my curtain-backdrop money from me, but none of them was going to rob the Grange of its dignity. The Lecturer's hour was the time for fun.

"Worthy Master," and my deep contralto voice was audible on the next farm, "if any one is thrown out of this Grange it should be Russ Stinett. He is a long-time member, and he knows the enormity of giving the password, yet I saw him ask this innocent candidate for the password."

Russ looked surprised. He had always liked me, and I had liked him. Hen Turner was Overseer. Now he rose to his feet, and since he was standing, and two of us could not be standing at the same time, and also because I had come to the end of my speech, but not to the end of my mad, I sat down.

"Worthy Master," said Hen, his ears standing out, even without benefit of cap, "in the Woodmen of the World we always do these tricks when we initiate candidates, and I can't see no harm..."

I was on my feet again, bombs shooting in the air. "Worthy Master, I should like to draw the Worthy Brother's attention to the fact that this is Frontier Grange, and not a meeting of the Woodmen of the World, and if he will communicate with the State Master of the Grange, or the National Master of all the Granges, he will soon be set right as to the appropriate ritual to perform when admitting candidates to the Grange."

A great and awful depression settled over the meeting. Mrs. Smarty had wet-blanketed the fun. Everybody sank into hibernation, or vegetation, or something equally animated. Simon Heminway had been conscientiously scratching away on a note-book. They had given him the job of Secretary of the Grange for the same reason they always made me programmer. And Simon had faithfully performed this office. Now he looked up calmly, having been so intent on duty that the fireworks had escaped him. He was standing up.

"Worthy Master," he said, "I would like to ask the Grange if I can have a table...just a home-made one will do...with a drawer in it...to hold my notes, and to write on. I certainly do need a table."

He sat down. He had served them faithfully through the terms of several Worthy Masters, as nobody wanted his office. Yet I knew from the hard, cold, indifferent attitude the Frontier Grange members now assumed that they had no intention of giving him a table. They did not like Simon Heminway. At times I wondered if some of them ever bit themselves, they were so indiscriminate in the way they spread their dislikes around.

Again I was on my feet, but not bursting any bombs to speak of. Considering that I owed my Grange dues, there is a possibility that I had no right to make a motion, but I did it, anyhow. "I

move that our worthy brother, Mr. Heminway, be given a plain pine table with a drawer in it."

I had to have a seconder. I meant to draw a second out of some one if I had to use a corkscrew. But there was no need. Gentle Mrs. Ike Helms, with her big, lovely dark eyes, ever my friend, now gave me that second, though she knew she was stressing before all those other women that she stood with unpopular Mrs. Greenwood. Worthy Master had to put the motion, and Simon got his table.

I went back up the snowy hill alone. I could hear the cars snorting as they warmed up for a start; the wagons clattering, while harness jangled. I had to be careful of the icy road, or I might slip and fall. The stars were little white holes in a ragged black mantle tenting the sky. As I walked through the farm gate, I could see below me the valley, lights yellowing in farm-houses as the folks reached them. None of these homes had been there when first I had confidently made my habitation on this hilltop.

For a moment I paused on the toothpick-pillared porch, looking down over the winter-bound farms. "I do not belong here," I was thinking. "I have never belonged here."

But I did belong there. We always belong where we are. Who was I, or even the National Master of all the Granges, to dictate what sort of Grange those good sagebrush people should have? If they wanted a Woodmen of the World Grange they should be allowed to have a Woodmen of the World Grange. They were having fun in their own way; it would keep them sane.

I could have shown my love for those people in so many kindly, tolerant ways. But I had not yet learned tolerance.

VI. OUTDOORS

The outdoor sports of us sagebrush folks generally led us away from our farms, though because of their great outdoor space and the fact that here was so much outdoor exercise, they might have been considered the sphere for outdoor sport. But when did man ever desire to get his sport on his own grounds? I shall never forget the sad disillusionment I experienced as a child when I discovered that the Sunday-school picnic at which I was really enjoying myself was only a short distance from my own home. We had met at the Congregational school-house and had gone in a body, through unfamiliar streets, to a small grove of native trees unknown to me. I was told I could buy candy at a little store not far away, and the little store proved to be Waters' store, where I always bought my candy.

In that farming community of southern Idaho, we played baseball in a natural amphitheater right beside the spillway where Charley Willey, the trustee, used to live. He was not living there any more. Will it be inappropriate if I relate here the tragic circumstances of Charley Willey's passing? He had been dancing with me in the big room over Dunn's store, where the Hazelton post-office lived. After taking me to my seat, he walked out into the hall—and fell dead. Charley Willey was as fine a man as I ever expect to know. I went to his funeral, though I hate funerals; I know I shall find some way of getting out of going to mine. Jack Overdonk's wife was there, and she would not speak to me. I wanted to say to her, "I don't blame you. But I am really innocent. Thank God and the oyster-stew women, especially the cove-oyster-stew women, that your husband did not help me to get my rights about that backdrop and the new curtain. If he had..."

But this is no place for the would-be illicit affairs of my life. I leave all such things to my Guardian Angel, and to the autobiography that will never be written.

BASEBALL beside the Willey spillway; rabbit drives everywhere, for the rabbits were everywhere; village and county fairs; and celebrations in conjunction with school doings. Oh, yes, and the movies! The movies came just before we left the farm, kicked off by the Federal Land Bank, like the rest of the city dream-farmers. But what I write about here occurred while we still believed ourselves likely to pull through, farmers and consumptives never giving up hope, though forced to give up everything else.

We farm people were always excited over the Hazelton Fair, and then again over the Jerome County Fair, which followed immediately afterward. All the prize-winning products were taken from the Hazelton Fair to the Jerome County Fair. My vegetables took some prizes, but for some reason, though not through my design, for I am far from being a shrinking violet, my products appeared labeled with Charley's name. Of course, it was a mistake.

For the sagebrush farm people knew that I raised an extraordinary garden. I sent to Burpee's in Philadelphia for my seeds, and I planted a great many of them in cigar-boxes which I begged from Hank Thorson, the druggist. These had to be crowded in the south bedroom windows day-times and carried to the kitchen night-times, while our bedroom windows were open. Tin cans, with the bottoms very nearly cut away, next received the sprouts. I had plants in bloom, some just fruiting, by the time the garden was ready for them. Upstairs harbored the plants until planting outdoors, and the mice and packrats nipped them off until I learned how to deal with them.

After my experience in failing to take the prize for my Golden Bantam corn, I never

126

entered anything again. I should not have minded if I had been beaten. I had raised perfect corn, and I looked the patch over for two ears, the entry required, that would be the exact counterpart of the illustration on the front cover of Burpee's catalogue. I found them, just a few inches long, every kernel as it should be, even to the end—plump, perfect ears. I should have adopted the stratagem of fastening them to the catalogue cover, right over the illustration, but the judges would not have believed their eyes. They were the kind of judges whose only criterion of excellence was giantism. They had not learned that vegetables have the equivalent of hyperactivity of the thyroid gland and that oversize is always at the expense of some other important attribute. The Golden Bantam corn that took the prize was at least a foot long, almost snow-white, a thin cob, kernels diminishing and disappearing at the end. It was certainly not the loss of the fifty cents prize-money that left me stunned. It was what this abysmally ignorant award implied of the people who had me at their mercy.

> *Oh the years we waste and the tears we waste,*
> *And the work of our head and hand,*
> *Belong to the people who did not know,*
> *And now we know that they never could know,*
> *And never could understand!*

Moral: Never be a specialist in truck-gardening when the judges of your products are village Babbitts.

But there I do the Hazelton men injustice. There was not a farmer in the Greenwood District who would not have made the award as it was made. At least I think I should have received an award of a tin spoon for being the only person in that part of Idaho who really knew how Golden Bantam corn should look. If I wrong some other Golden Bantam expert at present unknown to me, I will gladly share half of the tin spoon that I did not get with him or her upon receipt of proof, which shall be two perfect ears of Golden Bantam corn tied with green baby ribbon to the illustrated cover of one of Burpee's catalogues.

127

CABBAGES WERE OUR FIRST CROP

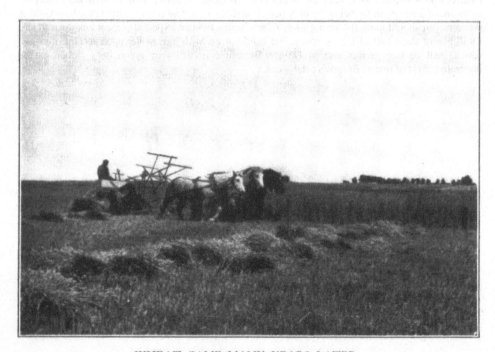

WHEAT CAME MANY YEARS LATER

The Baron was expert at nearly everything he tried to do. I suppose he would claim

potatoes, too, but my memory of paring stinking potatoes afflicted with black rot makes me stubbornly refuse him an award there. A United States Government man, what his office may have been I have forgotten now, judged Charley's spectacular stand of wheat as the finest in the State of Idaho. Charley had been willing to make the experiment of raising a certain kind of wheat which the Government was anxious to introduce to the Western farmers. When he told me what the Government man had said, I went out and stood on the brow of the hill, looking toward the volcanic cone and the white Sawtooth Mountains. There were acres of the most beautiful grain, waving its ripening heads in the breeze. My heart swelled at sight of it. Glory! Glory! for the beauty of it. Glory! Glory! for the use of it. Glory! Glory! for a perfect thing rewarding the long toil of my farmer's days.

The next morning I was too busy to look out-of-doors. The Baron was gone about a half-hour after breakfast. Then he came back. "Look," he said in a low voice, drawing me outside the kitchen door. I looked. I looked at the volcanic cone, standing black in the middle distance. I looked at the white Sawtooth Mountains, like a row of tents. I looked..."*Charley! where is your wheat?*'

"Flat as the pavement of Hell," he answered.

"Flat!"

"Rust got it in the night. Total loss."

The ignorant farmer thinks rust is the result of too much dew. As a matter of fact, the wheat did look rusty, but that appearance was caused by a fungus which came from weeds along the ditch bank. Little was known of its nature or habits at the time our wheat was laid low. But such wheat cannot be used by man or by beast.

Charley's sugar-beets were perfect. There were years when the white fly got the crop, but the year I lost the Golden Bantam prize his sugar-beets were perfect. They should have been, for if I knew how to raise Golden Bantam, he certainly knew how to raise sugar-beets. His beets were the product of knowledge, of science. For seven years he had worked for the million-dollar sugar-factory in Garden City, Kansas, where I made my home in the midst of a remnant of that colony which Queen Catherine of Russia had transplanted to teach her people the agricultural trade those Germans had known for generations. The United States Sugar and Land Company had imported a portion of this colony to raise beets for the million-dollar factory. So while I was becoming acquainted with a mixed dialect known as Russian-German, having acquired enough college German to understand these people fairly readily, the Baron was the center of their worship, speaking, as he already did, fluent German.

Charley was German only in so far as we call the Prussians German. His ancestors were the ruling Junkers, as I think I have said before, and a German baron was his great-grandfather. He might have passed for a handsomer Premier Göring, there being an uncanny reproduction of the chin and mouth. We had many French at the sugar-factory, speaking that dainty, lacy language which has always been most easy for me to read, but most difficult for me to understand when spoken rapidly. French, English, German, we lived together in more or less amity. The French were our chemists, the Germans our practical beet-raisers, the English our bookkeepers and managers.

There was no one there more worshiped by the Russian-Germans than Charley, who had a grandmother speaking almost no English. When my Walter was born, they made it a festival, presenting me with their precious hand-woven linens and bringing a platter on which reposed in splendor a whole boiled hen surrounded by little round dumpfnoodles, these edibles always being given to a new-made mother, as the Russian-Germans informed me.

So Charley should have known his sugar-beets, for he was familiar with every phase of the sugar business, from buying the right seed to sacking the refined white sugar. In Idaho the white fly got our beet-fields during the final years of our farming there, and before we left the farm, an expert in beet-culture told me there was a fortune awaiting the man who knew how to exterminate it. Before the white fly, nobody could raise sugar-beets that compared with Charley's. After the white fly only a fool would attempt to raise them. In our whole district there were no such fools.

The year before the white fly came, the Utah-Idaho Sugar Company offered two prizes at

129

the Jerome County Fair, each a hundred-pound sack of sugar. It was the year my carrots, under Charley's name, took the prize at Hazelton. I don't know how the judges ever made such a mistake as to give them a prize. I thought those carrots were all right.

One of the two hundred-pound sacks of sugar was for the best essay on sugar-beet raising; the other was for the best sugar-beets. I thought it was the only logical result that the man who knew best how to raise sugar-beets should receive both prizes. If he took no prize for his beets, his essay was proved worthless, even if he won a prize for the essay; if he took the prize for his beets and could not explain how he had done it, then the prize was awarded for an accidental accomplishment, a thing to marvel at, but not to admire.

Most men need a good laughing-nagging wife. I do not think a laughing wife is to be sniffed at, but a nagging wife who does not laugh is an abomination on the earth, who should have her endocrine glands taken out on a dissecting table and reconditioned. But what a laughing-nagging wife can accomplish with her husband is most astonishing. I do not claim to be this gifted creature, except in spots, though the laughing part fits me only too well to please everybody.

I told the Baron that those two prizes belonged to us. He had two afflictions which were not mine—or perhaps others would call them virtues. He cared nothing for competing, even when he was sure of winning, and he and his whole family abhorred any sort of publicity. When my *Atlantic* articles were published, Charley went to Hazelton and bought every copy, so that his neighbors should not see him glorified in print. I have no such inhibitions. I have been in many contests, but only when I knew I could win—including, of course, the Golden Bantam fifty cents prize-money. I was sure of winning that, and I think I shall never get over the disappointment. As for publicity, I never realize that I have caused any. When folks stare at me, I always wonder if I have managed to get smut on my nose.

Charley did not care about winning those two sugar prizes, but I did. I didn't give a Golden Bantam corn judge for the glory of the blue ribbons, but I did want that sugar. Think of getting two hundred-pound sacks of sugar so easily! I have a very estimable sister-in-law who thought the only art I exhibited in getting my articles accepted by high-brow Eastern magazines was the marketing art. "Annie seems to know how to commercialize what she writes," came the slightly off-odor praise. I fumigated the letter until I could get over my mad. A sister-of-the-blood wrote to say that a friend of hers who aspired to authorship wanted to know how I managed to break into the *Atlantic*. I wrote back that I took an ax.

The more I think of my sister-in-law's sister-in-lawsy praise, the better I like it. When we get a thing to the point where folks will part with good money to possess it, we have done something. So I wanted Charley to commercialize his brains and ability by winning those two sacks of sugar. And besides, as I said before, I wanted the sugar.

So I talked to him very gently until he reached the stage of a towering Premier Göring Junker rage, of which he is entirely capable, and I never let up until he threw his *Saturday Evening Post* across the room, swore at me, jumped to his feet with a great thump, strode with mighty strides across the linoleum of the living-room, across the bare boards of the kitchen, and banged to with a vicious bang the kitchen screen, where forty million flies thought they could not be wrong in expecting to get in at about that time, and they were not wrong. I smiled, and humming

 We'll have a little nest,
 Away out in the West,
 And let the rest of the world go by.

I inserted a clean sheet of manuscript paper in the eager mouth of the heavy old typewriter which understood me so well. Then I waited.

I knew he would come back. If he had not sworn at me, he would have remained out in the field, getting madder and madder. But the memory of those cuss words stirred up his sleeping censor, the miserable creature that Freud discovered using the conscience for a sheepskin. He got sorrier and sorrier the more he worked on the water, particularly since that was one day Baldy Parsons and Old Man Babcock were not stealing it. If the water had not been coming down, he

would have forgotten me, or maybe blamed me, sub-consciously, for his water trouble, when nagging was my only fault.

He kept thinking what a good wife I was, so innocent and so little and so frail (I had worked like a horse that day), and pretty soon he was on the verge of breaking into mental tears, in the way all Germans do when they are away from you and have wronged you so they know it. Often they wrong you and do not know it, in the good old way of all Germans, particularly Prussians, in respect of women. I understand the famous Henry L. Mencken is an exception, but not with me, for he detests me. He once did me the honor of a long hand-written rejection. I made out the word "rotten," though it might have been "mutton." I sent the letter back and in my politest manner asked for a translation. I know it is hard for you to believe, but he never answered. And I had always admired him so much.

So back slipped the Baron from the field, as I knew he would, and he was in his charming mood, when even Fu Manchu would follow him around like another Limpy. He had brought the reinforcement of Rhoda and Joe, just in case I should be in a beheading mood, of which I am entirely capable. "Oh! Smocky," I heard him say to Rhoda, "see the cinnamon rolls Mama has made. U-u-um!...the good smell of her bread! That womern shore kin bake bread like nobody's business. Where are you, Mama? Jodie has brought you something."

I could sulk, and think how I hated tobacco-chewing in a man, and if I had known when I married him...But I wanted those two sacks of sugar. The way to get what you want in life is to keep your eye on the objective and let nothing swerve you. I could enjoy my dignity and come up short two big sacks of sugar. Not I!

Softly I went into the kitchen, with one of those bewitching smiles on my face that you are sure I can smile, and I can, and there stood before me something more bewitching even than my wonderful smile. Charley, a child on either side of him, had a big branch of native willow erected over his head, like...was it Macduff's army that advanced on the castle where was the murderer Macbeth?...and in the arms of Smocky and Jodie were great clumps of wild goldenrod, which Charley knew I loved so well. And just as I entered the kitchen, Charley was saying, as he looked up at the bough drooping over his head, "I hear the little birdies singing in their nests," and both those ridiculous babies were also looking up at the bough growing out of their father's back, expectation written touchingly on their sweet, serious faces.

It was lovely. Besides, I knew now I was going to get my sugar. I took a crock which held water-glassed eggs in the winter and put into it the beautiful clumps of goldenrod; and I pretended that I did not see the Baron self-consciously slip into the chair in front of the typewriter, still wearing the Macduff disguise, by reason of which, of course, he was not supposed to be running the typewriter. I pretended that he was really a young tree which had suddenly rooted itself in the living-room, and I went about my destined business of piling cinnamon rolls on a clean plate and, ghost-like, passing them among the three so quietly sitting in the living-room. *Click-click-clickity-clickity-click*...I would get my sugar. Oliver Wendell Holmes says there are some words even in a good man that no one should stir up. Little he knew of their ultimate use.

I canned three hundred quarts of fruit that year. The Baron and young Charles and Walter, in a sheep-wagon which some one had left with us, went over Twin Falls way and bought fruit for very little money, picking it themselves. The Twin Falls country was twenty-eight or thirty miles west of us, but it had been settled about twelve years before Charley and I came to our farm. In fact, we were, as I have said before, the last frontiersmen of the United States. Never again can there be what we were, the radio having tied all mankind together in what is called civilization.

Twin Falls country should have a word here, for while we struggled, and there was much poverty among us, the Twin Falls farmers were prosperous, the little city of Twin Falls an ideal town, its public library the best I have yet found in the West. Large income from taxes made possible the purchase of the modern books of philosophy, psychology, and other nonfiction classes of which I am a dipsomaniac.

Every time I went upstairs to get sugar out of one of those prize sacks Charley won from

the sugar company, I used to stand at one of the little upstairs windows and look out upon the lovely acres of our farm—yellow where ripening grain stood, emerald where alfalfa ran, all the other crops with their coloring shading from ivory to vivid green. I thought of when I was a little girl, reading my geography book. "Volcanoes are mountains erupting ashes and molten rock known as lava," the geography said. It did not tell of a more important thing that comes from volcanoes, for in that day nobody knew that crops, the most wonderful crops, come from them.

All those fertile farms are fertile because of volcanic ash. And there were those fine crops because Volcanic Ash had been married to Maeterlinck's Fairy Water. The Jackson Lake Reservoir, located away up south of Yellowstone Park, held our water, its capacity being eight hundred and forty-seven thousand acre-feet. It was supposed to solve the water problem, but it did not; only about one-fifth of the drainage of the Snake River watershed was above this reservoir, so that four-fifths of all the run-off from this great drainage basin went on to the ocean. It was found that there were years when the run-off of the watershed above the reservoir was not sufficient to fill it. So that even with Milner Dam and considerable supplementary storage capacity, in extreme drouth years the Jackson Lake Reservoir did not suffice.

That was why they were building the American Falls Reservoir, with a capacity of seventeen hundred thousand acre-feet. Heading all this, I knew, was Russell E. Shepherd, who was called by the whole countryside, complimentary of his power and ability, the Old Man, though he was not an old man, but handsome, alert, prematurely white-haired. The name Shepherd was constantly on the lips of every irrigation farmer, and to leave him out of this chronicle, when it was he who brought us the Fairy Water and wedded her to Volcanic Ash, would be to leave the sun out of the summer sky. Crops from volcanoes—the lovely, flowing acres of green where only sage had been when we came! Crops from volcanoes!

BESIDES our Hazelton Fair and the Jerome County Fair we had the celebrations accompanying all school events. One year the schools of Eden, Hazelton, and Greenwood joined in giving an ice-cream festival to the school-children. The trustees announced, with swelling pride, that our school-children would be given all the ice-cream they could hold.

Our Jodie went around thrilling with the excitement of anticipation. He had never had all the ice-cream he could hold. On this happy day he meant to make that vacuum a thing of the past. He scrubbed his ears and neck until they were almost raw, and he blacked and blacked his shoes, trying to see if a higher luster might not be produced. All the way to Hazelton he hugged the dog Mister in his arms, and I could see that he was thinking happy thoughts.

His first mistake was not getting into line at once. He waited for the end of the line to reach him as he stood midway. When he realized that the tail was getting longer instead of shorter, as some of the first to be served hastened into place again, he finally got in line.

The local butcher was helping to serve. He did not know Joe, but he did know the little boy just back of Joe. He had given Joe the last scoopful out of the last freezer over which he was custodian. There it stood upon Jodie's plate in creamy lusciousness, and as Joe looked at it, his mouth watered. He had been too excited to eat much breakfast.

And then the butcher said, "Wait a minute! There is some better ice-cream over there in that freezer where that lady is dishing up. Here! You give your cream to this little boy, and go over there and get some more from that lady."

With one sweep of his scoop the butcher passed the ice-cream on Joe's plate to the plate of the little boy behind him. And there was Joe with nothing but a smear of cream across his paper plate.

But Joe was a mild little fellow. I never heard him say a mean thing about any one in his life. He always believes everybody's intention is for the best. So he took his dish hopefully over to the other line, getting in at the very tail, to begin all over again, standing patiently in the sun which beat down like a hammer that has been in contact with white-hot iron; and he moved by inches, slowly forward, until at last he could lift his dish expectantly to the flushed lady who was dishing out the ice-cream. One glance at his smeared plate was enough. "Go on away, little boy!" she

132

exclaimed indignantly, before the whole gaping crowd, who looked at Joe as though he were too vile to exist. "You can't have any more," she yelled.

"I ain't had any yet," said little Joe timidly, never believing that she would refuse him.

"Yes, you have!" she cried in outrage. "You can't lie to me. I can see the smears on your plate." And she cast that look of triumphant shrewdness around the crowd.

Joe, not being combative or a whiner, retired, to slip his permanently empty plate into a dry, weedy ditch. Out of those hundreds of children he was the only one that did not get any ice-cream. But more surprising, I think, is the fact that he did not tell me until he was going to bed, and then very quietly, with that dignity so pathetic in a little child. Our children never asked for money because they knew what a hard struggle we were having. I knew they did not ask, but the reason I did not know until after they were grown, when they confessed to me. My darling children!

But there were happy times for little Joe and the rest of our children when we rode to Hazelton or Eden to an occasional picture-show, the dog Mister coming along with us and guarding Sagebrush Liz as ferociously as though he were a pure-bred Airedale, instead of a cheap copy. I had taught him to walk on his hind legs. I believe that only a little patience would have been required to teach him anything. He loved us so, and he was so intelligent.

In both the picture-houses, Eden's and Hazelton's, camp-chairs and kitchen chairs were used. Hazelton's movie palace was in a former place of business, and here the shows were hardest for me to bear because the pianist thought that the prime necessity was noise. She could chord the most frightful chording I ever heard. And she did not do more because nothing could be worse, and the worst was not too good for her.

Hazelton possessed a stronger reek of barnyard manure, and there may have been Forgotten Men there, but it smelled to me more like forgotten baths. Perhaps it was just that the ventilation was better at the Eden house, for many of the same farmers frequented both. I recall the pictures I saw in those places to the accompaniment of the heavy, stifling odor of cow fertilizer and well-ripened sweat.

The Eden house had two tunes, which were played on the piano and on a drum. Or perhaps the drummer just went along with the tune. One of the tunes was for all the sad parts, and the other for all the gay parts. I like to remember when the gum-chewing pianist had an absent-minded spell and played the sad and glad tunes at the wrong places.

I have mentioned that we had our baseball team, and I mean to tell you more about that later. But the rabbit-drive was probably our most distinctive outdoor sport, a sport which will be lost to the world in the not far future.

It is not hard for me to recall these events. As I think of them, I get the feel of the quiet summer evening settling down on our farms.

I wash the dishes and tidy the kitchen while I hear Charley's whistling gradually receding toward the land called the gooseneck, where he is on his way to look over his water sets. A short distance behind him tag Rhoda and little Joe, together with the two dogs, Mister and Blackie. I can overhear the conversation in the next room. Charles, aged fourteen, is saying to his brother, aged seventeen, "You take care of the hogs, and I will milk the cow, and we can still have time for a game of golf." Then the boys come into the kitchen, Charles seizes the milk pail, and they both leave.

Their golf-course is laid out between the barn, the granary, and the hog-pens. There are plenty of hazards in the shape of wagons, sagebrush-pile, coal-pile, and miscellaneous farm machinery. The golf-clubs have been cut from the poplar-trees that cast a long line of shade at the west of the house. Walter has recently been at Pocatello for a year at the Technical Institute, paring potatoes in restaurants, firing furnaces, sweeping out stores, and doing anything to work his way while he studied. How he ever had time to be interested in golf, I cannot imagine, but he appears to have returned with a full knowledge of the game and the enthusiasm of a veteran. Golf has been played under many conditions and on many courses, but I doubt if any was ever more peculiar than this one, laid out in the barnyard of a pioneer sagebrush farm, the participants two farm boys fresh

from slopping hogs and milking cows.

In a few minutes Charles comes in with the milk, which I strain into crocks through a clean, scalded cheese-cloth. Down the steps of the dirt cellar outside I carry these crocks, one at a time, running up and going slowly down—and remembering the time when I stumbled on the top step, fell, broke the crock, sent the cream and milk all over the ground and me, and cut a painful wound on one knee.

With tin lids I carefully cover the crocks, ignoring the shocked admonition of every farm woman who ever saw me do it. They always declared that the cream would not rise if I kept the crocks covered. They would not believe me when I told them that nothing but a God-miracle could keep cream from rising if milk is left undisturbed in a cool place. Cream to them meant a heavy, leathery scum, like stretched skin, instead of the deep, soft, yellow film that my milk raised under those lids.

By the time the milk is in the cellar, the Baron has come back with the dogs and children, and the two boys are absorbed in their game of golf. Charley, the two younger children, Mister, and I get into Sagebrush Liz, which always looks patiently dilapidated, like an ancient spinster in an old sunbonnet. Instead of cranking her, Charley pulls her from the gate to the bridge where the canal crosses the road and then hoists himself into the front seat just as she glides downward like a dipping gull. At such moments Sagebrush Liz is a queen of grace. Most of us may exhibit some trait of the more gifted, be the circumstances propitious. Say what you will, there is a certain amount of luck in every success.

On this Idaho summer evening, it is remarkable that no breeze is blowing, for no matter how still the day, we almost always have the cooling zephyr that welcomes the night. This stillness gives me a curious feeling of lack, and a faint apprehension, as though there were something about which I should be worrying or rejoicing, I cannot decide which.

Skeleton Butte lies like a black, mourning figure to the east, with rosy clouds, like banners, stretched above its prone length. I am reminded of how this butte came by its name. A valuable horse was stolen, and the owner, with a friend, traced the thief to this hill. He sent a bullet through the outlaw's head, retrieving his own horse and also taking the thief's horse by way of interest. A year later the horsethief's skeleton was found where he had fallen, a friend stumbling upon it and identifying it by the watch lying along with the ribs, which the murderer had thoughtlessly overlooked—or perhaps he drew the line at picking pockets. From that day to this the long black knoll has been called Skeleton Butte, an impressive monument to a horsethief.

We decide to turn east, and we find a road upon which the county is evidently beginning some sort of grading. There are deep ruts in the heavy dust, and Sagebrush Liz, whose mood has been so buoyant on account of gliding down that hill like a gull, finds now that, after all, she is not the gifted creature she had imagined. She bucks the terrible road as nobly as possible, but finally, with breaking heart—I heard it thump—and dragging neck—it looked so to me from my seat in the back—she gives it up. Charley is forced to get out, as she wheezes the last breath out of her lungs. He gives the old girl new courage by cranking her up, we turn back, and dodging through clumps of sagebrush, where Lizzie feels more at home, we avoid the bad road until we come to a better.

We pass a two-room tar-paper shack. This is the home of Many-Children Brown, the man who has actually lost his Christian name, so far as we are concerned, because of the one distinguishing fact in his otherwise perfectly blank existence. Where his family sleep is one of those unsolved mysteries, along with light and electricity. It is said that Mrs. Many-Children Brown never bothers about counting noses to see if all are home safe at night. She knows they will all turn up at breakfast. The only thing that worries her is whether there will be enough breakfast to go around.

Jack-rabbits scurry ahead of Liz, and I think of how the food problem was partly solved during our first summer on our pioneer farm. Rabbit pie, with little biscuits for crusts, and fried Mollie Cottontail. Sagebrush Liz groans, puffs, her heart thumps like to burst, and I expect any minute to see her turn her headlights back to look reproachfully at us. Up a hideous hill we climb,

134

Lizzie digging her nails into the dreadful ruts and snorting like a dragon. Inch by inch we are making it.

At the top of the hill is the Brooke ranch, and in front of the ranch shack are the parked cars. We remember that there is to be a rabbit-drive here, and as we are about to pass, we are intercepted by a long, irregular procession of men and boys, carrying clubs, which debouches from the gate leading into an alfalfa-field. They look tired, and their overalls are wet to the knees, from running through the soaked alfalfa which has retained the moisture from the light shower of the afternoon. Most of them, we observe, are Arkansawyers.

There are about two hundred of these men and boys, and behind them come the women, who have taken no active part in the drive except to cheer, but they too look bedraggled. In the arms of nearly every woman is a baby. No wonder the women look tired, for they must have walked, carrying their burdens of heavy infants, for nearly a mile. But tired though they be, there is the glow of health in their faces, and their freshly abbreviated skirts give evidence of an attempt at keeping up with the styles, even out here in the sagebrush.

There is an air of anticipation which requires explanation. The night before, Dan Jean had introduced an innovation which means an epoch in the history of rabbit-driving. Dan had announced a rabbit-drive, and nobody had come. Being shrewd, he pondered on human nature, and soon after this he announced another rabbit-drive, at which free ice-cream cones would be distributed. It is one of the remarkable idiosyncrasies of the human race that you could not hire a man to ride several miles to the edge of the desert, there to struggle through acres of growing stuff, throwing clubs, for a distance of perhaps two miles during about two hours time, all for a matter of fifteen or so cents. Yet he will do this identical thing, for a man to whom he is indifferent, the bait being of the order of three ice-cream cones, if he gets even that many.

This refreshment having once been introduced as part of a rabbit-drive, never again can it be omitted. Besides, as we sit waiting for the procession of solemn, glowing, sunburnt, soaked Arkansawyers to pass patient Liz so that we may possess the road again, I remember that it had been whispered about that Dan Jean's ice-cream was to suffer eclipse. There would be not only ice-cream, but something more invigorating would be passed around freely. We were living in a country where the law might be no respecter of persons, though I have my doubts, but there could be no doubt that persons were no respecters of the law.

Since we have not murdered a single bunny, we cannot have the face to hang around, hoping for a cone—or something that warms you up instead of cooling you down. We therefore start off, only to discover that our boy Joe is missing. Trust Joe for smelling out where the ice-cream may be. Rhoda is despatched to retrieve him before he can disgrace the family by accepting a cone. Joe stows himself in the car, very downcast during the necessary scolding. I cannot help feeling a little sympathy for him. It is a fearful trial to be dragged away from any spot where ice-cream cones are about to be given away. Such events make up the tragedy of childhood.

We continue to the east through miles of sagebrush. It is growing deeply dusk, and the lights of Sagebrush Liz refuse to work. She seems to have used up all her energy in pulling up that ghastly hill, when she dug her claws in the ruts and snorted like a dragon. It is like adding insult to injury to expect her to show a lively glow after having been given such exhausting drudgery. It would be like making a poet cook the breakfast and then demanding of her a poem, after she had burnt the bacon and her fingers too. I never thought of Sagebrush Liz as temperamental, but that must be the reason she refuses to light up.

We turn a delicious curve and start on the road for home. It is cool—cool almost to shivering, but as calm as a sleeping babe. The sage is black blots on a background almost as dark. Then we see the canal. There is something spiritually beautiful about placid water. It gathers unto itself every bit of light and color of the sky, and it lies there smiling, like a lovely woman dreaming, awake, of her lover. It always grips my heart to see water like that. There is some ecstasy of which I am capable that I have never experienced, and perhaps never may experience, and placid water reminds me of it, without revealing what it might be. It is, even so, though it lack fulfilment, a

135

beauty almost too great to be borne.

Almost five miles to the farm-house with the toothpick-pillared porch. When we arrive there, we see from our hill that the cars are just leaving the Brooke ranch. They move like fireflies over the darkness of the valley, and there is the peculiar sweet smell, which no city can boast, of a late summer evening among the sagebrush farms. Within the farm-house Walter and Charles are playing the phonograph. I forget to ask them who won the golf game. Little Joe is begging to sleep with his mother as a special treat. Thinking of the ice-cream cone that he did not get, I make the arrangement.

My bed is placed so that, as it were, I may have my head out of the window. This night Joe thinks he would like to sleep next to the screen. I allow him to do so. We both listen drowsily for a few moments to the phonograph in the next room playing "Crying for You." I do not hear the last of it, for I am asleep, little Joe wrapped in my arms.

I awake once in the night and see the stars shining as though their whole object is to look down into my window. Stars! What am I doing here in this farm-house, so far from the life I meant to live? Foolish woman!...remembering the ice-cream cone you might have had.

BUT THERE WERE rabbit-drives whose conclusions were not so wistful. There was one pulled off, as we sagebrush folks expressed it, by Hen Turner, whose rented farm was close to the little gasoline railroad, next to the desert which was as unchanged as when the Shoshone roamed its reaches.

It is nearly six o'clock on the Idaho sagebrush farm, and a good many other places, too, I suppose. "Hurry and get the supper on the table, Mom. Hen Turner is to have a rabbit-drive, and there is to be five gallons of ice-cream." Nothing is said to me about anything stronger that will be circulating, because I am not supposed to be interested in such things. And, indeed, the idea seems very tame to me. I came from hard-drinking ancestors, and alcohol is practically water to me. When the men go slinking and slipping around, winking at each other, with a furtive hand on hip, I regard them scornfully. They think they are keeping something from me. Well, let them. I don't need it, and never did. It is all I can do to keep my feet on the earth as it is. And anyhow it would take a quart to their cup even to faze me, the poor, little, snivelling, would-be naughty men. I am almost immune to alcohol, but you should see my reprehensible carryings-on when I get a couple of cups of good coffee in me.

I have the supper ready in a short time, and in less time than that we are speeding toward the north, up and down the sweeping hills of the road, toward the Jerome Canal bridge that crosses near Hen's farm—not the part of Jerome Canal to be seen from our farm. Sagebrush Liz is at her best, taking the road like a bird. "Doesn't she go fine?" brags Charley. The man with an expensive car cannot possibly be as proud of it as the man with a flivver. You expect something of a car in which thousands of dollars are sunk, but when only hundreds have been invested, every perfect action has a peculiar grace. Such a car is a member of the family, to be petted, loved, defended. It comes nearest to taking the domestic place of the vanishing beloved horse.

We pass out onto the desert road, where on one hand is Hen Turner's rented farm, which has been cropped short by rabbits, and, on the other, the limitless sagebrush and lava rock. And on the farm, as well as among the clumps of sagebrush, the rabbits rush toward us, and away from us, by the affrighted scores. A crane rises and takes flight from among the shocks of newly-cut hay; a yellow-hammer is seated on the top wire of the farm fence, the ignored companion of a speckle-breasted meadow-lark. We can see a killdeer circling around, emitting its peculiar note of distress; a brown gull flies toward the blue Jerome Canal.

There is a nauseating odor of putrefying rabbits, as the dogs have killed many, and there have been other rabbit-drives here. This powerfully obnoxious smell grows worse as we near the wire pen in the corner of the fence, where rabbits have been driven on other occasions, and there clubbed to death and left to rot.

We are the first of the rabbit-drivers, as we are the first arrivals wherever we go. Consequently, I always carry a tiny book with me, in which I have jotted things I wish not to forget.

If I had not formed this habit, my punctuality would have cheated me out of years of my life. I have been so long out of touch with city people that I cannot remember whether they are afflicted with that bad habit of being tardy, which seems a part of the character of farm folks.

It is not just because there are chores to be done. In the winter the chores may be done at the discretion of the doer, yet Grange and Literary are begun nearer eight than seven, although everybody has voted for seven. There is something about farm life that seems to make the populace who embrace it act slowly, think slowly, and, I was going to say, feel slowly, if you will allow me to put it that way. But the last is not true. Farm folks go around with their feelings sticking out all over them "like quills upon the fretful porcupine." That sort of feeling, to my mind, is arrested development, a never-ending adolescence, if not childhood.

We stop our car at the agreed meeting-place, but we are driven away from there by the odor of decaying rabbits. So Sagebrush Liz is urged closer to the bank of the Jerome Canal, where we sit and watch the rushing waters which seem as much at home as though native to this region, instead of having been led by the hand of man from the Snake River seven miles away.

It is now three-quarters of an hour past the time set for the drive, and the men are arriving in cars and on foot, each with a club in his hand. When the time comes to get through the barbed-wire fence, I fervently regret having worn a dress instead of my knickers. Charley straddles the fence, pressing down the wires with one hand, so that by seizing him by the collar and doing some acrobatic climbing, I manage to get on the other side.

Eleven-year-old Rhoda walks with her father and me, but little Joe and young Charles have raced ahead. Mister, the dog, stays with us, as he is afraid of the clubs. As the men throw them at the fleeing rabbits, I think I can read his face. He loves to kill the poor, screaming little beasts in our own fields, but at a rabbit-drive he cannot be induced to take part in exterminating the very creatures he delights to destroy at the home place. His eyes say to me, "How do I know that these ferocious men will not turn on me when they are through with the rabbits?"

Rhoda is talking: "Don't you hate to hear the rabbits screaming when the men are killing them, Papa?"

"Well, I'd rather hear *them* screaming than to hear you screaming for food."

"I could never kill one of them." She shudders as she speaks and shakes her curly head.

I have reason to remember this conversation later. Charley picks up a corn-stalk and hands it to me. "You'd better carry a club if you expect any ice-cream," he admonishes facetiously, for, of course, the corn-stalk could scarcely brain a moth. But I carry it, as it looks dangerous, making me appear more in keeping with the scores of men and boys now hurrying across the field, and it is light enough to offer no impediment to walking. For walking here is not easy, as we zigzag among the shocks of hay and alfalfa stubble and climb another fence, into a discouraged wheat-field which the rabbits evidently thought was planted for them. About this time Rhoda begs that we walk more slowly. "A pain in my side," she explained.

"This is the way we cured a pain in the side when I was a boy," says Charley. He picks up a piece of lava rock, expectorates on the other side, and carefully replaces it where he found it. "You must always stoop," he directed.

Whether or not this is a sovereign remedy for a pain in the side, I never know, for immediately we are caught up in the excitement of nearly two hundred men and boys hurrying toward the bank of the canal, where the lovely silver-green water is rushing past the islands on which the native willows bend before the breeze. Just before we reach the bank, the order is given to spread our line and begin driving the rabbits before us, which we do, the little creatures dashing frantically ahead of the clubs.

It is a scene of the greatest confusion, men shouting at their dogs, which are racing about and barking, clubs flying in every direction. The rabbits begin to turn back, in their efforts to escape, which proves good strategy, as the man who has thrown his club is powerless to harm a rabbit dodging back between his legs. The situation is indeed ludicrous.

Farmers from Arkansas never used a club. They were expert shots with rocks, having

used them to kill squirrels from the time they were babies. I stand with my inoffensive corn-stalk, helping to draw the line closer toward the wire trap. Now the men have begun yelling like Indians on the war-path. I presume this makes the attack more effective, though I should think that a rain of clubs would be sufficient to terrify any animal pursued by another beast about forty times bigger than itself. The circumstances could be paralleled only in the pursuit of a caveman by a megalosaurus. Surely no vocal exercise would be needed by that prehistoric carnivorous monster should he take after one of our little forefathers. Of course, I do not include our foremothers. I am sure they would soon have old meggy turning tail and fleeing into the boggy lands, where, a few millions of years or so later, his skeleton would be discovered and carefully fastened together, to be stared at by students in universities.

Almost as many rabbits are racing back past me as are being driven forward. I hear a shriek: "*Mama! Mama! get him! Throw your club at him!*"

It is Rhoda's voice. I turn in surprise, to see my Rhoda, curly hair flying in the breeze, a huge clod in her uplifted hand, and the terrible light of slaughter on her pretty face. At that moment I realize fully how men can murder each other under the excitement of battle. It is a vivid example of mob psychology. Here is my tender-hearted little girl, eager to slay the very creatures that had so awakened her pity but a few moments before.

It is easy to understand why the Indians painted themselves in such a hideous manner. If I feel confident that my appearance will terrify my enemy, I can attack with much more power, for already I have begun his defeat through his eyes. Add to that the fear engendered through the ears, and there is little left to conquer. Ah, but not for a Crèvecœur! Neither sound nor sight nor any other thing can put fear in a truly brave individual. No wonder the Indians ate Crèvecœur's heart. Fearlessness may be insensitiveness, but true courage is moral.

The men and boys are now a compact group, in which I am not included, having lagged behind purposely. It is bad enough to hear the screaming of the little creatures as the men club them to death. I wonder if all animals are able to voice a cry of terror. I never felt much sympathy for fish because of their unresponsiveness, and I was therefore much impressed when a goldfish got caught between two rocks in his bowl and, not being able to go either backward or forward, began an insistent, thin little thread of whistle, or perhaps it might be called a fish's scream, until its mistress released it. But I never heard a worm utter a screech. However, I am still keeping my ears open.

The massacre is finished. The men and boys climb the fence and are some distance ahead of Rhoda and me. I know she would like to be with them, but she lingers behind with me out of filial affection. We have considerable difficulty in proceeding, as this farm is on the edge of the desert, with jutting hills of lava, impossible to irrigate and very hard to walk over. In many places we meet frozen rivulets of lava, almost rivers in fact, and pools whose infernal ripples are petrified just as they were at that far moment when this part of the country was a worse inferno than any hell ever imagined by man. As I walk over the black rivers of lava, somehow they appear red to my eyes, and I find myself wincing from contact with their fiery surface. I can hear the explosion of gases, and those horrific boulders I see in Hen Turner's field have been this moment hurled through the air from one of those volcanic craters. I am always impressed with the feeling that all this took place such a short time ago.

From this time forward we catch glimpses of the men only as we top some lava hill. We are now walking close to the fence along which the line of cars are parked, some of them comparatively expensive, glassed-in, but most of them humble open flivvers. In these cars are the women belonging to the rabbit-drivers, and there is a continuous wail, a mile long, from protesting infants. I seem to be the only woman there without a baby. Or, rather, my baby is in possession of a club as big as himself and is walking briskly in the rear of the army of hunters. I see his red sweater now and again as I peer ahead.

We come at last to a level field of wheat, cropped to the ground by the rabbits. I can see the men making their next-to-the-last drive into the pen in the corner of the far fence. It is all over, thanks be! when Rhoda and I arrive at that point, but the odor from previous rabbit-hunts is

prostrating. The men drive the next field, and then we all become aware that darkness has fallen.

A short distance up the road is the farm-house where Hen Turner and his wife live. We all move in that direction, as it is there that the ice-cream is to be served. Charley decides to go back after Sagebrush Liz, where we left her napping beside Jerome Canal, and Rhoda and I go into the yard surrounding the house. It is now so dark that we cannot discern the features of a face three feet away. I decide to rest on a piece of lava rock which has been placed under a tree.

You cannot appreciate what a tree means until you have lived in this treeless desert country. I well remember the first time my young children ever saw fully grown trees. Little Charles was looking out of the train window as we drew slowly into Salt Lake City. We passed close to some big trees. Excited and awe-struck, Charles pointed out of the window and asked, "Mama, what are those things?" It took me some moments to understand that he meant just big trees.

Trees always seem to me so compassionate. As I lean my head back against the trunk of this tree, which with a few of its fellows makes an oasis in this part of our desert, I gain a sense of calm detachment which is heightened by the obscurity of the night. Out of my cave of darkness, in which I have become a dryad part of the poplar's trunk, I can see the jovial group around the lantern that is set on a table beside the ice-cream freezers. Two busy women are dishing the cream into cones with teaspoons, so I am told, but I can see only silhouettes of those who reach out hands to receive the hunt refreshment.

I suggest to Rhoda that she get herself a cone, and I see her flit among the waiting crowd. Presently she is back with her cone, seating herself at my feet. Next, a figure looms out of the night which I recognize as my son Charles. He, too, has a cone, and he seats himself beside me. He notices my lack and says, "I just got this, Mom, and I haven't the face to ask for another just now, but I'll get you one in a minute. I've already started eating this, or I would give it to you."

I notice Rhoda thoughtfully licking her cone. "Do you think you will ever absorb your cone by that method?" I ask her.

"Every time I take a lick, I think I'll give it to you," she answers, solemnly.

I surprise the old tree with a sudden laugh. "My darling girl!" I say. "Eat it all down. I wouldn't touch a cone that any one else had begun to eat."

Instinct now leads little Joe to my arboreal seclusion. There are no promises of future delight from little Joe. As soon as he sees that I have no cone, he announces that he is going to get me one, which he does, a heaped-up one, such as a child must dream of receiving in Heaven. Charles, by this time, has finished his cone and is scouting for another. He returns shortly with another cone for me, with even more abundant frozen cream topping its mouth. This creates jealous emulation in the breast of Rhoda, and presently I am the awkward possessor of three of the fullest ice-cream cones I ever saw, for they are blurrily discerned through the night, as is everything else.

The children have procured more cones for themselves, and we are all sitting together there, very happily, in the June darkness of that Idaho evening. I meditate that I must photograph upon my heart these quiet moments with my little ones, for there is nothing truer than that we die from day to day. It will be but a few moments until these children, sitting contentedly nibbling cones with me under this tree, will be two men and a woman, and so many things may have happened by then to change them.

And now for Sagebrush Liz. Broken-hearted at having us leave her alone there on the desert road, she had burst, not a blood-vessel, but a wire of some kind. I think that was it, though I do not pretend to know anything about Lizzie's innards. She might have a gizzard, for all I know. I am one of the few women in the United States who have never had a desire to drive a car. I am not even a back-seat driver. I have implicit faith in the man at the wheel.

Steve Drake took his own car and towed Lizzie home. Ben Temple brought the children and me. It was eleven o'clock. I had a premonition that this was the last rabbit-drive I should ever attend.

139

I FEEL that I have a real interest in the Greenwood Baseball Team as I gaze upon the large green letter that I have buttonholed with black silkoline on the shirt-breast of my fourteen-year-old son Charles, who is so large that he is allowed to play with the men. I can never get used to looking up at the son who was a babe in my arms but a few days ago.

Charles has just returned from his daily swim, his blond curls still wet. The family are now ready to sit down to the kind of Sunday dinner they have ordered me to prepare, a most horrific dinner to my notion, but one which they thoroughly enjoy and miraculously digest. Frankfurters, sauerkraut, dumplings, stewed potatoes, cherry pie, and milk. Joe prefers chocolate cake, and I prefer cream pie, all of which are ready, so we are contented.

We have eaten amid much baseball talk. I wash the dishes rapidly and have soon donned a pale-pink linen dress, jade-green beads, and black hat, all out of one of those blessed relations' boxes that still come to us. Rhoda wears a pretty blue dress, out of the same box, and Joe is proud in his beloved Levis, the overalls that made Strauss famous. The Baron wears corduroys and a pongee shirt. Charles is in all the glory of his baseball suit. Walter had gone, horseback, on some adventure of his own, always a quiet, thoughtful lad, with something wistful yet stanch about him. Mister, the dog, goes with us, wearing the regal robes of a pure-bred mongrel.

Sagebrush Liz has been given a huge drink from the canal, and now she stands patiently waiting to take the family to the ball-grounds. She used to have a self-starter, but Lizzie is growing old, and the ambition of youth has worn out. Age is forced to effort by outward circumstances, and so Sagebrush Liz is compelled to action by cranking.

Half a mile we go, through green farminglands, and then take a road through the brush, climbing a hill. On the top of the hill we can see eight cars parked, and we know that on the other side is the baseball diamond, surrounded by sagebrush and set in a natural amphitheater up the sides of which the sagebrush crawls.

Sagebrush Liz tops the hill, and below us are more cars, with about a hundred people watching, while the two teams, Hazelton and Greenwood, warm up for the game. We drive down to a good position near the diamond, where Charley parks Lizzie and leaves me in order to visit about among the farmers. Little Joe and Rhoda go with him, while Charles joins the other heroes of our team.

Simon Heminway drives down the side of the amphitheater in his truck. That truck represents everything that he owns in the world, and he is buying that on time. Today he is making the experiment of selling ice-cream cones.

In front of me, sitting on the ground, are Hi Jones and his brother Hank, both from Hazelton. They are dressed entirely differently, each wearing a suit which looks as though it were draped over a six-foot pump; yet their attire produces so similar an effect that should they be suddenly snatched out of their clothes and away by Old Nick, as happened to the lady in the *Ingoldsby Legends*, I should recognize that apparel, no matter where it lay, as belonging to the Jones boys.

It is a peculiarity of our sagebrush farming community that any woman over thirty is called Old Lady So-and-So, whatever her name may be, and that brothers, no matter how ancient, are referred to as the So-and-So boys. The sister of the Jones boys, though younger than they, was called Old Lady Page. I can see her, not far from them, and although she wears a slimpsy, cheap black dress, which shows a coarse, machine-embroidered white petticoat at the bottom, still her clothes actually give the impression of being one with those of her two brothers.

Mrs. Thuringbird stands near Mrs. Page. She should have been born twins, as there is material enough in her to make two women. It is reputed that she can take a sack of potatoes and throw it into a wagon with ease. She has offered to wrestle any man in the district, and throw him into the canal to boot, but the men know better than to accept the challenge.

Near these two women is Mrs. Bancroft, who milks twelve cows night and morning, besides raising a large garden, caring for over a hundred fowls, doing all her own housework, and sewing, washing, ironing, cooking for a family of six. Needless to say, she does not look like "Miss

America." She never owned a pair of gloves in her life. Vanity compacts were not made for her. One Christmas when Hib, our baker friend and co-farmer, had sent me an enormous box of chocolates, I offered some to her at our house, where she had come to borrow something. "Nobody never gave me no box of candy in my life," she said, wistfully. Fancy being a woman and never to have had a box of candy given to you!

Hen Turner is the only dressed-up farmer present. He wears a new light-blue suit, a hat set at a rakish angle above his ambitious ears, and orange shoes. Baldy Parsons is near him, a bit sunken about the mouth, as his teeth are now in his vest pocket, having performed their Sabbath function of enabling him to sing in Sunday-school.

I forget to watch the crowd as my eyes catch the beauty of the Minidoka Mountains just peeping over the rim of the amphitheater. They are heavenly blue, with their long, graceful sweep set against a sky of lighter blue festooned with lacy clouds. Above my head a vague moon has ventured out in the daytime, lured, no doubt, by curiosity over the coming ball game.

They are beginning to play. Red Britton is at bat, swinging picturesquely like the wings of the school-house windmill. Once, twice, does Red strike without effect; a third time he strikes so vigorously that he loses his balance and keels over on his back. This unexpected acrobatic feat is received with howls of laughter by the sympathizers of the Hazelton team.

The next man up is allowed to take first base because of four bad balls. I may not report this game exactly right, but it was something like that. This man throws his bat to the ground just in time for the catcher to step on it as he swings his arm to throw the ball to the pitcher. He does an involuntary high kick with both feet, coming down on his back. It is now the turn of the Greenwood fans to roar with delight.

Hi Jones and his brother Hank are rebels against Hazelton, so now they lie back on the ground and whoop in ecstatic agony. Then Hi sits up and yells, "Yuh done fine, Hazelton! Always go to bed where yuh air when yuh git tired!" Everybody roars again at that, and having made so fortunate a début, Hi, with the help of Hank, keeps up a running comment at the top of his lungs during the rest of the game.

Simon Heminway has now begun to pass out the ice-cream cones. He is a short man, with small light-blue eyes, a stubby sandy moustache, and sandy hairs on his copper-colored hands. Whatever he says, he generally preludes with the expression, "As the old sayin' is," though he never tells what the old saying is. This trick of conversation always seemed most fascinating to me. I felt sure that some day one of those old sayings would surely come forth, quite involuntarily. But, as the old saying is, Simon never once betrayed the words of any of his old sayings.

Attention of the crowd is much divided between the baseball game and the cones, these being the very first cones to appear at any of our outdoor sports excepting rabbit-drives. My attention is so diverted that it is brought back to the sagebrush diamond only by the sudden combined yells of the spectators who have managed to look as well as nibble. I catch the cause of the excitement just in time. The shortstop jumps and catches the ball in one hand, and in so doing he loses his balance and comes down on his hands and knees, squarely atop of the runner who is at that moment sliding for second. I give a little whoop of my own, my mouth full of ice-cream.

And now I hear the pretty young daughter, lovely of eyes and lips, of one of our Southern States farmers say, "Oh! I just tipped my cone over, and it all spilled aout! Buddy, go over yander, and git me nuther one."

There soars a derisive jeer from the entire crowd as Benny Peters ambles toward the plate, the end of what should be a home run but which he is making a home walk. "Slide fer it!" they yell. "Hit the dirt! Oh! Oh! Oh! He's afraid to slide fer fear-a mussin' up 'is suit!"

I know Benny very well, his folks living about a mile from us, and I realize that the public charge is true. Benny, having been officially declared out, turns an angry face on his tormentors as he passes them to sit on the side-lines. He is six feet four inches tall, so that when he lisps, as he always does, and his expression of indignation happens to be, "Oh, prunths!" there is a combination of unusual effects.

The fellow from New York City, freshly come to Hazelton and called "Cheese" because he is helping to establish a cheese-factory there, is now the butt of the crowd. "Lick the whey outen 'em, Cheesy!" is the vociferous advice started by some unknown wit and adopted as their own by the whole crowd.

Cheese sees the ball coming high in the sky. He is an outfielder. He begins backing rapidly, with raised hands. Cheese has not yet learned caution in this our wild country. He back and backs, and the spectators, suddenly realizing what is bound to occur, begin to scream with joy. There is a huge clump of sagebrush directly behind Cheese. He is running backward, hands raised, eyes riveted on the ball, when over he goes, standing on his head on the other side of the sagebrush clump, feet waving in the air. Hi and Hank hug each other in a frenzy of joy, and I can hear their "*Uh*, huh! huh! huh! *Uh*, huh! huh! huh!" above the general roar. Any disaster to a city man is so much funnier than if it had been one of our sagebrush farmers. I find myself also delighted at this event.

Simon Heminway is now sold out. I have helped this feat of merchandising by consuming three cones. I can hear the little Banks boy's plaintive voice, "Ain't they no more combs? Is they all gone?"

Babe Pennybaker passes with his oldest offspring, the latter crying from every pore, as it were, his whole face wet with tears and melted ice-cream. "Want a comb! Want a comb!" he is bawling.

Babe is from Arkansas. He has this youngster and a new-born baby and a beard. Nobody knows his first name. When he was about to be caught by the draft, he married, like so many United Staters preferring even marriage to war. But it was not such a slacker job for Babe. He had been going with his girl for years, the two keeping company since they were infants. Babe was such a cute little thing that his mother never called him by his real name; so now here he is still "Babe," whiskers and all. But it seems perfectly natural to the colony of Arkansawyers who brought him along from their mountains where they chew each others' ears off over slight offenses. So they all told me, but I noticed they had no ears missing.

It is the pause before the last inning. There is a heated discussion just in front of Sagebrush Lizzie's nose between two of our Greenwood boys. "You ought to of caughten that there ball, Jerry. They ain't no excuse fer you a-lettin' it pass you up."

"Well, I was away off there outfieldin', 'n they was two gophers just a-front-a me, a-playen aroun' their hole, an' fust thing I knowed, the ball come a-circlin' aroun', 'n a-gittin' ready to light, 'n..." They pass on, and I, open-mouthed eavesdropper, sink back in Lizzie's arms, disappointed at failing to learn the finale. But it is not so hard to guess what happened. I am sure one of the gophers caught the ball.

The last inning may have been exciting. I forget the first part, and the last part I know nothing about, for our dog Mister suddenly springs out of the car and makes a dash up the side of the amphitheater, and in and out among the sagebrush that climbs the sides, until he reaches the rim of the basin. Then Mister begins a spectacular chase around the top of the rim, with a jack-rabbit just ahead of him. Most of us become absorbed in this race. This is outdoor sport even more exhilarating than the baseball game. Around and around they go, the rabbit never having the faintest idea of getting off the rim and striking out for the desert.

When the silly thing finally does decide to change its course, it dashes down into the bowl of our amphitheater, straight for the baseball diamond. The game there is almost over. Into the midst of the players runs the jack-rabbit, still pursued by Mister. But what a jack-rabbit! And what a dog! The rabbit is so exhausted that it is barely humping along; the dog is making only a pretense at running.

The baseball game stops at once. One of our Greenwood boys steps up to the rabbit and picks it up by the ears, laying it down in front of Mister, who immediately drops on his belly, panting, tongue lolling, paying no attention whatever to what lies before him. The rabbit reclines indifferently on the dog's paws.

142

Suddenly the rabbit decides to make another try for freedom. At a feeble lope, with Mister dragging slowly behind, it starts, but Red Britton, a big, gangling, homely farm hand, lifts the rabbit with one of his feet, and when it meets the earth with a thud, there is nothing left for Mister to do.

Then the game begins again. Greenwood wins, but I don't remember the score. We crank up Lizzie and start back through the sagebrush for home. And as we glide along the dusty, weed-lined road, Charles, in his elation at our victory, sings a parody, probably city-old, but country-new:

Out where a dog fight is a weed's sensation;
Out where there's no air in the service station;
That's where the West begins!

EVEN on Independence Day, work must be done on the sagebrush farm before celebrating can be begun. Early in the morning the Stars and Stripes have been run up on a wire stretched from the radio pole. Then all hands get busy to put the work out of the way so that we may take a jaunt in good old Sagebrush Liz. Besides cleaning up the breakfast and kitchen work, I can two enormous kettles of cherries and one of currants, having extracted the juice from the currants in the processer. Fruit goes right on spoiling while people are having good times, and conserving what is raised is half of the business of farming.

Rhoda, eleven, sweeps and dusts two rooms and makes all the beds. Joe, nine, feeds and waters the cows and a calf, brings in a hatful of eggs, shakes the rugs out-of-doors, and picks more currants. Charles, fourteen, picks cherries, draws water in a bucket from the cistern to fill the stove reservoir and to supply all other household needs, and then picks more cherries. Walter is taking the part of a man, milking, haying the horses, feeding hogs, and handling many other tasks. He is visiting in Hazelton today. The Baron goes to take care of his irrigation, followed by the two devoted dogs, Mister and Blackie. This means everybody occupied except Phyllis, the aristocratic white cat, who has her paws full just boxing the ears of her three obstreperous youngsters.

Joe has finally stripped the bushes of currants. They have ripened the earliest in thirteen years. All crops are ripening early, the wheat heading while still but a stunted growth.

Rhoda now has her work done and is beginning to rummage through everybody's belongings to find a tie to suit her fancy. She comes out with her father's best tie, to see whether it will match her corduroy breeches and cream-colored shirt that Cousin Peggy sent her. Charles enters the kitchen with the last of the cherries from four trees. And the Baron appears, the dogs following closely, tongues lolling.

I have strained the juice from some kettles of cherries and have a wash-boiler half full of bottles covered with boiling water. The juice, too, is boiling. So Charles takes charge of the bottle-capper; his father removes the sterile bottles from the boiler and pours the hot juice into them by way of a clean aluminum coffee-pot; and soon there is a tableful of bright red bottles. I strain the juice from the currants and set it aside, planning to make jelly from it on the following morning.

I now prepare the lunch, for which I have done most of the cooking and baking the day before. Early this morning I made the strawberry ice-cream, and it awaits our leaving in the outdoor dirt cellar. I am already dressed in my knickers and shirt. Suddenly some one remembers that no angleworms have been dug for fish bait, and there is a general exodus. I apply myself to washing kettles and such, after which I lie down for a few minutes, having been on my feet constantly since dawn.

The children come back with the bait. Then each one departs, goodness knows where, as people always do at such times, on missions which they fail to reveal before disappearing; and there is a crying hither and yon, "Where is Joe?"..."Has any one seen Rhoda?"..."What in the world can Charles be doing?"..."Where is your father, anyway?"

At last, becoming persuaded that unless some one makes a start, we shall never go, I take myself to the back seat of patient Sagebrush Liz, who appears to be standing with hanging head. Charles comes with the strawberry ice-cream, which he places in the luggage-carrier on the running board. Beside it is Lizzie's own particular drinking-bucket.

143

We wait, and we wait, and we wait. "Whatever is the matter with your father?" I ask Charles.

He replies, disgustedly, "Oh, he just keeps a-wandering around and a-wandering around, and saying, 'Haven't we forgotten something? Haven't we forgotten something?'"

These words conjure a picture so ridiculous that I lay my forehead on the back of the seat in front of me and laugh until I almost cry. Suddenly Joe, who has been slumped passively beside me, springs up, electrified, "And we *have* forgotten something!" he exclaims. "We have forgotten the bait!" And out he climbs to go after it.

At last we are all packed in Sagebrush Liz, along with the lunch. Walter, some time before, had waved a farewell and cantered down the road to Hazelton on the colt Florry. Off we go, past farms, and then out into the desert of sagebrush and lava rock. We are bound for an oasis, the Sprague place. It has upon it a pretty house, built of lava rock, a large lawn, and big trees. And trees mean so much in this desert country. Whenever I see them, I always offer up thanks to God.

"There's darling Mrs. Sprague!" I exclaim, as I recognize her figure coming to meet us. I leave the car and throw my arms around her. She seems as glad to see me. We had thought of carrying our lunch down into Snake River Cañon, but now we decide to stay in the shade of the trees on the Sprague lawn, and we invite the Spragues to eat with us. Mrs. Sprague, comfortably plump, with large brown eyes, hurries into the house, reappearing with sandwiches, delicious jam, cheese, lemonade, and cookies. Then we all turn to and eat. Mrs. Sprague and I are near together, and Charley is soon deep in conversation with Mr. Sprague, a thin man, with blue eyes. Both the Spragues are very intelligent city people who dreamed of fortune on the farm.

I am not fond of sandwiches, yet they are as manna there on the grass under the trees, intense quiet all around us. Although there are two small boys present, our Joe and the Spragues' Arthur, there is not an interrupting sound while Mr. Sprague tells how he got lost in the cañon of the Snake and for one whole night felt his way over jutting boulders and crevasses, on hands and knees, trying to get home before he should freeze to death. At any moment he was likely to slip over a declivity into the deep, rushing Snake below, or into a chasm out of which it would be impossible to make his way.

I open the strawberry ice-cream freezer, and folks! I *can* make strawberry ice-cream like nobody's business. We now witness the miracle of two small boys so full of other food that they can eat but one dish apiece of ice-cream. At first, young Arthur, who is seven, had refused positively to have any at all, but when I begin dishing it out, he gives a start of surprise and exclaims, "Oh, it's pink! I guess I'll have some."

Charley and Mr. Sprague join the boys in a game of mumble-peg, while Mrs. Sprague and I clear up the things. I hear a shout of delight and loud laughter, and I look up to behold little Joe squirming on his belly as though in an inverted fit. I cannot see his face. At my amazed look of inquiry Charley calls, "Can you hear Joe mumbling? He's rooting for the knife." And presently Joe arises, triumphantly, knife in mouth—a mouth whose appearance justifies the word *rooting*. Joe hurriedly hunts for water, his expression indicating that dirt is more acceptable to a small boy where it only shows and does not taste.

The boys are begging to go to the cañon of the Snake, which must be approached by a walk of about a mile. They gather all the fishing-poles and lines and, with Rhoda, start off. We elders decide to wait until it is a little cooler, although it is rarely really hot in our part of Idaho. The two men are seated near each other on kitchen chairs, and I can hear them talking about spraying weeds to kill them, which draws my attention to two other men in the next field, county employees, who are doing just that sort of work. Next I hear Mr. Sprague and Charley on that inevitable topic, the probable loss of their farms. I dare not think of the heart-breaking labor I have endured to reach this conclusion to the golden years of my physical activity, so I shut out the thought.

We decide to follow the children. Mrs. Sprague declines to scramble over the lava rocks, so I reluctantly leave her. Through Mr. Sprague's wheat-field we go until we strike desert, and then

on until we reach the rim of the cañon, which drops down from our feet like the pit of Abbadon. At the bottom crawls the emerald Snake.

Beautiful, treacherous river! Her bed is composed of lava boulders, the edges of which have been rounded by a thick coating of creamy sediment, the same that makes the rocks lying along the very banks of her stream, at the bottom of the cañon, look like the bones of prehistoric monsters. It is no place to swim and no place to wade, for there are some holes fifty feet deep in the lava crevasses, where a man might be sucked in, and under, forever. The Snake glides smoothly along, as though anxious to escape observation, for man has robbed her of the greater part of her power. Not twenty years before the Snake was a rushing dragon, her stream high up on her cañon walls, not placid green water as now, but scaley with silver lights and smoking with mists, a terrific force which one would have said no man could tame; yet tamed she is, though it is only the taming of a nature which is treacherous still. Rarely does human being enter this river and live to tell the tale.

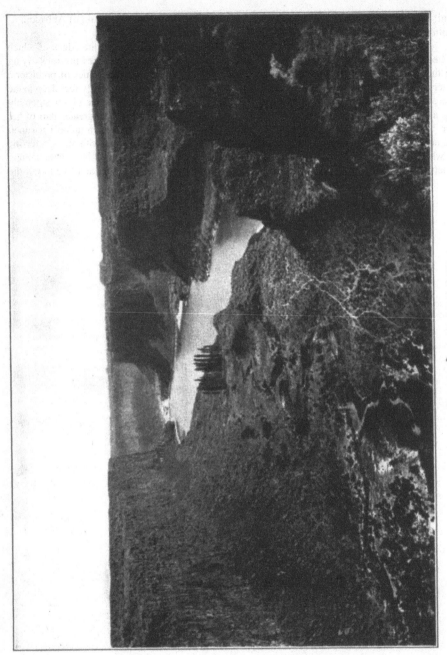

The Snake's cañon is a wide split in the earth, speaking eloquently of the days when all this part of Idaho was unimaginable hell. Its lava sides, cracked in the cooling to resemble cunning

146

masonry, might have provided the background for that Dore illustration of Milton's epic:

> *With head, hands, wings, or feet pursues his way,*
> *And swims, or sinks, or wades, or creeps, or flies.*

Excepting that I have no wings, my descent to the bottom of that abyss is made much in the manner of poor Lucifer's. Mr. Sprague is a fair substitute for wings, taking my hand to help me fly from boulder to boulder, across dangerous crevasses, moving always a little farther downward, most of the time traveling along ledges so high from the cañon bottom that one false step would mean a mangled body. And I am one of those unfortunate mortals who cannot stand altitude, or even to cross a stream of water on a narrow plank, without feeling my head pulling me down to destruction.

Realizing this and not wishing to cause any change in our plans, I compel my mind to think of nothing but the placing of my hands and feet so as to get a little farther down. Even so, I almost slide from a slippery, sloping lava rock, whose flinty surface has gathered unto itself the rays of the sun until it is hot enough to congeal an egg. Mr. Sprague fortunately interrupts my fall. My heart continues its normal beating, for I am not going to smash myself if it is avoidable; and if this should occur, I could know but little about it, so why miss a heart-beat?

Down, at last, among what appear to be the huge, bleached bones of some prehistoric creature. Imagine trying to clamber over the piled-up skeletons of the ichthyosaurus, the cetiosaurus, the megalosaurus, and all the rest of the saurus family, and you have some idea of the difficulties of strolling beside the Snake River.

I crawl and pull, hoisting myself along the river's side until I see a propitious boulder in the stream; and this I manage to reach by stepping carefully on exposed rocks around which the waters swirl. And on that boulder I sit, patiently fishing up crawfish after crawfish, with the unfearing trout gliding and flashing all around me.

Then I caught something. I jerked excitedly, and over I went, just missing being sucked into one of those bottomless holes with which the Snake is pocketed. I had scared not only the fish, but my companions too; so, as we had been there about an hour, we decided to return. I was not so anxious to go, being less upset by what had happened than the others were. It had all been so quick, and I could not see myself in the danger which so alarmed the families Sprague and Greenwood. But I was very wet, and I was not over-enthusiastic about crawfishing at the risk of my life. I should not have minded so much drowning with a few trout on my stick and a good big one on my hook.

As we rode home in the twilight, my thoughts were divided between many things: the beauty of the rose and gold sky, with lovely sky-lakes reflecting the purple sky-mountains; the memory of the roaring green of the restless Snake; the graceful patterns made by awkward cranes, into whose nests I had looked down from the cañon rim, flying to and from their big, ragged nests in the pines which clung to the precipitous walls; the ghostly cries of the cranes, echoing hollowly as accompaniment to the sound of great, slowly flapping wings; millions of sparrows high up on the cañon lava masonry, chorusing weirdly together and somehow adding to the savage beauty of the whole.

And at the same time with these impressions of the present and the past, my mind goes ahead to where the patient farm pets await my coming—so glad when I shall take them the pans of separated milk from the kitchen...several pans, washed and kept sacred to them...they will all drink together, five dogs, fourteen cats, and Pretty, the magpie. And how good bed will feel! And are we really going to lose the farm?

WE SINK into sleep as deep and peaceful as though there were no troubles awaiting any of us in this uncertain world. Toward morning the Baron will wake and lie there, eyes still closed, having what he calls "parades." Debts...debts...how to meet them...what is it all leading to? No! God Almighty Himself could not live the life of mortal man, happily, without some higher Being to rest upon. We must have faith that all is ultimately well. I did not know that then. I was still struggling, still determined to trust only in myself, still trying to reshape the pattern of my life,

147

which I thought had been forced out of symmetry.

Poor Charley lay there every dawn, having parades of debts, mortgages; nothing ahead but more debts, more mortgages. I had ever with me the sense that I was not where I belonged, which was false. We are always where we belong. When we have done the best that can be done with one environment, either we will no longer desire to leave it, or it will be rolled away from us like a painted scene upon a stage. But Charley's dilemma was worse than mine. You cannot say that debts and mortgages are right, because they are not right. No man can stand up and look the world in the eye when he owes money that he cannot pay and can see no prospect of paying. It is a form of dishonesty which is torture to a real man, for whom it is so often involuntary.

Charley was a brilliant man in the wrong place, for brilliancy is wasted in farming of the present, as it probably was in any past day. Five thousand years ago they used to throw debtor farmers into the canals to drown and sell their children and wives into slavery. When we were on the farm, times had improved, for Charley was not forced to drown himself, except in a frightful despair which to a sensitive man is worse than physical death.

But we often forget our individual problems in some form of innocent amusement. I call going to the movies in that wilderness country a form of outdoor sport because the part of it I loved best was the going and the coming. The sunset, and the stars, and the little town of Hazelton glimmering through the twilight, the dusky trees, my darlings near me; then, after the show, the deeper night, with the blue-black sky, the sweet, fragrant air, the up-and-downness of the gliding road, the far-off farm-house waiting, and the barking of the welcoming dogs, with Mousie, my beloved little gray cat, climbing bat-wise up the screen to have me come and say goodnight to her. A sleepy murmur in the brushy bottoms of the poplar-trees near my bedroom window means that Pretty is complaining over my having been gone so long.

We discuss going to the picture-show at the supper-table on Saturday night. I decide against Hazelton's, since my ears are very sensitive, and I can no longer stand the frightful chording of the woman who maltreats the piano there. Even the repertory of two tunes at Eden, with the drum, is better. It is ten miles away, but the faithful flivver will take us there.

Joe, aged nine, has been driving a team all day, helping to haul the red-clover hay, which is being stacked beside the barn. Charles, aged fourteen, for the past three days has been cutting hay for a neighbor, working from seven in the morning until six at night, ten full hours, for two and a half dollars a day, the going wages, as we say in Idaho.

Charles will drive Lizzie. He is five feet eleven inches tall, weighs one hundred and forty-eight pounds, and might well pass, for twenty years. And he is an expert, careful driver, although, of course, his driving is permitted only because his mother and father are present. With Rhoda and Joe also, Walter preferring the relaxation of manufacturing his own radio, the car is too full to leave space for Mister, always its guard while we are entertained. Mister does not know we are to leave him behind, and we dread driving off without him, for he is always so disconsolate at being deserted, trotting back from the gate with such a hangdog look.

The family hurry with their supper of some of my famous Boston baked beans, bread and butter, milk and gingerbread, a terribly unbalanced meal, which I did not learn to compose in a home-economics course and know better than to provide; but sometimes over the whole countryside there is the smell of cooking beans, and then we all know that the larder is almost bare, hens moulting, garden stuff gone, hogs sold or not ready to kill. However, on this night the supper is one of convenience as well as necessity, and it is soon despatched.

Walter, as usual, goes out to feed the stock; Charley goes to irrigate; Charles goes to milk; Joe has gathered eggs and is set to collecting his best clothes; Rhoda is busy about the same task for herself; I am washing dishes. Joe is one of those individuals, such as I was when a child, who has no clothes-consciousness. When he takes off his clothes, they immediately begin hunting places to hide from him. His shirt sneaks one place, his knickers another, one shoe divorces itself as far as possible from its mate, and although Joe is one of the first to get up in the morning, he must hunt for an hour to find enough habiliment to avoid shocking the neighbors. On this night he may go in

clean overalls and work shirt, but he must wear the coat to his best suit. So Joe goes prowling upstairs and downstairs, and I even stumble over him making a search among my cooking-utensils in the bottom of the kitchen cabinet.

I call Rhoda to the rescue. It always ends that way. And she has been on the scent only a few moments when she discovers Joe's coat in the unfinished room upstairs. Having washed himself, Joe appropriates some of the dreadful hair-ointment warranted to give the high, patent-leather finish fashionable at this time, and although Joe has pretty, wavy hair, he manages with this evil-smelling stuff to plaster down the top of his head until he looks like a mouse that has been drowned in a mop-pail. But I have not the heart to criticize the little fellow; he enjoys so imitating Charles and Walter, and, like all imitaters, he overdoes it just enough to betray his lack of genius for the thing. I regard what he has done to himself affectionately, remembering how willingly he works about the farm from dawn until dark, with never a complaint, never a hankering to stop to play, or, if there be any hankering, hiding it deep in his true, loving heart.

I cannot help thinking, as we speed over the miles in Sagebrush Liz, that there are compensations in being poor—not so poor that your stomach is empty and your feet bare and your back shivering, but so poor that you must ride in an open flivver. For here on one side of the road is the new-cut hay, and there on the other side is a field of white clover. If some manufacturer ever takes a notion to bottle those combined perfumes, his fortune will be made. I make mention often of Cabell's certain place in Heaven for old-fashioned women, which smells of mignonette and where a starling is singing. I hope there is another corner of Heaven dedicated to the smell of white clover and new-mown hay, where laughing women like me can go and be with the little children.

Miles of farmingland we pass: we see the fields of wheat, the fields of barley, the fields of potatoes, the fields of beans—here in a country where there was nothing but sagebrush when the Baron and I came. I know that if I were standing in the middle of that bean-field, looking over it, I should see a constant movement of the soil, as the bent backs of the bean-plants push their way out of the darkness. One can actually see them grow, like a purposely accelerated motion-picture. Their growth is so noticeable that there is an uncanny feeling of animal activity, as though they were stretching their bodies up out of the soil where they have been lying.

The next field is wheat, with an odd appearance on account of the many dark-green barley heads raised above the wide expanse of lighter green. Through some inadvertence the barley has been sown with the wheat, and thus each barley stalk, distinctly isolated, lifts its individual banner, as though leading a platoon of wheat in the army of summer. Foolish barley, so brave, so self-deceived! So like visionary mankind, who, like the barley, shall be cast aside when the wheat is threshed. Wheat the great mass of mankind; the barley the dreamers. Dreams are needed to float the banners of inspiration, but the fate of the barley is to be cast aside.

I am not as melancholy as my thoughts appear in print. I see the Jerome Canal in the distance, and "my heart leaps up when I behold" the beautiful, man-made river, standing up out of the valley like those mirages we so often observe on our western horizon, looking outward from our ranch. The Jerome Canal at this point is confined in rock walls, to keep it from flowing into the valley that sweeps below it. Not so far back we crossed our own Jerome Canal bridge, and there the stream is wide and turbulent and deep-blue—so much beauty flowing under that bridge, scarcely noticed each day, but now flowing over my heart forever, never to be ignored.

I think I would rather make a canal or plant a tree than build a house. Especially in making a canal should I feel that I were exercising some of the prerogatives of the Creator. Water has a special sort of mystery which nothing else in nature holds. It is a vibrant, living thing, whose life is so much less understandable than that of plants and animals. It suggests the infinite. No scene is perfect without it, however charming. I feel close kinship to animals and plants, a kinship that is physical and mental, but there is something in my soul that yearns toward the waters of the earth.

We reach the edge of the town of Hazelton, where our mail is distributed, and there, on his lawn, is the rural mail-carrier, feeding a lamb with a baby's nursing-bottle. As hurriedly as may be done respectably, we go on through our town, as it is nearing eight, and always the moving-picture show in Eden has opened doors at eight. A crowd of seven people are strolling up and down

Hazelton's Main Street, and five cars are parked against the curbing. Lights are shining in our grocery-dry-goods store, in our grocery-butcher shop, in our grocery-post-office, in our restaurant-drug-store, with two or three people in each one. The hardware store, too, is still open. It is a busy night for the merchants of Hazelton.

On we speed, the scene ahead of us growing more velvety with dusk. The sun is sinking into a lake of rose and gold, so I know there is likely to be a little sprinkling of rain, some wind, and yet generally fair weather. This forecast, which I make to my audience in the car, proves to be correct. I cannot see, in this time of governmental economy, why Uncle Sam does not dispense with all other weather prophets and employ me alone. It is a fact that my study of the sky has never failed to result in a correct prediction.

It is a pretty road on the way to Eden, as a road should be that leads to a place of that name, nor is it guarded by even a cherub with a wooden sword; but at the edge of the little town we see a warning in huge black letters that we must not drive more than fifteen miles an hour, so Sagebrush Liz crawls into Eden on her belly, like a dog that has been scolded for chasing the neighbors' turkeys. I wonder what would happen if we went dashing through at, say, thirty miles an hour. The only official authorized to stop us is probably working on his farm some miles away. Or maybe he leaves the farm for his wife to work, just lounging around Eden "to ketch them pesky smarties that comes hell-bent-fer-breakfast at twenty-thirty miles a-nour" through Eden.

Eden seems much busier than Hazelton. I might be wrong, but it looks as though there are two more stores than we have in our town. Probably a grocery-barber-shop and a grocery-undertaking parlor. I say probably. I am not sure about it. The unusually crowded Main Street may be accounted for by the fact that the Ladies Aid of the Union Church has a table on the edge of the pavement, where home-cooked food is displayed, the guardians and salesladies being two very large and amiable-looking women of the kind that seem to bulge at all corners of public Ladies Aid affairs. As Simon Heminway had done at the Greenwood-Hazelton ball-game, these pneumatic ladies are selling ice-cream cones.

Six cars are parked in front of the moving-picture house, the proprietor of which stands outside in his shirt-sleeves, and a-few-other-things, loafing and inviting his soul. No crowd seems to be jamming into its precincts. Upon inquiry from the shirt-sleeves, and a-few-other-things, we find that the crowd was late in coming the previous Saturday, so the time has been changed from eight to eight-thirty. We have at least twenty minutes to wait. The bill is Lon Chaney in "The Phantom of the Opera." A little later, as we kill time walking down Main Street, I overhear a conversation between two highly illustrated young ladies, the artist's superscription alone being omitted.

"Goin' to the show t'night?" (Vigorous gum-chewing. Cleans your teeth—forget which brand, but of course other brands do not.)

"Y' bet! Wouldn't miss seein' that bird." (Gum here, too. Cleans her teeth too, I suppose, but they do not look it.)

"What's the show?"

"It's 'The Panthom of the Opry.'"

THE FIGURE that now rises before us might be considered a "panthom" from the past. It is the fat, good-natured person of Tony Work, so long, so very long gone from the field of my life. He looks just the same, except more fat, and he worships me with his eyes in the same faithful-dog way, though I am sure there is not as much to please those eyes as when first he saw me. Or is there? Perhaps more.

Tony tells me that since he left our neighborhood, he has worked in many different parts of southern Idaho. Now he is located as hired hand on a fruit-farm near Eden. He is what is called a prominent man, in the Idaho farm sense. I overheard Simon Heminway asking Charley if he knew where he could get a prominent man to work for him. I thought that Simon was getting pretty ambitious, as well as impractical. Most prominent men I know would make very poor farm hands.

150

After he was gone, in answer to my surprise, Charley explained that he meant a *permanent* man.

Tony begins talking, and with what he says, and what is flashed upon the screen of my mind by remembrance of things the Baron has told me, I find a story more interesting than the strained, improbable action of "The Phantom of the Opera."

I did not know until after Tony had left us that he had ever been married, or that his wife was dead, having left him a baby daughter, who was living with his wife's folks in some Middle Western state. Although Tony had perfect features, beautiful, large brown eyes, teeth fit for advertising dental paste, nobody thought of him as handsome, for he lacked personality. He had come back from the Spanish-American War only to enter a hospital. In this environment his pulchritude registered well, since he was not able to exercise much personality in any case. He fell in love with his young nurse, and it is presumed that she did the same with him. They were married.

It did not take a year for her to grow tired of looking at that meaningless perfection. When her baby was born, she was ready to fall desperately in love with her physician. She would have fallen in love with almost any one who happened to be on terms of intimacy with her at that time. Love is not a destiny unless it is allowed to grow roots too deep to pull up. At first it is always conditional. It might have been any one who was good to Tony's wife, because her affections and her instincts were alive and famishing. Hunger knows no laws. The biological urge is so much stronger in women than in men that it is a wonder women have not shattered the universe in fierce rebellion against the bonds of nature which so seldom mean satisfaction for them.

Doctors are used to female patients falling in love with them. Most doctors are not vain. As a whole, it is a most admirable, merciful, sane profession. If the poor woman had been grounded in psychology from babyhood, as some day all persons capable of education will be—oh, say, nine thousand years to come—she would never have done what she did. For that matter, she would never have married Tony in the first place. Suicide is a poor way out of anything. You can learn to endure any one if you have the Kingdom of Heaven within. And a mother cannot get away from having been born a mother even though she become invisible to fleshly beings.

And now Tony is telling me that since he lived near us, he has had a mail-order wife, found in a matrimonial paper, a woman a good deal older than himself, with a little money. She had come to Idaho to her bridegroom. The union, though it may have been registered in Heaven, lasted not six months on earth. Jeff had introduced Tony to the matrimonial paper that introduced him to his bride.

Uncle Sam, with little borrowed wings, and a quiverful of arrows, and a bow, which maybe he stole, was no more successful in Jeff's case. Jeff had been divorced from his first wife, the woman who had always worn black, as poor little Susie, her deserted child, had described to me. He got the divorce, for she ran away with another man, taking her baby and leaving Susie behind. She had gone to more black dresses, more smell of manure, more drudgery. But the face at the table was different, and maybe the new husband thought, once in a while, to bring her home a few yards of gay percale.

The letters that Jeff had said meant so much to him that summer had come from his mail-order fiancée, to whom he had become engaged through the matrimonial paper. She had considerable money, and an old mother. It seems incredible that she sent her money on to Jeff, sight unseen, but it is even more incredible that he invested it in a tidy little farm. The foolish girl and her old mother came out to Idaho to live with a perfectly strange man. She and Jeff were married, and they had a baby, but the poor young woman was afflicted even as Tony. She had no personality. Jeff was very intelligent, capable of appreciating, and also of interesting, a superior woman. Not having been grounded in the kind of honor that considers the unattractive as worthy of sacrifice, he left his wife. But he did have his own kind of real manhood. He did not steal her money from her, or take anything that belonged to her except her affections, and affections that need not be won are rarely appreciated.

It seems opportune to tell of Jeff's father, who had been a widower several times, and who was in one of those periods when Jeff brought him the precious matrimonial paper. Through

this strangely sordid, strangely romantic source, Jeff's father secured himself another wife, with money, from Alabama. What wonders me, as the Idaho farmers say, is whether a hometown man could have won this moneyed widow so easily, or whether the thought of the romantic West may not have added to the lure of an unknown correspondent.

The Alabama woman was a homely, motherly-looking being, willing to do all the drudgery while Jeff's father talked socialism, anarchism, and all the other *isms* so fascinating to men who love to settle the universe while their wives chop the sagebrush. Why this match ended in divorce, Tony did not say. I suspect, from what I know of Jeff's father, that he had such easy success in getting this wife that he could not resist trying out a new one. And why not? It was little or no expense to *him*.

The new wife, also with some money, survived him. I often wonder what such men as Jeff's father do when they step out of the flesh and find they are not dead, after all. It would be such a surprise to Jeff's father, who always referred to God as "Old Uncle Billy."

It is eight-thirty, so we part with Tony and go at once into the picture-house, passing shirt-sleeves as he watches the crowd arriving, counting them to see whether to open at eight-thirty next time or eight, as formerly. The interior has the familiar odor of unwashed bodies; the pianist is ready with her two tunes and forgets only twice during the evening—once when she played "I Love You Truly," intended for all the sad parts, while the foolish boy sat down on the lemon cream pie; and once when she played the other tune, "Red Hot Henry Brown," when the old mother was dying on her son, as we sagebrush folks express a passing away. There is a drum which rolls ominously, sometimes loudly, sometimes softly, but always rollingly.

The show is over. I step into a foot of irrigation water which flows between the sidewalk and the dusty road. My low shoes are full of water, but when I reach the car, I pour it out and forget it. I have no thought of dying because of wet feet, and I never take cold, being careful to eat only germs like the ones already roosting despondently on my lips or lying in wait for the kind of physical weakness that I do not have.

We sail the ten miles home through air that one would like to carry about forever, to sniff at every once in a while as an intoxicant. I have seen sunsets I shall never forget: one in Michigan, as I stood with my back to the University Law Building; one in Kansas, facing a limitless green alfalfa-field; one in California, looking over the bay from San Francisco; one...no, myriads, here in Idaho, the land of the most glorious sunsets of all, with plenty of sky room to stage them and no intervening obstructions to shut off the view. But nowhere have I felt more strongly the beauty and mystery of the night than in Idaho.

I feel it, something calming and soothing, as we ride those ten miles. My nose tells me what fields we are passing, for the road is perfumed all the way. It is good to be drawing near home. Rhoda and Joe are both fast asleep, and my own eyelids drop drowsily now and again. Over the Jerome Canal bridge Lizzie hits the uneven planking. The Greenwood School is dark before us. There is no light in the Teacherage, the residence that was made out of the little rough-board school-house in which I taught. It had been hauled the mile from its former position and painted gray, and no one would have dreamed that thus the homely old school-house had entered Heaven and become an angel.

In the farm-house on the hill, whose toothpick-pillared porch the moonlight reveals, we can see the orange glow of a light. I know what will happen when we go stumbling into the house, half-drunk with sleep. Walter will spring up, a fanatic light in his eyes, the head-phones still over his ears, connecting him with his homemade, built-by-sections radio, one of the first boy-built radios in the West.

"Well, folks!" he will say, triumphantly, "I just got Memphis, Tennessee!"

152

VII. SEX

I am writing this chapter months after the rest of the book was finished. I am including it because I believe that without it a true picture cannot be given of us sagebrush folks. Yet it is hard for me to tell what I shall tell because some of the grossest things I must relate were perpetrated by people I liked. Out of a sort of loyalty to my affections, in some cases I shall give them other names, making them live in this book a Dr. Jekyll-Mr. Hyde existence. Now I think of it, that is what most of us live, and certainly, from my point of view, it was true of them.

The men did the gossiping, for the world's greatest gossip is the farmer. He feeds his brain on other folks' affairs. I was the involuntary eavesdropper.

But if it was the men who did the gossiping, it was a certain group of farm women who perpetrated a joke so vulgar, so indecent, that I cannot tell it here, although I recognize the weakness of my shrinking, for the nature of the joke was so revealing as to be important. Neither can I bring myself to relate the obscene dream of a woman in another group, although it set the whole district rocking with great belly-laughs. I regard this as my infirmity, for, being a writer, I should paint the picture as it is.

I blame this reticence on the horrifying ignorance in which I, the daughter of a physician, was reared. My knowledge of birth was this: a little girl drew me into a corner of the school grounds and told me that Ruby Dyke's mama had a baby last week, and "she told Ruby all about how babies are born, and Ruby told me, and if you will promise never to tell, I will tell you. It's when the baby is ready to be born, the mama's belly-button spreads wide open, and the doctor lifts the baby out."

I never talked with any one on that subject, and all mention of such things was carefully avoided in my home. The truth broke upon me with a sickening shock. After my father gave up the practice of medicine, his big home office became our library, books covering every wall, from floor to ceiling, excepting only window-room. Among these were hundreds of my father's medical volumes, segregated into a forbidden group. I was an obedient daughter, but Bluebeard's surviving widow had nothing on me when the mood strikes me. I took from his medical library a calf-bound book, opened it at random, and nearly perished. The illustration that leaped out at my eyes was my punishment. I had learned, at eighteen years of age, how babies came.

It seems incredible, but I could relate worse ignorance on my part with regard to what is now called *Life*. That early hedging-in probably accounts for some wildness in my blood which impels me to come out with things that are supposed only to be whispered. At seventeen, an innocent bystander, I listened to some married women warning some engaged girls of the horrors of wedlock, and I threw a bombshell into their midst by declaring stoutly, "I think I should like marriage!" and I knew no more of marriage than I knew of birth. But my instinct was true. For it is the human mind and body that poison marriage. The laws of nature are made for contentment of the individual and service to the race. They are good. Marriage is another place

Where every prospect pleases
And only man is vile.

Cultured New England spinsters were my early school-teachers, any one of whom would have fainted at the word sex. Such association made possible my understanding of the stiff Middle Western farm women, and its effects forever rendered a dirty sex joke to my mind reason for

153

justifiable homicide.

I parted company with both the bawdy-minded and the nasty-nice in the training of my children, who, I resolved, should not be reared in the state of ignorance which passed for innocence in my youth. From birth I told them all there was to be told, year after year, making them understand that God had made no mistake and that all was right with the natural laws that govern man except when man loses control of himself.

It was not strange, therefore, that whenever any creature on the farm gave birth, the children ran to me to be present at the important event. And I think that word *event* is, in this case, used most accurately, for its Latin components are *e*, meaning "out," and *venire*, "to come."

Jersey II was having her calf on the hillside when my children ran for me, and there we stood, the five of us, watching the calf drop, wabble to its feet, look about with bright eyes, as though it had only slept overnight in its mother's womb. The mother licked it affectionately and then began to eat the afterbirth.

When the children asked me what she was doing, I explained all about the afterbirth, but I could only guess that perhaps some medical value lay in the cow's consumption of this provision of nature's for the unborn calf. I had only learned that cows do eat their afterbirth through the joke that all cow-punchers tell of the farm woman who gave birth to a baby when the hired hand was her only attendant. He had been a cowboy, and after the baby was laid in bed with the mother, he swung into his saddle and rode hell-bent-for-breakfast to the doctor's in town.

"I'm afraid she's gonna die, Doc," said the cow-puncher. "I been a-tryin' an' a-tryin', but I jist kaint git 'er t' eat the afterbirth!"

I have told you these things about myself to let you know that I was neither loose nor a prude. I believe, myself, that it was worth losing Eden to gain passion. I am no sentimentalist about love. I do not need to have passion decked like a Christmas tree, but neither will I tolerate seeing it festooned with malodorous garbage. Physical love is not indecent unless it is the action of indecent beings. You can just as well change "Home Sweet Home" and hate yourself by singing,

 'Mid cesspools and sewers
 Though I may roam,
 Be it ever so stinging,
 There's no privy like home.

You can pollute or purify everything you look upon. You can make desirable or disgusting every natural function of the human body. What an obscene, pornographic curl of flesh is the human ear! The nose is nothing better than a phallic symbol!...And so we may slip and slink, strewing ordure over the clean path of nature.

Every child should be taught the nature of passion, and how it will inevitably become that sad thing, lust, unless he learns the power of sublimation, out of which grow the mightiest works of men. That was what was the matter with our district—there was often enforced sublimation in the slavery we endured, but sometimes that sublimation, because enforced, was maddening, so that women ran away with men, and men from women, leaving lawful mates behind, and even little children.

HAD THE STATE COURSE OF STUDY included instruction in the power of passion for good and the technique of sublimation, some of my boys in the little old rough-plank school-house might not have been involved in that Spanish-fly affair. I had heard the farmers refer to Mame Griffith as "a chippy," and after it happened, I also heard them add that because she was that thing, a half-dozen farm youths had decided to see what would happen if they spiked her bootleg drink with Spanish fly. And what happened was that she went stark, raving mad, and they had to lock her in a room in the bleak Hazelton Hotel, with a doctor in attendance, for they thought she would kill herself. The dose had been too strong. She nearly tore down the hotel.

Some of those same boys were involved in the trial at Rupert, when we were still a part of Minidoka County. I had heard that the girls of the district were known according to their degrees of "easiness." The Emmet girl, Katie, was said to be easiest of all. But her father did not know this,

and he was determined to fix the responsibility for Katie's kid that was coming. Who the father was Katie did not know. She accused a number of the farm boys, and since she was under age, it looked pretty serious for them. The verdict was that any one of them might have been the father. All should have been forced to help support the child, but nothing was done.

Tillie Beerbach was full of life and laughter one day, and the next day she was dead. I know now that the laughter was to cover her anxiety, and I know, too, that the poor girl died in horrible agony. Old Man Harris was going down the road in his wagon, when he saw Tilly burst, screaming, from her married sister's shack. Scream after scream pierced the air, and Tilly ran frantically toward the big Mormon gate, made of barbed wire, with a loop over a pole to fasten it shut.

Old Man Harris stopped his team and climbed down over the wagon-wheel. He picked Tillie up from the irrigation mud and carried her into the shack. Hanging from a nail he saw a fountain syringe, from the tube of which a dark dribbling of moisture lay on the rough board floor. Near it stood a slop-jar. Old Man Harris picked up a big bottle bearing the label "Carbolic Acid." It was empty. He carefully replaced it beside the slop-jar. Then he went out to find some one who could go for a doctor, though he felt reasonably sure Tilly was dead. He felt he should not meddle with anything, so Tilly lay alone there in the shack, mud on her face and in her hair, until the doctor arrived.

The druggist remembered selling the big bottle of carbolic acid to Hen Beckstead the day before. Tillie's sister and her family had gone to Burley for the day, and Tilly had refused to accompany them. Hen had ridden to the Mormon gate the night before, and Tilly had gone out in the dark for a few minutes to see him. She had come back with something wrapped in a corner of her big apron.

I heard the farmers saying she had it coming to her, she was so hot after Hen. Nobody blamed him for Tilly's death. You see, he had not meant to kill her. He had only meant to murder the unborn child. It would have seen the light in a few months.

There was a beautiful, sweet child I saw so often at our school-house doings. I always wondered how her father and mother could have begotten any one so dear as Ellen Evans. Her sweet disposition shone through her pretty blue eyes. The family was very poor, winter and summer the seven of them living in a two-room tent. So when Ellen graduated from the Eighth Grade, she went to work for a farm family a long way from her folks. The farmer's wife was going to have a baby, and Ellen was to be nurse for the mother, caretaker for three little ones, and housekeeper and cook for the husband.

The new baby was three days old when the husband slipped into Ellen's narrow little room and assaulted the girl. The poor child felt the disgrace of the dastardly affair so keenly that she could only weep every minute she was alone, and she was afraid to tell any one because of shame. The next night she barricaded her door with a wash-stand and two heavy lava rocks, and, after stealthily trying it, the husband decided he might attract the attention of his wife if he persisted and actually broke in.

It was a pity that Nature could not have had mercy on Ellen. The day came when she had to confess to her mother what had happened. Her father had the farmer arrested, and the law compelled the assaulter to support the child and pay Ellen's hospital bill.

Ellen would not give up her baby, although there were people who would have adopted it. She stayed on at the hospital, studying to be a nurse, and finally she married well, a man who knew her history and took her little one into that happy home. I will say this for our sagebrush folks: I never heard the slightest shadow cast upon the name of Ellen Evans. There was not one of us who would not have fought for her.

Luly Demorest's was a different case. She was one of the most beautiful girls I ever saw, with abundant dark hair and bewitching, mysterious dark-blue eyes. Her figure was slim, almost childish. In the city it would have been said that she was seduced. But the hired hand knew better.

He told the story himself, his amazement carrying over into the narrative. It was a

laughing matter among the farmers, that story he told.

Rangey and fairly good-looking, he was not crazy about girls. Luly watched him, saying nothing. She slept in the house, and the hired hand slept in the granary. One night he awoke to find Luly astride his loins.

I often think of Blondy. Her hair was like pulled molasses candy, her figure full and shapely. As for her mind, she would have made a first-class stenographer or a very good teacher. What happened to her was not along these lines.

A stone's throw from her father's tar-paper shack, over the barbed-wire fence on another farm, was the tar-paper shack of two brothers, Harry and Lew Whitehead. Both had been barbers in Twin Falls, but, like the rest of us, they were farming in the sagebrush with the idea of plowing up a fortune. They made the effort only one year, selling out to a city family from Des Moines, the daughter of which distinguished herself in a pie-eating contest, as you have heard.

It was natural in that lonely wilderness that Blondy should fall in love with one of those young fellows, and it happened to be Harry. There was no one for her to be with after the Whiteheads left, her solitary adventure being an invitation to the deserted shack, indignantly refused by virtuous Blondy. Nobody knew of this propositioning from her. For some curious reason it was the young man who told. He did so with the declaration that he was sure he could get her next time.

There was no next time. Blondy went to Twin Falls to do housework. On the street she met Harry. He had been married for some time. Nobody knew how many times they met after that. It was the nurse in a certain doctor's office who told a friend of mine the rest of this incident.

"The first I saw of this girl was when she staggered into the Doctor's office, white as paper. She had tried to induce an abortion. We took care of her.

"The very next year, here she came again. She had done the same thing. I said to her, 'Well, who's the man this time?'

"She said to me, 'Same man.'

"And would you believe it?...Here she came in the same fix the next year. I said, 'Same man?'

"She said, 'Same man.'

"'My God, girl!' I said, 'what do you let him do it for?'

"She said, 'I can't help it.'"

I heard that Blondy had married a farmer, and then I heard that she was divorced from him. Shortly after that I saw her. Blondy's bright mind had been subdued to her body. She was pretty no longer—a large, shapeless woman. I had liked Blondy. I had liked her very much. It makes me wonder whether Schopenhauer is right, that we can do what we wish, but we can only wish what we must. And I think of those words of Einstein's and apply them, as excuse, to Blondy: "Our future is predetermined...without doubt my own career was predetermined beforehand by a multitude of factors over which I had no controlling power whatever, determined first of all by those mysterious glands within which nature, as in a laboratory, prepares the elixir of life; namely, the hormones of internal secretion."

The whole countryside was shocked by the news that Old Man Branch had been murdered by his fifteen-year-old son Reffie—short for Ralph. Shot in the head, he was, with his own gun. His brains were shot out, and he was still gripping the green onion he was eating when they moved his body away from the table. Folks said they were not surprised. That Reffie Branch was too quiet to come to any good. He always acted like he was trying to keep away from folks.

I know now that the boy was living in hell, and when you are living in hell, you cannot be very sociable with other people. Old Man Branch was a brutal slave-driver; no one could doubt that who once saw that subdued family when he was near. We had very little chance to see them, for he kept them there on his isolated farm, working day and part of the night. They never came to our good times.

There was a girl older than Reffie, a pretty, rounded girl with lovely brown hair and dark eyes. She was very shy and modest. Besides this girl and Reffie, there were seven younger children.

One day Reffie was about to plow, when he noticed that one of the cows was missing from the piece of pastureland. He crossed the field, looking for it, and instead found his mother, groaning and sobbing behind a strawstack. She had come there feeling certain of secrecy.

Reffie demanded the reason of her tears, and at last she told him. The story came out at the trial, just as she had related it to him. Betty, the eldest girl, was in the habit of collecting the eggs from the barn in the evening after supper. One night she found her father there. He seized her, caressed her with ferocity, and finally, there on the hay, her own father forced the poor child of barely seventeen years. He threatened to kill her if she told any one, and he commanded her to return every evening. He also formed the habit of bringing her little cheap presents from town—beads, rayon hose, and such. The poor mother had been glad at this manifestation of affection.

Reffie was crying, too, when the story was done. And he was swearing—"Damn him!...damn him!...God and Jesus Christ damn him!" Then he said to his mother, "Don't cry no more, Ma. It don't make no mind. I should ought to of killed him long ago. He'll get his come-uppances."

His mother hardly heard him. What could a fifteen-year-old boy do to right this horrible affair? She dragged herself up from the straw some time afterward. It was time enough for Reffie to go to the house, get his father's shot-gun, secrete it under the door-step, and begin his plowing. The lost cow had strayed back to the pasture while he was with his Ma.

That night he made no move to come in from the field until his father shouted in exasperation from the kitchen door. Then he took his time, unharnessing deliberately, knotting up the straps, and leading the horses to the canal with the ends dangling. There is nothing more peaceful than the sound of horses drawing up great soughing mouthfuls of water in the quiet of a desert evening. Reffie was not thinking of that. He was remembering now how his sister Betty's body had changed...he knew now...she was going to have a baby...her own father...

He pitchforked a mangerful of hay to the horses and left them contently *chawnking* as he slipped stealthily around the back of the house and carefully surveyed the kitchen through the extreme side of the open window. There was no screen. It had been one of those hot days in spring which nature means as a warning of summer's coming. The family were all eating, his father's great back toward the window.

Dragging the gun lightly from under the step, Reffie placed it on the window-ledge, took careful aim, and fired. Brains all over; family screaming and scrambling; green onion gripped in the old devil's hand.

Reffie jumped on the bay mare and rode to town, where he gave himself up. The trial was very brief. He was acquitted.

AND WHAT was the Baron doing to prevent this constant smudging of his little wife's snow-white mind—a mind which had not only been ignorant of the existence of passion, but which had to awaken, without warning, to the frightfulness of lust? Often he came between her and what might have been.

It comes back to me as I write, that morning Ben Temple dropped in on his way to town and ended by spending an hour with us. Ben came to see Charley, of course, but he liked to talk to me. Some remark of mine was the cause of a chuckle on his part, and then, as I ironed a shirt, he attempted to tell a story.

"That reminds me, Mrs. Greenwood, of the traveling salesman who went to the country hotel."

The Baron had been tapping away on a pair of the children's shoes. He had a tall iron last and a box of shoemaker's tools, and he kept many a little shoe together for weeks longer than would have been possible otherwise. At Ben Temple's words, he stopped tapping and stared across at him fixedly.

"Don't tell her that story, Ben," he said quietly.

Ben evidently thought Charley did not mean his warning, for he gave another little chuckle and continued, "The hotel clerk gave the salesman a room right up over the hotel office, and..."

"Don't tell her that story," the Baron repeated.

Ben smiled broadly and went on, "...and the salesman says to the hotel clerk, he says, says 'e..."

"I said, 'Don't tell her that story!'" Charley had stopped working and was staring at Ben, who chuckled, but looked a little undecided.

"He says, says he, 'If I should wake in the night, and want anything, I'll just drop my shoe good and hard...'"

Ironing away there, I was beginning to feel panicky. I liked Ben Temple, but if he told me any dirty sex story...

The Baron answered for me. "If you tell her that story, Ben, she'll hate you forever!"

Ben began, in spite of this, "So the traveling salesman had a woman in his room that night..." Ben looked at me, and then at Charley, and then he concluded lamely, "It ain't such an awful bad story, Charley...anyhow, I've forgotten it." And thus he sponged the slate clean.

I could go on and tell more stories of lust and passion gone wrong. I could tell how Polly Jetter threatened her father-in-law with a butcher knife when he laid lustful hands upon her, his mind poisoned against the girl by her step-mother-in-law, who thought that because Polly was pretty she must be bad—the step-mother-in-law looked a good bit like an ambitious catfish. I could tell...but I will stop here, ending my Decameron of the Desert. The rest of this chapter belongs in my heart, for the two stories that follow affect me deeply. Especially Bessie's. I will tell hers last.

Basil Werkman was by far the most shining gem among our young men. He aspired, and he could learn, qualities which set him apart. He and his mother, with the help of two young sisters, farmed their acres, after the head of the family had been electrocuted while helping to take a hay-derrick under the telephone and electric-light wires on the outskirts of town. Out where we were, there was no such danger, as we had neither telephones nor electric lights. Almost every year farmers near town were electrocuted in this manner.

Mrs. Werkman did any kind of work she could find in Hazelton—anything to bring in extra money, and the little family pinched and schemed to send Basil away that he might become a doctor. It was impossible to send him East. His college was near enough that he could come home at Christmas. And it was then the terrible thing happened. Folks pointed out that it did not happen to Beulah West until after Basil had gone away and studied medicine. "Him studyin' t' be a doctor, 'n everthin'," they muttered darkly to one another.

Beulah and Basil had been chums in the Hazelton High School. Basil had no money to spend on her, but her folks were very poor, and Beulah knew how to enjoy just being with such a lad as Basil. After they both graduated, the following summer Beulah would ride to town with Basil, perched on the wagon-seat beside him, he so blond and big and strong, and she so little and dark.

After it happened, Basil said he remembered how restless she was that summer, moving uneasily about and casting looks of apprehension around her, for which he could not account. He rallied her on her nervousness, but she just laughed—and ended the laugh in a peculiar frozen stare.

Basil had thought nothing more of the matter. Letters between them were not frequent. She may have been in love with him, but he was not in love with her, and, besides, he was a real student, devoting every moment possible to his work. He was baching in one poor room.

At Christmas he found his little chum very ill. Her mother explained that she had been having spells. On Christmas Day she became so violent that she was taken to the Twin Falls hospital. The doctors thought an operation would set her body right and result in healing her mind. I do not know whether cutting her open did her any good, but it did establish the innocence of Basil. A small portion of our sagebrush population believed this, but the rest still hinted, and more than

158

hinted, at beastly things.

Christmas Day Basil was with Beulah—in fact, he had scarcely left the hospital after they took her there. "Hold my hand, Basil," she had said. "If I hurt you, please forgive me. I know what I am doing, but I can't help it. I feel something take hold of me, and then..."

So he sat holding her hand, and she seemed more peaceful because of it, when suddenly she screamed, sat upright, and sank her sharp white teeth into Basil's wrist. The blood ran, and the sound she made was horrible, but he sat there, patiently, until the paroxysm passed. That night Beulah died.

Basil did not know what was being said about him until he came back. And then he met that coldness and suspicion which was like a blow upon his sensitive heart. Folks stared at him curiously, but whenever he turned to meet their eyes, glances slid away from him like snakes.

Only a few believed him innocent of attempting an abortion. Those few said Beulah must have been bitten by a mad coyote, since those demented animals sometimes bit our cows and dogs and made them so dangerous we had to shoot them. The others...the others still believed because it was what they could understand, and because Basil should not have aspired beyond the plow. And they were among the folks he had always known. His heart bled. And I know, because I know what kind of a lad he was, that it left an everlasting mark on Basil Werkman.

What happened to Bessie came to me as such a shock that I went crying up the hill toward home, raining tears down on the *Segregation News*, in which I had read it, and lifting my swimming eyes to the cool, blue, cloud-decked skies as I sobbed, "O Father! Forgive Bessie! Forgive Bessie!"

Of all the young people...no, of all the people of every sort that I met in the sagebrush, I loved Bessie best. Her mother had run away with some man, leaving five children to the later mercies of a stepmother. This woman was good enough, doing her duty faithfully as a farm woman, but there was no love for those children in that home.

Bessie was by far the brightest student in my little rural school, quiet, lovely, gentle, and as pretty as a sweetbrier rose growing in the cool of cañon walls. Curling dark-brown hair, black lashes and brows, low, white forehead, delicately pink cheeks, and perfect, white teeth. Her smile was shy and sweet. And I loved Bessie.

I loved Bessie so much that I have never mentioned her a single time hitherto in this book, and I had expected to finish its pages with no mention of her. It hurts so to write of gentle, lovely Bessie. There can never be any compensation for the grief I feel for her.

After that school year with me, her folks moved away, and I never saw Bessie again. I heard, some time later, that she had married, and the man had taken her to live in a cabin up a wooded cañon where the Snake River rushes and boils downward, a stupendous stream of ever-changing violence.

It was not the isolation, I am sure. Bessie had known worse than that. It was something overpoweringly crushing to her affections, to that trusting gentle heart of my dear Bessie—something which involved her little baby, for she had resolved not to leave it behind to suffer as she had suffered.

Bessie wrapped a rope around them, tying her baby to her breast, and jumped into the Snake River. Battered and beaten almost out of recognition, they found the two when they came to hunt for them. That moment when there was no love left in the world for Bessie...when she tied her babe to her breast, looked down on the Snake, and leaped...Oh, Bessie!

VIII. WAR

The World War was a great pleasure to us sagebrush folks. It injected into the monotony of our existence a romantic spirit which linked us with the outside world of action and emotion. Usually this very outside world showed only antagonism and greed toward us farm people. Nobody who has not actually belonged to the farming class can realize the gulf that lies between agriculture and the rest of society. It is not so much the farm disposition that causes this; it is the attitude of the rest of mankind during the thousands of years through which they have regarded with scorn and contempt the slaves who feed them.

Farm families do not like the position they occupy, and they are forever conscious of the line of demarcation. The farmer and his wife act like dyspeptics—hypersensitive to society at large. Be careful how you joke a farmer about his affairs: he has a real grievance, and he is constantly suspecting that you may be making fun of him. Under this suspicion is the yearning to be accepted like other folks. Hence, any propitious event that allows his hard hands to grasp the soft hands of the city man in some semblance of friendship is touchingly welcomed.

We sagebrush farmers helped elect President Wilson on the platform that he kept us out of war. We commended him even more heartily when he stood aside, because he had to, and allowed a Republican Congress to put us into war, his part being to act as Master of Ceremonies, wearing a silk hat and voicing seductive phrases. I worshiped Woodrow Wilson, placing him with Washington and Lincoln, and many an argument between Charley and some other farmer was applauded by me, silently, because my man was praising and defending my idol. Yet, after all, it appears to me that President Wilson was forced into the position of one who covers the questionable deeds of others with apt Words. When the deeds became openly offensive to him, and nobody cared that they were, his heart broke. To my mind he stands the most pathetic figure ever to hold the Presidential office. He was so sincere and, because of the nature of the opposition to him, so ineffective. We sent our boys to murder others. What for? "*To make the world safe for democracy!*" What's that? The kind of government at the mercy, and lack of mercy, of interested politicians. I have very few illusions.

Out in the sagebrush, when our stand-pat Republicans read those words of President Wilson, "To make the world safe for democracy," they were properly miffed. That was one of the reasons Charley spent so much time defending Wilson. Our disgruntled Republicans were sure that Wilson meant to make the world safe for the Democratic Party. "Why, Charley, they ain't no other meanin' for them there words! Ain't Wilson a Democrat? And don't that there paper as good as say that he wants our boys to go over and fight for the Democrats? If democracy ain't a place where Democrats rule, then what is it?" And Charley might explain and explain, even going so far as to read the definition out of my big dictionary. The more he said, the stubborner the sagebrush Republicans held. "Ain't that jest what we was sayin', Eph and me? It's fer the Democrats! Ain't he a Democrat President? 'Course he wants a democracy! Fer Democrats!"

When Wilson finally wrote the proclamation of war, at the dictation of Congress, everybody fell in line. No one would have dared to express an adverse opinion. A call was sent out over the sagebrush wilds for everybody to meet at the school-house. We had a session so moving that had any unfortunate German passed, however innocent, we would have rushed out in a body to his wagon and torn him limb from limb. Mobs are hideous things. The unreasoning beast in all of us is unchained when we act in mobs. Crowds have always seemed repulsive to me. They represent

160

humanity at its worst, a great, flabby monstrosity, ready to devour whatever prey is drawn to its attention by whatever person takes the trouble to lift a public voice.

It was roses, roses all the way...

But Browning's hero found out just how much those roses meant—and so did poor, tottering Woodrow Wilson.

We were a mob of patriots out there in the brush, just as the entire nation went mad with patriotism. *Peter Piper picked a peck of pickled patriots...* that's what we were, pickled patriots. Somewhat superficial Alexander Pope had his moments of wisdom: "A patriot is a fool in every age," he wrote in the "Epilogue to the Satires." Charley completely forgot a part of his racial origin and called all those of the blood of his good old *Grossmutter* that hideous name, "Huns"...and I was more guilty than he, for I egged him on. Left to himself, he might have retained some sanity, for his sister Margaret, whose hair had been that lovely German blond, was a rabid anti-English, and Charley thought the world of her.

I am a great hand to make speeches, privately only if it is impossible to make them publicly, for I dearly love to have a crowd at my mercy and allow no quarter. Rather a large crowd had gathered at the school-house, mostly men. You could generally count on Old Lady Babcock and Mrs. Greenwood being on hand when there was business large enough to draw the men to the school-house. It was to this group of sagebrush people that patriotic Mrs. Greenwood made a speech so thrilling and inspiring that not a soul remembers it to this day, not even the lady herself. She was filled with such passion that what wonders me, as we say in the brush, is why she didn't mount Old Buttons and start immediately for Washington, proselyting all the way. But even Joan of Arc could not have gone very far with a baby astride each hip. The voices of the home infants have probably drowned out the voices of many a nationalistic band of angels.

It was while Jack Overdonk was still with us. He was very bad on the cornet, which he liked to play, and very good on the guitar, which he might be persuaded to play, while he sang,

O Susannah, now don't you cry for me,
For I'm goin' to Louisana...

CHARLES O. GREENWOOD, SENIOR, FARMER

I planned the patriotic program, and recognizing that Susannah was entirely out of place at this meeting, I had Jack sing what he could remember from the Spanish-American War times,

162

while Mrs. Curry played the organ for him.

> *Just break the news to mother,*
> sang Jack so pathetically that we all wanted to snivel,
> *And say how dear I love her;*
> *Just tell her not to wait for me,*
> *For I'm not coming home.*
> *Just say there is no other*
> *Can take the place of mother;*
> *Then kiss her dear sweet lips for me,*
> *And break the news to her.*

Jack was standing beside the organ, which we had placed between the two rooms opening into each other, Primary and Upper Grades. He was not a large man, as was the Baron, but as he stood there, with no other man in competitive height, he looked very handsome. A good-looking man need not have so great a voice to move women, and the men present were all imagining themselves dying on the field of battle, so Jack's song proved heartbreaking.

By the time he had finished the last word of the last chorus and Mrs. Curry had concluded with a little more chording, for without the music, *um...tum, tum, um...tum, tum,* was all the accompaniment we could have to our songs that day, we were all wallowing in sentimentality. Most of our mothers were already in a better world and therefore, I hope, past grieving about our little troubles in this unreal existence. And we need not be weeping about not going home, because in the course of an hour we should be doing that very thing, with cows to milk and chickens to feed and supper to get and children telling good on each other what Johnny did while you was gone, Ma, and Bessie took the...and Mamie went and...

Yet we were melted almost to tears. I dared not look at the stubbled face of my neighbor across the aisle, Eb Hall, for fear of blubbering, so I kept my gaze fastened on the back of Ben Temple's sheepskin coat, of course sneaking a glance now and then at Jack, with the undercover, unpatriotic thought of how handsome he looked, as dark men can look. Once when my patriotism got almost too much for me, I was saved by happening to glance at that old hypocritical water-stealer, Baldy Parsons. It is an invigorating thing to have so lively a disapproval of some one that it can counteract in part such mushy melodrama as we are likely to build out of a suppositional situation.

Ben Temple and Old Man Babcock, with Eph Parish between, sang three solos together, there being no parting there—into bass, tenor, and baritone. They were not three different songs, but that surprising Spanish-American War ballad in which the forces of nature so kindly co-operate, the sun dropping at the end of each verse. You get a touching...sniff! sniff! where's my handkerchief?...picture of an old mother, "feeble and old and gray"...what in the world was she doing having a son that age?...more like his Grandma, I'll say...and then we see his sweetheart...and then...well, I don't think old Towser was mentioned...nor Aunt Maria, her with the arched-up eyebrows and the arched-down mouth...nor the iron deer on the lawn...but anyway, after each personal mention, the old sun drops like a plummet. It is presumed that while the next verse is being sung, Old Man Sun is climbing back up into position to make true the affecting words:

> *Just as the sun went down!*

It seems to me the composer might have worked the moon in to drop half the time, or a few falling stars. Evidently the heavens had no N.R.A. code in that song. It strikes me now like that Baron Münchausen tale of the severe winter when sounds, as well as liquids, were frozen in the air. Ours was an event during the Spanish-American War just thawing out. Perhaps even the words REMEMBER THE MAINE! might next have startled our ears.

We were pickled Americans—One Hundred Per Cent Americans, as intolerant and unloving as bigoted churchers. It meant we hounded our good neighbor Burkhausen so that the banks, by means of Federal agents, bled the poor old man white, forcing him to buy Liberty Bonds; and he who had lived so peaceably and harmoniously among us scarcely dared to go to bed at night

163

for fear a mob of us sagebrush One Hundred Per Cent Americans would arrive to tar and feather him and his good old wife—his good old wife who could not imagine what had happened so suddenly in this land of the free.

It meant that there was a certain amount of unwritten discord between Charley and his sister, the one who had inherited the beautiful yellow hair from some Teutonic ancestor and who was as rabidly intolerant of the English as the Baron was of the Germans. His old German teacher in the Columbus High School, who had made a pet of Charley and had brought him home some edelweiss when she returned from one of her European vacations, she must have turned in her grave—or, since only her body was there, what a flutter there must have been in Heaven as she recounted his disloyalty to some of his Junker ancestors—perhaps the original Baron himself. Worst of all, what would that long-dead, wonderful old Grossmutter think of her favorite, who would have willingly seen her birthplace, lovely Bingen-am-Rhein, swallowed up in flames? As for Charley's wife, the all-English girl, one generation removed, she applauded what she called his remarkable fair-mindedness, not because of her English blood, but because she was an One Hundred Per Cent American—a pickled patriot.

One of our sagebrush heroes of the World War was Mike Gogenslide, he who supplied the school-house scarecrow with the worst hat in the district. From military pillar to military post he was shifted, until he was utterly bewildered. In the first place, Mike was not at all certain what the war was about; in the second place, he had never wanted to fight anybody or anything in his life; in the last place, he went through the whole affair in a kind of dumb unconsciousness, putting a foot forward or behind as ordered, neither resenting nor accepting—a rural patriot, who, no doubt, listens to the Armistice Day orations over his radio—anybody can have a radio—with a kind of mild, impersonal wonder. He never left American shores, and he came back to his tenant farming neither better nor worse for the experience. He might have dreamed it. I suspect we have a lot of military heroes like that. Not that I would take the glory out of war. Oh, no! I am all for waving the flag and *hip-hip-hooraying* while some mother's son has his head shot off with a shell. It looks so glorious to see the blood spurt up out of his neck, and it proves we all love our country so.

We had other heroes—some who volunteered and were not just drafted, as was Mike Gogenslide. Of course, that makes it even more glorious for a fool boy to go out and get his abdomen ripped open with a bayonet while his mother goes crazy at home. Never mind; they will pin some medal on her—a ribbon and some words. That pays her for bringing him into the world and training him and loving him? How can you doubt it? Well, this is not wartime, so I shall not inform on you.

They came, those young volunteers, the young men for whom I sold my honor for a mess of commas. Thundering horseback up the hill in a cloud of dust, dressed in their khaki uniforms, so proudly they came to say good-by to Teacher, because I...I had explained in school what a noble thing it is to die for one's country. Charley was Exhibit A of my intolerance; Old Man Burkhausen was Exhibit B of my pickled Americanism; these fine young fellows were Exhibit C of my unintelligent barbarism. It was really I who sent them into that war.

I was so glad that I had sprinkled their examination papers with illegal commas. I had done that much for my country—though some years in advance, I must admit. Well, anyway, here were my hero boys, going out to murder and be murdered in this glorious way. I felt very sentimental as I stood on the toothpick-pillared porch and watched them pound away on their horses, dust boiling out of the earth to race along with them. I wanted to shed tears. In my mind they were already gloriously mutilated and dead. They would never come back. And that gave me a thrill, too. The *never-nevers* in our lives are always so thrilling. We love to feel that utter hopelessness which is so seldom justified by facts. They all did come back, all five of them, never having left American shores, even as Mike Gogenslide, who was dragged into the war and, because he was not willing to murder any one, is somehow not so wonderful.

We all wanted to go Over There. Had there been nothing to prevent, the whole of America would have poured onto the field of battle, suffocating the enemy lands in a thick lava-flow of

foolish humanity. My compatriots and I would have swarmed first over the battlefields of the Allies, spilled over in unmanageable masses into the German trenches, pushed on by the mad ingress entirely over the enemy country, so that the Germans would have been forced to brush United Staters from the mouth of Big Bertha before they could fire her—swarms, swarms everywhere. We would have gone there crazily, to scrap and be scrapped. We felt a kind of wild insanity, very much like being in love, and we were all eager for it, to break the dull monotony of living, even as we forever snatch with ravenous fingers at the illusion-garments of the great biological frenzy.

> Bliss was it in that dawn to be alive,
> But to be young was very heaven!

It does not seem possible that we could ever go to war again, knowing, as we do, how unintelligent, how ridiculous, how mad, how criminal, how frightful is all war. But let the band play, with drums and fifes and bugles; let somebody think up some catchy slogan; let the papers headline the thing right; and watch us! Again like sheep we shall all go astray. I know how straight I think and feel now, but I should be afraid to trust even myself in such an atmosphere. I wonder how many more thousands of years will have to pass before there are Jesus Christians actually practising what He taught? I wonder how many more thousands of years will have to pass before ordinarily rational human beings will see the unintelligence and weak-mindedness and lack of ingenuity there is in wholesale murder in the name of something we call "our country"? Madness! Madness, rather than kindly, tolerant, considerate love!

Over on Stubbs' corner, across the way from my childhood home, the annual circus—Ringling Brothers, Sells-Floto—always erected billboards on which the pink-skirted equestrienne, my especial envy, leaped through a flaming hoop, and the blood-sweating behemoth stunned you with the size of his wide-open pink jaws, dotted on the sides with blunt teeth, which I fancied had been sawed off in an effort to make the plasma-perspiring monster of less danger to children.

I think I might have gone into what used to be called "slow decline" if I had missed one of those circuses, though I do hold it against the memory of my father that he did not show me every side-show. The pictures on the canvasses outside the little tents looked more interesting even than the billboards. I never told my father I wanted to see the sideshows, so I cannot blame him entirely. He used to pass them with the remark, "Nothing but a lot of fakers."

I felt about the World War as I did about the circus. Only, in this case, I was not simply denied the sideshows. I could not even see the big top. And I have always been a pickled patriot—until now.

Every time I heard of any one I knew going Over There, I went over with them in imagination. My Cousin Marc went over and drove a whippet, he and his best chum, the chum shooting the gun and Marc driving...and then something so hideous happened that I must not tell it here. I heard that my girlhood friend Joe Walker had gone over, his wife with him, she as nurse, he as physician. Joe used to call me "Pikie," instead of...well, my other nicknames—I was seldom called by my own name, seeming to remind everybody of something else. So there was Joe—bombs bursting in air, and here was Pikie—cows mooing in air. To me, who loved life with passion, to me it was tragedy not to be in the thick of things.

I WAS BURSTING with patriotism, that madness of provincial minds. I kidded myself along by trying to think that everything I did was in some way a sacrifice upon my country's altar. It was with that exalted sentiment that I made pies, baked bread, mended enough overalls to reach twice around the globe, churned, hatched chicks, and made soap. I loved to make soap....I loved to do everything I did, and therefore I had no sense about economizing my strength, nearly killing myself with less outward showing of accomplishment than a less enthusiastic, more selfish woman might have produced.

We had plenty of clean, white lard for cooking, so I saved other drippings for making into soap. A can of lye, a stick of sagebrush, the wash-boiler, and the fascinating job was ready to begin.

165

I stirred and stirred, mixing grease with lye, lifting the scraggy sagebrush every once in a while to see how the mass dripped. When the mixture finally ran honey drops from the tip of each little twig, the soap was done. It looked delicious enough to eat, but the smell was different. It penetrated everything and killed all the delightful odors of outdoors with which the little house was saturated.

I think I have said before that my sense of smell is keen. While I was pouring the soap into wooden grocery boxes to mold, the stink—I can't help it, that's the word—was ferocious. I had to fix my mind, frantically, on the beauty of the hot, amber mess. When it was almost hard, and the worst of the...yes, the stink had faded into the air and turned into nothingness out on the desert, because where there are no noses there can be no stink—but you can't make me believe it—when it was almost hard, I had the delightful pleasure of cutting the now ivory, solidified soap into bars of equal size. City folks cannot return to the pleasures of childhood as farm folks can.

City folks do not create in the imaginative way of children. You have no idea how soothing, yes, even charming, it is to take a butcher knife and cut into bars your own home-made soap when it has reached cheese-like consistency.

The whole operation, step by step, has its rewards—except smelling the stink; I was never able to extract enjoyment from smelling the stink, and I would rather be haunted by a persistent polecat than forced to smell boiling soap. The boxes have been standing outdoors, and I have the men carry them upstairs and turn the cakes out on the floor of the room where old clothes hang from the bare rafters. All around the walls are little windows, through which I never fail to look at the lovely, untamed valley, and the mountains, every time I go upstairs.

Now I have the fun of building the bars of soap into ivory towers, in order that circulating air may be about the business of curing them. Not only have I had the pleasure of creating something—a thrill almost entirely lacking in city life, but every time I go upstairs to make the bed in the partly finished room, I can glimpse those ivory towers, and I get such a feeling of wealth from having so much good laundry soap that John D. and J. Pierpont might envy me. What good is it to be so rich you cannot feel it all? There is a limit to the amount of emotion a human being can experience. No one could feel more richness than I felt when I used to see those symmetrical piles of my own home-made soap.

I suppose the joy of making that soap should have been its own reward, but I did so want to work in my country some way. To be really inspiring every concrete task should have a trimming of abstract principle. I had to make that soap, but I wanted lace on the panties of my necessity. I think most of us who were left Over Here had that same hunger. Which reminds me of the rotogravure of an actress in a magazine my brother Bert sent me when Joe was a little fellow. The child gave a cry of disgusted modesty at the sight of the ruffles of lace high up around the lady's thighs. "Mama!" he exclaimed, "that lady's panties are too short!"

I was in the predicament of trying to array my daily tasks in patriotic panties that were too short. We One Hundred Per Cent Americans were so proud of the lace on our patriotic panties that we cast all other clothing aside and took to snatching the clothes from other people's backs, to shame them publicly should they be wearing simple B.V.D.'s.

About this time my dear Aunt Nellie came to see us. She is my mother's youngest sister, and her voice was even lovelier than that of my charming Grandmother, who sang in oratorio in England and brought her melodeon by ox-team across the North American continent. My mother died when I was a child, but she is vividly living in my mind. How could any one forget so much of loving, laughter, and music as was incorporated in my mother? Those three things constitute a charm which humanity, made aware, never willingly allows to perish, the most seductive charm of all.

We had no musical instrument in that poverty-stricken farm-house, but we must hear my Aunt Nellie sing. It is a dreamlike, enchanting summer night, with a great moon mellowing the cloudless sky, the valley, and the mountains. Crickets chirp sleepily in the grass, and frogs croak softly along the banks of the canal that flows below the house. On the edge of the toothpick-pillared porch sit the little family, Aunt Nellie standing in front of us, a queen, with that highbred poise of

her head, the clear light of the moon shining down on her. Between the Baron and me are seated the four *Kinder*, pretty Rhoda, her father's arm around her, Charles next to her, then Walter, then Joe, leaning on his mother's lap. We sit there entranced, while Aunt Nellie's lovely voice floats out across the great, broad, quiet valley. She is singing of a river that flows through the district of Württemberg:

Never! never! can I forget that night in June
Upon the Danube River!

And then, to the little family so filled with the hunger for music, she sings,

Boy of mine!...Boy of mine!...

And there sat I, moved almost to tears by that sympathetic, golden voice—she had preferred to be the mother of ten children rather than give the world a voice, beautifully trained though it was.

So the Danube River flowed through the very Germany I was aching to destroy—a beautiful river, which love could never forget. But *hate could*; hate can do anything vile. Woman! how could you sit there in the moonlight, holding on to your own little boy, eyes damp because of "Boy of Mine," thinking of those three *boys of mine* and enthusiastically condemning to murdering, and to being murdered, the *boys of mine* of other mothers? Mothers, you and I and all other women could put a stop to this thing called War by rebelling against it! Let's refuse to participate in anything so senseless and horribly destructive, not only of material things, but of those loving ties which make life worthwhile. THOU SHALT NOT KILL! Do we need another Moses to tell us that? There was Jesus. But what good did that do? They were Christians who fought the last war, forcing the heathen to help them.

I hatched chickens with an eye on Uncle Sam—surely it was patriotic to bring more food into the world. Of course, it would have been necessary for me to hatch those chicks had there been no war—the very same number of chicks; but I must feel that I was doing my bit to the bitter end—things which I think go together, as you can readily see. What amazes me is that I did not stick an American flag in every nest where a hen was setting, or maybe a touching legend, such as "Doing her bit for Uncle Sam," or perhaps "Setting her sit for Uncle Sam" would have been better.

Charley had made me a wonderful chicken-run, a square frame of planks partitioned into long, grassy runways, the whole covered with chicken wire. At one end was the trap-door through which the hen and new chicks could be inserted. Thus there were sunshine and liberty for the mother and children.

Before I went on the farm, I thought vastly amusing those Easter cards with an old hen stretching her neck madly from a slatted coop toward her wandering balls of yellow fluff. Why should not a hen be the object of protection by the Humane Society? The most faithful creature I ever knew was a hen under whom I put her own and another hen's chicks; she hovered that too-large tribe until she died, her comb faded white from worry, a martyr to motherhood if ever there were one. There is nothing more perversive of a hen's natural instincts than to make her a prisoner when nature is inspiring her to wander about, in order to teach her little ones how to look out for themselves.

After I had all eight runs tenanted with families, one chick, more independent than the rest, decided to See America First, before settling down in the old home run. I found him huddled against the plank separating him from his brothers and sisters, and I took the prodigal son and dropped him in beside his mother. No one has ever told the story of the prodigal's mother, but if she acted as that hen did, his father would have been forced to kill more than a calf to keep him at home. In the poultry case, which was not a parable, the hen pecked that unlucky youngster until I had to iodine him practically all over.

Hens have such flat, inexpressive eyes—very ineffective, I should say, in registering the emotion of love—that I have always underestimated certain of their mental faculties, among them arithmetic. When the hen and her chicks were settled for the night, I slipped the little outcast under her wings with the rest. I am sure she must have counted her babies before hovering them, for in

the morning, as soon as she looked over her brood, with a cry of vengeance she dashed at her adventurous son and began to do him to death. Fortunately, I was at hand and saved him.

I named him Peewee—the only chick I ever honored with a name, and he haunted the kitchen door, in order to follow me wherever I went as soon as I came through. Out to the garden, out to the sagebrush-pile, out to the granary, hanging the clothes on the line, always there was poor little Peewee trotting after me, anxiously stepping as I stepped. All his brothers and sisters grew beautiful white plumage, but Peewee became naked, losing all his down except for a few white feathers on his wing-tips. He was so naked you could see his heart throb, and all his other organs were visible through his transparent skin. I call that the nakedest naked there could be. Even a nudist colony would have blushed for him. He wore a perpetual blush himself, the sun baking his delicate body a dark red, which in no wise prevented the exposure of his internal mechanism.

Peewee went about the dooryard next to the kitchen, emitting continually a forlorn *peep-peep-peep*, all the time that he was separated from me. I thought it was a pity I could not teach him some hobby, so as to take his mind from his one absorbing thought of being with me. Then one day I was absent in Twin Falls, on the invitation of Mrs. Asper, and when I came back and was just settling myself for the evening, having cooked supper, washed dishes, strained the milk, set bread, and a few other things, I became conscious of a sense of strangeness and began to analyze its cause. Ah! No peepings at the kitchen door! "Anybody seen Peewee? You seen Peewee, Walter? Who's seen Peewee? Folks! Children! Be still a minute! Haven't any of you seen Peewee?"

No one has seen Peewee. I think. "Who fed the chickens?" "Charles fed the chickens." "Where?" "Across the canal." "Where did he get the grain?" "From the granary." I run down to the railroad tie that serves as a bridge across the canal. I am so dizzy-headed crossing running water and climbing high places that I scarcely ever cross the canal there. I am determined to do so now, for I must find Peewee. But I am not called upon to risk an accidental bath in the canal for his sake. I find him just where the tie rests on the near side of the stream. The mute little corpse tells its own story. He had attempted to follow the rest of the flock and had been pushed from the tie by the stronger birds, perhaps his own brothers and sisters, who were now almost grown, while he remained a pigmy. Blighted affection had made him bald of feathers, and blighted affection had dwarfed him. Now he lay dead, exhausted by his successful struggle to make his way out of the water. I have seen few more pathetic sights than the body of Peewee, as it lay there on the canal-bank. Am I a sentimentalist? All right! I'll bear that epithet for Peewee's sake. He loved me. I would do more than that for those who love me.

But Peewee had not died for his country, no matter how I tried to find a place for him on the roll of honor. And I had to go on taking care of hundreds of other chickens, who were just chickens, never having been named. It is a crime not to name animals. They understand, and they cannot exercise their individuality under a generic name. I don't think you would like it yourself, to have no name. I am told that God knows us all by name, and that is a most comforting assurance.

I can hear Gabriel saying, "Lord, there's a woman down there keeps bothering me with prayers to You."

"Who is she?" says the Lord.

Gabriel answers, "It's a woman sitting at a typewriter, wearing a black Miriam Gross dress, with a kinda sassy look about her."

"Oh, yes," does the Lord say? "I've seen that woman pecking around in my back yard, I mean on her typewriter. Throw her some grain. She's always squawking."

It's not that way at all. When Gabriel complains, the Lord says, "That's my little pet lamb, Annie," says the Lord. "I had her named from birth. Give her something better than she wants."

And that is what happens, dear reader, and all because the good Lord knows my name.

BESIDES making soap and raising chicks for my country, I remodeled a dress, inspired by patriotism. I had been wearing that dress summer after summer, faithfully attending church in

the school-house in it. I needed that thin white dress, for the school-house was not opened through the week, and the hot air was baked into everything, the feeling of it intensified for me by the big blue bottle flies buzzing hymns against the dusty window-panes.

Perhaps you remember Mrs. Quackenbos, the teacher who read to her pupils my note inquiring which side of a cow to sit on while one milked her. It was at the very end of that school year that Mrs. Quackenbos was responsible for the ruin of my one best summer dress. I had bought that dress from Best and Company at the same time as the pretty wool suit I was wearing when I met Tony and Jeff. It was really a darling frock until Selma got through with it, even though the styles had gone right on without it.

Selma was a hearty country girl Mrs. Quackenbos had brought with her from Oakley, where the teacher had a farm, run by her son Cliffy. Selma was to be Mrs. Quackenbos' maid of all work, receiving her remuneration in change of scene and a chance to attend the Greenwood School. She was graduating from the Eighth Grade that year and had no white dress to wear on Closing Night; so Mrs. Quackenbos inevitably thought of me, because on a warm September night she had seen me wearing my one best summer dress to a meeting of Frontier Grange. Folks inevitably think of me when there is anything they want that is most precious to me, and my worst vice is being afraid of acting stingily. Consequently I have spent a good part of my time regretting my unintelligent generosity. Still, Jesus said, "Him that taketh away thy cloak, forbid not to take thy coat also." That is always the way I end.

Selma came for the dress, and she looked to me especially fat that day. I told her she could not possibly get into it. Up the hill panted Mrs. Quackenbos, a good deal like the approach of a threshing-machine. She sat down solidly in our living-room, and assured me that I was exactly the figure of Selma. That confused me a good deal, so that I might have done anything. I have a passion for the truth. My friends had told me that I had a pretty figure. If I looked like Selma, I did not have a pretty figure. I had never accepted the statement of my friends without some doubt. My conceit is large, but not for my looks. Mrs. Quackenbos was not my friend, therefore she was more than likely right. With the humblest of spirits I gave her my best dress that Selma might be garbed appropriately when she received her certificate of graduation.

That night, when I saw how large Selma bulked against the row of window-blinds above the home-cobbled stage I had a feeling of anxiety for my dress, but when I considered that Mrs. Quackenbos had assured me I looked just like Selma, and also when I reflected that Selma was certainly wearing the dress, I sank into the ease of an innocent bystander, beginning to form vague resolutions about dieting. My sinking was part depression. If I looked like...Selma...if I really did look like...

The next morning the dress was hurriedly delivered, and Mrs. Quackenbos departed for her farm, faithful Selma being loaded into Cliffy's wagon, along with a great feather bed crowned with a dish-pan, a rocking chair, two straight chairs, and a few other articles. The old school-house in which I had been Teacher had not yet been dragged to the school-house yard to be made into a teacherage. Mrs. Quackenbos and Selma had kept house in one of the school-house rooms where the hammering had gone on during my own closing-day exercises.

I opened the newspaper wrapping around my best dress. The worst had been thoughtfully folded out of sight, so the shock was not so sudden. But when I shook out the folds, I found that the crocheted tops of the buttons had been worn away by the thumbing required to push them through the buttonholes, and nearly every one of the buttonholes was burst. Selma must have worn my dress burst and pinned in place. I remembered then that she had shown no rear view to the audience. The seams of the waist were so strained apart that she was extremely fortunate there had been no sudden explosion to expose her, half-naked, to the impure glances of the farm men.

I decided that morning that I had to have a new dress. So I wrote something, and an Eastern magazine editor accepted it. But by the time the check came, I needed something else worse, so I patched up the old dress the best I could and went right on wearing it. At the time we went into the World War, I had again decided that it was certainly done for. God bless the Eastern

magazine editors! Whenever I absolutely had to have something, there they were, patiently waiting to receive my manuscripts (they were published a long time ago, so don't be surprised that my name means nothing to you now) and paying me good money for them. When this second check arrived, I was sure I would buy another dress. I had sent for the Best and Company catalogue and had picked one out—it was such an event that I could not bear to select one from the big catalogue of one of the two mail-order houses whose means of reaching the farmer is called the *Wish Book*. You see, we used to sit around through the winter, having its fascinating pages read aloud to the family and picking out all the things we would order when the crop we were planning to plant should come to harvest. And that same scene was duplicated in almost every other sagebrush home. So hard we worked, to be paid in dreams which always failed.

Nothing but Best and Company for me, I said, for I was small, and the young-girl things looked best on me, besides requiring very little altering. Yet while I was making soap and hatching chicks and doing a hundred other things with one eye cocked on Uncle Sam, in the back of my mind my conscience kept nagging me: "You can't spend that check the editor sent you...you can't spend it on a mere dress...your country needs you....You are not eating any sugar or wheat bread...but there is that check..."

Well, it ended with my hunting up some scraps of organdie and some dainty old embroidery, and once again I became a creator. Nobody else in the world knows as much as a farm woman about how God felt when he created the universe. She is forced to create all the time, and, like God, generally out of nothing. I took my dress money and bought a Liberty Bond. I learned by chance, from a letter of my stepmother, that my father had invested thousands of dollars in Liberty Bonds. Yet I dare to say that what he did was not as much as what I did, though I am not belittling his act in any way, naturalized citizen that he was, a patriotic American who could still parade the floor, looking very handsome, and sing in a fine voice,

For he is an Englishman!
and,
Rule, Britannia! Britannia rule the waves!
Britons never, never, never will be slaves!
I ask you where...please tell me!...where have we a United States song that will make Americans stride their library floors, with flashing eyes and lifted chests, singing defiance to Destiny? One only song worthy of my beloved country we have, and that by a woman known only to school-children, and when sung, apathetically sung. Oh, for a song, a marching song, worthy to be sung by men and women and children marching together with flashing eyes and lifted chests, a song of our glorious native land! Must such a song be born only of beastliness and bloodshed?

I finished my poor best white dress, and it then figured in one more brief but feeling episode. There was a picnic of the county Grangers in a grove near Eden, and Ray McKaig came to orate into us the consciousness of our despair and our power. On chairs, widely spaced, plank seats had been laid before a temporary rough-plank platform, on which Ray McKaig stood to speak. But before his oration we spread our lunches together on plank tables. Cloths were stretched the length of these tables, and then they were adorned with the pride of accomplishment of every farm woman in the county, from Mrs. Greenwood's famous potato-chocolate cake, walnut-filled, and with caramel icing, to Mrs. Hatch's famous pickle lilli. Each of us farm women had something for which she was known far and wide, and there were all those prize edibles waiting for the eating. We ate with our eyes as well as our mouths, and I pity the poor city folks who never have the opportunity to sit down in the open air and eat all they want of such cooking as was laid out on those impromptu tables under the trees of that grove in Eden.

After we had eaten, Ray McKaig stood up before us and told us what fools we were and how we might redeem ourselves. When he had reached the highest pitch of his fervor, our good friend Hank Thorsen, the druggist at Hazelton, in a moment of lapsed consciousness, stationed himself at Ray's feet and began passing out advertising balloons. Children swarmed from among the plank seats toward the druggist as though he were the Pied Piper of Hamelin, and even the eyes

170

of the grown folks became fixed on those globes of red, green, and yellow.

Ray McKaig is a fiery man, and he grew more and more exasperated as he felt that he was losing his fight for the attention of the crowd. Had he come all the way from Boise to talk, unheeded, over the tops of a bunch of colored balloons? Suddenly, startling our somnolent, balloon-occupied minds, Ray asserted himself, emphatically, somewhat after this manner:

"And you can see for yourselves, by the figures I have just quoted, how you have been cheated and...*Mr. Balloon Man! will you please move some other place?*"

We were all a little shocked. The druggist was held in great respect by us simple farm folks: his store glittered so, and we could not imagine any one unsuperhuman being able to buy so many things at once. Ray McKaig did not know that he had to win us back again in the face of our sympathy for Mr. Balloon Man, who carried with him, I am sorry to say the attention of a good many of us, eyes still following the colored balloons just around the side of the platform.

When Ray McKaig was done—and I hope it did some good, though I cannot see that Idaho farmers are any better off than any others, which means nothing very optimistic, at best—we sat there visiting a few moments, we women, the men leaving the plank seats to hobnob in groups, calling each other by Christian names and slapping one another's backs, things we women would never have dreamed of doing. We always observed the utmost formality with one another, even after years of acquaintance, and even friendship.

I was sitting beside the Southern bride of Kerry Rawson, son of a wealthy Boise lawyer. Kerry, that one summer, was playing at farming on his father's ranch, bought as a speculation. His bride was having a great time of it, imagining she was really doing something because she could make sour-cream biscuits. She was an attractive young woman, a college graduate, but oh! so ignorant of real things. And real things are the stuff from which life is made.

That day she was wearing an exquisite frock of peach-colored organdie, with an ashes-of-roses pattern blossoms running over it, and it was lined with soft, peach-colored taffeta. She was a brunette, pretty enough, with mountains of assurance. I felt that shrinking inferiority engendered by my old, patched, Liberty Bond white dress, and of course I would refer to it, as all folks do to any subject they would prefer unmentioned, once they lose their poise. Normally I have very little self-consciousness, being almost entirely unaware of myself at practically all times, a statement which may amaze people who consider me egotistic. I am. I am so egotistic that I can forget myself.

"It looks as though my dress were about to burst out again," I remarked fatuously, grasping at anything to make conversation with this city woman—pathetic, though I did not know it, in my eagerness to conciliate this glorified being from my lost world. Her attention was drawn to the shabby dress—no shabbier than the dresses of all the other farm women present. Then I added, "I suppose it is time for it to burst, or something. I have worn it for years." And I smiled, flutteringly, as though I had made a humorous speech which she must recognize.

She stared in contempt at my pitiful dress and remarked, turning cold eyes away, "Ah couldn't stand to wear a frock mo' than one season."

I deserved that blow, that terrible, cruel blow, for my foolish effort at toadying to a city woman. It was like a dash of cold water, invigorating, even baptismal. I stared, in my turn, at that magnificence of colored rags which had so awed me. I looked around at all those sagebrush farm women in their antiquated, faded, even patched, best summer dresses. Most of them had babies in their arms, as I had my Joe, and every face to me was firm and self-reliant and noble and wise. They could *do* things that the world needed. They made excellent, clean, properly fed homes. They brought large, useful families into the world without complaint. Talk about the salt of the earth! They were the *backbone* of the earth. Without those patient, hard-working women the world must perish. For no man would go on farming alone, or even working as the farm woman does, for any reason whatever. And once the farmer lays aside his tools, the world starves. And I don't mean maybe! Oh, wonderful, self-sacrificing, self-immolating, pioneer farm women! Oh, precious, invaluable farm women on every farm! Oh, blind and greedy world that rewards them only with forgotten graves!

171

But I must not be too intolerant of that young bride, so haughty in her sense of superiority, the swan...no, the jackdaw there among us swans. Her eyes were not opened. I knew how she had come there that day. Her young husband was trying to look at ease with a group of red-leather-colored farmers. Both of them were playing at going to a farm picnic. They thought they were really living it, but they had none of the reality—just dreams. They knew they could escape any minute. Dad was up there in Boise with the money ready for their transportation, and a beautiful home was waiting for a worshiped son and his bride.

How different it was with all of us—yes, all of us—for we were trapped not only by our poverty, but by our passion for the land! Passion of any kind places you at a disadvantage in life. You can never be free to make other choices.

My father was what might be called a wealthy man, wealth being a comparative matter. At least, he owned two beautiful homes, as well as a cañon home better than our farm-house, a cañon home with running water, tub, sink—things which would have made me feel rich to have. He had other property with houses, interests in many mines, and a drug-store which my brother Bert managed and made profitable.

He might have helped Charley and me, but he did not. He was a very sick man, his mind scarcely in this world at all. I had a stepmother, about the same age as my older sister, kind enough to me, but not as a mother would have been. My father had one horse from Kentucky which alone cost him a thousand dollars. Yet I never expected help from him. I am glad it did not come. We might have held on to the farm, and I should have been a worn-out drudge, with no strength to write this book about farm folks—the first book to be written from the inside by a pioneer farm woman, and, hardest fate of all, a pioneer farm woman of a type never before known—touching elbows with civilization, serving a mythical market which never by any chance could be in favor of farm folks. I thank God that my father had not the heart, because of sickness and other factors, to see how his daughter and her little children were suffering. It is the long run that counts in life.

172

THE TOOTHPICK-PILLARED PORCH
The dog Tag, Charles, Walter on the colt Florry, Hib, the master baker, and a farmer friend.

MY GIRLHOOD HOME
Dr. Pike's house in Provo, Utah: twenty rooms, terraced lawn, grounds occupying a quarter of a city block.

I turned pitying eyes upon my neighbor in the peach-colored organdie frock. "Wouldn't

173

you like to come to a meeting of our Literary Society?" I asked her, thinking that if she became acquainted with those farm folks she would see that there was something greater than fresh frocks every season.

"Why, yes," she said, her eyes kindling at the thought of another farm thing she could play she was doing—she would have plenty of stories to tell how she and Kerry went on a farm when she married him.

So she came one night to go with me to the school-house. She and Kerry were too early, Literary not beginning for an hour. I sat and talked to her—or, rather, she gave me an intelligence test, in the course of which she discovered that I had studied in three colleges, one of them the University of Michigan. At the name of that institution I saw her stiffen, a look of horror coming into her eyes.

"Ah know about the University of Michigan," she declared. "Ah had a friend, Pete Stevens, went there; from Alabama, he was. But he didn't stay. Would you believe it, Mrs. Greenwood, when he went into a classroom, theah sat a big buck niggah, and my friend, Pete Stevens, he said to that big niggah, 'You get out of heah, you niggah, you! What you doin' in this white man's college?' And would you believe it, Mrs. Greenwood, that big buck niggah didn't make a move to go, but just sat theah, and he said, 'Ah got just as much right to be heah as you have. Ah paid my tuition, and heah Ah'm goin' to stay!' And with that my friend, Pete Stevens, he said, 'Well, if you stay, Ah go!' And he marched out of that college and nevah went back!"

I felt an inward scorn at this intolerance. But don't give me too much credit. Had a colored man come to her door, the Southern bride would have called him a "niggah," and fed him, and given him work. I might have fed him, but it would have been with that peculiar squeamishness which Northern women feel who have never had anything to do with Negroes. I saw but one Negro in my entire childhood, and I did not see a colored woman until I was an adult. I am certain I could treat them as human beings, and shame on me if I could not, since I so treat dogs and cats. But I have not yet learned the easy familiarity of the Southerner with the black man. I don't think my scorn of Mrs. Rawson need be taken too seriously.

It was not until I was walking down the hill with the Rawsons that it occurred to me what a terrible breach of considerate hospitality I was about to commit. In my hand were sheaves of paper: I was to give a book review that night, the topic being *Up from Slavery*, by Booker T. Washington. How could I ever explain that this was not a deliberate insult?

On the program I read the review—I consider that one of the greatest autobiographies ever written—and I waited for Mrs. Rawson to march out of Literary with head high. She did not make a move. I could see her eyes wandering over the indigent-looking audience, most of the men needing hair-cuts, their long locks plastered with water but sticking out at the ends, and most of the women with attempts at keeping up with the styles in coiffures falling pitifully short of their object. Mrs. Hatch always oiled her hair, which fascinated me, for I was intent on getting rid of the natural oil in my hair with a weekly shampoo—laundry-soap shampoo. The younger generation were advertisements of their various mothers' tonsorial aptitude. We sagebrush women cut all the hair in our families.

For years I barbered my youngsters' heads, even doing a pretty expert job on Charley. Toward the very last of my years on the farm I laid down on that job. This was really the beginning of the end of my slavery. The whole family seemed to have but one idea when there was anything to cut, from rubber boots to wire—my hair-cutting shears. If there is any barber reading these lines, he will know how I used to feel at the weekly hair-cutting when I found my shears dulled and nicked. I bore this, and bore it, not without complaint, and at last—a last which had lasted years and years—I said, "I will not cut another head of hair!" I was a little aghast and astonished at my own voice, scared even, and then tremblingly elated.

The whole family stared at me in dismayed surprise. I think they saw themselves dragging around yards of hair for years to come. It would not occur to them that any one else might cut their hair. And we certainly could not afford town barbering. But we could afford tobacco—smoking and chewing. I had never uttered a single complaint about either habit, and they

174

were not the reason for my rebellion. They were only the justification. I cannot imagine a farm woman having any habit that would require the expenditure of a single penny for herself alone. Mary E. Wilkins Freeman, while she was still Mary Wilkins, wrote a story of a farm woman, in which she incidentally described how this woman ate the scraggy edges of the omelette that the rest of the family might be spared that sacrifice. A New England farm woman that...well, I suppose the nature of a farm woman is always the same, whether on a parsimonious, stark New England farm or on a pioneer sagebrush-desert farm.

Mrs. Rawson was sizing up all those farmers, their wives and children. "Yes, Boone, deah. Ah act'ally began my ma'ed life on a Weste'n ranch. You have no idea what rough, uncouth people Ah lived among...."

I waited for the explosion of indignation from Mrs. Kerry Rawson. Then, as she smiled vaguely at me while I was taking my seat at the desk in front of her, I realized that she had not heard a word of what I was reading. Her mind had been far from my effort.

"UP FROM SLAVERY" was my last book from the outer contemporaneous world. Until that time I had reveled in all the current biography, philosophy, psychology, and like subjects. I began reading the best fiction when I was a very little girl; writers of every nation interested me, and, being omnivorous, I practically read myself out along that line. The day I discovered what my father's big library meant for me is marked as one of the most notable in my life. I happened to open *The Arabian Nights*, read a few lines, and my heart literally stood still—at least that was the effect upon me. I remember looking up, child that I was, and thrilling at the vision I saw of endless worlds which opened to me. I was not just Doctor Pike's daughter Annie, I was an adventurer through the ages. Oh, my dear books, how I love you! I shall never be able to express what reading has meant to me. It has liberated me when I was in slavery; given me joy when I was in the midst of bleakness; taught me control of a nature too passionate; revealed to me myself.

I read so much fiction in my younger years that I scarcely ever read it now. Only superior craftsmanship can lure me in that direction. I have never needed to be entertained. So, for years on that sagebrush farm, while I worked from dawn to dark, I read my few pages every day, remembering them, exhausting all that was best in the books that most interested me.

What enabled me to do this? It was a beneficent arrangement which brought the books to our door from the State Library at Boise. I had learned that a case might be obtained by any responsible farm person if the carriage from the Library were paid. I wrote things for editors, and the checks paid the freight.

The mail; boxes from our relations; the traveling library case—such joyous occasions as no power of wealth can surpass! I could hardly wait to get my work out of the way before I sat down on the floor in front of that treasure case, to handle those books and read snatches here and there. To be perfectly frank, Jeanette Bennett and her brother George and I were almost the only readers in our neighborhood. The Bennett children, city-bred and born readers too, read the fiction; I read the nonfiction. Surely it was worthwhile to feed three such starving souls in the desert.

Then an appalling thing happened. A case got lost in transit, and the State Library would send me no more. I cannot see how I could have been to blame, since the case was being forwarded from Boise, yet I had to be punished. I suppose some one was reprimanded at the other end, and the farm woman had to bear the reflex of that blow. Probably the person involved, no doubt as innocent as I, determined that she would be responsible for no more books that I could lose. The solution oftenest presenting itself to me was that I was under suspicion of having made away with those books, for the letter regarding the lost case was all but insulting. Just another of those unjust visitations on the farmer's family because there is no power there to retaliate.

All my life in the sagebrush I was forced to speak two languages. The one was the restricted, halting tongue of two or three syllables, chosen carefully, and with painful precision of selection, that nothing might be misunderstood and that the stigma of pride of learning might not be fastened upon me. I was free to use the other only when I was writing. I must confess that an *Unabridged Dictionary of the English Language* is the most exciting book I ever read, and I cannot

pass a day without reading it, a habit which dates back as long as I can remember. I have a storehouse of words which I dare not even write—lovely, juicy, marvelous, magic words, which, written, would be called "pedantic." Yet they and many of their foreign compeers are my beloved, horizon-stretching friends.

THE WAR! THE WAR! Down at the school-house was a constant boiling, like a great kettle, patriotic city steam scalding the quiet rural air—speeches, speeches, speeches, to pry loose the few coppers still clinging to the interiors of overall pockets; to make farm women cook such penurious concoctions as city women would scorn to attempt; to force contentment with barley and oatmeal when the farm granaries were bursting with wheat; to give, to whom you knew not, to do without, for what you could not be sure.

Because there was a cook-stove in the Teacherage, the sagebrush women were called there by the Government home-economics experts, dressed, these college cooks, in immaculate, starched white, with smooth, untroubled brows and delicate, perfectly manicured hands. They had called us together to lecture us on food conservation, us who were the champion food conservationists of the world—pioneer farm women, struggling without money and almost without materials.

We sat there in the Teacherage, on chairs we had brought with us, and watched those women demonstrate the making of bread with a pat of dough about the size of a baseball, smiling condescendingly, as they did so, into our enigmatical sagebrush eyes. Those college cooks had no faintest suspicion that the night before we had battled with dough the size of four footballs, and that we had left at home, when we had come, the great, sweet, light loaves airing on our kitchen tables, before stowing them away in the tall cans used for bread-boxes, bought for a small sum from the grocery stores, no manufactured bread-box being large enough to accommodate any batch of farm bread. Not only had we just baked it, but such a batch would be baked several times a week by each of us farm women. So much foolish advice is wasted on farm folks, who just lie low, not sayin' nothin', like old Brer Fox. But lots of good it does them, for citified Brer Rabbit always has a Tar Baby to stick to Brer Fox no matter how he may struggle, thus reversing the original Uncle Remus story.

Then there was that night in the school-house when Frontier Grange showed how dumb it was to a city speaker. City-dumb, I mean, for there is nothing so dumb to a farmer as a city man trying to talk farm—country-dumb. In a fit of patriotism the National Grange had filled a Grange-magazine issue with doggerel "of-thee-I-sing" efforts, using borrowed tunes, even as our national hymn of hate has for a scandalous number of years taught churchers and little children the drinking-song "Anacreon in Heaven." (Dear me! Debunking "The Star-Spangled Banner" again? Don't you know, woman, that Congress decided all that? Yes, and Senator Reed Smoot tried to exclude the unexpurgated great literature of the world, forgetting, or perhaps not being familiar with the greatest of all—the Bible. My tender mind traveled from Genesis to Revelation twice over, and dipped in at scattered intervals of print, and was not thereby besmirched. Dwelling upon the unspeakable is what besmirches.)

The school now owned its own organ, which was even followed later by a piano. Some farm woman played, while we Grangers stood, open National Grange magazines in hand. Our eyes were fixed on the speaker of the evening, a lawyer from Rupert, long afterward sued for sending obscene matter through the mail, which has nothing to do with the episode I am relating, unless as a matter of revenge, since brilliancy and beauty may be the ornamental architecture built above a cesspool.

This speaker was famous throughout southern Idaho, and we were feeling very happy about being honored by his presence. We were all horse-tired after the long day's work, and none of us, except possibly Old Bab and Baldy Parsons, had any ambition to be a singer. But we must sing for our country, and so that was what we did. Some one at National Grange Headquarters was lacking in visual or auditory imagination, or never would such a tune as "Old Black Joe" have been

176

considered appropriate for a patriotic song that should inspire farmers to put more mortgages on the farm for the sake of the United States of America.

We sang, trusting eyes fixed expectantly, proudly, gratefully, on the speaker-to-be. But we did sing somnolently, without exclamation points or flag-wavings. We were tired.

O-o-o-o-old Glory,...O-o-o-o-old Glory,...
Old Glo-o-o-ory wa-a-a-aves on hi-i-i-igh....
We'll li-i-i-ive for yo-o-ou, Old Glo-o-o-ory,
And for yo-o-o-ou we-e-e-e'll di-i-i-ie....

We sounded as though we were already dying, right then and there, reminding me of a band of melancholy cattle mourning under the freshly skinned carcass of one of their number, strung up on the beam of a hay-derrick. And then something terrible happened. The handsome speaker leaped to his feet "as though stang by a bee" and, brandishing a fist in our bovine countenances, he yelled, "For God's sake don't sing like that! If you give to the War like you sing, we cannot expect much from you!"

The speaker was no doubt handsome, and he was certainly, from all reports, a magnetic orator, but he was neither a psychologist nor tactful. We were dead on our feet, yet we had been willing to come to have him wheedle the blood out of our veins. We had stood up when we would rather have sat down; we had tried to sing when we would rather have remained silent. And now we had been bawled out for our efforts.

I was always very sensitive to changes in the atmosphere of sagebrush farm audiences. I felt the chill that suddenly pervaded the whole mass of human beings crowded into those school-house seats. The speech began, the orator being just as good-looking as before, and he made an astonishing, highfalutin, spread-eagle, star-spangled speech, yet that night there was promised for the cause of the War the smallest amount yet pledged by those poor sagebrush farm folks.

You cannot slap a farmer in the face and get away with it. He may look dumb, but something is going on inside him which is not dumb. It takes tired men a longer time to think out an injustice, and it takes them just as long to get over it. They have no time to train for thinking, and they are too tired to do it. They plow their brains into the earth that you may eat. Somebody must do their outside thinking while they provide the bread for the world, or the day is coming when that great mass of suffering dumbness is going to stop the wheels of government. Your prize anarchist is not a Communist, but a farmer, and with good reason.

OUR GOVERNMENT was snooping around everywhere, feathers and wings spread, pecking this way and that, like a broody hen. It behooved each man to leap first, crying "Traitor!" in order to avoid being leaped at with the same damnable epithet. The self-righteous One Hundred Per Cent Pickled Americans, of whom I was one, went about in the armor of holiness, casting eyes of suspicion and hatred upon everyone within their range.

We sagebrush folks hounded good, old, blameless Burkhausen, and our Government was hunting down the foreign-born who lacked citizenship papers. Out of the cities of the East rose a great horde of the hunted, moving like a tidal wave toward the wide-spaced farmlands of the West, where they might lose themselves under the privileges of agriculture as an essential industry. Particularly the artists and thinkers surged toward us, all ambitious to be farm hands.

The first of our deportation farm hands was Mischa Pushkin. If he or any of his people read this book, I want him to know that never would I have parted with him if the decision had been mine to make. I would have been willing to slave on my knees, my broken-nailed hands raw from the scrubbing-brush and soap, if I could have kept him. For he was a wonderful artist, a fine musician, and music means so much to me. From those artists and musicians among my ancestors, I was born an instrument on which the arts can play.

Mischa Pushkin was a delicate little fellow, blonde-haired, with fingers which almost emitted harmony of themselves. He brought a suitcase and a violin-case. The Warrens, folks who had bought land for speculation purposes and who left us soon afterward, had sent him to us. He was married to their niece. They sent him, they said, to be our unpaid farm hand.

177

I fixed the upstairs bedroom for Pushkin—cheap iron bed, old-fashioned wash-stand, chair, dresser, worn rug. But he had four gorgeous pictures, framed by the four windows in that room—the checkered gray and green of sagebrush and alfalfa, and beyond that the blue Minidokas, lovely, enchanting mountains.

I was sweeping the living-room the first time I heard Pushkin's violin. I would like you to see me there, dressed in my white black-dotted house dress, a nurse's little white cap controlling my fluffy blonde locks but not hiding them. I learned that trick of the becoming little caps while I was in the hospital after Rhoda's birth. I do not know whether the custom still persists, but while I was there, my little white caps swept like a contagion among the sagebrush farm women, giving us all a picturesque uniform head-dress which defied changes in style until we went to the school-house meetings, for only then were the little caps discarded. We had something of the artistic look of Brittany peasants.

You can see me sweeping away on the linoleum of that living-room. Suddenly there came those full-voiced notes from Pushkin's violin, in harmony so exquisite that I was transfixed, face uplifted toward the sounds, broom gripped rigidly in my hands. Brahms, I think it was. I was so agitated that my memory of the feeling it gave me is more vivid than the identity of the music.

I do not know how long I stood there, petrified, "Statue of a Woman with a Broom." When I came to myself, my eyes rested on the stairs which ran up one side of the living-room, with their plain banister of a slim square piece of timber. Huddled there, chin resting on fists, elbows on knees, was Walter. It was taking him longer to come from under the spell of that music than it had taken me. His would have been my case as a child, but the world of practical living had racked me into a pained apprehension of its existence from my native planet of music, art, literature.

I had fourteen dollars I had earned writing. Once again this was dedicated to the buying of a new summer dress. But that pitiable figure on the stairs—my beloved first-born! I love all my children, each holding a place in my heart sacred to that child alone. I am hurt and healed by what happens to each of my children in a different way with each child. My beloved eldest-born, you will never know how I have brooded over you in secret; what tears I have shed inwardly for your frustration; how I would have laid myself, body and soul, on the altar of sacrifice for you, had it been necessary or possible.

I spoke to the Baron about having Pushkin give Walter lessons. Pushkin himself, feeling, I am sure, his inadequacy as a farm hand, had suggested this means of retaining his place on our farm. It was a heaven-sent opportunity. Fourteen dollars might begin payment on some kind of fiddle, and in the evenings, after my day's work, I could sit down at the old typewriter and plug out something more that would keep the instalments going. But Charley said positively no. He would not have Walter fiddling, and he would no longer have Pushkin on the place. The Russian was worthless as a farm hand, he said, and so no longer welcome to his board and room.

Two excuses I have for Charley: for one, he had keenly sensitive ears, and for the other, farm men are never interested in the pursuit of the arts for their children. It is the farm women who lift their children above the soil. All around me, out in that sagebrush wilderness, the last frontier, bounded on all sides by what we call civilization, what aspiration there was came from the women folks—for their children. Many children in the Greenwood District were studying music after a fashion, though it must be admitted that their performances convinced me they were almost all paralyzed in their music sense. Still, who will say that trying to produce music is not better than sinking into a milking-plowing-chawingterbaccer machine?

There were those two excuses for Charley—not very good ones though, for he might have borne the fiddling of his own child, and, fine as he was in so many ways, he should have been of superior fiber to the majority of those stubble-bearded, manury-heeled farmers. No! I will excuse him no longer. Only for those wrongs against me, of blindness to my natural atmosphere, do I forgive him, for I have not a doubt that I wronged him just as grossly. We married folks do that to each other. Whenever I hear of one in a marriage who claims perfect happiness, I wonder how much that happiness is costing the other one. Marriage is give and take—sometimes joy, very often

178

misunderstanding and pain.

I do not excuse myself for what happened then to Walter. I was to blame for not raising proper hell until I got my way about that opportunity, which, God forgive me, never came again. I was very mild on that farm. I can recall only a single occasion on which I showed temper, and of that I have forgotten the reason. But I was so mad that I flipped my dish-towel in the direction of the Baron. The thing that is most impressed on my memory was Charley's look of stunned astonishment that I should be showing that unusual temper and in such an extraordinarily vulgar manner. I retired at once to the kitchen, and there I doubled up with laughter. Oh, I have fought with people, but not with my relations. I flew at my brother just once in all my life, and that not many years ago. There was silence between us for a moment; then we both burst out laughing.

There are occasions when to blow up may mean the salvation of some one—yourself, or the defended one, or even the one blown up. Especially the one blown up. In my married life on that farm I did not blow up enough. That does not mean I failed to act. I am an introvert made extrovert by fate. I am never content to be a mere spectator. I want to use as much of me as possible in doing something every minute. But I am patient.

It took me eight years to lie down on the job when no fence was put around the big kitchen-garden I raised. I did that stupendous labor, with a hoe and my hands, for eight years, along with all my other work, and watched the horses trample it, the hogs root up the potatoes, the cows eat my Golden Bantam corn; the chickens scratch up my seed and peck the cheek of every beautiful tomato. I was more patient than Job, for Job was the least patient individual in all literature. He reproached God, and quarreled with him, and complained, until God is the one who should be called patient that he did not snuff Job out, instead of Job getting the praise because he was bearing, impatiently, that from which he could not get away.

At the end of eight years I amazed Charley by no begging for seed, no yearning over the soil of the garden-place, no mention of growing things. I did not even send to Burpee's for a catalogue, but since for years I had patronized them, they sent one anyhow. I did not even open it. I did not rise at four, through a passion for growing things. I actually lay in bed until five in the morning. When I rebel, I rebel. I was through. Even a fence would not have impelled me out to the garden. I had suffered too much. I WAS THROUGH.

I did not have eight years to form that iron resolution which would have meant the beginning of a musical education for Walter, if not for a profession, then for a glorious release. I blame myself for not going ahead, anyhow, and having Walter take lessons under that all-but-genius, Mischa Pushkin. But I was young, and Charley was my husband, and I was always thinking, "I must be as good a wife as..."

Just how far should the will of one partner in a marriage be forced upon the other where their children are concerned? There can be no arbitrary decision. But it seems to me now that every marriage should be a dedication to the future of the children of that marriage. What greater thing to achieve in life? Not in indulgence, but certainly in self-sacrifice, lies the great opportunity for noble action given to parents, who must expect nothing in return.

Everyone should be educated from birth in the psychology of sex, marriage, and parenthood. Had Charley and I been trained in our duty to our children, he would have agreed with me, as I should have had enlightenment enough to insist, that Walter be given lessons by Mischa Pushkin, him who had been commanded, when a child, to play before the Czar, who had accompanied with his violin most of the great singers of our day—I saw his press-clippings. But now, forever, I am haunted by the memory of that pathetic little fellow, crouched day after day and hour after hour on that primitive staircase, listening to the music of Pushkin's violin. My beloved eldest-born, you cannot forgive me. I do not deserve it. I do not blame you.

The surge of the hunted aliens began to sweep over our sagebrush land its flotsam and jetsam of farm hands of every description. It brought to us English George, conscientious objector, and Russian-Pole Gus, with unpronounceable last name. Never shall I forget the terror that seized

179

me at sight of Gus. Charley had seated the two young men—Gus a good deal older than George—in the living-room. I did not know they were there, and as I took into the room a glass lamp that I had been filling with kerosene and polishing until it was like a diamond bowl in my hands, I saw Gus for the first time. I was so terrified I simply stood still and stared at him. His appearance seemed to me most barbarous—the slightly oblique black eyes, broad, high cheek-bones, mysterious atmosphere of power.

English George worked for us only a few days and then was transferred to a help-needing farmer. Gus was on the plow at once. He took Pushkin's place. Evidently Pushkin had never handled horses before and was a little afraid of them. While plowing he exasperated Charley and bewildered the horses by a continual stream of "Get up!...*Whoa!...Get up!...Whoa!...Get up!...Whoa!...*" It was ruining the horses, so Charley had to take him off the plow. "Put him to work in your garden," he said.

Put him to work in my garden! I said nothing. I never did make objections in those days—and the garden fence I wanted I never got. When the Baron told me to put Pushkin to work in my garden, he revealed that he had forgotten two things: what expert care is necessary in the raising of vegetables, and that the family must depend on that garden for its food, winter and summer, except for meat, butter, eggs, milk, and flour. The exceptions look bigger than the rule, but try living on those things alone and discover what it means. We literally lived out of the garden in the summer, eating almost no meat then excepting when there was help—and again, the exception seems bigger than the rule. Meat meant big pot roasts to be cooked in the pressure canner at threshing or haying or spud-picking. The rest of the time we ate bacon and chickens, I killing, picking, and cleaning the fowls.

I watched Pushkin sow handfuls of lettuce-seed in great gobs and sprang upon him as though stang by two bees. "I'll sow the lettuce," I said, fixing my mind on his heavenly music in order to born the self-control necessary for any one who loves to garden—*sowing lettuce-seed in great gobs*...my heavens!

"You plant these onion sets," I suggested gently, punching holes with a stick at the right intervals along the row, so that by no chance could he be led to sow the onion sets in gobs.

There we spent an hour or so, my Minneapolis Symphony violinist and I, the sweet air rolling up to us from the greening valley. His mother had been of the Russian nobility. I wondered if she saw him now, down on his knees near the farmer's wife, thrusting onion sets into the fertile volcanic ash with his violin fingers.

Charley and I were consumed with ambition to do everything possible that would help to feed the world. I had encouraged him to add what was known as the Wolf Forty to our one hundred and twenty acres. It was a beautiful piece of property, adjoining our farm on the east. Every bit of Charley's time must be given to irrigating so large a ranch—though not large as compared with most Western farms. He had to have hired hands and could get none. Pushkin was our first hope, a hope which fizzled out. Then the full tidal wave struck the Greenwood District, and the farm lands swarmed with the hunted aliens.

Counting Pushkin, we had at one time four farm hands, two sleeping on some hay in a wagon, one in the granary, and the violinist upstairs. The Government told us we could not be patriotic if we used sugar and flour for cakes and pies, so my burden of cooking was somewhat lessened. I had only to feed ten people three hearty meals a day—country meals, not piffling city pick-ups. Three hots every day. Breakfast: stacks of waffles or hot cakes; French fried or German fried potatoes (but we must not mention the word *German*); bacon; eggs in any form; muffins, biscuits, or toast; jam. Breakfast was begun with stewed fruit of some kind. We rarely saw oranges or grapefruit, such novelties being festive events for the children. Bananas, too, were rare. Dinner at noon was a big meal, almost such as the city families have on our eating holidays, Thanksgiving, Christmas, and New Year's Day. Supper was almost as big, with the addition, for dessert, of oatmeal, cooked to custard in the pressure canner. And coffee three times a day.

I had been making pies and cakes almost daily, with several big bakings each week of

bread, rolls, and fancy breads. I had enough to do, even relieved of pastries, for there was the big kitchen garden to hoe and irrigate every day; the chickens to set and hatch and care for; the washing and ironing for those ten people; and the added mending, for I could not see even the hired hands going around in rags when a few minutes and a needle would set them right.

Much of the mending I did on the sewing-machine we had bought in Kansas at a sale. I felt a little guilty every time I used that sewing-machine. The million-dollar sugar-factory had imported the Russian-German beet-raisers under contract. When some of those families thought they were not being dealt with fairly, they tried to leave the country, and the sugar-factory seized their household goods and sold them. My machine had been run by one of those Russian-German women.

One of our hired hands was an Arkansawyer who had never laid eyes on an irrigation ditch until two weeks before Charley hired him; one was an English conscientious objector; one was an I.W.W. who was also a Russian Bolshevik, a disciple of Trotsky; and there was Pushkin, who had never before eaten at table with the proletariat.

There were many heated arguments at the table between Pushkin and Gus whenever Charley happened to be absent, each claiming to be the better Trotsky man. In one of these I accused Gus of belonging with the I.W.W., a fact which he admitted with a smile. I told him to tell Mr. Greenwood, not being sure whether he should remain. Gus was splendid help. Charley had to have help. Therefore the discordant views of Gus were overlooked.

I shall be forever grateful to Mischa Pushkin for an unconscious service he rendered me. When I found how useless, even destructive, he was in the garden, I would no longer allow him there, taking over the irrigation myself. His only idea of irrigation had been to flood the garden, making it necessary to cultivate, with rake and hoe, every inch of the surface. Besides, many plants and seeds were washed away.

By going out to irrigate while the two babies were asleep, leaving the noon dishes to he washed until I was through, I could manage very well. It was a few days before Pushkin left us that he came out of the kitchen door on his way to visit his in-laws down the road of the Lincoln Highway, and as he turned the corner of the house, he called to me, "Mrs. Greenwood, your baby is crying."

I was surprised at that, for I never had crying babies. Little Joe had been made comfortable in bed and was asleep when I left, and he would undoubtedly go back to sleep. I hated to leave the irrigating. The water had not crawled entirely the length of the corrugations, and, besides, the work of irrigation is most fascinating.

I had put Joe to sleep in the bed that stood in the southeast corner of the bedroom, and Rhoda's bed was in the northwest corner. After pulling the blinds down I had opened the window at Joe's head about six inches. When Pushkin said my baby was crying, I was surprised. I had left him asleep, and, besides, I did not have crying babies.

The irrigating had to be done, so my first inclination was to stay in the garden until the water reached the foot of the corrugation, spaced according to the room needed for the vegetables planted. Everything in a garden fascinates me—irrigation, planting, spraying, picking the big worms from plants...and under any other condition I am demoralized at the sight of a worm. It would not hurt the baby to cry....I had made him comfortable, and he would go back to sleep....But my feet carried me to the house without my own volition.

Something must be burning in the oven. I looked in. No, nothing. I opened the bedroom door. A great cloud of black smoke gushed out of the room into my face, and I could see the mattress beyond a mass of leaping flames. Of course, my first instinct located my babies, seated side by side in the other bed and crying in fright. Neither of them had any experience with fire, and nothing had been said to make them fear it. Yet they knew.

Without reasoning, I beat down the flames with my bare hands, working so rapidly that the fire was smothered. How I did it I cannot now understand. Then I seized the smoldering, smoking bedclothes and dragged them into the yard. Back I sped, and the mattress was dragged out

181

in the same manner, the great burnt hole still red and smoking. Ordinarily I could not have lifted that mattress. Frenzy provided the power, the power of the insane, which I had known from a very little girl, when one of my father's asylum patients dragged him the length of a long ward by his beard.

I went back for Joe and Rhoda. We three sat down upon the sloping door of the dirt cellar, our hearts still beating wildly, and I know I must have been as white as those two poor, terrified babes. Falteringly Rhoda told me how she had found a match in her father's dressing-gown—the gorgeous one I had bought him for Christmas the second year of our marriage. I had taught her to bring all matches to me, for with the farm men all smoking around the place there were matches scattered everywhere. I had always thrilled her little heart with my extravagant praise for this act. She had called and called, and I had not come, and then she thought of striking her find. The flame had bitten her little fingers, and she dropped the match on the inflammable cotton-lined quilt. There was immediately a burst of fire like an explosion, which had sent the baby girl out of her bed to her brother, and there the two clung to each other and screamed.

So I thanked Mischa Pushkin, little as he knew what had happened, and little as he deserved my gratitude, in one sense. A day or so later he left. English George was already gone, but the Arkansawyer and Gus remained as our farm hands, the Arkansawyer now going home nights to his little family. They were campers, and they lived in a covered wagon, one of the last of the Westward, ho! caravans to the last Western frontier. Gus preferred to continue sleeping out-of-doors, but he liked to talk to me in the cool summer evenings, while I mended.

Charley was always so tired when he came from his long day's work that he would go to sleep over his paper or magazine, sitting in his big chair near Gus and me. I was on one side of the table, in my white, black-dotted house dress, wearing my little white cap on my fluffy blonde hair, my needle weaving in and out. Gus was on the other side of the table, his wild, barbarous handsomeness no longer wild and barbarous to me. I could no longer imagine how I had come to be so frightened of him at first sight.

Gus was a graduate of Columbia University; his friends wrote for the magazines I most adored. That was not idle boasting, for every word he spoke bore the authenticity of truth. As he talked, my needle would pause, and I would lean forward on the table toward him, with what expression I knew not in my eyes. Books, plays, music, art—Gus had come from that world which I loved and for which I was starved. And I think he found in me something of an oasis in that wilderness.

He loved to work. He told me, with a shining of good teeth and black eyes, "I love to sweat." And he was so clean. Every day he bathed in the upper canal and washed his shirt, socks, and underwear, hanging them on the native willows bending above the stream. His clothes were not nearly dry when his long swim was over, but he dried them on his splendid body.

He liked to sing. As he plowed, his voice rang across the acres, and his favorite was a Negro melody, of triumphant repeated line,
Sometimes I feel like an eagle in the air...
And when all the joy had been wrung from this, softly floated to my kitchen door the same melody in a minor key:
Sometimes I wish that I never had been born...
And I would stop at my work, so impressionable was I when I was young, my heart breaking with those words, for in truth, in the midst of that terrible labor, with my little, shabby children needing so much and my own ambition as a writer thwarted forever, as I thought, sometimes, I was sure that God had forgotten me and mine, and I wished...I wished I never had been born.

It was while Peewee was still alive and sadly wandering about that Gus helped me band the legs of the chicks in the runway Charley had made me. I tried always to be as scientific as possible about all the things I did. With the aluminum bands I could keep track of the generations,

182

so as to weed out, by eating, the boarder hens—those which no longer laid eggs. I also punched holes in the skin between the toes of the chickens to mark the age of each generation. Bands and puncher were Kansas acquisitions.

Gus caught the chicks, handed them to me, and I, seated on the side of the runway, punched and banded. All around us was a wonderful green-growing world, crops pushing higher and higher, serene blue sky, close above, festooned with a few filmy clouds, the serener valley stretching below, green and gray, and, farther over, the blue Minidoka Mountains. We were both subdued to the mood of the lovely, quiet day. Gus was leaving us on the morrow.

The neighbor to whom we had sent English George was also a One Hundred Per Cent Pickled American. While George was out in the field, our friend had searched the lad's pockets. Being without honor, as are all pickled people of every description—religious, political, professional, he felt at liberty to trespass in any manner possible. I.W.W. literature was found in a pocket of the boy's coat, and unmistakable evidence that he was a conscientious objector. Not to be willing to murder his fellow-men told damnably against English George. He was hustled into the county jail. Charley told Gus of the matter, and that was why Gus left us—to go to the succor of his friend. George had been released, however, and was gone. But Gus was immediately locked up as a dangerous suspect. He wrote us later that he had talked his way into jail and then talked his way out again. I could well imagine his doing both.

WE WERE now down to one farm hand, who moved about the farm and in and out of the house as silently as a shadow. I could have no help myself, for the Arkansawyer cost us a hundred dollars a month and board, and yet he knew nothing of how to farm irrigated land. We were paying high for the war, yet all our prices were arbitrarily fixed by those who never thought of computing the cost of productions; consequently we were able to pay almost no debts except labor costs. Good Old Grandma Government told us we must go into debt to feed some of her sons whom she had sent out to murder her neighbor's boys. Logical that, don't you think?...Sane?...brainy?...Christian?...decent?

I went absolutely nowhere, and I worked from dawn until dark and was never rested. My fingernails were broken below the quick, and my heels were cracked and bleeding. I was the Great Beast of Burden of the American nation, the Forgotten Farm Woman—not just then forgotten, but forgotten throughout all history. There were times when it struck me as a terrible way to live, and, as Gus used to express it, I longed for the Open Road.

That summer, while the lads of many nations were butchering each other Over There, my children knew only happy tranquillity on the sagebrush farm. Walter and young Charles went swimming in the weir, flies droned about, myriads of birds darted and winged above, and the mountains and valley below us were visions of hazy blues, greens, and browns. The two boys were really going barefoot for the first time in their lives.

They had tried going barefoot several times before, but the cinder path, the sharp-edged lava rocks, and the stiff stubble of the cut alfalfa were too much for them. Now their father told them that they should be ashamed to wear shoes in wartime, for the Civil War, in which his Yankee father had been a soldier at nineteen, had started the fashion of shoeless urchins. Since the World War was something real that these little fellows could share with the grown-ups—and how grateful children are for such interests!—they bravely trod, if somewhat gingerly, the alfalfa stubble and the rough, sharp earth.

The two boys were working for Liberty Bonds, beginning with the War Savings Stamps. Each of them had a milk customer, there being two city speculator families, without cows, at some distance on either side of us along the Lincoln Highway. Little Charles trotted, barefoot, to one with a bucket of milk, and Walter trotted, barefoot, to the other with a bucket of milk. The stamps were bought. The boys watched with proud eyes as each one was glued in its place on the squared card. And that was all there was to it, so far as they were concerned. Our debts had to be paid. If Uncle Sam kept our prices down below costs of production, we had to get money some way to pay our grocery bill. So the stamps went for that.

It hurts me to think of those War Savings Stamps—of those little, bare, trudging feet. But I am indignant clear through when I think of my hundred-dollar Liberty Bond. My father had given me that hundred dollars with the words, "I want you to put this away somewhere so that no one can get hold of it. When I was a young man, many a time I walked the streets, desperately in need, when a hundred dollars would have meant a godsend to me." He was a sick old man when he gave me that present, and I think his mind was already fearful of the will he finally made, in which he called my own mother by the wrong name and made other glaring errors, a will dispossessing his children of their own mother's right in what he left. I was the one who blocked the suit to break that will. I did it out of respect for my beloved father's memory. I could not bear publicly to accuse him of being *non compos mentis* when the will was made. Too quixotic? But the farm would have swallowed it all.

I had given the hundred dollars to Charley to put into a Liberty Bond for me, and this he did. The Baron was as generous as possible—when he had any money. I shall never forget the beautiful dress he bought me in Boise, while he was on a trip for the Water Company. All the money he had went into that green dress—looked like spring, he said, and he wanted it for me.

The local chapter of the American Legion was building a hall in Hazelton, to be used for any public purpose of a decent character, especially for dancing. The finance committee approached everyone. We had no money in the world but that precious Liberty Bond, which my father had made me promise to keep sacred for possible future need. The committee promised Charley that if he would allow the Legion to borrow my bond for collateral, it would be safely returned in a short time.

There was a great scandal in Hazelton concerning some one who had made away with the securities pledged in this manner. I never knew whether the charges were false or true. I did not know that the Legion officials, or one of them, had stolen my bond until the need, the desperate need, for that hundred dollars came. I did not even know it had been pledged.

WE ATE strange bread those days, some of it making us sit down to the table with apprehension. It looked as though it had been made in an adobe-yard. Still, my barley and corn waffles and hot cakes were delicious. We did without wheat flour almost entirely, in order that our savings might be shipped abroad. And it made me furious if I found sugar in the bottom of the men's coffee cups.

One day Charley came home and told me he had turned the names of the flour-hoarders in to the Government. A Federal agent had insisted on the disclosure, and Charley had felt that his service to his country required it. For the first time I was a little shocked and dismayed, pickled American though I was.

"But they are your friends!" I said to him.

"I have no friends that are not helping the Government during this war!"

The blood of martyrs spoke there. Charley would have burned at the stake for this worthy cause—or this cause of whose worth he was persuaded. And I applauded him. I applauded him every step of the way—when he renounced his German ancestry; when he helped hound our old German neighbor into buying more Liberty Bonds than he could afford; when he turned on his former friends and betrayed them. Oh, Patriotism, what crimes are committed in thy name!

A woman is always more to blame than a man. Women are the mothers of the race, and the men are their little boys. We women must see straight, and for a long time we have been making a very bad job of it. We covet the trivial responsibilities that belong to the men, and in so doing we overlook the vital responsibilities that Nature has placed upon us. According as the women of the nation accept their job as women, so goes the welfare of the nation.

Joe was still a baby at that time, and I was still suffering from the phlebitis which had made me unable to walk the first winter after his birth. I suffered inferno as I worked. Charley was irrigating too large a farm for one man, with everything else to look after. Our Country! We must struggle on, in poverty and pain, for something we had named *Our Country.*

Wash-days were hardest for me. The children were always mud-grimed, from making

play dams in the irrigation ditches, from sitting in them, from all sorts of dirt and water contacts. Those muddy clothes were not the worst of it. There were the men's dreadful bandanas, stiff with mucus, and the men's equally dreadful socks, stiff with dirt and sweat. I made washing easier by calling the socks the Dirty Berties, and the bandanas the Filthy Bilthies. I sang hymns, too, that I had learned in the school-house church, and they were all about the good Lord saving my little peanut soul. The smell of hot suds always makes me feel sick. It was not so bad when I could wash out-of-doors, though the labor of carrying water from the boiler in the house was hard for me. Yet I still love to see a line of clean, fresh clothes billowing in the breeze.

In summer I always crawled out of bed an hour before any one else was stirring, to work on my beloved kitchen-garden. I always felt very near to God there, so early in the morning, with the dew still beading the green stuff, even though I might be quarreling with Him before the day was done.

Ray McKaig was still at his work of organizing the farmers into the Non-Partisan League. He said we were to have as our head representative Senator William H. Borah, because he had put into the Republican platform a plank advocating the public ownership of electric-and water-power. And lots of good that plank did us—got the votes of the farmers, and then it was forgotten.

At haying-time Charley told everybody his help could not have supper at our place. I thought no one would come. I know everybody blamed me, for I was always playing Mrs. Smarty and trying to break agelong customs. No, Charley had thought it out himself, in consideration of me. The men did not like it, for they always count on those gorging picnics at each other's farms, having no mercy on the women folks. I was so grateful to Charley for that. No man but a former city man would have dared to do it. Those mountains of dishes at the end of the day were almost too much for me.

Mrs. Asper had had a serious operation and was really not able to be around. Something happened that her relations could not help her—cutting their own hay, or something. She was a born farm woman, yet she broke into tears as she told me of what she had suffered as she fed that crew of men. Did they care? They never gave her a thought.

About this time Charley hatched a setting of eggs with his mowing-machine, cutting off the mother hen's head at the same time. The children brought the bewildered little chicks to the house, and that night I put them under a broody pullet. She was distracted almost to frenzy next morning when she discovered them. At last, though, I think she was persuaded that time for setting had been shortened on account of the war. We did not have the N.R.A. then, or she would have known that she was operating on the shorter hours of the new setting hens' code.

The children were always bringing me wounded beasts or birds. I had a hospital of them on my back porch. There were birds everywhere on the farm, although our orchard trees were spindling things. They nested on the ground and in the alfalfa—meadow-larks, redwinged blackbirds, mourning doves, purple martins, pheasants, orioles, hawks, canaries, mocking-birds, killdeers, kingfishers, and up above, passing over our heads in graceful patterns, the sandhill cranes, wild geese, and teal and mallard ducks.

There was almost no fruit that summer of the war. We sagebrush women had always depended on a trip to Twin Falls, where the farm orchards supplied our needs. That year the commission men bought all the fruit and shipped it out of the country. And the Government was urging us farm women to can all the fruit possible! The country women of Idaho were robbed, for they could not afford to buy canned goods.

The memory of that time, when my children tagged my footsteps like four little Peewees, is very dear to me. They were always trying to help. I had just papered the rough boards of the pantry shelves, and I dropped some casual complaint to Walter concerning the pestifurious flies (an adjective seriously used by an Idaho legislator while Charley was a lawmaker). A few moments later I was horrified to observe a trickle of molasses all over the fresh papers. Could I have been careless or absent-minded? No. Insanity was the only explanation.

"I thought it would catch the flies," explained Walter, with innocent pride.

Whenever I went to garden, there they all were, right on my heels—little Joe staggering about over everything indiscriminately; Rhoda pulling up the young beets to nourish a milkweed, which she affectionately denominated "thome nith lettith"; Charles thoughtfully working his way up a row of beans and pulling off their heads, to help them through the ground, as he explained; Walter damming corrugations, so that there was presently a maddening network of criss-cross trickles. And Brownie, one of the stupid dogs, who always approached me with head on one side and a positive leer of almost unbridled affection for his mistress, sitting down to adore her on one of her prize tomato-plants. It was often too much.

The boys left the cover off a sack of poisoned oats, and one of my beautiful White Plymouth Rock hens, descendant of prize Kansas stock, staggered out of the granary to die. Charley was milking, and he cautioned Rhoda, "Don't tell your mother about that hen." Two minutes later the tale was unfolded. Rhoda could not bear to see the poor hen die, and she brought her to my hospital, although she was apparently past recovery, comb already purple. With a caponizing knife (Kansas relic) I slit her neck, then slit the crop, removed the poisoned grain, washed the interior with tannic-acid solution, poured a little down her gullet, sewed up the crop with silk, sewed up the neck skin. She was in my porch hospital for a week, then out and singing her laying-song.

Simple events of busy days. Thus we went struggling on through the war, sacrificing all our interests to a cause which nobody clearly understands and whose conclusion is equally doubtful. Through it all, Nature remained so tranquil—enough to shame the passions of man. In the winter the Minidokas were pearly white, the cañons showing in cold blue veins. And the summer evenings were heartbreakingly beautiful. As I gazed upon them from my hilltop height, I experienced a loss of personal consciousness, a blessed oblivion.

THEN CAME THE END of the World War. We sagebrush folks could scarcely believe the news. We took no part in either the fake celebration or the real celebration. We were aware of them only through the newspapers. But the war was over. The papers had no more interest for us. Eb Hall no longer came eagerly up the hill with our mail to discuss a few items head-lined on the front page while I ironed. He was such a clean, fine fellow that it does no harm to say how much I enjoyed him. I was always amused at his never-failing mispronunciation of words. He had chosen the name of his eldest son from the biographical part of an unabridged dictionary in the office of the doctor for whom he was waiting to take to his wife's bedside.

"Finest name in the dictionary, *Aristol*," he declared proudly.

When he was gone, I looked for that name. It was Aristotle. There was another unique name in our district, *Usona,* given to his daughter by Hogan Stinnet. I asked him where he got that pretty name. He said out of Montgomery-Ward's catalogue, name of a stove. I looked it up and found it explained in the catalogue as United States of North America.

Just before the Armistice, Eb Hall came up from the mail-boxes on the school-house corner, waving our newspaper, the ever admirable *Idaho Statesman*. I was ironing in the living-room, and Eb entered full of excitement. "I see by the paper," he announced importantly, "that General Choss is in Berlin."

I was dumbfounded. I knew my war pretty well, but I had missed this Choss fellow. After Eb was gone, I opened the paper, and there in big black headlines I read:
GENERAL CHAOS IN BERLIN

We were all crazy during the war, all but the conscientious objectors. I hereby make avowal that I am a conscientious objector for the next war, and I do not mind if it comes in my time, for I would like to suffer for Peace as much as I suffered for War.

Everybody was infected. Little children could not escape. My babies went around trying to think with their little brains how to make more money to buy more War Savings Stamps to buy more Liberty Bonds to help the Government to send more lads to murder more lads. Such a jolly insanity, that.

Little Charles came home from school, cheeks flushed and big gray eyes shining. "Mama! Don't they give money to people who find out things?"

"Sometimes, Charles, if it is important."

"Well, I have just 'scovered why the sea is salty. It's 'cause all these ships are being sunk by the Germans, and they had lots of salt in them! Do you think I could get any money for that?"

After the Armistice, life went on as usual. Yet not as usual. Such things leave scars. No individual escapes the blow that he deals another. All nations are suffering today from the orgy of murder in which they indulged. Oh, what a mess is this that we call Civilization! What a failure is this that we call *Christianity!* What pitiful savages are these that we call *Mankind*! I had always believed in a God who smiled and had a strong sense of humor, otherwise he would be less than man, and, moreover, he would be insane. Since the World War I am constrained to believe in a God of tears, unshed though they be.

About that best white dress I so much wanted: I never did get it. Charley's lovely green frock did not come until just before we left the farm forever, which was a good thing, for there was no sagebrush occasion on which to wear it—knife-pleated pale-green georgette crêpe over silk, trimmed with silver and pale-green beads, a lovely, springlike dream. I had another best dress several years later, a blue, trimmed with scalloped white organdie, the goods sent by my sister-in-law Laura and made up by me.

But I did send my fourteen dollars to Best and Company, ordering the white dress and a Chemcraft set for Walter. I had guessed his ability along that line, though how could chemistry ever take the place of music in his heart? The dress sent me was not the right size. I managed to scrape together enough money for postage to send it back, but I could not make the little cost of insurance. I had Mr. Kelley, the rural-carrier, post it for me, for I knew I could trust him. On its return trip the package was lost in the mail.

IX. POLITICS

We had a sort of minister, who preached on Sunday and farmed the rest of the week. There had preceded him many itinerant pastors, all blurred together in my memory. Our farmer-minister always knelt down on the oily yet dusty school-house floor when he prayed. He was an earnest man and, I think, a good man, and as he prayed, his long, bushy eyebrows moved above his little, kindly, emotional, dark-blue eyes like two animated mustachios. I think his heart really felt for as much of mankind as he thought had a right to be saved. Of course, he and the women who were my best dislikers expected to be the judges. What wonders me is how so much intolerance could occupy the same heart with so much kindliness. Or is the word kindliness out of place? It will take some one with a vocabulary to express this situation.

We had revivals, and folks went up and sat on the front seats which are before the front desks, praying and groaning and halleluiahing, facing the impassive blackboard on which might be written such questions as *What is a gerund?* or *Find the cube root of* 75946. My feelings were torn between the desire to go up front and groan and pray and the passion to answer those questions, both being equally impossible of accomplishment for me, for I never could remember what a gerund is, and cube root is a root I was never able to dig up. And as for going up and groaning and praying, just when the farmer-minister was saying, "Is there any sister or brother here who wants to confess Christ?" I was always busy wondering how his wife was ever going to get the spots out of his pants.

A frivolous mind is a great impediment to getting religion. But there is nothing I could rub on my head to cure it, I suppose. And there is nobody who would more enjoy doing the halleluiahing than I. I have a prodigious contralto voice, practically useless except for halleluiahing. Yet I had to sit there, glued to my seat, with the frivolous speculation as to whether the earnest preacher with the waggling eyebrows had a wife who understood how to remove those praying spots from his trouser-knees.

Sometimes the preacher would begin to weep over the Demon Rum. This seemed a strange thing, since he must undoubtedly have had a spell of weeping over the Demon Rum before Prohibition. And now he was weeping *during* Prohibition. I think he was perfectly justified, if any one is ever justified in weeping over the follies of other folks when they are none of his business. Folks died of too much drinking in saloon days; during Prohibition, in the region of the Greenwood District, the boys were dying of alcohol poisoning, and both girls and men were being paralyzed by jake gin, and one of the boys had gone blind from drinking something sold as alcohol. The preacher really had reason to cry if he was thinking of those things.

There were two farm-houses where the crop was advertised for some distance by the odor of the mash, and one of these farm-houses had tried to get rid of incriminating evidence by dumping it a good way out in the field. The sheriff, who would really rather not have arrested the bootleggers, was much embarrassed when the hogs and hens came staggering toward the house, singing "Sweet Adeline!"

He had undoubtedly arrested the bootleggers. At least, I assume he did, because, of course, our own county would have an honest sheriff; but I did hear of counties in Idaho where the bootleggers elected the sheriff they wanted. They had the money, and they desired a safe man in

office. Business is business, you know. I don't see why the bootleggers should not run their business as the other money-makers do.

There were stills out in the desert; the children often came home to tell me of finding one when they had gone in search of a strayed horse or cow. Because of my attitude Walter and Charles always revealed the shameful news in hushed voices. Once a W.C.T.U. woman came and worked us into a frenzy, and all she wanted was a dollar from each of us, to join the W.C.T.U., so that she could take the dollar to help pay expenses to the next group of women, where she would work them into a frenzy and collect enough dollars to go on to another group of women, to work them into a frenzy and collect enough dollars...I often wondered what happened when she reached the end—whether she back-tracked, working the same women into frenzies and collecting more dollars. Once I suspected the whole thing was specious and unintelligent and emotionally orgiastic. But if she had come and I could have found a dollar, maybe between the kitchen door and the sagebrush-pile, that maybe a rooster had dropped out of his hind pocket—none of the farmers had any money—I would have joined. I considered thinking up something that would work our sagebrush women into a frenzy so that I could collect a dollar from each of them to pay the W.C.T.U. woman. Well, we all had a good cry, anyhow.

It never occurred to me that my private practices were not harmonious with those white-ribbon principles. I made cherry brandy and peach brandy which might have been used for dynamite. I never drank any of it, so I felt perfectly virtuous. I know now it would have helped me to bear a lot of injustice if I had sampled a bottle once in a while. Ah, but that is a legitimate reason for not drinking! We should never bear injustice. We should fight, change things, or run away. Or turn the other cheek. Yes, He was right, and I am wrong. The other cheek is the way to inner power and peace. I wish I had always done that—and yet I cannot regret a single fight or a single running-away.

One day George Buckley, the water master, called to see Charley on business. The Baron was not a supporter of Prohibition—his German-stein ancestry made that impossible; but neither was he a guzzler, nor did he make wine and brandy as did his practically W.C.T.U. wife, who lacked only the rooster's dollar for the frenzying of other women.

So the Baron asks his practically W.C.T.U. wife where he could find some peach brandy, and without a thought that she is breaking the law of her country, she tells him, "On the top shelf in the pantry, beside the glasses of currant jelly."

She goes to help him, and comes back bearing two glasses into the living-room, and stops to ask George how Pearl is, that being George's wife, of whom he always proudly declares, "Pearl said it is so, and *Pearl knows!*"

While George is answering my questions, Charley is tussling with the cork in the peach-brandy bottle, and it pops out, suddenly, with a report perhaps not so loud as Big Bertha's; and the practically W.C.T.U. wife flies to the kitchen door, watching from its recess the drenching of the ceiling and the consequent downpouring of good peach-brandy rain, saturating the two crouching, laughing, shouting men.

I always wondered how Christ had the face to turn that water into wine when it would have been such a gorgeous opportunity for him to preach a sermon on the Demon Rum. I wonder why the churches never think of the fact that He said not one word about how terrible it is for folks to take a little wine. The women churchers, W.C.T.U.'s, especially surprise me. Recently it was recorded in Time that the President of the Woman's Christian Temperance Union gave it as her opinion that Christ must have miracled some unfermented grape-juice out of water. Not half the miracle that must have taken place had the wedding guest proclaimed that weak stuff the best wine yet, upbraiding the master of the house for bringing it out last, when most of the guests were so far gone they could not appreciate it. Jesus never did any unfermented, weak thing. What He did was never negative. His *Unalogue* was as positive with THOU SHALT! as the *Decalogue* of Moses was positive with THOU SHALT NOTS! And therein the Supreme Psychologist spoke the Voice of the Universe. Listen we will not, and therefore perish we must. It is the Law. Unfermented grape-juice?

189

Don't make me laugh!

Kidnapping and racketeering were not the result of the Eighteenth Amendment. I have not kidnapped any one, nor have I racketeered noticeably, yet I have been many times since Prohibition in desperate straits. I have not even bootlegged. I had a good mother! She never said a *Thou shalt not!* to me in her whole loving life. But every night I knelt in my little white gown at her knee, and I prayed, and she was always there in the home where I could find her.

The United States of America has failed the mothers of America, and the mothers of America have failed the American home. The mothers who have failed are of two classes, those who have been released from responsibility, and those who have been enslaved. The women who imagine they are free, because they spend money lavishly, produce the *legal* racketeers and kidnappers who use our nation as a happy hunting-ground. The *illegal* racketeers and kidnappers come from the homes of enslaved mothers of the slums, and they are what they are because they envy and would emulate the legal racketeers. We have not the pitiful, unknown infant wreckage of the slums upon our minds because they are unknown—sacrifices upon the altar of a greedy and blind nation as truly on the road to perdition as ancient Rome...*unless!* When those children of enslaved mothers manage to survive through such torments and degradations as would warp the soul of any of us, what do they see? Diamonds glittering; women in gorgeous clothes with careless, conscienceless men, riding, dining, dancing, living in unparalleled luxury.

What can be done in a brief time may be done by the Man we have in the White House. But the years that have built up the degradation of the big cities since we were a hardy pioneer people will have to be matched by years of tearing down and building up in the right way. *The slums must go!* There must be a living wage for every man, and a good home for every man, woman, and child! And before we get through with it, the people have got to *know* that *God lives!* This I have learned through extremes of such pain and joy as mortal woman can know!

Careless women, women who today spend their thoughts, their time, their money, on themselves alone, they are already dead. And yet...is there yet a flicker of life? What have you done this day for some child? It may be too late for those who are grown, but on you hangs the responsibility of having failed in your life unless you help to change conditions for those enslaved mothers of the slums and the unfortunate spawn that swarms the city streets of the vilely crowded areas. When any nation shows such extremes of want and riches as there are today—even now—in the United States, its doom is written on its forehead. *"Cain, where is thy brother?"*

AND AFTER FREEING the mother of the slums, her who needs first all that we can give, let us next free the Beast of Burden of the nation, the American farm woman. How? Any way. Politics? Yes. *Any way!*

Out in the sagebrush the farm women had their farmer-preacher, but, as elsewhere in rural America, the religion of most of the men was politics. Of course, though Baldy Parsons and his like sang hymns a-Sundays and stole water a-weekdays, most of our sagebrush men never troubled their minds over whether they would meet their loved ones anywhere, let alone Heaven, or whether there is or is not a God. But most of them practised the religion of politics. They had their spells of emotionalism, even as the churchers, getting even more worked up, or perhaps it was just the different form of expression. For while the churchers were groaning and praying and halleluiahing, the politicos were fighting each other with the good old fists.

They themselves, however, were doing the fighting, which is more than can be said for our world's brightest statesmen who brought about the beastly shambles of the World War. Our sagebrush farmers were fighting to reinforce opinions which meant very little so far as their condition was concerned. What they should have been pugnacious about was the fact that when they could have sold their farms for big profits, they clung to them to serve their country by feeding the world. At least, that was the reason Charley turned down an offer which would have left us free of debt and with eighteen thousand dollars to the good. Not much to a millionaire, but eighteen years of living for us, or a home and ten years of living—and living well, with all we knew of economizing.

190

After the Armistice there was the terrible let-down of realizing that our land was worth less than it had been before the war, that there was nothing to do but to worry over the mortgages. The price of wheat had been arbitrarily fixed, but not the price of labor or of anything else that the farmer used. We could have paid off our mortgages and kept even with our expenses had the law of supply and demand been allowed to operate, as in every other field of business. Millionaires were made by the war, and the American farmer was impoverished.

Through the winters following the World War our living-room was lined with farmers discussing national issues, while they smoked their cigarettes and pipes, and spat tobacco juice into the coal-pail, and cooked the mud and manure from boot-soles on the sides of the base-burner. They had no solution for their own dilemma, the dilemma of all agriculture, but every one of them knew what the Government should do about the railroads and other debatable problems. And I sat there in my corner, tapping away on my faithful typewriter, both of us turned into misty ghosts by the tobacco smoke. I heard the farmers, and I did not hear them, as I wrote the little things which brought the meager amounts so precious to the children and me, the only money I ever handled.

The men generally ended by agreeing with each other there in our living-room, but outside it might be different. Baldy Parsons and Old Man Babcock once went to the school-house corner for their mail and ended by having a terrific fight. The mail-boxes were arranged on an old wagon-wheel whose axle had been set on top of a post, a most ingenious and practical convenience for the rural mail carrier, who was able to sit in his cart in muddy weather, or his car in good weather, and fill all the mail-boxes quickly, with a twirling of the wheel.

Bab and Baldy both took the *Segregation News* from their boxes. This paper, published at Hazelton, was eagerly absorbed by the women folks especially, from motives both of pride (when they were mentioned) and of derision (when they were not mentioned). For one of the Brooke girls was the reporter, and the locals usually ran something like this: "Nellie Brooke is visiting with Mrs. Herman Badger for a few days....Bertha Badger was at the Brooke home for dinner Thursday....Among those who went on business to Twin Falls during Fair Week were Aleck and William Brooke...Grandpa and Grandma Heller were visiting their daughter, Mrs. Henry Brooke, during Saturday and Sunday. The old folks are feeling well, and report a good rainfall at Oakley, where they have a farm....John Heller and Aleck Brooke were transacting business in Jerome Saturday."

I might add a note here that John and Aleck were seven years and nine years, respectively. What business they could have been transacting at that immature age may be guessed from the item that one day I proudly read in the column: "Joe Greenwood and Bud Jean were transacting business in Twin Falls Saturday." The two boys were about seven years old, and they both came home with toy fire-engines, which they bought at a chain store for ten cents apiece. The *Segregation News* paid our Greenwood reporter a not too exorbitant sum, space rate, so the long word *transacting* not only looked important, but padded the line.

After the local *News*, Bab and Baldy dragged out the Back-Home papers, Bab's being Republican, from Missouri, and Baldy's Democratic, from Ioway. Both men went to the school-house fence and sat down on a little rise of ground, opening their Back-Home papers simultaneously. Old Man Babcock struck a match on his boot-sole and puffed the flame through tobacco grounds, which, through this alchemy, turned from brown to glittering copper. Then the two men read aloud to each other the identical big black headlines in their Back-Home papers:
PRESIDENT WILSON APPROVES

THE LEAGUE OF NATIONS

Bab continued, while Baldy paused, "What wonders me is why fer this dunderhead Senate can't git t'gither on this here League uv Nations thing."
Baldy Parsons could only mumble, having left his teeth at home in his Sunday-vest

pocket: "The Senate is right! Wilson is locoed, fer sure. What wonders me is how any bozo with guts kin see England lick us."

"Wha'd'yuh mean, England lick us?" demanded Old Bab, neck feathers rising like a game-cock's. "Wha'd'yuh mean, England lick us?"

"I mean 'at them damned English is alwuz lookin' out fer a chancet t' git our goat, that's what I mean! I knowed a Englishman back home, 'n he wuz the orneriest dog-gone son-uv-a-gun the Lord ever let live. He oughta a ben tooken out 'n shot. Why, when my ole lame mare, Nellie, got over in his field of corn, 'n et till she 'most died, that ole whelp says, says he, 'Mebby that'll learn yuh a lesson t' keep her outen my field!' Them's the very words he says, says he. All them English is alike. I got no use fer the English. I'd like t' see 'em all in hell!"

"They ain't nothin' wrong with the English!" muttered Bab. "My ole Gran'pop wuz English, and you never seen a finer ole feller anywheres. Wilson's a XYZ damned fool, that's what 'e is, and this here League uv Nations is all a damned graft and poppycock!"

And then he added a few more expressive words, the like of which sickened me when first I heard them, but they seemed to be indigenous to the farm, so it was not long before I heard them without nausea, bearing, but revolting, just the same. I think perhaps they should be written here, in the interest of faithfully reporting the farmer minds, without which filth very few could be found where we were. Personally, I could commit murder because of indecent words. I believe they are the resort of weaklings, as substitute for what mental and moral strength they lack. Old Bab was no worse than most of the rest.

Old Baldy was not more virtuous in his expressions than Bab, but he did recognize the obscenity as an effort on Bab's part to besmirch his most sacred principles with worse than barnyard manure. He was enraged, as Bab had hoped, and feared, he would be. "You're a XYZ damned liar!" yelled Baldy, slapping Bab in the face. "I'll learn yuh t' say such things about Woodrow Wilson!" bellowed Baldy, giving Bab another blow. "Yuh can't git away with nothin' like that around me!" Whereupon Bab landed a fist on Baldy's toothless mouth, from which he would have been forced to spit all his front teeth had not the dentist Back Home already possessed himself of them. After that both old reprobates rolled and fought like two dogs. Had they been Arkansawyers, of course, they would have arisen with all four ears chawed off.

Just as they were on the point of ear-chewing, out burst the whole school for recess. That debasing fight was a horrifying spectacle for those innocent, immature minds to be observing. There was probably not a boy there who could not have done better. The result was that around every table in the sagebrush that night the combat of the two belligerent farmers was related with appropriate gestures.

There was utter silence at Old Bab's table, Old Lady Babcock having sense enough, for once, not to tell Bab what she would have done if she had been in his place; which, of course, she would not have done, for nobody can ever be in any one else's place, and if it were possible, he would act as he himself, only, would in that place, and not as any one else would act. Let that settle this question for good and all.

Baldy Parsons had to talk. He had come so near to licking Old Man Babcock that he was quivering with exultation. But his bragging was nipped in the bud by Mrs. Baldy Parsons, who began on him promptly: "I should think you'd be ashamed, Josiah Parsons, a man of your years, fightin' before all them school childern, an' gettin' yer nose bloodied all over yer overhalls, and bustin' two buttons offen yer shirt, an' makin' me out the wife of a rough-neck, an' how kin I ever have the face t' meet Revener Warren when he comes t' the school-house t' preach next Sunday, an' what will they think of us over to Hazelton,..." and how this, and what that, until Baldy wished that Old Bab had beaten him to a pulp, so that when they dragged him home on a hay-slip, maybe his wife would shut up. But little did he know her, even after being married to her for thirty years.

I AM NOT SURE whether I am Joan of Arc reincarnated, or just a part of John Brown's soul. All I know is that I am always filled with burning zeal for something or other. I was the only woman in the Greenwood District who figured prominently in politics. I threw myself into causes

192

which were lost before they were begun. I attacked people in high places and got well slapped for the same. I wrote some articles for the *Atlantic Monthly*, whose editor, Ellery Sedgwick, has been my good and invaluable friend. In those articles I told something which put the then Governor David W. Davis of Idaho and Banker John Thom, one-time Republican Senator from Idaho, in anything but a favorable light. It was these two who tried to discredit me, as a matter of (as they thought) righteous revenge.

John Thom dedicated several issues of his Idaho magazine to attacking me. I am not sure whether the journal was founded for that purpose. I know only that the editor was thoughtful enough to mail me copies of the issues. Governor Davis wrote the *Atlantic* that I was a liar. The *Idaho Statesman* wrote the *Atlantic*, not knowing of the Davis protest, to say that I had told the truth concerning John Thom and Governor Davis, but that I had placed the *Statesman* in the wrong light.

I had not intended to injure the *Statesman*, as I have always admired that paper, but I meant every word I said about Governor Davis and John Thom. I was helpless to combat them at the time, and it looked as though they might have me licked; but since that day all three of us have met defeat in one way or another, and probably if the men and I could get to know each other, we might be the greatest of cronies.

In the midst of the desert, with lava buttes for neighbors, lies the town of Jerome, and in this town was located the bank of John Thom, the friend of Davis who was Governor of Idaho when Charley went to the Legislature as Representative from Minidoka County. Unlike Twin Falls, Jerome was practically isolated, not being surrounded by prosperous farms. The *Idaho Statesman* bore me out in my statement that a plan was hatched between John Thom and Governor Davis to take parts of three counties, one of them Minidoka, and create another county, to be called Jerome County, with its county-seat Jerome City, location of the Thom bank.

We Greenwood District farmers and the farmers around Eden and Hazelton and Russell Lane were in Minidoka County. We had already helped, by means of taxation, to build the county court-house at Rupert, a thriving little town on the Lincoln Highway and also on the main railroad lines, which Jerome was not. If Jerome County were made after the fashion planned by John Thom and Governor Davis, it meant that we poverty-stricken farmers must have our taxes raised in order to build another court-house at the new county seat, and also that we must help to build a road through the lava rock desert to Jerome.

In the Legislature, Charley bent every energy to defeat this project, but he was fighting against forces too great for him. He had been elected by the Non-Partisan League farmers, and the other Non-Partisan League legislators supported him, with the few Democrats who happened to be elected; but how could they do anything in a Legislature overwhelmingly Republican, headed by a Republican Governor?

It was near the beginning of this session, just as Charley began his efforts for the right, like a lesser Woodrow Wilson, that Schumann-Heink was to sing in Boise. There were no radios in those days, so the coming of Schumann-Heink to Boise was a state wide event. Charley was in the Legislature, and therefore, poor fellow, making a little real cash. He sent me the money for my railroad fare. No one could be more generous, when he had money, than the Baron. And, to such a nature as his, to be unable to exercise this generosity was warping and debasing.

I have reached that most glorious age when, as Matthew Arnold so aptly expresses it, I can see life steadily and see it whole. I am allowed the privilege, I hope, of writing of myself as though I were some one else. At last I can stand on the outside and watch myself go by, with only such emotion as I should feel in the case of another. This attitude is mistaken for egotism. I have plenty of that, or I should have been crushed by fate, but my frank description of myself and others has nothing to do with egotism. I have felt from birth that I must state the truth of human life as I see it. There is something so imperative in this that I have no free will in the matter.

But that does not mean that all the truth of every human relationship I knew on that sagebrush farm will be stated here. Only that the impulse of my being is to state the whole truth before I die, in some form or another. It is a cruel drive, allowing me no indulgence of personal

reticence and laying me open to criticism by those whose opinion I hold dear. Yet when I have been able to define a thing as it is, I feel a compensating happiness which would actually make it possible for me to cut myself off from all human relationships—nay, I say it solemnly here, such a course is rendered almost obligatory.

This book is not autobiography, yet much is in it that will offend the sensibilities of those who live more strictly personal lives than I have ever lived. This must be. I do not write here of myself as myself, but only as a woman of a certain type, whose life was so ironically twisted. I write, too, of the man I married, but not fully, and in these pages I cannot do justice to him in any adequate way, for it is not a simple matter for me to explain a person so different from myself. That would require a study entirely out of proportion to the intention of this book. I regret that this must be so, for it must ever be the sincere resolve of my heart to do him justice. Who is it has said that mercy is not needed where justice is given? These bare pages cannot tell the lovely things that Charley did for me in little ways during the course of those farm years—even of the efforts he made to help me in my writing by taking over the housework himself, a dish-towel pinned around his waist, while I sat at the typewriter through the white, snowy days, plugging out a very miserable book of fiction which I had named *The Lesser Man*.

Christmas of the year before Charley went to the Legislature was marked by a great event in my life. I received my first check from the *Atlantic Monthly*. To be published in the *Atlantic* had been the aim of my ambition almost from childhood. As I write, an amused remembrance thrusts its head into the midst of this statement. After the article for which I received this check was published, a professor of English in Columbia University came striding into his classroom to meet a class of which my cousin Nellie was a member. He bore in his hand a copy of the *Atlantic*, and holding the magazine up before the class, he began:

"My wife is a college graduate. She has been trying for years to get into the *Atlantic Monthly*...and yet here is a mere farmer's wife who has done it!"

And then he read the article by the mere farmer's wife to those students who were training, and also straining, perhaps, to get into the *Atlantic*. There were a few things that professor did not know about me.

After the article was published, Dr. Winship, of the *Journal of Education*, wrote me: "*Fame is yours!* The article is better than I could have imagined! Do you really know what you have done? William Allen White, who had already published books, when an article of his was accepted by the *Atlantic Monthly*, wrote me, 'I have at last reached the goal of my ambition!'"

Sarah Comstock, the novelist and magazine writer, whom I had met in Garden City, Kansas, wrote me: "There is not a writer here who would not give his or her head to have done what you have done—you are in the *Atlantic!*"

Something of the feeling of these writers I had as I stood in that poverty-stricken living-room, which the years had robbed of every amenity and grace, gripping that hundred dollars the *Atlantic* had paid me and the letter from Ellery Sedgwick, my ever kind and patient friend. Such transcendent moments as that I have learned to suspect. Things do not always follow on each other's heels as we think they will.

But it did mean a real thing. It meant I could have my teeth cared for, as they so badly needed. I had begun to wonder whether I too must pay the ultimate sacrifice of my pretty teeth—that which was taken for granted by every farmer and his wife in the district. And I could buy me a new hat! Heavens, what an extraordinary event!

Before I went to Boise, I cured the Devil Sow and another hog. This was after they were dead, and the curing was done with salt and brown sugar. I had never cured the meat before, and it looked like such an undertaking that I could scarcely sleep after I saw all that pork spread out, so pink and clean, on newspapers laid on the dining-table, with all its leaves put in.

I had heated the water in my wash-boiler, but I looked perfectly blank when I saw the men hunting for my galvanized tub. This I had secreted in the cellar, so that I might have it clean for bathing purposes. It was mean of me, and my conscience smote me, as I watched them fill the

194

barrel by the granary with the boiling water and drop into it the hot stones they had heated with a sagebrush fire.

The Devil Sow had little, mean, human eyes, and she twitched her tail in the most vicious manner. She was always somewhere that she had no business to be—down on Steve Drake's, or Earl Andrews', or over on Dan Jean's. It did me good to salt down that old girl. Jeanette Bennett came and helped cut up the fat for lard. There were sixty pounds of it, mostly from the Devil Sow. And her hams and bacons were enormous.

I left the children with Jeanette and her family while I went to Boise to hear Schumann-Heink and to get my teeth fixed. The Bennett family moved into our house until I returned. My children could not realize that their mother was about to cross the stretch of snow that reached out into the desert, to where the Gallopin' Goose cut across, importantly puffing its way from Minidoka to Bliss. Walter went with me, on Old Buttons, so that he might carry my suitcase. I walked.

I was wearing my great, heavy farm shoes, and my city shoes were in a paper, under my arm. The snow was deep, there was a road only part of the way, and there was more snow falling. At the station...but I must explain. There was really no station—just a big box which one might climb into from behind, but without any fire. I sat outside in the snow, the suitcase serving for a seat, and changed my shoes. Walter took the heavy old farm shoes, tied the strings together, and threw them over the saddle, back of the horn. Old Buttons, much disturbed at being tethered in the snow-storm, pawed at the frozen ground in worried distress. At last he broke loose, and we lost sight of him in the wall of falling snow, my heavy shoes dangling and bouncing on either side of him, the last thing we could see.

I danced and whistled, stopping only to encourage Walter to do the same, for it was bitter cold, and the snow was falling faster, and in such big flakes that it was like the cotton strung on threads that is used in Santa Claus store windows. The Hootin' Nanny should be coming along soon, so Walter stood on the track waving a dirty piece of cloth fastened to a rough stick. This operation was called "flagging the train," but it looked to me more like *ragging* the train.

When I had whistled everything danceable, I decided to stand still and freeze, and the conductor of the Gasoline Split-the-Wind could chop me away and load me like cord wood. Remembering my "Bluebeard," I kept calling to Walter, "Sister Anne! Sister Anne! can you see anything coming?"

Thicker and thicker the flakes fell. Nothing visible beyond an arm's length. Even sounds were muffled—if there were sounds. Dead quiet; dead white; a faint whistle; a faint clanging of bells; Walter leaping from the track just as a great dark bulk suddenly emerges from the thick white screen, with its constant, dazzling, whirling motion. Out of a black side oozes Old Man Babcock, a shining new pitchfork over one shoulder and a shining new shovel over the other—in the middle of winter! I was glad Walter would have company.

Charley met me at the Boise station, and I saw a quickly disguised look of shocked surprise flash across the handsome face of the Baron. I knew before he spoke what was the matter. "Is that the best hat you have?" he asked.

You see, he had been away from the brush for a few weeks; he had seen other women's clothes; he had not seen me during that time; the sight of me under those circumstances was revealing. The first thing he did when we reached the hotel was to hand me a ten-dollar bill from a folder which had so long forgotten the feel of a bill of any kind. "Be sure to buy yourself a hat today," he said.

What a day! Actually to go from shop to shop, trying on this hat and that...to be young enough to have bright, fluffy hair and eager, shining eyes. I bought a black-satin hat, perfectly plain except for some silver ornaments, also severely plain.

I was ready early that night to go to the Schumann-Heink concert, and while Charley was gone from the hotel room, I stood at the window and looked out on the busy streets, the shop windows dazzling with color and light. I was so happy—so happy! I heard the Baron close the door and sink into the big, comfortable rocker, and I turned, still smiling with happiness, and seated

195

myself on his knees. He put his left arm around me, and took both my hands in his one big right hand, and gazed thoughtfully at them. There had been a peculiar stillness about him ever since his shocked moment of our train meeting.

I was embarrassed at the look of my hands, and I doubled them up quickly; but with his big fingers Charley opened them, still gazing in that strange way. I wondered if he were remembering when they were pretty and white and well manicured, for at the time I met him they did no manual labor of any kind, except for the dressing of myself. The fingers were still long and tapering, but the nails were broken below the quick.

The Baron still stared at my hands. There was a scarlet, leaf-shaped burn at the base of my right thumb, and lower, on the little wrist, a duplicate. At the base of the index finger of the left hand there was a fresh, deep scar: the sharp butcher knife with which I was cutting around a ham bone had slipped. On the back of the right hand were open, raw blisters from bacon grease, which had spat at me from the frying-pan. But worst, worst of all, I hated those stubby, painful nails, broken below the quick.

The Baron was speaking, and I could see a faint mist in his eyes. "Poor little hands!" he was saying, "how could I do that to you?"

I knew that his heart was swelling with remorse. One of my hands I withdrew from his, to put my arm around his neck, and I kissed him. It touched me deeply to know that at last he had seen those hands which had so faithfully served him through so many months of toil too great. I had never pitied myself, yet I was glad of his pity just the same—glad, yes, but I knew he would forget.

That night we had to sit on the stage of the Boise theater to hear Schumann-Heink sing. Charley had not been sure of my coming, and when he was sure, it was too late to get reserved seats. There were so many people on the stage that from my seat I could almost touch the gray-haired, motherly-looking singer. The audience loved her. I was enchanted. It was the first entertainment I had heard outside the Greenwood District. I kept saying to myself, "At last the door is opened...I will write and write...and my little family can hear things like this..." If I had only known how many years would pass before...

Next day I sat in the gallery of the House of Representatives, proudly wearing my new black-satin hat, and watched and listened as Charley fought to save the overburdened farmers of our part of Minidoka County from the self-interested plan of Banker John Thom and his Republican friend, Governor Davis. The Baron's handsome figure moved before a map, a pointer in his hand. He was wearing millionaire-tailored clothes found in a box from his sister Laura. How fortunate it was that Charley's brother-in-law and he were of identical figure. I was proud of him, but I was apprehensive. What he could accomplish in that hostile atmosphere was the ripple of a polliwog's tail among a shoal of sharks.

As soon as I returned to the farm, I wrote an account of this fight, and the *Atlantic Monthly* paid me another hundred dollars. Then it was that Governor Davis had a letter in the *Atlantic*, saying that I did not tell the truth. John Thom published a magazine in which he made the same statement, adding, moreover, that all the farmers in our part of Idaho were prosperous—they were, in his magazine. I was a poor farm woman. Probably what I wrote did look warped from the points of view of a successful Republican politician and a successful banker. It is conceivable that for them the very truth would take on a different aspect from what it disclosed to me. The *Statesman* said I wrote the truth.

Senator Henrik Shipstead of Minnesota wrote me that he had nearly decided to keep out of politics, but when he read my articles, they determined him to get a seat in the Senate so that he could help the farmers. Governor Lynn Frazier of North Dakota, now Senator, also wrote, commending my work for the farmer.

Besides these two men, I number in the Senate among my personal friends Senators Elbert Thomas and William H. King, the latter a brother of a girlhood sweetheart of mine. And there is my father's friend, George Sutherland, so often in our home, on the Supreme Bench, so that I now have just as much passion for politics as in my sagebrush days. It is in my blood.

196

I rightly say that it is in my blood, not because my father was a politician, but because my childhood was made aware of politics by things which are unforgettable. I sat on the horse-block in front of our beautiful home, a little girl, fascinated by the flickering kerosene torches of two opposing rallies. Buggies and wagons drove slowly past, harnesses creaking, as the drivers kept even with the marching, shouting men. Bands!—there were actually seven of them in the procession in which Reed Smoot, Will King, and Dr. Pike's hired man carried flambeaux. The opposing parade had the glory of the Salt Lake Marching Club, dressed in full, Oriental breeches, shiny black boots, zouave jackets trimmed with gilt braid, and little red Turkish caps. With these marched George Sutherland and Dr. Pike. Of course, not long after this Reed Smoot and Will King parted company. But that night they were rallying against George Sutherland, who was running for the office of Mayor of Provo. He suffered a crushing defeat. But instead of committing suicide, on he went, until he reached the job of Justice of the Supreme Court of the United States.

My father had gone to the Legislature of Utah—I had thought he was going to Washington to help the President. Anyhow, the band played just as loudly in front of our home as though he had. And here was Charley, my husband, in the Idaho Legislature.

THE FIRST PLANK of the Non-Partisan platform was not for the farmers, but for the soldiers—our boys were still Over There. The Non-Partisans promised the soldiers one year's moratorium on debts contracted previous to the war. In case the soldier wished to farm, this might give him a chance to succeed. It was persistently rumored that the Government meant to give all soldiers so disposed allotments of land for farming, and that this land was to be that very tall-sagebrush land where little Charles, in his red coat, had been lost that first year after we came to Idaho. The last I knew, that land was still uninhabited.

Our Non-Partisan legislators, from all the counties of the State, worked frantically to put this over as a welcoming gesture for the boys, who might come home any time—the War, of course, was only going to last a few weeks, or months, at the worst. But the Republicans had a different plan, and, being in power, they were able to put it across. No jobs—oh, my, no! All a soldier wanted as reward for his compulsory murderings was to see his name in print, to have a ribbon with a piece of metal attached pinned on his breast, and to gawp at a statue erected in his agglomerate honor. He had no stomach, no family, no necessity for a bed. Waving the star-spangled banner and hearing spouted to a crowd of dormant folks: "We are honoring here today, fellow-citizens...one of the boys...umpty-umpty-ump...sacrifice...umpty-ump...country...umpty-ump...brave...umpty-ump...'In Flanders fields the poppies blow...throw...grow...umpty-ump...That was all the returned boys needed.

The Republicans voted them monuments, all alike, after the manner of so many dozens of spoons, one to be placed in each county-seat, so that when the boys were going around from place to place, looking for jobs and being turned down, they could crawl around at the end of the day and gawp and gawp at all that glory made into a big doll to stand up in a public place where nobody would ever look at it after the politicians had the fun of having one of the wives unveil it, and one of themselves star-spangle speech it, before a mass of sheep in human form with hearts which would be sheep or wolf according to what the speecher wanted them to be.

As I sat in the dentist's chair having my teeth fixed, I could see through the window, over the sash curtain, myriads of black flags waving in the breeze. I said to the dentist, "What are all those black flags waving out there?"

He stopped his work of mixing a filling to glance out of the window. "Those? Oh, those are just the American flag! They were put up there when the boys left for the war, and they have never been taken down."

As I sat there, I wondered what those boys would think when they returned, quietly, from the front, walking up those streets where they had marched so proudly, scores of bright, red-striped, blue, starry banners floating from every building, and now—nothing but black flags...debased black flags...no jobs...a lot of insignificant statues stuck up for the pleasure of the unthinking politicians. Well, you see, they were either the creditors of the soldiers, or their friends were, and the State

197

could pay for the statues, but who would pay what the soldiers owed? A year is a long time to wait for your money—but a longer time to wait for a job, hounded by your creditors.

We favored the League of Nations in our platform, but of course we got nowhere with that. And the Non-Partisans, together with some disinterested representatives in both the old parties, passed a very fine education law, which came to nothing whatever because an enabling act was not included.

The Non-Partisans successfully stood against the eight-hour labor law for women, because the politicians, induced by the business men, amended the law to read, "except in emergency." Idaho already had a nine-hour law for women which was really being enforced. The eight-hour law, with that vicious amendment, would have meant that employers of women might declare an emergency lasting for fourteen or more hours.

The *Idaho Statesman* thought I wronged it in criticisms I made of a front-page article published by that generally estimable paper. A certain well-known Boise minister had been sent to France, at the expense of interested politicians, to secure as many signatures of Idaho soldiers as possible to a set of resolutions denouncing the Non-Partisan League. You see, it would be easy for a minister of the gospel to circulate among the boys. He would be under no suspicion of playing politics in the trenches. It would be taken for granted, when he was allowed to go where he would, that he was preparing the souls of men to meet their Maker. If they were being prepared to live, that might have been thwarted, but dying is so much more unimportant. So come on, holy man! You cannot do any harm, and maybe you can make these conscripts resigned to the butchering!

But the effect of the holy man's mission was to betray the farmers. There were several hundreds of our Idaho boys Over There, and the very fact that, for all his circulating about, dodging shells, and slinking here and there into dugouts, he could obtain only sixty names is extremely significant. But take those sixty names and spread them across the front of the best paper in Idaho, and they can be made to look like sixty million.

Nobody will ever know how black was the misrepresentation of the Non-Partisan League made by that minister of the gospel. But if he misrepresented the farmers as the churches and ministers thereof misrepresent the Christ, then it was aplenty. It is the churches that have compromised the Christian message. *Love* was the whole gospel of Jesus. Not love of your own soul, but love of your fellowman—particularly of little children, the victims of a barbarous civilization, who flower into suicides, murderers, racketeers, kidnappers, even the conscienceless rich. The churches damn their own souls with their chanted rituals. The only church that is not damning its own soul psychically, and that means spiritually, is that church which, when the minister's appeal is ended, goes out immediately with love in its heart and a bread-basket over its arm.

The world is full of benighted weaklings, who follow, like sheep, the strongest voice. It was these among us farmers who caused our defeat at election, although we did make a brave showing. When they saw those sixty names on the front page of the *Statesman*, the panic-stricken farm people suddenly remembered the safe fold: Pa had always been a Republican, or a Democrat, and our family always voted that ticket, and so I...The poor Idaho soldiers, hundreds as they were, lost through sixty men their only offer of any personal compensation for their confiscated years.

Home again from Boise, there was more than enough to do. I never wrote in the daytime. It seemed to me that until I was successful, I had no right to write except at such times as other women would be doing fancywork, or reading, or going to the movies. The tired worst of me went into those night writings, yet they were accepted by editors. I had time only for short articles. When I realized that longer articles might be acceptable to the better magazines, I had the frantic thought of carbon-copying my letters to my folks. They had written me how much they enjoyed this account, or laughed at that, or shuddered at the other. I do not believe that our human relationships should be neglected for anything else. Our dear ones, relations and friends, are the greatest riches we have, and without them how empty is wealth! I did not begrudge those I loved, who loved me,

the letters I wrote, ghostly in the murk of farmer smoke. Little enough, I think it was, to pay for those boxes of things which kept us clothed and the loving letters I received.

Cousin Joe wrote me something which put into my head the idea of those carboned letters. I sent the originals to Ellery Sedgwick of the *Atlantic*, first drafts though they were. One of my letters that he printed was written to Charley, left behind in Boise, fighting uselessly for the farmer. I give a portion of it here, as it so reflects my little children at that time.

The description in the *Digest* of how grateful our poor wounded boys were Over There for their ice-cream, served only to the seriously wounded, made me press my hands to my eyes to keep the children from seeing the tears that would have flowed.

Little Charles! He has been trying all day to express how much he missed me while I was gone, and how glad he is that I have come back. But in between his protestations of love, he was a very limb of Satan. For that matter, all my little branches were limbs of Satan today. Perhaps it was because it was wash-day. You know I hate the smell of soap-suds as much as you hate the smell of manure. So it is just possible that mother's mood may have played a part in the complexion of the day.

You should have had a movie of our family life. I fear you would never return. It began early, with Rhoda dashing to the reservoir for a dipper of hot water. She had been playing in cold water—you know what a fish she is—and she wanted to warm her hands. Charles interposed himself like another Roderick Dhu.

This reservoir shall fly
From its firm base as soon as I.

Rhoda believes that actions speak louder than words, so she up with the dipper and whacked him over the head. Charles was dazed, but one of his feet remembered the proper answer; and upon Rhoda's screech, Walter took a hand, and in his forcible efforts to punish Charles for mistreating his sister, he stepped on Joe's hand. Now, I leave you to imagine the orchestration.

It had all happened in the wink of an eye, and their poor mother was totally unprepared for the terrific bedlam. I thought, "I must do something quickly, but, what?" What would you have done? I'll tell you what I did: I broke into peals of laughter that stopped every last one of those children dead in their tracks, their last yells frozen on their faces. I believe they thought that at last they had driven their distracted mother insane.

Taking advantage of the sudden lull, I told Charles to try the boat for which I made a sail yesterday in the tub of water in the kitchen, directed Rhoda to watch him, took little Joe on my lap and nursed his hand, and whispered to Walter, "You won't interfere any more with the children, will you?"

"I don't know whether you mean yes or no, mamma, but I'll try," he said.

Again, in a quite heartless manner, I laughed at my children's cries of woe. But I secreted my head behind the wringer to do so, and did not let them see me. Joe didn't like something, and in a fit of temper threw himself on the floor screaming. That is something I will not tolerate, so I spanked him and laid him across a chair where he could enjoy his grief at his leisure.

Charles saw his opportunity, and began to imitate Joe's cries, which, of course, made Joe bellow all the more. I looked in on Charles meaningly. All that I accomplished was that Charles lowered his tones to what he thought was about right to reach Joe's ears and escape mine. But I was on the job. I slipped through the bedroom, catching him unawares, and gave him a nice sample of Ivory Soap. Now you may add Charles' howls to Joe's.

Rhoda, hearing his agonized cries, began also to cry at the top of her lungs through sympathy. Of course, Joe, who had failed to notice mamma applying the bad-boy cleanser, supposed that Charles was giving a more vigorous imitation, so his howls of protestation grew louder also. Thank goodness we do not live in an apartment house!

I went right on with my work serenely. I felt neither anger, sorrow, nor amusement, until Walter leaned over me (he was turning the wringer) and at the climax of the orgy of wails murmured, "Mid-African jungle."

199

It sounded so exactly like a jungle of wild animals giving voice to their emotions that I shook with laughter. Charles found it the proper occasion to brush his teeth, which he did for upwards of half an hour. And it effected a complete cure—at least for today, which is saying a good deal for a child who likes to tease as docs Charles.

WE SAGEBRUSH FARMERS took our politics seriously, as everyone else in the United States of North America should do. The men did more thinking nationally than the women did. All the women and most of the men were voting as they voted because some one in their families had voted that way before them. It was unintelligent. But it may have worked some of the time. Witness me. I voted against Franklin D. Roosevelt, and no one mourned the ousting of Herbert Hoover more than I did. I still think Mr. Roosevelt's speeches were very weak before his election. I sat before my radio, scornfully listening to him assure the Mormon Church that the railroads in which it is interested would have adequate protection, just as I scornfully listened, in the same manner, to Charles Curtis, in the Mormon Tabernacle, the same church edifice used by Roosevelt, making a political speech in favor of Reed Smoot. It was not a matter of politics with me. The whole thing looked shoddy.

But now...yes, Roosevelt is the man we need. Action! *Action*! Mistakes? Of course! We learn by mistakes. But we learn nothing by inaction. You must plunge into the water, or you will never know whether it is hot or cold; whether it will help your rheumatism or leave you as crippled as you were. It does not matter how many commissions you appoint to think and investigate for you. In the end you must plunge and find out something for yourself by action. Talking is most pernicious. We Americans are a nation of loose-mouthed spectators. How many of us are really living? We are not even a nation of *thinking* Hamlets. But the result will be the same—bloody murder of the innocent along with the guilty.

The Progressive Party was the successor of the Non-Partisan League. Once again Ray McKaig got out and built a state-wide organization. Tactics were different in the Progressive Party. The League had generally simply indorsed men nominated by one or other of the old parties. The Progressive Party put its own men in the field. They even tried to get William E. Borah to head the ticket as a Presidential nominee, but Borah was nobody's fool, to risk all he has gained in Congress in order to be defeated for the office of President.

I was asked to stand on the Progressive ticket for County Superintendent of Schools. This invitation filled me with elation. I had always wanted to try out certain educational ideas, and this looked like an opportunity. I thrilled at the thought and began planning nearly all the school work for outdoor, applied experimentation. The pupils would go to Steve Drake's farm and measure his hay. They would go to Dan Jean's and calculate the percentage of profit that should accrue from his wheat crop, considering all factors. They would study the geological formations, the lava, the craters, there in our back yards. They would bring all their treasures of Indian arrowheads and spear-heads, so liberally sprinkled over all our farms, and while they walked the fields looking for more, their teacher would tell them the history of mankind. Good-by to the school-houses, the prisons of childhood! Good-by to every teacher who was not healthy enough or interested enough or informed enough to go out-of-doors with those youngsters and keep up with their bodies and their minds! Oh joy, to learn without a text-book in your hand!

I had a shock coming to me. After even the slightest investigation I discovered that the office of County Superintendent of Schools was nothing but a bookkeeping job, a job which a brainless cash register might do, and only called a job because politicians need offices. And there was a rigid, ironclad Course of Study, which must not be monkeyed with under any consideration. You have to have Courses of Study for uninspired, unintelligent teachers who are just in the school-room to draw their pay.

Yes, I should be allowed to visit each school and smile on the rattled teacher trembling before me; though maybe she could teach better than I could, I could *can* her on a whim. For of course I would look superior, as though I could beat her teaching with one hand tied behind me.

And the round-eyed, subdued children would gaze on me as though I were the President of the United States paying them a visit, sitting up like little wooden figures and tiptoeing out at recess, with serious side glances at me, instead of *clomp-clomp-clomping* with the emphasis of relief, chests swelling to let out a tremendous whoop even before freedom was quite gained at the door.

Of course, I wrote the Progressive Committee to take my name off the ticket. I felt pretty bad about it, too. It meant that the educational clock would be set back about a thousand years. In other words, it would remain where it was. Back to the washboard and the dishpan for me. And all that freedom for children fermenting in my brain. But as I worked there, with my blistered, cut, burned, broken-nailed hands, I saw over the top of the kitchen range a vision of the education that is to be. Experts in their lines will travel across the United States from school to school. There will be no Miss Smith in Room 12, who is stuck in the Third Grade and hates teaching the little brats. When the expert in geology comes to the Greenwood School, nothing but geology will be taught for a solid two weeks...field work...eyes, ears in use. The little tots in one division, and the big fellows in another...only two classes necessary. Let the little ones drop out when they are tired. Let them go home, if they want to, or rest where they are, with plenty of milk to drink and fruit to eat. The teaching of English, writing, reading, arithmetic is incidental to their other work. Can't you see them joyously learning? Children are so patient. I wonder that they have not risen in a body to slay their jailers, the average teachers, in order to escape from their unnatural prisons, the schoolhouses. Herd them in! They are not a natural part of the whole of creation. They must be chained to wooden seats.

And our great literature—now used for the torture of babes, forced to read and commit to memory what they do not understand and therefore do not love. Only the greatest of public readers should be permitted to touch this literature, in giving it and interpreting it to the child. Let the children hear the gorgeous thoughts and language. Let them be told the magnificent imports of these things. Then let them memorize great literature as a privilege. No wonder the bulk of those who graduate from high school really know nothing of the literature of the nations! And as for other subjects, babies are not too young to be taught psychology, history, and biography. But we shall have to rewrite our history books to take the glory out of wholesale murdering, and to teach, for example, that although George Washington was undoubtedly an admirable character, he did not lick the British with six soldiers.

The truth! Nothing is so beautiful as the truth. But not the sentimentalized truth. Being sentimental brings most of our tragedy and blots out the sense of humor. I could not be a county superintendent, but I did go down frequently to the school-house. And speaking of truth reminds me of the Washington's Birthday program in which Rhoda took part. She was a tall girl for her age, with a remarkable memory and a gift for the dramatic, so the teacher chose her to be George Washington's father, boys of her size never having been taught to do anything in public but sing-song and forget. Bud Jean was small for his age, and he had a conscientious mother, who, the teacher knew, could be depended on to put Buddy through his paces.

All we proud mothers were present, and two fathers. There are usually two fathers somewhere at a daytime school program, who think children are important and education should be encouraged. (Or is it that they just have more determined wives?) I could see the strained intensity of my dear friend Mrs. Dan Jean as Bud marched up to position, and Rhoda Greenwood's mother was rigid with attention. The dialogue began but did not conclude as written, for the infallible Rhoda strayed from the text and inverted the words to a meaning much more human and believable. We have all become so familiar with the cherry-tree story that we no longer actually hear it, so no one there detected the changed ending except me, and I nearly burst with the joy of it.

Buddy Jean said: "Father, I cannot tell a lie. I cut down your cherry-tree."

And Rhoda's reply was this: "My boy, *I would rather have you tell a lie than cut down my cherry-tree!*"

Two honors were bestowed upon the Greenwood family who lived on the hill above the school-house in the dark-green shingle-walled house with the toothpick-pillared porch. Charley was

nominated for State Senator, and I was appointed a Judge of Election. Of course, since we had the primary system, Charley's nomination was only tentative—any other name might be written in the nomination ballot. The county Progressive Party leaders had agreed on him, subject to the approval of the members of the party. Not so thrilling as an emotional stampede, everybody grabbing banners and marching and yelling something like this:

We're headin' fer th' last round-up!
Too-ul-le-laa!...Too-laa!...Too-lee!...too...loo!
We're headin' fer the la-a-a-a-a-ast round-up!
　　　　Whoopee!...lemon-peel!...nobody's business!...dust in the road!...cats on the roof!...whoopee!...Jones!...Jones!...Wow!...Wow! Wow! Wow!....*Jo-o-o-o-o-o-nes!"*

For that is the way we Joyce-Ulysses-brained folks nominate our Presidents of the United States.

The primary is different. Our Progressive Primary was what would be called by us farmers gol-awful different. You will understand why when I relate my adventures in the office of Judge of Election.

We sagebrush Greenwoods were at that stage just before we acquired our winded, second-hand car, Sagebrush Liz, when my only means of locomotion to Hazelton was a two-wheeled cart. Our buggy had become antiquated, so we gave it to Old Man Ferrin, whose kind old wife sometimes helped me on haying or threshing days. Charley had at that time the opportunity to get, second-hand, the Mormon white-top with U.S. Mail stenciled on its canvas and dashboard in bold black letters. As Mrs. Raine, who played the harmonica, would have said, it seemed hardly impossible that the white-top could wear out, but it did. And there it stood, out by the granary, a rheumatic old wreck, porcupines coming to play peek-a-boo through the spokes of its wheels, Russian thistles growing thickly, higher than the axles, and dying there and drying up there, in a prickly hedge which would have given pause even to the trumpet of Prince Charming had the Sleeping Beauty been cuddled on one of the ripped seats from which excelsior protruded its coarse, spaghetti hair.

The two-wheeled cart was really purchased for Walter, so that he might get to the high school, six miles away. Florry was chosen to be the cart-horse. She had changed from a bay colt to a gray horse, my astonishment at this course on her part being stunned bewilderment. Charles, eleven years old, harnessed her to the cart and was to be my driver. As we rode along, I kept thinking how hard it was to believe that the frisky little bay colt Florry had grown into this great gray beast almost sitting in our laps, for when she switched her tail, it brushed my knees.

Florry knew me well. Many, many times, when she was that little bay colt, she had forced me to burst shrieking from the kitchen door, to chase the ornery little devil away from the clothes-line. She loved to progress along the line, grasping the clothes between her teeth and dragging them down into the dirt. And when I hung Charley's trousers out to air, having sponged them with gasoline, pesky Florry would have them by the legs, ready to walk off with them, no doubt congratulating herself on getting a suit out of the thoughtful relations' box. For while among humans this is a man's world, horses know nothing about the dominant sex, and not a horse would ostracize Florry had she attempted to wear the pants. Nor would she have to trot off to Hollywood to do it, either. Of course, I was not very ingenious, or I should have seized upon this natural inclination of Florry's to train her to bring in the clothes off the line.

The dust was so deep, that Primary Election day, that the Lincoln Highway was like a river of flour; so Charles and I decided to avoid suffocation in the cloud we should make and the denser cloud of more powerful vehicles passing us. We struck out for the desert, where the road paralleling the Hootin' Nanny was hard and bumpy, with little likelihood of our meeting any one. As a matter of record, we met not a person, though myriads of jack-rabbits scurried out of the sagebrush just ahead of Florry, and we saw a coyote slink across the landscape not so far beyond.

It was hardly a road that we took—more of a trail, interrupted by great, sharp, black lava boulders, the sagebrush scratching at our wheels as we traveled. Florry sidestepped every rock in

our way and hauled a cart-wheel over, every few minutes almost throwing one or the other of us out of the cart. Up above, the sky was a pale blue, with fluffy summer clouds, and we could see to the horizon on all sides—mountains north and south, and black buttes to the west. Tar-paper shacks, set amidst green fields, dotted the landscape at far intervals, like little black boxes with slightly curved plank roofs. The warmth brought forth the wild, pitchy odor of the sagebrush, whose bushy, velvet-gray heads crackled as we brushed past it. Jack-rabbits popped all around us, and grasshoppers fired their machine-guns, whirring over us like miniature airplanes, until I kept dodging them with the feeling that they might get into my ears or hair. Distant dogs yipped—always there were farm dogs yipping in the summer, and generally in the winter, no matter when you listened.

Florry, stubborn little devil—or big devil, since she was practically sitting in our laps—Florry refused to tread even the smallest fragment of flinty lava, and there were plenty of splintered lava fragments about, for not far from us was the black cone of an extinct volcano. Charles urged Florry on, and she started to cross a stream under a railroad trestle. Two long planks spanned the water, these slight bridges being intended for the wheels of vehicles. With the utmost insulting determination, Florry planted her great fore-hoofs upon them, perfectly aware, I am sure, that should she be successful in the crossing she designed, the riders in the cart would be cast out like two frozen beans among the refuse rejected by the farmer's wife. And our fate would be worse than that of the beans. This was evidently a canal; it was axle-deep and very, very wet. Charles had to use all his strength against the horse, seesawing with the reins until a worried look came and deepened on his face.

A little later Florry received her punishment. The whole thing made me think of the struggle of poor Christian, with one difficulty after another. We were now about to enter the Slough of Despond. Florry had no way of saving herself at our expense this time. There were no rocks and no planks, just deep, bottomless, gooey mud, caused by a farmer's waste water running on this unused road and soaking in, down to bed-rock. Muddy roads are always a part of the irrigation season, but it is a criminal thing to neglect the water as this farmer had evidently done. Certainly it might have been turned in some direction of need.

Water among us sagebrush folks was money. When a man stole your water, he committed grand larceny, no matter how much he himself might feel his crime mitigated by the hymns he sang to Jesus a-Sundays. Water in the sagebrush country is not free, as the rain from heaven. Both the just and the unjust have to pay for it, or it is shut off, though the Water Company is not hard-boiled about it, so far as I know. If your head-gate is stuffed with weeds or gunny-sacks, it may mean the loss of all the money you can make that year, for your crop will die. There is dry farming in Idaho, but our farms were not operated in that manner.

The stores will not carry you forever, though the Hazelton stores were certainly long-suffering, and they must have lost a great deal of money through the farmers being unable to meet their bills. When another farmer steals your water, he takes the clothes from your children's backs, robs your wife of the medicine she probably needs, takes every penny out of your own overalls' pocket. It is no wonder that almost every year farmers are killed at the head gates, one discovering another in the act of stealing water. There is sometimes, too, the murder of a ditch-rider who happens to catch the water racketeers, the answer to expostulation being a shot in the head.

Many times Charley came to the house for his gun and with it went walking away in the dusk up our main canal. I knew then that Bab or Baldy had stuffed our mutual head-gate when it was Charley's right to the water. He said he would fire a shot in the air to scare the guilty robber, but I was never easy until he came back. Then I stabbed him with my eyes to discover his dreadful secret. Fortunately, he never had any. He did not even fire his gun. The gunnysacks or weeds had not been replaced during his absence, and no one appeared, though he sat there with his gun on the canal-bank, in the still of the long evening, for over an hour.

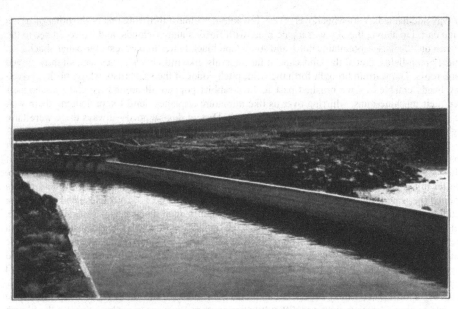

IRRIGATION WATER LEAVING THE MILNER DAM

IRRIGATION FURROWS FROM HEADING DITCH IN NEWLY CLEARED LAND

Florry was pretty sore at us by the time she had dragged four hoofs, weighted with a ton

or so of mud to each, through that morass. I could tell by the scowl of her backward-pointed ears that she thought we were doing it on purpose. Any moment I expected her to lift a mud-laden hind hoof and lay it, pathetically, in my lap. I am surprised that she did not think of this, instead of blowing out disgusted groans and snorting several Bronx cheers at those goofs in the cart.

The next trial bothered Florry not at all, for though she was in the utmost danger, little did she know it. Right perkily she shook the mud from her hoofs and began tromping and stomping on a condemned bridge. Of course, the County would have been blameless had she stomped and tromped the bridge down into the very wide and deep canal over which we were passing. There was a law in Jerome County at that time (and there may be now, for all I know) that whenever a bridge was about to cave in, the County need not replace it until it did cave in and some one was drowned, if the responsibility of the drowning were shifted to the shoulders of the drowned by posting the bridge in big letters with the words:

THIS BRIDGE CONDEMNED

That's all. After that you might consummate your own unwilling suicide if you dared. It might be Hen Turner dashing for the doctor, or it might be little Buddy Jean being taken for an appendicitis operation. To go back to the main road would mean a loss of three miles and then the recovering of those three miles, with perhaps fatal loss of time. But it was your funeral if you crossed the bridge. And at next election the county officials could brag of how economically they ran the County when they were in.

Well, we did not burst through. Florry felt so happy that she tromped and stomped her hardest, and lifted her head joyfully, and waggled her ears just to show that she didn't give a damn for those two idiots in the cart. Yet for all her exuberance we did not go through into that drowning-deep canal. It was not meant to be. I was meant to be a Judge of Election, and not a citizen of that little silent camp on the barren hillside, which we presently passed. There it baked under the pitiless sun, the little mounds of drowned babies and the little syphilitic babe, pocketed, every mound, with gopher-holes.

We entered the little town of Hazel ton, for which I have a particular affection. We passed the tiny frame eating-house of Mrs. Reynolds, who declared that she had once been a servant in the home of President Taft; Longenberger and Belmont's; Daddy Ayer's hardware-store; Hank Thorsen's drug-store; the telephone exchange, in a tiny box of a building; Dunn's store, where was, in a corner, the post-office from which Mr. Kelley brought our mail; the bank, of which Gundelfinger was head, and before which, after we left the sagebrush, one boy would be murdered and another incriminated, through the machinations of a despicable county official, planning to collect a reward. On the corner opposite the spot where this crime would be perpetrated stood—and still stands, the last I heard—the ugly, bleak, frame hotel.

Charles stopped the cart in front of Hank Thorson's, and I climbed, very gingerly, around the muddy wheel, thinking for a moment that in order to save my best dress I might be forced to seize Florry's coarse black tail and pull myself up over her broad flanks. I never did get that white dress I wanted so badly, and the dress I was wearing in that cart was my first and last best summer dress while I lived in the sagebrush. Charley's sister Laura had sent the goods to me, light blue, with lovely, fluted, white-organdie scalloping for trimming. I had made the dress myself, and I was almost bursting with the pride I felt in wearing it. Laura will never know what that fresh, new material meant to me. Everything else I ever made on the farm was cut out of something already used. One of my dresses was made of twenty pieces, and you could not see where I had joined them. The result of those days is that now I cannot see a dress without making it over in my mind.

Having said good-by to Charles, I stepped up into the drug-store and asked Hank the direction to the Progressive headquarters. I know he misunderstood me, for he would never have sent me where he did deliberately. It was the drab, gray hotel. I crossed the street to that homely edifice and opened the front door. There was a long, unpainted pine table the length of the dismal

lobby. This table was surrounded by men, practically all our local business men except Hank Thorson, although the only faces I can remember were the handsome visages of Charley Barlow, who was manager of the grain-elevator, and Gundelfinger, the banker—both men comparatively young. If the others could have arranged to be handsome, I might have remembered them. But I have an idea they will not die of this disappointment.

As I remember, it was the two men mentioned who arose, smiling, and one of them took a step toward me. They must have thought instantaneously that I was a rebel from the Progressive camp. Yes, I am sure only two of them stood up. If it had been all of them, I should have remembered that. My dress was pretty, and I did look well in it, and there had been a day when I was able to get all men on their feet with such a combination. But I was only a farmer's wife now, and my skin was burnt, and I had lost that look of easy life which is so seductive. Yet one thing I do remember, and that is that every one of those men smiled most beautiful smiles at me. Still, there are two smiles almost indistinguishable—the admiration smile and the political smile. After all, their smiling might not have been a tribute either to my dress or to my personality.

In the first place, I saw them so seldom that they could not know my dress was new, and in the second place, not one of those men knew anything about my personality; and when they read this book, as they will, for we always read what is written about ourselves, they will say to each other, or to their wives, or to themselves, "Well, I'll be damned! So *that's* who she was!" But they knew me as well as the farmers of the Greenwood District did. For that matter, I did not know myself then any more than they knew me. It is so strange that a woman could be there in that sagebrush country for years and years and nobody know her, not even her husband, not even herself. But it is true. And it is not important.

"Did you come to vote?" asked the beautifully smiling Charley Barlow.

"I am looking for the Progressive Primary headquarters," I answered, smiling just as beautifully. I even modulated my rich contralto voice so that no windows were broken when I spoke.

And then,...brothers!...sisters!...did you ever watch the moon blot out the sun? No, that is not rapid enough. Did you ever see all the blinds in a brilliantly lighted house pulled down at the same moment, leaving you out on the lawn staring up at blank blackness? No, nobody ever did. But that was the effect of what instantly followed my words. Lights out! A frigid voice—I have forgotten whose—answered, very courteously, though like the cold sound of ice crackling from the eaves, "You will find it farther up the street." It was really very nice of them only to freeze me. They might have kicked me out.

Some day I shall probably walk up to Mr. Hitler and ask him if he is the Relativity Einstein. I should have known better than to ask for the Progressive Party Primary at the Republican Primary headquarters. I slipped out of the hotel door and walked east, snickering inside myself. I ought to be embarrassed on such occasions, but I never am. They simply strike me as funny. There are people who are silly like that, you know. Well, live and let live, I hope is your motto. Such people as I come in handy for door-stops, magazine-racks, mops, and other domestic purposes.

I should have known that the Republican Party would be in the big hotel and the Progressive Primary in a little runt of a vacant shop. Two booths had been arranged by erecting one partition and covering the fronts with some sort of curtain. I knew that inside would be a shelf on which to mark the ballot, and a pencil on a string with which to do it. A little table was pushed against one wall, close to the door, and at this was sitting a farmer—unmistakably a farmer, according to Steve Drake, whose definition I give here as he said it to me: "If you see a man, and he's got a fairly good suit and coat, why, that's a tramp; if you see a man in a ragged coat and worn-out overhalls, that's a farmer!"

I never saw this farmer before. He was from Russell Lane, a portion of the farm country so designated because of a man of that name, as Greenwood was named after me. The Progressive farmer had opened a big journal of some kind on the very little table—such a little table when I

remembered the Republican table. There was supposed to be another Judge of Election, but no one coming to claim that office, the farmer and I solemnly swore each other in. I felt the responsibility keenly, for this was my first active venture into politics, though, even as I had an ardent ambition to revolutionize education, so I had long wanted to put my spoon into the kettle of political soup. It did not smell right to me. I thought maybe I could taste it up.

I had not even voted after my first vote, having made my home in seven different states since that day, though not all since my marriage. My first vote was really notable because, out of regard for my father's politics, I being at that time one of the Pa voters, I checked every name on the Democratic ballot except one, and for that one I substituted the name of a man whom I saw constantly in our home when I was a child—along with George Sutherland and Will King and a number of other fine men who never became Senators and Supreme Court Justices, but remained our substantial small-town backbone: Banker John Twelves, Judge Dusenberry, Major (U.S.A., retired) Berry, and numbers of others, with wives whom I remember with emotions of affection.

I voted for Reed Smoot in a booth erected in half of a livery-stable. My father would not much have minded that Republican dereliction from Democratic righteousness. But there was no disguising from myself that my father would not have been delighted with my embracing so enthusiastically this Progressive Party. The year 1932, in his name, and also my own, I voted the Democratic ticket in one instance—for my dear friend Elbert Thomas, known to his family and friends as "Tommy." I was practically certain my vote was what had kept Reed Smoot in the Senate, and maybe it was my vote that put him out. Well, nobody pays any attention to a woman so flabby and brainless as to skitter around from party to party, voting in her Pa's friends, and finally voting them out in order to vote in her own friends. Politics is something you must make up your mind about as soon as possible, and you must then stick to that same opinion the rest of your life, as though fixed to it with airplane glue.

In that little runt of a shop, there we sat facing each other, Judge of Election and Clerk of Election, all day long. At noon, one after the other, we went over to Mrs. Reynolds' eating-house, where I, at least, received my full money's worth, in food and conversation. Some one had told me that whenever she overcooked anything, she served it just the same, with the cheerful remark, "Just a nice Portland brown...just a nice Portland brown...." She liked me, and after the three other little tables were provided with steaming food on thick china, she seated herself on the other side of my table and entertained me all the rest of the time I was there. Little, dark, chipper, stories concerning her marital ventures were floating about, but all she told me were of having been a servant in the home of former President Taft. At least she knew the members of the family by name, and she related in detail circumstantial anecdotes which were either the invention of a genius or the experience of a close observer. She could neither read nor write, but she was a keen little business woman, and a good cook, generally.

When I had voted for Reed Smoot in that livery-stable, there was the smell of manure and the stamping of hoofs and whinnyings from horse to horse. In that tiny shop where the Progressives were to vote for their nominees, there was only the flat, lonesome odor of pine boards, which seems to ooze out of long-vacant stores, and there was no sound anywhere but the occasional whirring of a car, going in the direction of the Republican headquarters.

At the rattle and bang of a farm wagon, great hope was aroused in the perfectly silent Clerk of Election, and also in the perfectly silent (but not naturally) Judge of Election. I was sure it was the beginning of a full day when the wagon stopped in front of our bird-house, and a great farmer, in ragged clothes, entered, gave us his name, and went into a booth to vote his nomination of a candidate. I could have hugged him. I felt very important. For this was my first voter, I who was a Judge of Election.

We sat and sat and sat. The farmer smoked. I knew he was in misery because he was refraining from chewing on my account, a noble tribute, of which I hereby make acknowledgment. After all, I think the pretty dress did have some effect. Certainly I had no chance whatever to exercise any personality, my variety not being of the deaf-mute kind.

We had one voter. That night I was quite crestfallen, riding home in the cart on the Lincoln Highway, dust and all, in just as dumb depression as I had sat in dumb hope facing that good, dumb farmer. But a little thought kept running around in my head like a mouse hunting for a piece of cheese it could smell somewhere. At last the cheese was found. It was this: Of course the farmers did not come to vote at the Progressive Primary. All sorts of unfarmery folks had rushed to the Democratic and Republican primaries. That was because there was some contest as to which men the members of those parties wanted. With us it was different. Our committeemen had chosen candidates, and the farmers were satisfied.

Still, I did not feel so much better when, the next day, Charley returned from Hazelton and remarked, "Your Progressive Primary is the laughing-stock of the town."

"Let them laugh!" I challenged valiantly. Well, maybe they had a right to laugh...and, on the other hand, the Baron had Junker blood, and he had also been a farmer many years. It may be that he did not like his wife spending the day with another man in that bird-house. I have an idea that there are a good many men who would have felt that way. If he had only known how I sat there suffering to be talking, and the poor farmer sat there suffering to be chawing....

The Progressive Party had a platform totally different from that of the Republicans and the Democrats. Remembering that this was in 1922, it may interest you to know what we then advocated, and to see how much, or how little, has been accomplished along those lines since then, not by farmers, of course, but by any agency.

1. Abolishment of economic advantage by possession of which a small group controls our natural resources, transportation, industry, and credit; stifles competition; prevents equal opportunities of development for all; and thus dictates the conditions under which we live.

2. *A state-wide open-primary law and a sound, workable initiative, referendum, and recall.*

3. *Public control of natural resources; just taxation of all land values, including land containing coal, oil, mineral deposits, large water-powers, and large timber-tracts, in order to prevent monopoly. We favor the gradual exemption from taxation of the products of labor and industry.*

4. *Public ownership and operation of railroads, and enough public utilities to compete with monopoly.*

5. Equal rights for all citizens: free speech, free press, and free assembly for all lawful purposes, as guaranteed in the Constitution.

6. State efficiency and tax reduction, by the abolishment of the State constabulary, the cabinet form of government, *and other tax-eating, useless commissions;* the reformation of the State highway and game departments, and the election of the State utilities commission.

7. *A State graduated inheritance tax and income tax on incomes over $5,000—like the Wisconsin law.*

8. *A guarantee of bank deposits law.*

9. The well-known and just demands of labor, including an exclusive State-fund compensation act similar to the Ohio law.

10. An *impartial* enforcement of all laws, including the prohibition law.

11. *Laws to protect individual and cooperative enterprise from monopoly.*

12. *A national soldier bonus, paid for by tax on excess profits.*

13. *Money control to be taken from the private monopoly of the Federal Reserve System and restored to the National Government.*

14. *We pledge ourselves to take the judiciary out of politics.*

Those were all, and had they been the Republican platform of 1932, and had Hoover stood upon it, he might have been in the White House yet. For there used to be excess profits, and there would then have been no opposition votes of non-bonus-angered veterans. As for the guarantee of bank deposits law and money control in the Government itself, it looks as though President Roosevelt has stolen that old thunder of ours. As it stands, had there been wise officials to operate it, I dare to say here that that despised farmer platform might have prevented the depression

in these United States. Did you lose money in banks? Nothing of the kind could have occurred had the Progressive Party gained national power. But then, it has always been the little also-rans who have advocated the measures that finally move the world when adopted by the big powers. The members of the minority rule the world—after they are dead.

H. F. Samuels headed our ticket as nominee for the office of Governor. Like Norman Thomas, who heads the Socialist Party, Samuels was a gentleman. Not a born farmer, nor even a city dreamer farmer, he got into the game through patriotism. Having made a fortune by perfecting a process for the extraction of zinc from low-grade ore, he bought logged-off land in northern Idaho and put thousands of acres into the service of raising food for the Government. A lawyer by profession, he was a deep thinker, a wide reader, and a broad-minded man. Through his agricultural interests he came in contact with the Non-Partisan League, and he became so deeply interested in what it proposed that he made a journey to North Dakota in order to interview its staunch supporter, Governor Lynn Frazier. Back he came to Idaho, a complete convert to the farmers' party. Not an ordinary person, this H. F. Samuels: well-educated, cultured, and successful in his chosen career; acquainted with politics, having been elected on the ticket of one of the old parties as a county attorney; not, therefore, a disgruntled, defeated politician; a rather handsome man, with sincere and courteous manner, and a good public speaker. We were very fortunate in having at the head of the ticket such a splendid character to represent us farm people.

Following the primaries came the rallies, ours, of course, being held in the Greenwood school-house. There we had funeraled the syphilitic babe; holied the building by groaning, and praying for our little peanut souls, and singing hymns to poor Jesus. And there we had danced, some of us ragging, and some of us fighting, and some of us, such as Mrs. Greenwood, from the house on the hill, just yearning to do both and keeping it bottled up, with the danger of a psycho-release in murder or something.

I was not allowed to rag, being the wife of one of the chief ragging-abhorrers, nor was it permissible for me to fight, but I would not be denied my politics. I distinguished myself by being the only woman in the district to attend those rallies. Even Old Lady Babcock had the decency to stay home in her tar-paper shack and allow her lord to represent the Babcock family. Brilliant as I knew the Baron to be, I would not allow him to think for me, strange though it may seem; nor would I vote any ticket just because he voted it, or because Pa voted it, or because we always voted that way in our family.

There I sat in a child's desk, in the Greenwood school-house, the only woman among a roomful of mackinaws and sheepskin jackets covering work shirts and overalls. Shaggy-haired from home barbering, or lack of it, with an occasional bald head, fingers thick and stiff from hard outdoor labor, my farmer friends were not the dumb-bells they looked. The Baron was moving about from place to place, always the born leader. My presence was not questioned by him as other than perfectly acceptable. That seems to me a remarkable thing in either farm or city man, considering all the circumstances.

The first rally was of our own Progressive Party. Our own men, led by Charley, got up and expressed their opinions. Until that night I had been extremely sensitive to their—to me—frightful lapses in English. Having spent my entire childhood under the pedagogical care of Boston schoolma'ams, it was not until long years after I was a woman that I was able to shed the awful accuracy of my speech. I had not then learned that speech and writing spark to life only as we are able to reflect our own time. It is a vicious mistake for teachers of English to plug away at trying to make twentieth-century students write like those of any other century. Pathfinders, that's what we need, those who dare to loosen up the language, not afraid to adopt some of the gorgeous slang invented through the genius of the people who live. I myself have no doubt that one of the greatest reasons why Chaucer, Shakespeare, and other writers have survived their own ages is because they were able, and courageous enough, to express their own ages. I believe we should know our English so well that we can violate the rules in the manner most pleasurable to other people, as well as to ourselves.

209

That night of the Progressive rally I was able to hear the *I dones* and *I seens* and *he has cames* and *he has wents* without flinching, and maybe throwing a fit, or passing into a state of merciful unconsciousness. I was glad that night that those farmers had a language of their own. I looked at the weather-beaten, earnest visages of our speakers, and they appeared to me to shine like the Shekinah.

Said one speaker: "The Republicans and the Democrats have both of them a sure remedy for curing what ails us farmers. The Republicans say that all that is the matter with you is that you are overburdened with taxes, and that when you no longer have to pay these, you will be in a prosperous condition. How many of you men here tonight have paid your taxes?"

Not a hand went up.

"Then," continued the speaker, "if you have not paid your taxes, you should be prosperous, but since you are not prosperous, the taxes cannot be the big problem. Now the Democrats," he said, "say that all that is the matter with the farmer is that he should quit raising so much hay and grain and raise more cows and hogs. If we did this, there would be bound to come a crash, none of us raising enough hay and grain, and all of us going in for raising hogs and cows in a big way. And when the crash came, the Democrats would say that all we farmers need to do is to stop raising so many cows and hogs and raise more hay and grain."

One speaker appealed to us to vote the Progressive ticket straight. I felt a little shaky about the men on our ticket. Except, of course, my own man. Charley was running for the office of State Senator from Jerome County. But most of the other men were such little men indeed. Why must all big things begin with little men? Is it because only the crushed and unsuccessful can feel enough discontent to fight for justice? The advance guard of every reform is composed of more or less undesirables. But that is not what damns the cause. It is the indifference of the great body of people. Whenever the politicians see that the people are bound to bring something to pass, after the pariahs have sacrificed their lives to the fight, then one or the other of the big parties adopts the cause for a plank in its platform, a sort of spring-board for diving into office. They stand on it, but sometimes when they get the votes because they are standing on it and appear, ready for action, they fail to make the dive. The people do not forget.

"Better vote for a poor man who believes as you do," said one of our speakers, "than a clever man who believes in the opposite principles, for the clever man can do more harm by reason of his very efficiency in the wrong direction than the less capable man can do when he is trying his best along the line you believe right."

I was convinced. I made up my mind to vote a perfectly unscratched ticket, a very difficult thing for me to decide. I find such fascination in revolting from the massed decision of a few people. Of course, if I had been included among the deciders...

We knew that the Old Parties would be winging down upon us in no time, and we all agreed to attend every rally. But we knew, what they did not, that they might talk their heads off, and it would not change our settled course. That laughing-stock Progressive Primary did not mean what the Republican and Democratic politicians thought it meant.

The Republicans came and—canny folk—brought with them frankfurters, buns, coffee, tin cups, canned milk, sugar, tin spoons, and a gasoline stove. Our Progressive farmers, and the one farm woman present, all fell to with the utmost cordiality of welcome when the refreshments were passed. There we sat, like dumb, driven cattle, chawnking away on our buns and hot dogs and swilling down our coffee, and Brer-Foxing by not sayin' nothin', and just regarding speaker after speaker with round, expressionless eyes, and every man and one woman of us with our minds made up past any changing. Fifty thousand, or more, years is a long time to bear injustice.

Then came Senator William E. Borah a-campaigning—not to the Greenwood school-house; he was too big for that. He was too big for anything. Almost too big for our puny universe. The star Betelgeuse, dwarfing the sun as it does, and washing out our globe as a wet sponge a fly speck—Betelgeuse would have been almost too small to accommodate him. Ramping and stamping and bellowing all over the State of Idaho he came, little politicians rushing out to meet him with

210

threats and scrambling out of his scornful way to avoid being mashed under his foot.

From what Borah said, you could not have believed that he was in Congress by the vote of the people of Idaho, but solely by appointment of God Almighty Himself. And maybe he is, for in spite of all the poisonous, antagonistic fulminations of the other politicians of Idaho, Borah stays right on being a Senator in the Halls of Congress. He is a strong man, and not to be sniffed at, no matter whether we agree with him or not.

Borah began by condemning everything done by the Republicans during his absence from the state—the cabinet form of government, the state constabulary; coming out flat-footed for the direct primary, in spite of the convention plank in the Republican platform; splitting his party wide open and not giving a damn; challenging Moore, the Republican candidate for Governor, to reject the Republican platform and make one of his own.

I was sick with bronchitis on election day, but I was doing a big washing just the same. We had no money to pay for laundry work, and, besides, no laundry wagons came out into the sagebrush where the telephone and electric light had not yet penetrated. Some one in a car took me to town to vote, and I simply left the tub of suds standing, donned my coat and hat, and was off for the six-mile ride through the cold.

By this time, in the history of our district, some of our folks had old, rattletrap, second-hand cars—but cars just the same. The Progressives had requisitioned every one of these to get the farm folks to town. As we rode along, we passed car after car bringing voters back from Hazelton—that done, to start back again with more voters. Some of the drivers were in borrowed cars, Ben Temple for one, who year after year, when he planted his crop, smiled at the thought, "This here year I'm a-gonna git me a new sheepskin coat, by God!" But every year the crop cost more to raise than he could get for it; slipping back...slipping back...was good Ben Temple, and all his labor lost. I thought of that as I saw his tattered coat fluttering in the seat of that borrowed car.

I did not know Frank Melotte except as one might know a shadow. He lived on the desert edge, alone, in a tar-paper shack, and always had a brooding look about him. Returned volunteer, he was now trying to help the farmer in his battle, thus helping himself. He had been drafted into the World War, but nobody needed to draft him into the war for justice in which we farm folk were engaged. The car he drove was his own second-hand flivver.

It seems so strange to me now that my heart was not touched by that pitiable, round-shouldered, raw-handed, shabby farm woman I saw climbing down over the wagon-wheel in front of Irvine's store back in Provo, as I sat so smugly, the Doctor's daughter, in that fringed-top phaëton. On election day in 1922 I watched those poverty-stricken farm families walking on the streets of Hazelton with a painful swelling in my throat. A baby in the mother's arms, in almost every case, and a baby a trifle older in the father's arms, and scared, dumb, staring little fellows clinging to the father and mother at whatever vantage-point they could find, all of them dressed in the poorest of clothing. I could see back of them the years of thankless toil, the crops raised at greater cost than the price for which they could be sold—hopes blasted, year after year, ground down into the soil. Infamous, luxury-loving, self-indulgent Government of these United States! What do you mean by allowing interested profiteers to set the price of wheat below the cost of production and get away with it? What are you thinking of yourself in proposing any arbitrary price-fixing that is not based upon absolute computation of the actual cost of production?

That night the men stayed in town to watch election returns—and oh, how I envied them! To be alive in every pore as I was, and not to be allowed to live all the life I could live! I was up early, as usual, next morning, and at six o'clock I was busily engaged in turning hot cakes, pouring coffee, stirring fried potatoes, watching omelettes, frizzling bacon, setting table, skimming cream, and a few other little things, when I heard Ike Bennett's wagon come lumbering into the farm on the road above the orchard. I remember my pancake-turner was poised for another cake flip-flop when in through the kitchen door they burst. Yes, our dear friend Hib, the baker, and jolly Steve Drake, and they were all singing, for my benefit, at the very tops of their voices, standing together for a moment so that I could get the full effect of their song:

211

Three cheers for the red, white, and blue!
Three cheers for the red, white, and blue!
The army and navy forever!...
Three cheers for the red, white, and blue!

As soon as their voices had ceased, but not the shining of their eyes, I cried breathlessly, *"How did it go?"*

"We've carried Jerome County, and we may have carried the State!" Ike Bennet assured me.

"It's too good to be true," I exclaimed happily. I had forgotten that Charley was now a State Senator. The farmer's cause had swallowed up all selfishness on my part and, I am sure, on the part of the Baron also. When I thought of it, I was glad, for now perhaps he could do something in the Legislature for the Idaho farmers. But the thing that impressed me most of all was that two years before we had gained ten thousand more votes than in our first campaign, and that the Progressive year we had gained still ten thousand more. I knew from election returns that at the next campaign we needed only an additional five thousand and one votes to make the state Progressive. I had a vision that such would be the event. But I was just seeing things. There was something so seriously wrong with agriculture that only a governmental major operation could cut out the cancerous growth of rapacious middlemen. No, the farmers would not stick together; particularly blind were the farmers' wives. And why should either of the Old Parties do anything for the farmer when it was sure of his vote anyway, because Pa had always voted that way, or we had always voted that way in our family...?

Through me, Charley drew the solid Mormon vote in both his elections. In our part of Idaho, when we first went there, the population was preponderantly Mormon, which meant not such an extravagant number even so. During Charley's second campaign there were only a few among us, and the Mormon Sunday-school, which had used the school-house one-half of each Sunday while the Union Sunday-school used it the other half, had entirely died out.

The Mormons who live in that part of Idaho are not much of a credit to the faith, the men proudly swelling their chests with the announcement, "I'm a Mormon!" and the next moment biting off a chaw from a plug of terbaccer or pulling out a whisky-flask with the kindly offer of a snootful, which, of course, are habits not sanctioned by the Mormon Church, though it is at present rather badly affected by modern trends of society. If the Mormon Church should stop sending its young men on missions, where they convert themselves, it could not retain its solidarity.

I know all that can be said against Mormonism. I doubt if any outsider knows the Mormon religion and its practises better than do I. Some of my very dearest friends are Mormons, and I have no desire to meddle with their faith, which cannot be any stranger than what I believe. I have no desire to meddle with the creed of any church. There is enough good in each one, if practised, to revolutionize the world in which it has influence. I do condemn the churches, including the Mormon Church, for not living an acting loving life as defined by Jesus, while going right on singing and praying about saving their little peanut souls. Forget it! Go out and save your brother man's body and mind! Our souls can be trusted to take care of themselves. And, for God's sake, cut out the ritualistic abracadabra dowsing-rods! There is nothing supernatural. "If anything is divine, all is divine; if anything is human, all is human." "All things were made through Love, and without Love was not anything made that hath been made." Nor can anything more be made of good to the human race except through absolutely disinterested, dis-creeded, dis-prejudiced, dis-judging Love!

At the Ladies' Fancy work Improvement Club I was one day a guest. I was trying to behave myself properly because I had gone as the guest of my dear friend Mrs. Dan Jean. And then, of course, it had to happen. Two or three of the women began running down the Mormons. I wanted to keep my mouth shut. I always do too much talking. It is hard for me to believe that the world will get along about as well without my trying to reform it as if I were always in hot water because

212

of my altruistic squabbling. I looked desperately around me for some one else to take my place, and there she sat, Mrs. Ross, a little, dark woman, and a Mormon, I knew.

"Mrs. Ross," I said, beginning to be exasperated at her silence, "aren't you a Mormon?"

"Why, yes," she admitted, falteringly, "but I do think the ladies are right about this..."

"They are not!" I proclaimed boldly. "Maybe there is a rotten bunch of Mormons up here in southern Idaho. Perhaps you know them, Mrs. Ross, but I do not think you should allow it to be said that all Mormons are of the same stripe. Some of the finest people I know are Mormons..." and so on, and so on, for Mrs. Greenwood was galloping away, maybe on the Tenth Crusade again, the one she always wanted to lead. And there sat the other women, their faces growing harder and harder, and not a word in answer. What a fool I was! The Mormons must rise or fall by their own deeds, and nothing I can say will have any effect. If they are more interested in their rituals than they are in spreading disinterested Love throughout the whole world, and that is all the message Jesus brought, the Mormon Church also will die, along with the other churches that are now at their last gasp because they no longer function as missions for the unfortunate, from whatever source.

I could not go rampaging around, making other women hate me, without having it winded abroad that I was a Mormon. Thus, I pulled the Mormon vote, while Charley pulled all the rest. He was handsome, charming, with attractive manners, and that combination always makes all the women wonder how he ever happened to marry that woman, meaning me. I could tell them. I picked him out and picked him off, as nearly every woman does, if she has any gumption.

IN 1919, when Charley went to the Idaho Legislature as a Representative, there was a terrible epidemic of influenza sweeping the country. In our part of the world the school-houses were turned into hospitals, and folks died like flies around a saucer of poisoned paper. There were really not enough well folks to take care of the sick, and there was no one to go from any house to another house to help.

On the point of leaving for Boise, Charley was stricken. I nursed him through all right, but he was no sooner gone than Rhoda, Joe, and Walter fell sick. And then little Charles, my only help, struggling around sick so that I should not know, could no longer keep going.

In those days, when the bond was so strong between my children and me, I could cure the three younger ones by my words or my hands. I had not thought of this until Charles sickened. I made Charles feel faith enough in God that he was completely healed by morning. No sooner had I left the little fellow than I myself was prostrated. Again I declared my belief that my loving Creator had no intention that I should be sick with little children depending on me. I fell into a sound sleep, and awoke healed. I could have healed the other three had it occurred to me. It is man who limits the power of God by his lack of trust.

Charley was hardly gone to the Legislature as a State Senator when I was suddenly laid low with pneumonia, pleurisy, and facial neuralgia. There was not the faintest warning of my impending illness. As I stepped from an evening bath in the galvanized tub, I had to call to my children, a towel wrapped about me, and they came running, slipped my nightgown over my head, and between them fairly carried me to bed.

Hib was with us. He telegraphed for Charley, then scrubbed the house from bottom to top, using a tub and broom. We no longer had any rugs. Charley's first act was to get some white mule from a friend who knew where there was a still. This man I married was a veritable angel of mercy in time of sickness, and he believed, as I believe, in that other angel of mercy in time of sickness, the benign alcohol. Because there are dipsomaniacs who should be under lock and key and the care of a physician, the rest of mankind were not to be allowed alcohol for medicine. Paul was wrong in so many of his teachings that he did more harm to the Message of Love than he did good. If my brother should not eat meat, I will not stop eating it. He must be put where it cannot bother him to see me eat it, or he must develop the will power to resist. No, I do not like Paul. He is no more sacred than I am. He was just a man, as I am a woman. We both believe in Jesus. But Paul had it in for the women. Some woman had jilted him. The scar of that disappointment shows through the

213

drapery of nearly everything he says.

We had not abundance of bed linen, so every day Charley washed and ironed a change of sheets for my bed. Every day he bathed me from head to foot, and combed my hair, and prepared dainty things for me to eat, which I could not eat, I was suffering so. I should have gone insane without that corn likker to soothe away the pain occasionally. The Baron thought it would please me to hear him reading to the family. I was diverted through *Pudd'nhead Wilson*, but when he was about half through *A Connecticut Yankee in King Arthur's Court*, I called, feebly, to have him shut the door. Even now it makes me feel sick, momentarily, to recall how I was tortured by even the faintest sound.

If I ever remark that I am not feeling well, it is a good idea for folks to put me to bed, forcibly if necessary, for I shall be on the point of death. My head so tyrannizes over my body that some day my body is going to die of it, and then it will be just too bad for my head, and serve it right. When I go down, I go down dead, and the faintest complaint is a serious signal. And when I come up, I come up bounding. No lingering convalescence for me. There are too many interesting things to do, and see, and smell, and hear, and taste, and feel. It is my head getting its innings at last, and a good thing for the body, too, for the time to forget you were ever ill is when you are getting well.

I cannot remember how soon I was well from that terrible torture. What happened, probably, was that suddenly one day I insisted on being wrapped in blankets and propped up before the typewriter. I cannot stop writing. Then I must read. Maybe all I could do that day. The next day I would try to dance. The third day I would be tottering about my work, on the job again.

Charley went back to the Legislature. When he returned, bringing with him all the books in which were compiled the laws enacted during that session, I sat cross-legged on the floor of the unfinished room upstairs and read every word of them. And yet the searing effect of that sickness was so great that I can recall nothing of them, I whose memory is almost unimpeachable. Probably there was nothing striking enacted.

There were to be no more political campaigns in Idaho for me. I was to go out to teach, to try by that means for a way out of the poverty of that sagebrush farm for my little family. Yet politics is to me the most worthwhile interest of an American citizen, and in my mind I am in the thick of national governmental affairs every day I live. I shall never stop wanting to taste up the political soup, stirring around with my spoon to find out just what is at the bottom of the brew, determinedly attempting to give justice to all by my vote, not afraid to admit mistakes, and backing any one else who has the same ambition, be he, or she, Democrat, Republican, or Socialist.

X. FAITH

The wilderness had taught me lessons; I had learned from bearing children and from seeing death; I had taken part in the sagebrush recreations and outdoor sports; war brought knowledge which will last me the rest of my eternity; politics gave me an insight into practical economics. I had the greatest lesson yet to learn, one which I had never learned before, the lesson of faith. It did not last me always. I had to learn and relearn, until now I have no doubts, and nothing can shake my faith in a beneficent God. I am about to tell you of when I turned my case over to God, with such astonishingly dramatic results, at which time I was not a Christian. How I became a Christian, and to what it led, is a story in itself—a story not yet completed.

I might have gone on down through that poverty to my grave, and my children...what would have become of them?—if it had not been for Walter. There was an attractive girl in the Hazelton High School whom Walter liked as he had never liked any girl before. There was also a foolish young girl teacher, a graduate of a good college, who had not yet learned to confess that she did not know everything. Why should one know everything? God needs no understudy.

It happened that there sprang up a fierce antagonism between the young girl teacher and the young girl Walter liked. The teacher was no doubt an unusually bright girl, but her judgment was poor, and she overestimated the power of the institution from which she had graduated to strike awe among the high-school students she was teaching. Gradually all her classes were on terms of rebellion with her.

Caroline, so I shall call the young girl Walter liked, was influential in turning Walter against the teacher, but this antipathy was more than fostered by the foolishness of the teacher herself. Walter was not the only boy liking Caroline. She had half a dozen other admirers. Among these was Red, a boy for whom she finally showed open scorn. Hell hath no hate like love to madness turned in anybody, man or woman.

One day, as the school wagon passed Caroline, walking beside her bicycle, Red said, "There goes that——" The epithet was vile. Walter immediately struck him on the jaw. Then the fight began which ended with broken ribs for Walter, crushed backward, as he was, against the driver's seat. It was suspended on the plea of the driver that the boys wait till they reached the Greenwood school-house, where they could fight it out.

On the grounds of the school-house, in the presence of the fathers of both boys, eighteen-year-old Red and sixteen-year-old Walter fairly flayed each other, closing each other's eyes and doing other damage. The principal of the Hazelton High School sent for the boys. They were not presentable for a week. At the end of that time they went to him, Red with a well-coached witness. Before Walter could utter a word, Red told the principal that Walter had called the foolish young teacher that vile name which Red had flung at Caroline, whereupon he had hit Walter on the jaw, and the fight was on. Walter quietly denied this version, but Red's statement had been corroborated by his friend, and the principal preferred to believe them.

Charley had scolded Walter for his low grades under this teacher, grades common to the rest of her classes, and I had challenged the Baron to stop scolding and do something. That had made him turn Walter over to me, since I was always advising and therefore should know how to act. I did. When Walter came home with his story about Red's stratagem, I took my boy out of high

215

school. There was no law compelling attendance, so I was entirely within my rights.

Walter began to work with passionate interest on his boy-made radio. There was friction between him and his father about work hours and late radio hours at night, for the boy-made set would not bring much in until after eleven o'clock. Then came what happens so frequently because of misunderstandings between father and son: Walter decided to run away, he and a good-natured farm boy whose father was likewise having trouble with him—the ordinary sort of trouble so very common between adolescent lads and their fathers.

I knew of the run-away plot only an hour before the time set for their going. I knew that if I opposed or informed, I might never learn what had become of the boys; and if they were compelled to remain, it was undoubtedly only a question of time until they would slip away without telling me, that time perhaps forever. I did not feel that I could risk such a thing, so I packed an enormous lunch for Walter, had him bring me the shoe-blacking and a piece of beaver board, and I myself printed with the blacking on the beaver board,

GOING AROUND THE WORLD!

This legend I strapped on the side of his old straw suitcase. It seemed to me that it ought to get him some car-rides from folks as foolishly imaginative as his mother.

He was gone, and the Baron was upbraiding me for not letting him know, and I was lying stark awake, wondering where my beloved boy might be that night. I slept scarcely at all until I heard he was safe with a good Christian Science family, owners of a music-store, in Rocky Ford, Colorado. In between the time he had left me and his succor by those good people, he had been in a railroad wreck, caused by a flood, which nearly drowned everybody on the train—particularly the freight-car riders, one of whom was my sixteen-year-old boy. At Colorado Springs he was about to be placed under arrest for the murder of a man found dead in a box-car. When he said his name was Greenwood and that he had an uncle in Colorado Springs, the police wanted to test the truth of his story by taking him before my brother-in-law Ed, and Walter was much agitated, fearing that the incident would be disgraceful to his uncle, a prominent man of that place. Luckily for Walter, though unluckily for the poor wretch, the real murderer was discovered just then, and Walter was allowed to go.

At the time I took Walter out of school, my peace of mind began to be greatly disturbed. What was I to do with him? Was this to be the end of his education—fourth year high school, and not yet graduated? What would happen to a boy with his fine brain and no education? That seemed a terrible fate to me, for I have never known a human being more eaten up with ambition than I am, and not to have been able to learn would for me have been deep tragedy.

I decided to go out and teach, the profession I disliked—and still do dislike, though not teaching in and of itself; I am now a pretty good teacher of the things I know enough to teach, but I can never teach in any school or college, for I do not believe in teaching in the manner it is now done. I tried in every way I knew to get a job, yet I might have failed but for my good friend Mrs. Sullivan, who had named the Greenwood School District after me. It was she who obtained for me, through her recommendations, the post of head of the history and English departments of the Acequia High School, a rural institution depending principally for its support on children outside the district, called "paying students."

When Walter ran away, I did not break my Acequia contract. Rhoda wanted music lessons. I would go anyhow, and she might have them. It looked, too, like a way out for the little family, and with the greatest gratitude I took it. I did everything to make myself subservient to the incoming principal, even going so far as to dub him the complimentary "Professor," a title to which he had no right whatever. He was practically illiterate, although he could do some mathematics, having been a carpenter in his native Denmark; yet he told me he had taught school for twenty years, a matter which quite overawed me. I did not know until long afterward, when Mrs. Mead told me, that from the first moment he had tried to get me out of the school in order to put in my

216

place another woman—a woman he had brought with him, along with his wife and two boys, the youngest, he said, adopted, though this child was his very image, in a most startling reproduction. The other woman the Professor left in Rupert; for himself and his wife and the children he rented a farm not far from the school-house.

I have never had any trouble getting along with children and young folks, though occasionally I am on the point of beheading some adult, without, as yet, carrying this inviting project through. Yet it was not long after I began teaching—and keeping house for Rhoda and Joe and me, Charles having been left with his father on the farm—that my troubles began. Pupils became more and more insubordinate. I knew I was doing right, and I could not fathom the reason for this hostility. Then something happened, and it was this event in my life that made me know what faith can accomplish, what a momentary resting upon That Which Is can effect in a crisis.

PROFESSOR LARSON I shall call him in this book. He deserves no anonymity, but he has a good old wife, whom I would not hurt. However, no one who lives in that part of Idaho will be deceived, nor would any one there be indignant or sorry if I used his real name. What follows is public knowledge and, as I state it, beyond dispute.

Almost Larson's first words were an effort to throw me out of my job. "I have a woman at Rupert," he told the trustees, "who's a fine teacher, and she can take Mrs. Greenwood's place. I have worked with her before, and I would rather work with her now."

The men on the board, one a fellow-Dane, the other a very sanctimonious churcher, were in favor, as honorable men so often are, of breaking my contract and putting Larson's woman he had brought with him to Rupert in my place. But Mrs. Mead reminded them, "Mrs. Greenwood has signed that contract, and so have we. When I first met her, Mrs. Greenwood told me of a teacher that the trustees tried to throw out at Buhl. The teacher sued them, and she went and sat on the school-house steps every day, ready to teach if they would let her, and the court awarded her a year's salary, just the same."

That gave pause to the two honorable gentlemen. Lucky for me that I was inspired to tell that tale by way of entertaining the Mead-Gillespie family when they had me stay to dinner the night I came to see Mrs. Mead about the school. (I cannot forget that thirty-mile ride through the wilderness on the Gallopin' Goose, my shoes too shabby, the waist-line of my suit too high, my ostrich feather, relic of early married prosperity, hopelessly out of style.)

The big square school-house held all the lower grades on the ground floor. All the high school was upstairs. I had a big, draughty room, which in winter was never warm, and Larson gave me the whole of the high school to discipline while I taught my classes up in front. I could have done this successfully under normal conditions. But conditions were not normal. Larson still had hopes of ousting me, in spite of the fact that Mrs. Mead had reminded him that my Bachelor of Letters degree was what accredited the high school. He himself had nothing but a certificate for teaching, won by a county examination which any eighth-grade pupil might pass. His classes were small, and he taught them in a little, pleasant room, which was always warm.

But I never envied him his easier life and bigger pay. I was so happy to be earning money, I who never had a piece of money in my hands except what little I could earn writing, which had been only enough to clothe me and pay my dentist's bills and buy a few things for the children. As I said before, farming is no part-time job, nor is writing. The articles I wrote for the *Atlantic Monthly* and the *Nation* were first drafts—I could never have found time to copy them, nor money to buy paper to do it on—and they were written after days of from twelve to sixteen hours of labor. Strange that I could write at all. But, of course, others might have done it easily. I do not know. At last, however, my heart was filled with joy, there in Acequia, though I was overworking again, keeping house and teaching...and I had to write, even then. I hoped that through my efforts the little family could be lifted out of the poverty into which it had sunk.

My school trouble came to a head through a purple-eyed boy whom I shall call Wendell Troughton. He was very often absent. Larson was having trouble with the boys, and he had an idea

217

that Wendell would be a good one of whom to make an example, since his parents were among the least influential in the district. I had happened to come upon Wendell nailing boxes at the cheese-factory for his pocket-money. All education is not in books. It is a part of real education for a boy to earn his own pocket-money. Who doubts that a sixteen-year-old boy needs to have a little money on hand, which he himself has earned?

When Wendell returned after one of these absences, Larson met him at the top of the stairs leading to the high-school rooms. "Did you bring your excuse?" he demanded sternly.

"No, sir, I didn't bring no excuse." Wendell's answer was quiet and courteous.

"Why not?" shouted Larson, glaring savagely in his face. "You go straight home and get your excuse, and don't you give me no back talk, neither."

Wendell navigated deliberately toward the huge black sombrero he habitually wore. He removed it from the hook carefully, as though it were precious glass. He placed it reluctantly upon his head as though it were a crown of thorns. He took down his mackinaw and proceeded to put his arms into the sleeves, as though into dens of rattlesnakes. Then he slowly drew from his pocket his white canvas gloves and inserted his hands as daintily as a maiden fitting a new pair of suedes.

Larson stood fuming, heels flicking up and down, hands twitching, eyes like those of a vicious horse. Before the second glove could be pulled on entirely, he had seized Wendell by the shoulders and, taking him by surprise, literally threw him down the high flight of stairs. Wendell was as big as Larson and more muscular. Only the unexpectedness of the attack overcame him. As it was, after falling with astounding scuffling bumps and clatter of heavy boots, when Wendell regained his feet at the bend in the stairway, he called in defiance which could be heard throughout the building, "I'll bring my Pa to see you, you low-down, cowardly dog!"

"Do it!" yelled Larson. "Bring your Pa and your Ma both. I'll show 'em both around!"

Immediately after school that day Larson went in his Ford to inform the officers of the law of Wendell's incorrigibility. And after this visit those very officers revealed that Larson was doing everything in his power to put Wendell Troughton in the Reform School at St. Anthony.

The next day after Larson's trouble with Wendell came his encounter with charming Sterling Baker. I am not sarcastic. I use the word *charming* advisedly. The very thought of Sterling Baker's winning smile makes me laugh.

Sterling smoked. All the boys in the high school except the Italians smoked. Some of them were more successful than others in disguising the fact. At first they had smoked away from the school-house, until Larson began his crusade against cigarettes; then all of them took delight in smoking as near to the school as possible. The adventure was in the danger of being detected. Youth must have adventure. There must be risk to give piquancy to life, even if it be acquired in no more noble manner than by smoking a forbidden cigarette on forbidden ground. Out of such illicit daring is the very material for the making of legitimate heroes.

Time and again Larson sneaked around the school grounds in order to surprise the smokers in their barn conclaves, when they gathered in the school stable-shed to mount their horses for the ride home. As his suspicious, bald-domed visage was thrust suddenly through the doorway, often a film of smoke could still be seen floating in the air, but never would there be a cigarette in a boy's fingers. Once two cigarettes lay openly where they had been flung at sound of his step, but not a boy would admit knowing anything about the incriminating smoking white stubs lying there on the manure.

Larson had told me that he was "laying" for Sterling Baker. "I've smelt it on his breath," he informed me. "He can't fool me. I'll get him yet. There's a law agin minors buying tobacco. I'll make it hot for them as sells cigarettes to these school-boys!"

Larson, as a reformer, was well within his rights, but reform is not popular among those who are breaking the law, nor among those who connive at the infringement. He was in the thankless position of trying to save boys from the evils of tobacco when their male parents not only smoked, but winked at the same habit in their offspring. Larson had no support whatever (except, sympathetically, from me), and his influence decreased daily. He was within his pedagogical and

legal rights in his anticigarette campaign, but the damning fact began to be circulated that he never threatened a boy unless his victim was alone.

Had Larson been an admirable man, the example of his abstention might have had its effect. Emulation of an inspiring character is the groundwork of successful reformation. My boy Walter wore his shirt-sleeves rolled to the elbows all one winter and consistently went without his coat, because one of the truly great teachers with whom he came in contact, John Wilson, last heard of in California, did those very things. Those clothes habits were only the outward indication of what was taking place in my boy's heart and mind because of that inspiring young man—handsome, strong, normal, as he was—when he taught in the Hazelton High School. It was a sad truth that the boys of the Acequia High School hated Larson so much that the very fact of his not smoking made them want to smoke.

"Sterling, do you smoke?" Larson accosted the lad at the head of the stairs, as he had done Wendell. Crafty man that he was, he had learned the strategic advantages of that position.

Sterling dropped his eyes but did not answer.

"Answer me! I want to know whether you smoke. Answer me!"

Still Sterling made no reply. That should have been answer enough, the reason for his silence being so apparent that there was no need for vocal reinforcement. But Larson was one of those petty souls who insist upon the degradation of those they have accused. The boy might easily have attempted a lying defense, and Larson had not enough sensitiveness to respect Sterling for not lying. Instead, he swung his arm around and slapped Sterling in the face, pushing him toward the stairs.

"You know you smoke!" he yelled. "You just get out of here until you can answer me."

The sequel to this act was not long waiting. On the following morning Mrs. Baker, Sterling's mother, accompanied by her close friend, Mrs. Laudenslager, faced Larson at his desk.

"Professor Larson," said pretty Mrs. Baker, her brown eyes on his face, "I came to see you about my boy Sterling. He has been having some trouble lately with both you and Mrs. Greenwood..."

"Did you want to see Mrs. Greenwood?" Larson hastened to interrupt.

"Yes, I want to see Mrs. Greenwood after I have seen you. But..."

Larson's interrupting was again hasty. "It won't do no good to see Mrs. Greenwood," he said. "She is the most egotistical person in the world. You can't get nowhere with her by talking to her. You got to..."

Country people, who live slow-cogitating lives on the farms, can be diverted easily from their original intentions by designing persons of more foxy capacities. The adroit manœuver was Larson's. What Mrs. Baker did within the next few minutes was as far as possible from her thoughts when she entered Larson's classroom. She told me the whole affair later.

That night Larson took a special trip to Rupert to see a certain woman there. I know it looked to him as though the Lord were helping him to prepare an opening for the teacher he had in mind. A mean man will have a mean God. Such a God requires only that you keep your brains constantly, patiently on the end you wish accomplished; pretending to others that your intention is totally different; turning every occasion into the channel of your desire; and being perfectly ruthless, as you are sure God must be, with your enemies. There was one other factor on which Larson counted—the superior advantage of a man because he is a man, coupled with the inferior wits of a woman because she is a woman.

I HAD BEEN HAVING a very disagreeable time with that school. Each day brought a new crisis which seemed to push me farther from my ideal of what my work should be. But suddenly there came the preternatural calm of a week when I had no need to quell incipient rebellions; there were only those curiously watching eyes I could detect fastened upon me. On that night which marked the start of the unraveling of the whole contemptible plot, I was preparing to go home when I remembered I had left a book on Larson's desk. He taught one period of penmanship to the whole high school, at which time I studied in his room at his desk. I took the

219

book and was leaving, when Larson, who was at the blackboard, turned half-way toward me, still continuing to write, and said, in a remarkably uninflected voice, "Have you heard about the petition, Mrs. Greenwood?"

"Petition...petition?" My thoughts were bewildered; then they flew to his recent trouble with Wendell and Sterling. "Have they circulated a petition to dismiss you?"

Still continuing to write and never looking into my eyes, he murmured, "No, Mrs. Greenwood, they've got a petition against you."

"Against me!" I threw back my head, and involuntarily I laughed aloud. After a while I was able to say, "That's the funniest thing I've heard in many a day. A petition against me! What in the world is the matter with them? I have done nothing wrong."

Larson did not join in my mirth. With very strange concentration he still wrote slowly on the blackboard, without facing me. He spoke again in a somnabulistic monotone: "I know you haven't done nothing wrong, Mrs. Greenwood. Don't you let them bluff you. You stand up for your rights."

"Certainly I will!" I returned with light-hearted confidence. "Who is getting up this petition?"

"Why,...some women I believe."

"Have you seen it?"

"Why, yes, I..." He consulted his book and wrote industriously.

"Of what am I accused?"

"Why, I don't just remember..."

"When is it to be presented?"

"Tomorrow night. I thought you ought to know."

"Well, I should think so!" I agreed, with some levity. "Did they contemplate for a moment presenting a petition to the Board of Trustees and allowing me no knowledge of the affair?" I was beginning to catch a glimpse of some secret plan to oust me without representation, and my fighting blood was up. "It doesn't worry me," I added with a calm which I felt completely, reiterating what seemed unanswerable argument in time of trial, "It doesn't worry me for I have done nothing wrong."

With what simple, childlike faith I considered that because I had done no wrong, no harm could befall me! As though the world were run that way! I was ripe for the lesson of my life. And I approached it with smiling calm.

On my way home I decided to run in to see Mrs. Sanderby at the little old school-house opposite, where she taught. My face was wreathed in smiles, and I spoke eagerly, "You can't guess the news, Mrs. Sanderby! Some women are getting up a petition to put me out of the school. Isn't it funny?

At the word *petition* Mrs. Sanderby's jaw dropped, and a pained expression came into her eyes, changing quickly as she noted the smile upon my lips. "Oh, Mrs. Greenwood! I've known it for a week, and I wanted to tell you, but I was afraid of the effect it would have on you. If I had only known you would take it like this!"

"Why, of course I take it like this! How else would I take it? I have done nothing wrong. Professor Larson just told me so. He said, 'You have done nothing wrong, Mrs. Greenwood. Don't you let them bluff you. You stand up for your rights!'"

Mrs. Sanderby's mouth dropped entirely open, then shut with a snap, then opened suddenly for speech. "Well, then, I'll just have to tell you! I wouldn't have, if he hadn't said that. I heard it from a good source, promised not to tell who, that Professor Larson wrote that petition himself for those women, sent them out himself to get it signed—Mrs. Baker, Mrs. Laudenslager, Mrs. Duggan, and Mrs. Brady."

"Oh, I can't believe it!" I spoke with entire conviction. "He has been such a good friend to me all along."

"That's just what you think. I have been told by those who know that he has kept a trail

220

hot to the three trustees, talking against you and trying to get you out."

"I can't believe it! Somebody who is his enemy has circulated the story. I won't believe it!"

"Mrs. Greenwood, I wouldn't tell you if it wasn't so, and if I didn't know positively. I thought you ought to be told. You'll find out what I say is true."

"But why should he want me out? He has praised my work to me again and again and never offered any criticism."

"He'll say that to you, but he'll tell another story to the trustees. He wants you out to put another woman in your place. He has another woman waiting at Rupert for your place. She has been waiting ever since school began. Some one told me who made me promise not to tell that this woman is his polygamous wife—he is a Mormon, you know, and all those women who started the petition are Mormons; that's where he gets his pull with them—and this polygamous wife has been teaching with him before now...."

"But there's no such thing as polygamy any more. Good Mormons don't practise it, nor do they recognize it as right," I said.

"Well, you can call it what you want to. His other woman has been living in Rupert ever since he came. You know his first wife is ten years older than he is, and you know how she dresses and looks. And that child they say is adopted is the living image of Professor Larson!"

"The child does look like him. But still I will not believe it."

"Well, I am just telling you what I was told by some one who knows. Larson goes nearly every day to Rupert, you know. What would he be running into Rupert for all the time, and what would he adopt that child for that is the mortal image of him when he has children of his own, and he in debt bad, and why should he have been dinging at the trustees every day to hire a woman he can get for them at Rupert? That is his polygamous wife, and he wants her to support herself and help him to get out of debt. That boy Hans is hers."

"Well,...thank you, Mrs. Sanderby. I know you believe these things, but I am sure you will find they are untrue. I know you will be glad to find them false."

"You certainly have been a true friend to him, Mrs. Greenwood." She looked admiringly and pityingly at me.

"Of course I am his true friend," I replied, unaffected by the quality of her regard. "Why should I not be?"

I did not credit for a moment these stories, which I believed the rankest slander. I went at once to the Mead home which was next to the little house I rented. Mrs. Mead, a middle-aged, competent brunette, was in her bedroom, lying down. She said she was sick. She did not explain then, as she did to me later, that it was the petition against me that had made her sick. She was a woman of conscience, and she was not persuaded of my iniquity, even though she had become unsettled enough no longer to be intimate with me. Her eyes faltered and dropped when I said, smiling, "Mrs. Mead, some one has started a story that Professor Larson has written a petition against me and is trying to get me out of the school. I don't believe it." There was the fraction of a second's hesitation before Mrs. Mead answered, scarcely lifting her eyes, "I hope you may prove right, Mrs. Greenwood."

"Oh, I know it!" I responded. "He has always been such a good friend to me. He has continually expressed his satisfaction with my work." Then, becoming aware of something extraordinarily constrained in Mrs. Mead's attitude, I added, "If he has not been a true friend to me, if he has been treacherous, I shall know it as soon as I get to the meeting tomorrow night. I presume it will be in the school-house and that I may be allowed to be present?"

"Yes, it is to be in the school-house; the trustees have not been meeting at my house for some time. And of course you can be present. I want you to understand just how this is, Mrs. Greenwood. These women came to us with a petition to have you discharged. We told them that we could not act unless they had the names of the majority of the taxpayers on that petition. We trustees had nothing to do with that petition."

"Mrs. Mead, Professor Larson never once told me of a single thing that he disapproved in

my teaching or in my behavior. If I have made any serious mistakes, I am wholly unconscious of them. There can be no truthful charges made against me, and I am not afraid of the untruth."

As I creamed the potatoes for dinner that night, I noticed Professor Larson cross the yard before my kitchen window on his way to visit Mrs. Mead. I felt sure he was going to protest in my favor, that his visit was probably entirely in my behalf. How comforting it is to have a true friend! If we have done right and have one true friend in the world, nothing can hurt us for long.

How should I have felt if I could have heard the words that were being uttered at the very moment I was thinking those thoughts? Mrs. Mead told me later that she was saying, "There is one thing I can say for Mrs. Greenwood, Professor Larson, in spite of all you have said against her: she had never said one thing against you. On the contrary, I have criticized you several times when I feel sure you were entirely to blame, and she has tried to assume all the fault. I can tell you, Professor Larson, Mrs. Greenwood has been true-blue to you!"

Joe and Rhoda had scarcely said their prayers and been tucked into bed with a kiss apiece when a knock came on the kitchen door. There was a fire only in my cheerful little kitchen, which I used also for a dining-room, and there I was settled to make out my lesson plans for the next day. My visitors were Mr. and Mrs. Troughton, the latter looking apologetically doubtful in spite of her Dantesque eyes and nose, and the former looking firm and masterful in spite of his watery red eyes and not too magnificent proboscis. When we were seated, Mrs. Troughton fixed her melancholy, dark gaze upon her adored Jake, who at once declared, "Mrs. Greenwood, something happened today that made me so dog-gone sore I hain't over it yit. Them women come and got my wife to sign their dog-gone petition."

Mrs. Jake interrupted piteously. "I didn't want to. I kep' a-sayin', 'Jake'll be here in a minute. Wait till Jake comes!' An' they kep' sayin', 'It don't make no matter. They's got to be a change in the school,' they says, 'an' this'll he'p to start things right.' An' I kep' sayin', 'Jes' wait till Jake comes ..!'"

Jake snorted. "They knowed better'n to wait. I'd a-showed 'em where to head in. We got plenty agin Larson—the way he throwed Wendell down them stairs, and a-tryin' to put him in the Reform School; but, Mrs. Greenwood, we hain't got nothin' agin you, an' never have, an' I told my wife here that we jes' got to hoof it over here and let you know how she come to sign that there dog-gone petition. An' now I want to know. Hain't they ways that we kin git her name off'n that there petition?"

"I'm afraid not."

"Gosh! That makes me so dod-gasted mad I could wallop some one. An' in my opinion it 'ud be that there skunk Larson. He's at the bottom of this, Mrs. Greenwood; believe me, you'll find it's so. Hain't they nothin' we kin do? Gosh! I sure hate it to git out we signed a petition agin you. Why, when we was a-leavin' tonight to come here, Wendell, he says, 'Why don't they sign up a petition to put ole Larson out 'stead o' her? They ain't nothin' agin her!'"

"Ain't they nothin' I could do, Mrs. Greenwood?" faltered the repentant Mrs. Troughton.

I had been considering. "I'll tell you, Mrs. Troughton. Tomorrow night you be sure to come to the school-house, and you can say there that you want your name withdrawn. That will make it all right, I think."

"You bet we'll be there!" answered Troughton heartily. "That's what we'll do, Ma. We'll show them women they can't put nothin' over on Jake Troughton jes' becuz he hain't to home when they call with their dog-gone petitions!"

That night I composed myself calmly for sleep. Before I drifted into tranquil dreams, I prayed earnestly: "Dear Father, I don't know how to manage this case. Wherein I have done wrong, I know that you will punish me as I deserve, and I do not ask for mercy; only let me learn the lesson that I may not do wrong again. Wherein I have done right, I know you will be with me. I fear no evil."

I went to sleep as a babe upon its mother's breast. For the first time in weeks a masked

man with a stiletto did not appear in my dreams. Not being superstitious, I had not paid any attention to this constant nightmare. But I know now that God tries continually to warn us of trouble from ourselves or others by means of our dreams, and while Freud is, in the main, right, Adler and Jung come much nearer the truth. The masked man with the stiletto was not a sex symbol; the mask, the stiletto, meant the deceiving and base plotting of Larson. And after I turned the case over to God, the symbol of this menacing danger was abolished, for where there is perfect trust in God, there can be no danger.

I have muddled my affairs more than once, trying with all my wits to compass my desire. I want you to note how God managed this case after I turned it over to Him. Do you think that one mere mortal woman could have brought to pass the astonishing details of all that followed that prayer? If you do, you attribute to me greater powers than I possess, and you credit Chance with properties which insult the intelligence and must place you in the ranks of those who believe in coincidence so extraordinary as to make it, in reality, God of All. It will mean simply that you choose *Chance* working as God, while I choose *Intelligence*.

AFTER FIFTEEN YEARS OF IT

Next morning God put it into my mind to write a letter of invitation to every one in the district to be present at my trial. I knew there were people in the neighborhood who wished me

well. It would be pleasant to see their faces leavening the antagonism. My enemies had reason for being present. My friends knew nothing whatever of Larson's machinations, if such there were, and they would not be present unless...unless they were *invited*. Then why not invite them? Was not this my particular party? Were not all the ceremonies in my honor—or dishonor? Therefore let my friends as well as my enemies witness them.

I was not crude enough to make any line of demarcation. I wrote neat little invitations to every mother and father in the district, smiling as I indited my request to those whom I knew to be responsible for circulating the petition. "Dear Parents" (I put in the actual names, to make the appeal more personal): "This is to inform you that there is to be a meeting at the school-house tonight to consider a petition for my dismissal from the Acequia High School. You are respectfully invited to be present."

THOSE INVITATIONS I placed in the hands of every pupil in the high school, with the admonition to be sure to take them home, which I had every reason to believe had been done when I saw the immense throng that packed the big assembly-room that night, filling every seat, sitting in the deep sills of every window, leaning against all the walls, and overflowing into the hall, or, rather, never having been able to flow into the room. I had never seen so large a crowd at the school-house.

I had been hopeful that Larson would be among the early arrivals, for I wished some immediate strengthening of my conviction that he had not failed me. I felt that I could tell whether he had been treacherous as soon as I should see him that night. He would not be able to conceal the aura of truth or falsehood which would surround him on such an occasion. Instead of Larson, the first arrivals, after I had entered the big room, were Mr. and Mrs. Troughton, who seated themselves immediately back of me. The door was in the rear, and I had taken a seat near the front so as to be able to observe the crowd by turning to face them, and also to make note of every person entering the door without being under too close observation myself.

The crowd began to come, to grow, to overflow. I felt a pleasurable excitement, I could not have told why. I should have been weeping over my coming disgrace. Instead, I was thrilled by the prospect of I knew not what. Part of my emotion was eager anticipation of the exoneration of Larson, and part of it was my unacknowledged desire to face him in event of his guilt. That latter a strange matter for enjoyment!

Before the crisis that faced me, I realized that most women would have been depressed and nervous. Something peculiar about me. I was as calm and gay as a June morning, with all the birds singing and the sun shining in a clear, blue sky. Instead of hiding my weeping eyes in the curve of my arm, bowing down thus on the desk before me, or sitting with lowered, red-rimmed lids, which would advertise a night spent in worry and tears, or gazing about agonizingly for one friendly face...only one friendly face!—instead of any of these possibilities for some women—but not for me—,with a half-smile on my lips I sat turned in my seat, watching the door expectantly, as the crowd oozed into the room, slowly but surely—the biggest crowd that had ever been together in the Acequia High School's large assembly-room.

One curious thing suddenly struck me with its unpredictable import: uninvited, nearly every high-school boy was there, and they had unconsciously formed themselves in a long, packed line at the back of the room—for what purpose, I asked myself, glad, not dismayed, at the sight. They were lead by Herbert Thompson. That made me a little sad for a moment. "He has come to see me disgraced," I thought. For I had had serious trouble with Herbert. I had always felt sincere concern that this lad with the fine brain should have given me so much trouble in my school work.

I saw handsome Victor Harper edge his way in, followed by Glen Mortimer, a really mild young man who had one day come to school with a murderous bowie-knife thrust in the top of his boot, that being his means of achieving some distinction. Following him was Wendell Troughton, accompanied by Sterling Baker, who, being observed by his mother, was emphatically motioned to leave. This device failing, Mrs. Baker hissed across the room, "Go home, Sterling! Go home!" But Sterling had been obeying his own will too long to be reformed in a single night by his doting

mother. He slunk near the door, apparently deaf to the insistent message and blind to the admonishing gestures. The doorway was crowded with high-school boys, and as far out into the darkness of the hall as my eyes could distinguish them.

From my point of vantage I could see everybody in the room. The long line of high-school boys at the back was interspersed here and there by men of the community. I noticed that in the exact center of this line stood Mr. Mead. He never looked more grimly the counterpart of Woodrow Wilson. And farther along the line was Meredith Spenlow's father, who had come, as had most of the farmers present, in his overalls, nor waiting to shave. I considered this a higher tribute than if the farmers had decided upon personal pride, which would have meant bed instead of coming to see me through.

By the side wall were Mr. and Mrs. Bagnel, both untiring workers, and intelligent, their children distinctly among those most carefully reared in the community. They obeyed their parents respectfully, an astonishing tribute in these days when all that parents are allowed by offspring is the right to spawn them.

Grouped together at the center rear were the four women whose names headed the petition against me. I frankly studied their faces, but they carefully avoided meeting my eyes. In the next row to me and on the front seat, without a desk, I could see the bald head of Larson, who had tiptoed into the room, eyes averted from me.

Mrs. Brady was dressed after the flamboyant style preferred by her daughter Clarissa, whose idea of being perfectly attired was a few scant yards of red satin. She was a showily good-looking woman, radiating animal vitality and considerable intelligence, but common—a woman of common, coarse standards. The other three women, Mrs. Laudenslager (Rosa's mother), Mrs. Baker (Sterling's mother), and Mrs. Duggan (Alberta's mother), were all women of natural refinement.

Mrs. Duggan had two distinctions for me: she had an enormous amount of beautiful rich-brown hair, like a cap, over almost her entire head; and she had confessed at one of the Mormon testament meetings that one night the Devil had tried to smother her. The wonderful hair I envied her. I do not know why, but it was always the yearning of my heart to sit on my hair. Of course, I know that extremely long hair simply typifies woman's subjection to man, but I have always felt that if I could stun a few men with a Lady Godiva cape of hair, I'll boun' you I could get my own way a good part of the time. As for the Devil—I regarded Mrs. Duggan with roundeyed awe. The Devil manages to smother all of us without letting us know it, but she had known!

I liked those three women very much, and I had another little sadness at my heart to think that, Mormon women as they were, I was now the object of their attack. The Mormons had always been my friends. And certainly I had been to the Mormons, as Mrs. Mead would have said, "true-blue."

The room was now crowded, packed—people jammed in windows and crushing each other along the side walls; and out of the dark hall stared a craning mob. Big Trustee Jensen was splendid that night. Injustice he had done me in the past; injustice he would do me in the future; but that night he was magnanimous. The mob spirit occasionally—very occasionally—works for betterment. That crowd was there to have the truth sifted out of the bushels of lies they had been forced to store in the granary of their minds for months. Even Herbert, I am sure, was there for that purpose, though he believed the truth would damn me. Beside him had crept his friend Willard Ingoldsby, a lad I had been forced to reprimand; he had gone home thinking I would beg him to remain, but I had done nothing of the kind. Willard was probably hoping something would happen to cause the ejection of both Larson and me, for he had some right to his grievance against the Professor.

Never before had Trustee Jensen been given the opportunity to harangue so large an audience as it was his duty, as chairman of the trustees, to address that night. All Mormons are easy speakers, some of them too easy, damning their religion with their boring flow of words. One might

226

almost suppose that the repressed desire to speak in public had been the reason for many conversions to that faith. Sometimes I think that I might have been a Mormon had I not been talked out of the communion of Latter-Day Saints. I shall never be saint enough to bear being bored to death, no matter how earnest the long-winded speaker.

Jensen saw before him every important individual in the community where he most desired to be a person of consequence. Particularly was this a chance to impress those he would have think well of him—the other church folks, those who attended the Union Sunday-school in the Acequia High School assembly-room. Every one present was distinguished by Jensen through all the thoughts he had accumulated around them, carrying them in his head, as he had, for years. They were the voters who had made him trustee and who might make him so again, the only political position to be had in that community. And they should see how fair he could be.

Justice herself could not have held her scales more carefully than did Trustee Jensen that night. He stood near the center of the room, among the desks, turning to meet the gaze of all as he spoke. I was glad he had chosen that particular position, for it made possible my observation of the drama of that whole hall while keeping him in view every minute.

"Ladies and gentlemen!" (There was an unmistakable Scandinavian accent.) "I suppose you all know why we are here. A petition has been presented asking that Mrs. Greenwood be put out of the school. Now, I want Mrs. Greenwood and you people to understand that the trustees have nothing to do with this here petition."

Mrs. Baker interrupted somewhat indignantly. "Mr. Jensen, you told us yourself to get up this petition!"

"Certainly I did. I told you if you wanted Mrs. Greenwood fired, you would have to get a petition of the taxpayers, otherwise us trustees couldn't do nothing about it."

I stood up. "Of course, Mr. Jensen, I understand." There were other things I understood that I did not see fit to reveal—such as that a petition from the taxpayers might forward his Old World compatriot's plan to be rid of me.

Jensen nodded his thanks to me. "It's jest this-a-way. Some folks ain't suited with what Mrs. Greenwood does. We're here tonight to give everybody a square deal. We're here to listen to what these folks has to say. We want to do right by the parents of the children what goes to our school. But understand me. We gotta have some real charges agin Mrs. Greenwood, and what's more, we gotta prove them charges. Otherwise, if we try to put Mrs. Greenwood outta her job, she can sue us in the courts and collect her salary just the same as if she taught."

It flashed upon me that I had told Mrs. Mead of such an incident, quite innocently, my first week in Acequia. She had evidently recounted this case to the Board at some moment when they were thinking of acceding to Larson's demand that he replace me with the woman at Rupert. A queer coincidence that I should have prepared, unconsciously, so weighty a rebuttal.

"Now, the first thing to do," Jensen continued, "is to call off this here list of names and have the ones tell their grievances that petitioned."

Mrs. Baker gasped audibly. "I didn't suppose when we came here we had to say anything. It's all written in the petition."

Jensen turned to Mrs. Mead. "Being Clerk of the Board, will you read the petition, Mrs. Mead?"

Mrs. Mead looked embarrassed. "I can't do it. I left my glasses home."

An imperative undertone came from the pretty despot, Mrs. Mead's daughter, Helen Mead Gillespie. "Herman, you read it!" Herman, being one of the best husbands in the world, without any hesitation took the petition from Mrs. Mead and, laying it on the desk I used when teaching, sat down before it and began to read:

"To the Members of the Board of the Acequia High School:

"We, the undersigned parents and taxpayers of the Acequia School District, do hereby respectfully petition that Mrs. Annie Pike Greenwood be dismissed from her office as teacher in the Acequia High School for the following reasons, to wit:

(Ah, ha! That to *wit!* A rather curious expression for four farmers' wives to think up all by

227

themselves! I glanced thoughtfully at the bald head on the front seat.)

Gillespie was reading:

"First, she is too nervous to be in a school-room.

"Second, she has a bad temper.

"Third, she uses language unbecoming a teacher.

"Fourth, she punishes misdemeanors with low grades in class work.

(*Misdemeanors!* How many farmers' wives customarily use that word, or even consider its meaning? Again I regarded the bald head on the front seat.)

"Fifth, she has spoken to pupils in a way that no teacher should.

"Sixth, she has circulated vile things among the girls.

"Seventh, she has miserable discipline.

"Signed (first of all) by Adelaide Brown Baker!"

Gillespie paused. Everybody in the room was regarding me with unconscious intentness. Those were pretty serious charges to make against any one. Yet I could not keep from smiling. I suppose there were those present who attributed my unseemly amusement to brazen lasciviousness, considering the indictment just read. In fact, I must confess further that the amazing falsehoods in that document assumed for me such gigantic proportions in the literature of humor that I could scarcely keep from laughing aloud. I *knew at last,* and it was as though I had imbibed an intoxicant. I sniffed the scent of battle joyously, with a particular ecstasy such as nothing before in my life had ever aroused.

"Adelaide Brown Baker?" repeated Gillespie interrogatively.

"Mrs. Baker, will you please give me your reasons for wanting Mrs. Greenwood turned out of her position?" prompted Jensen.

"Why, I thought the petition was clear enough without my saying anything."

"Clear enough, yes," Jensen said. "But clearness don't put nobody outen a job. You gotta prove beyond a doubt what you say when you bring charges like them. Now, please speak up, Mrs. Baker!"

"Well,...I have got something to say against Mrs. Greenwood. She told Tom Wrench that he might as well study out of Sterling's history book because Sterling never did." (Text-books were supplied by the district and therefore were not the property of the pupil.)

She stopped and looked directly and accusingly at me; and I rose to my feet, with a smile, to fire the first gun.

"You are right, Mrs. Baker," I said. "I did say that to Tom Wrench, and it is true. Sterling never studies."

Mrs. Baker showed great indignation. "Then, Mrs. Greenwood, why have I never been informed of this?"

"You certainly have been informed, Mrs. Baker, to the very best of my ability. Every month..."

Mrs. Baker did not let me finish. She knew the ears of the crowd were alert, and she was sure of exposing me now. "Mrs. Greenwood, this is the first time I ever heard of this state of affairs, and I think I had a right to know." She looked around at all sides with the air of one now sure of supporters.

I turned to the bald head on the front seat. Strangely enough, Larson had not once turned to look at the two speakers in the dialogue just recorded. His were the only eyes not fixed upon us. "Professor Larson," my voice was imperative, "kindly bring the report cards."

Without answer or look Larson obediently sneaked past the crowded side wall to the door, worming his way through the hall. While he was gone, Mrs. Baker sprang to the attack again, as one who, having an advantage, might as well annihilate the victim at once. "And, besides, Mrs. Greenwood, you told Sterling to go and never come back!"

"No, Mrs. Baker, I did not say that."

"You did, Mrs. Greenwood!" Mrs. Baker's voice rose excitedly. "I have it from witnesses

who heard you say it."

I wasted no words, nor gave warning of my intention. With perfect calm I moved quickly down the aisle, and, grasping Sterling Baker by the arm before he had time to think of evading me, I faced his mother and the breathless silence. "Sterling," I said, regarding him earnestly so that he must meet my eyes and yet so that his face would be exposed to the crowd, "Sterling, tell me truthfully, did I not say when you asked about your coming back, did I not say, 'Come back when you can control yourself'?"

It may have been the psychological effect of all those faces fronting him with their stern expectation of the truth that made Sterling answer, without equivocation, "Yes, Ma'am."

"Did I ever tell you to go and never come back?"

"No, Ma'am."

I needed to say no more. His mother gasped; her face flushed vermilion; she seemed stricken. Had I been without sympathizers before, I was left in no doubt as to the feeling of the majority then. The crowd burst into spontaneous cheering, stamping, and clapping. Now the packed school-room was alertly awaiting developments and expecting them to be favorable to me. I had raised their expectation of the drama so high that if I had failed to give a perfect performance from that time forth, they would have felt the fury, not of outraged parents, but of betrayed connoisseurs. Their course in moving pictures had made them relentless critics.

Larson came back with the report cards and handed that of Sterling Baker to me, slinking into his seat again with his back still to the crowd, most abnormally the only person facing that way. I advanced to Mrs. Baker, and, holding the back of the card for her to see, I asked, "Mrs. Baker, are those your signatures for five months?"

Mrs. Baker answered falteringly, "Yes, they're mine."

After informing the people that it was Sterling Baker's report card for the previous months, I said: "Mrs. Baker, you have just said that you signed this report card, and at the same time you say that you were not aware that Sterling was failing, consistently, all year. How can you say this, Mrs. Baker, when these are Sterling's reports to which you signed your name? September, *U;* October, *U;* November, *U;* December, *U;* January, *U.* It is printed in plain type on the front of this card that *U* means 'unsatisfactory.' Mrs. Baker, I had not time to walk the three miles to your house and the three miles back in order to inform you that Sterling's work is unsatisfactory. This card was supposed to keep you informed. It cannot be considered my fault that you did not so understand it. You learn by this card that Sterling, also, has nothing but *U*'s under Professor Larson, proving that my class is not the only one he neglected. I wish to say this, Mrs. Baker. I have never had any real trouble with your boy. He does not study, and he is mischievous, but he has always been a gentleman toward me."

There was now a feeling of expectancy so great that, to put it in the words afterwards used by Mr. Mead, "you could cut it with a knife." Jensen directed Gillespie to read the next name. The three women who were left were beginning to look self-conscious and extremely uneasy.

"Sarah W. Laudenslager."

Mrs. Laudenslager moved her arms on her desk nervously. Then she began: "What I have against Mrs. Greenwood is that when Rosa took part in a play and couldn't be here, Mrs. Greenwood docked her credits in English for it. And I can testify that Rosa could not be here."

I smilingly faced Rosa's mother. "That is what Rosa accused me of doing, Mrs. Laudenslager, and she refused to believe me when I assured her that I would do nothing of the kind. In fact, she made a disgraceful disturbance over the incident, a disturbance which I am sure you, her mother, would have condemned. Professor Larson, please give me Rosa Laudenslager's card."

Larson meekly passed the card to me, his gaze returning to the flooring at the front of the room. His eyes were the only ones not fixed intently upon me. He had evidently found something of interest in the planking of the floor. He had been a carpenter in the Old Country, you know. I remarked to Mrs. Laudenslager, "This failure to take part in the play was in December. I would like to read Rosa's record in my English class for the year so far. Kindly observe whether there is any

remarkable dropping of grade in the month of December. September, *F,* which you know means 'fair'; October, F; November, *G;* December, *G;* January, G. Rosa's grade in December is as high as she ever got in any month. At the beginning of the year, Mrs. Laudenslager, you explained that Rosa was behind the others in her school work, but that she would try to keep up with them, and that you would do all in your power to see that she studied. I promised my help also, and, believe me, Mrs. Laudenslager, I have faithfully, and without variation, assisted her, even though Rosa in December was as rude as possible concerning the play. I do not think a teacher should be so childish and petty as to take revenge for misdemeanors.

"Now let us compare Rosa's record under Professor Larson with her record under me. She has three subjects under me, all of which have shown improvement since November. She has one subject under Professor Larson, and in that subject she has never made a grade higher than *F,* and two months she even sank as low as *U.* In all fairness, can you attack me as having lowered Rosa's grade over her absence from the cast of the play?"

I seated myself, and smiles and whispers went around the room. Gillespie read from the paper, "Jennie B. Duggan."

Mrs. Duggan began at once, as though she felt her position, at least, to be unassailable. She was possessed of a thin, somewhat nasal voice, pitched too shrill and high. In spite of this speaking tone she sang rather sweetly. When she began, the notes of her words were high, but not extremely loud. "Mrs. Greenwood talked to Alberta in a way no teacher should do. One day when Alberta didn't put her books away quick enough to suit Mrs. Greenwood, she screamed at Alberta, 'Alberta Duggan! You put your books away!'" Mrs. Duggan's voice arose to a most offensive, piercing shriek. So offensive, indeed, that had the episode occurred as stated, it would have been most damning for me.

I arose, still smiling. "You are right, Mrs. Duggan; I said exactly what you say I did—but not in the way you said it. I realize that I possess a voice which I could make heard in Rupert or Minidoka from where I am now standing. But I think you who listen to me will not call it shrill. On the day in question I had tried to conduct a spelling lesson. Alberta had persistently ignored my suggestion that she put away her books to begin taking dictation. She was holding back the class. I looked at her; I suggested mildly that she clear her desk; finally I stood over her, and I said, 'Alberta Duggan! You put your books away!'"

My contralto voice, low-pitched, big, and full, filled the room with surprising force. The crowd in that school-room that night was as impressed by the amazing volume of my voice, which they could see I was producing without effort, as Alberta had been. I paused to allow the sound to die. Then I continued in conversational but perfectly audible accents, "And did she put her books away, Mrs. Duggan?"

"Yes, she did!" came the lightning defense of Alberta's mother. I swept my audience with a comprehensive glance. "If by speaking in that manner I accomplished what other means had failed to do, I believe I was justified in making use of my voice as I did."

An interruption took place at this point. "I want to ask," said Mrs. Bagnel from her seat at the farther side of the room, "I want to ask: Mrs. Duggan, didn't you ever whip any of your children?"

Mrs. Duggan answered, "No, Ma'am; we believe in ruling by love. Our Savior said..."

"I thought so! They act like it!"

A ripple of laughter ran around the room, and the two women glared at each other. Mrs. Duggan transferred her outraged gaze to me. "There must be something wrong with the way you manage in the school-room, Mrs. Greenwood, because Alberta never had any trouble with a teacher before!"

I replied quite calmly, "Some weeks ago the girls in the high school told me, in Alberta's presence, that Alberta had made life miserable for Mrs. Sanderby, and Alberta admitted it as a great joke."

Mrs. Duggan sat up, electrified, and turning to Mrs. Sanderby, who sat across the aisle at her left, demanded, "That isn't true, is it, Mrs. Sanderby?"

Mrs. Sanderby, taken totally by surprise, would rather have let the dead past bury its dead, but here was I interrupting the ceremonies. She was forced to confess, "I'm afraid it is, Mrs. Duggan. Alberta did not always act as she should have done."

"Then why didn't you tell me?" demanded the outraged mother.

"And that is not all." I turned to another corpse, more recent. "Only last week Professor Larson told us in teachers' meeting that Alberta had been impudent to him, and that he had said to her 'You shut your mouth, Alberta Duggan!'"

The mother who had reared Alberta by love alone was stunned. This was so much worse than anything of which I had been accused that Mrs. Duggan's jaw dropped, her face crimsoned even more deeply than it had at Mrs. Bagnel's insult, and her eyes became fixed in tense horror. But only for a moment. She was not a stupid woman. Arousing herself, she demanded of the bald head on the front seat, which had never once relinquished its carpentry cogitations, "Professor Larson, is it true that you said that to Alberta?"

Professor Larson rose, undulated slowly down the aisle, smiling deprecatorily as he went, and in his most suave and conciliatory manner began, "Why,...I believe I did say something...like that. You see...Alberta was...quite provoking..."

Mrs. Duggan dropped her chin in her hand, her eyes falling in desperate humiliation. I hated seeing her so hurt. She was really a gentle and conscientious soul. Larson backed his way again to his seat and, once there, looked at one spot on the floor directly ahead of him.

A contemptuous murmur of disgust swept like a tidal wave over the gathering. Larson heard it, and without turning around or taking his eyes from the fascinating flooring, his bald head became a shade more pink. In all literature, I ask you, did you ever read of a man's head being covered with a blush? His blushing bald head faced the crowd, while his blushing visage looked in the opposite direction, examining the cracks in the floor.

Gillespie read, "Eva C. Brady."

Mrs. Brady needed no urging. She was loaded. She knew she had a legitimate objection to me. "I have something perfectly terrible against Mrs. Greenwood. She passed a paper around among the high school girls with a vile thing written on it," she shouted.

Even then my cheeks did not flame. Quite shamelessly I explained. "I wish every one here to understand the circumstances under which that was done. Some young men from Rupert had made an insulting remark to two of our high-school girls. I objected to having those young men invited to the following party. Clarissa Brady demanded the reason why. Thinking to convince her, I wrote, partially, the insult, never dreaming that one of the girls to whom it had been made was Clarissa herself. It was Clarissa who allowed the paper to pass from her hands. I had no intention of giving the information to any one except her, and only to her because I felt sure that she would not continue to demand that the Rupert fellows be invited if she knew the truth. There..."

"The whole story about those Rupert boys is a lie!" Mrs. Brady screamed the interruption.

Suddenly, and unexpectedly, Gillespie stood up at his prominent position in the front of the room. "It is not a lie, Mrs. Brady. That story is God's truth. Your daughter and another girl were standing at the foot of the stairs. I had come to fix the lights, and I was standing at the head of the stairs. One of those Rupert fellows leaned out of the car and called to the girls, 'Come and get in, girls! We're in for a *raping* tonight!'"

The horrifying word shot through the room like an obscene missile. There was not one person present who had not some familiarity with it; but never before had they heard it publicly hurled in speech, in all its naked beastliness. There was a second of shocked, disconcerted silence, during which each one avoided the eyes of his neighbor. I was the first to recover. I realized that I must be the first to take advantage of this psychological moment.

"Mrs. Brady," I said, "I supposed when I tried to protect your daughter from those base young men, I should at least merit your gratitude. Judging from the manner in which you have taken my action in this matter, I should have pleased you better had I cared nothing for your girl's fate, and, with my eyes open to the vileness of those rough-necks, had I allowed her to associate

with them, making no protest, on the theory that I was hired to teach her, and not to save her. I had thought there were things more important than lessons from text-books. You would lead me to believe differently. In spite of your attitude toward me, I do not regret the course I took with regard to your daughter and those human skunks. I would do it again, under the same circumstances, for I need only the approval of my own conscience."

My voice had sunk to the greatest solemnity. I felt just what I was saying. The people were impressed. Poor Mrs. Brady shrank beneath their indignant eyes.

"Mrs. Jake Troughton," read Gillespie.

Mrs. Troughton, rose, trembling from head to foot. Seated just in front of her, I turned to look up at her as she faced the crowd, and I closed one of my hands tightly over hers as it rested upon the desk.

"I jest want to say," Mrs. Troughton's voice shook, "I jest want to say that I ain't got nothin' agin Mrs. Greenwood. She's always done right by my children, and I ain't got nothin' agin her."

"Then why did you sign that petition?" exploded Mrs. Baker.

"I signed partly becuz you women was bounden I'd do it,...and partly becuz I wanted to git this thing before the public 'stead of havin' Mrs. Greenwood talked about behind her back!"

It tickled me immensely to have Mrs. Troughton turn on those women the very arguments with which they had broken her faith with her adored Jake. I gripped the rough, bony hand encouragingly. Mrs. Troughton sat down.

"Samuel Baker," read Mr. Gillespie.

Mr. Baker stood up, awkwardly, by reason of the sleeping infant he bore in his arms, the good husband that he was. "I haven't a single thing against Mrs. Greenwood," he said. "I didn't sign this petition until just before I came into this room, and then I signed it because my wife felt that it was not fair to her unless I did. But I *have* got something against Professor Larson. When he slaps my boy in the face because that boy will not perjure himself by saying whether he smokes, I think he is overstepping his authority as principal of this high school!"

Trustee Jensen towered over him. "Do I understand you to say that you signed this petition to put Mrs. Greenwood out of her job although you haven't a thing against her?"

Baker did not reply. Jensen turned to Gillespie. "Are there other people's names that are in the room?"

"No, sir," answered Gillespie. "I have looked these over. In fact, Mrs. Mead allowed me to look this petition over before coming here tonight. Those who have spoken are the only parents signed up who have children under Mrs. Greenwood. The rest are taxpayers who have nothing whatever to do with her."

"You told us we had to have it signed by taxpayers," Mrs. Baker challenged Jensen defiantly.

"Certainly. We couldn't act unless it was. But the fact remains that there's only you four women against all the other parents of the high school. And so far you four women ain't brought nothink we can fire Mrs. Greenwood for. If we tried it, she could draw her salary by the courts and do nothink but come here every day."

I stood up. I was no longer playing a farce. I was dead in earnest. "You need never fear such a course from me. If the parents of my pupils don't want me, I will leave this district at once, never to return."

This seemed to strike Mrs. Baker with unusual force. I saw that I evidently appeared to her in an entirely different light from her preconceived notion of me. "Mrs. Mead," she said, "you told us that Mrs. Greenwood said 'she would come here and sit at her desk and draw her pay if any one ever tried to put her out."

"No, I didn't," denied Mrs. Mead. "What I said was that when Mrs. Greenwood first came here, she was telling me about the case of a teacher near Buhl who went and sat on the school-house steps every day, and drew six months' pay."

232

Desperately Mrs. Baker spoke out: "Professor Larson, we want to hear from you! I remember you said that you could support this petition with some of the blackest things. Now it's up to you to let these people and Mr. Jensen know that we had reason for bringing this petition. We want you to speak! We demand it!" Mrs. Baker was nobody's fool—certainly not Larson's any more forever.

AGAIN that electric effect of suspended breathing, while Larson advanced to the center of the room, drawing from his pocket a sheaf of manuscript. Even then there was a chance for him. I refused to condemn him utterly until there was no more hope. Those women had so greatly misunderstood me and my motives, might they not have done the same thing with Larson? Perhaps he had really prepared a paper in my defense, since he had always praised me so highly. That must be it. He should not receive judgment from me until he was unqualifiedly proved a Janus.

"Mr. Jensen," Larson had turned to the Chairman of the Board of Trustees, "I should like to have these here high-school boys leave the room before I begin reading. I do not think this is the place for pupils to be when a teacher is being tried."

I felt my first unqualified suspicion. I sprang to my feet while the last word was still in his mouth. "Mr. Jensen, I want these boys to remain!" I insisted.

"But, Mrs. Greenwood, this no place for pupils when a teacher is being tried," explained Jensen patiently.

"Mr. Jensen, isn't this my trial?"

"I guess it is, Mrs. Greenwood."

"Then I believe I should have the right to say what persons should be barred. Herbert," I addressed the long, lank lad with the keen eyes at the back of the room, "Herbert, are you here as a friend of mine?"

I had counted on his intelligence to grasp the situation, and I gloried in his wit when he immediately answered, "No, Ma'am. I guess I have caused Mrs. Greenwood as much trouble as anybody this year."

I addressed each boy in turn, and each one, taking his cue from Herbert, replied in the negative. I turned to Jensen. "You see I have not packed the house. I did not even know these boys were coming."

"I came here because everybody seemed to be getting an invitation, so I thought I had a right to be invited too," volunteered Herbert. He was sniffing in the direction my bloodhounds had taken.

"I insist that they be allowed to remain," I repeatedly emphatically.

"Very well," said Jensen. "I guess you're the one to have the say." Jensen was splendidly fair that night. Of course, it must be taken into consideration that whatever motives had drawn the crowd, it was now almost wholly for me.

Larson looked as though he did not know whether to proceed or not. Finally he began his paper with a long prelude about the unsatisfactory attendance of the parents at Parent-Teacher Association meetings. He told the audience how few visitors had been to the school, taking occasion to dwell glowingly upon the fact that Trustee MacMillan, who was seated near him, had not been remiss in making calls. He then dwelt at great length upon the cigarette evil.

This stodgy, irrelevant paper, coming in the midst of a discussion so heated, seemed funny in crescendo to me, and I could scarcely control my mirth. The crowd did not feel as I did. That to me made the situation more humorous. The people were bored, restless, indignant, outraged. It was as though, watching the cinema, they had seen the heroine dash for liberty with the villain a breath away, when a big fat woman with a big fat hat had sat down in front of them. The difference was that in a picture show they might have squeezed to one side, but there was no getting around this dreary exhibition of Larson's. Just as the crowd was about to groan or tear up a desk and brain the offender, the big fat woman took off her hat and exposed an even more exciting scene. Larson said something more about cigarettes, and Mr. Mead strained intently forward. When Larson began to expatiate about the criminality of men who bought from stores and resold to

youths, Mead yelled, "You mean that I let men have cigarettes, knowing that they'll give them to boys! You know you do!"

Larson abased himself as humbly as Uriah Heep, denying any shadow of such a thought. But Mead was not satisfied. He was not another bloodhound, sniffing. He was a lion, roaring, and his prey was in sight. It was plain to be seen that just the sight of Larson was enough to enrage him, and that Mead was not only ready to place his own construction on anything Larson might say, but he was lying in wait for something to pounce upon.

Larson, having done his best to make the lion purr, proceeded, "And, besides the cigarettes, we have the awful presence of Sen-Sen to endure." (I recognized that Larson, a man without sense of humor, was trying to be humorous. I detected something else. His too amiable, too cautious approach appeared to be for the purpose of directing suspicion away from him as to any ulterior motives concerning me. Just so would a man write who wished to appear disinterested. Particularly since the whole object of the meeting was to discharge me.)

He was continuing: "The boys would come loaded with that objectionable odor until Mrs. Greenwood and me could hardly stand them." (He was endeavoring to prove his total lack of malice toward me by including me in this harrowing experience. I knew this must be making a great hit with the boys at the back of the room. No wonder Larson wanted them removed while he cracked his little joke at their expense.)

The lion gave a great roar: "Yes, and they bought it at my store. And they had a perfect right to buy it. There's no law in the State of Idaho against the use of Sen-Sen. And I'm tired of your insinuations. By God, I'll..."

The room was so crowded that Mead started to climb over desks to get at Larson. Helen Gillespie's voice thrilled the air, "Dad!" and Gillespie pushed the crowd away as he took great strides down the room, calling as he went, "Dad!"

Gillespie, throwing an arm around the infuriated Mead, drew him out into the congested hall, and possibly farther, until the merchant could calm down. Up to this point the paper Larson had so carefully prepared was the most inappropriate document possible for the occasion. He had seized the opportunity to let his light shine, and it proved to be a very little light indeed. No one would have grieved if he had left it home under a bushel.

He was sneaking up on his subject cautiously, diplomatically, as he thought. Diplomacy and humor, all in one man, and that man Larson! "Now, as to the lady here tonight," he read, his voice becoming very sad—his back was turned to me, and he could not see my face. "Now, as to the lady here tonight that the petition is about, I am sure that she has my sympathy. I feel great pity when I think how her heart must ache."

I did not wish to be rude, but involuntarily my head went back, and I smiled the broadest smile of my life, my shoulders shaking in my efforts to suppress a hearty laugh. The crowd, its eyes fixed upon me during Larson's lachrymose declaration, responded with emotional reactions similar to my own, smiles being kept within bounds only because of the suspense which must hear every word. At last the show was on again. The fat woman had not only removed her hat, she had even slumped down perceptibly. The comedy promised to be as entertaining as the preceding feature.

When Larson had written that paper, he had pictured me in the greatest distress, a public Niobe, with a red nose and all the other weak uglinesses that accompany a woman's feeble protest against adverse fortune. Instead, I was an inward tumult of laughter at the ridiculous farce he had staged. I had an almost irresistible impulse to step to the piano and begin playing "Chopin's Funeral March" to the accompaniment of his doleful voice. He was saying, "No one could feel sorrier than I do that this petition has been brought. Mrs. Greenwood is a lady of great education. She prepares her work careful. She is never neglectful of what she should do. The lady is *true-blue*."

I think he should have given Mrs. Mead credit for that last statement. That he intended it as a climax is doubtful, but as such it was received. The crowd broke into loud cheering, stamping, clapping, and whistling that might have warmed a disgraced woman's heart. As Larson resumed, I could tell at once by the quality of his voice that he had accepted the applause as a tribute to his

oratorical ability. His voice had attained the confidence of one who is at last certain of his popularity.

"But I am sorry to say that there is some things that can be said against the lady. The lady is too nervous in a school-room. Little things that she could overlook, she takes as big things. I am sorry to say that she has a bad temper. The lady, I think, would like to be principal. And her language has been far from discreet, and not all what a teacher's should be. For these reasons I do not think she belongs in a school-room."

He made a few more futile remarks which I hardly heard. He took his seat. I stood up, half facing the people and half facing Larson's back, the bald head directly under my eyes. I purposely paused until the eyes of every other person in that room were fairly riveted upon me. The room became so quiet you could almost hear the breathing. I looked down upon Larson's averted face, drooping lids, and that bald head. Then, with a wide sweep of my arm and a smile of contempt which the whole room could see, I let my voice boom out in its deepest tones.

"Professor Larson, at last the veil has been torn aside. You are not the man I thought you were. I feel no sorrow, for if I should grieve, it would be for a true-hearted friend who did not exist. We mourn the dead, but we do not mourn those who have never known existence. You say you pity me. Keep your pity for yourself. You are going to need it. With such principles as you have exposed here tonight, the day will come when you will surely need all the pity of which you are capable for yourself. Only this afternoon you said to me, 'Don't let them put anything over you, Mrs. Greenwood, for you have done no wrong!'

"And so I have taken your advice. Do not deceive yourself—my heart has not felt the slightest pang tonight, nor at any other time. I am perfectly calm in the consciousness that I have done no wrong. That does not mean that no wrong has been done. I realize now what has been the cause of my trouble the whole year, and the reason for the spirit of insubordination in this school. I did not have your support, your backing. How far you have betrayed me, these boys know better than I, and in seeking to blast my reputation here tonight, you have succeeded only in revealing yourself to them. Let what follows be upon your own head.

"As to your charges: First, I am too nervous for the school-room." I held out my arm, lifting my hand that all might see. "I ask this crowd to regard closely my hand. Do you detect even the slightest tremor?" I paused. Every eye was fixed upon my hand as it rested as calmly upon the air as the breast of a dove upon its nest. "Does that hand appear to you to be the hand of a nervous person? Yet wouldn't you consider it pardonable, after all that has passed this night, if that hand should tremble ever so little?

"As for temper: As God hears me, I have never once, not even to the slightest degree, known what it is to be angry in the schoolroom. I never in my life had a real fit of temper. How many of you here tonight can truthfully say the same? If I had pushed a boy downstairs, this charge might have been brought against me, and justly. If I had slapped a boy in the face, his mother and father would have been justified in considering me unfit for the schoolroom. But the worst that can be said of me is that I have spoken with severity. I admit this. In fact, I consider this a very necessary thing to do in a school-room.

"The third charge is that there were little things I should have overlooked. I suppose by that is meant the eating of apples during class recitations, the juggling of rulers for the benefit of admiring schoolmates who should have been giving attention to the lesson. Ladies and gentlemen, parents, there are no little things that can be overlooked in a school-room! Good discipline is made up of innumerable little things, not one of which can be overlooked. You should thank me, parents, that I am not the kind of teacher who is willing to overlook the wrong acts in a school-room, for the little ones invariably lead to the big ones. There is no half-way in discipline.

"Now, as to the last, that I have used indiscreet language: Once committed, I had actually been so indiscreet as to forget the criminally improper words that I must now admit I have been guilty of saying. I am going to make a full and frank confession right now. If there is any one present who feels that he is not able to endure the revelation, I beg that he will either plug his ears or withdraw from the room. I will not belittle my offense. I will state it in all its baldness. On one

235

occasion, ladies and gentlemen, I said..." I paused, bent forward confidentially, and sank my voice to its lowest but perfectly audible note, "I said...'devil!'" I gave horrified inflection to the word. "And on another occasion I said..." I again gave the word shuddering emphasis, "I said...'hell!'"

The room broke into roars of laughter, the men's hearty voices swelling, with the crisp crackling of the women's laughter sputtering in the midst. There was not a farmer present who had not spoken worse words that very day. I became suddenly very serious. My audience, observing the change, sobered to perfect stillness. "I said that I would not remain here a single day if the parents of my pupils wished me to go. But I should consider it an injustice, not only to me, but to my pupils, if I departed at the request of only a few parents. Mr. Jensen, I believe that nearly every parent is here tonight. I desire that you take a vote of this meeting. If it proves to be the wish of the parents here tonight that I resign, I will do so, and I will appeal to no court in any way whatever."

I sat down, and Jensen announced, "You have heard Mrs. Greenwood's request. Nothing has been brought against her that will hold water. Do you want to vote whether she will stay or go?"

Mr. Bagnel was on his feet. "In my opinion the whole trouble is with this high-school principal. I move Mrs. Greenwood stays."

"Second the motion!" from Victor's father.

"All those in favor of Mrs. Greenwood staying as teacher in this here high school make it known by saying 'Aye!'"

A mighty shout went up that fairly lifted the ceiling.

"All those opposed say, 'No!'"

Of course, there was not a single *no*. I am sure Mrs. Brady would have liked to dissent, but the other three women afterward expressed to me their abhorrence of Larson for having used them as cat's paws. Mrs. Brady's only comment, later in the evening, was, "I wish I could talk as Mrs. Greenwood can," which would lead me to infer that in her opinion I had escaped the just fate of the guilty only through the glibness of my tongue.

Jensen pronounced my sentence in the following words: "Mrs. Greenwood will continue to teach in the Acequia High School. A motion to adjourn is in order."

The motion was made and carried, but nobody adjourned. Everybody simply congregated in different groups about the room, and everybody avoided Larson, who would have welcomed any sort of affiliation. He did not seem to comprehend what this night meant in his career as a teacher in the Acequia High School. Most of the men gathered at once around me, congratulating me. In the center of the room the women formed a nucleus from which suddenly emanated the shrill voices of two angry females. "You did, too!" "I did not!" "You did!" "I didn't!"

"Mr. Bagnel," I smiled at him, "you'd better separate your wife and Mrs. Brady while there is still time."

A man gripped my hand. "I wouldn't of missed this meeting tonight for the best moving picture in the world. By Jimminy, you was great! Why, I never seen a lawyer could beat you. I sure would hate to have you get after me. I sure would hate to be in that skunk of a Prof's shoes."

I had gone alone to that meeting across the long stretch of snow that lay between my house and the school-house. I had looked up trustingly at the blue stars, knowing that God would conduct his case without my planning. I returned over the same route, which wound in and out among the snow-covered greasewood. The stars looked down with the same happy reassurance. And I was not alone. I was attended by a bodyguard of men who seemed reluctant to leave me. At parting, Herman Gillespie said, "I heard some of the men talking tonight of riding Larson out of the district on a rail. For that fellow to accuse her of temper and nerves when she gave such an exhibition of self-control tonight!"

That night I knelt beside my bed and prayed this prayer, "Thank you, Father!" That was all. Need I have said more? I had turned my case over to God. Could mortal man have done as well with the material at hand? Was there any material not at hand that was needed? Chance? Don't say

that to me! Every chance was against me. If I had failed in faith and had tried to make the battle alone, fear would have been my undoing. Fear is always undoing. Trust is always triumph. But you must have something in which you can trust so implicitly that there is no room for doubt. It is enough for me that the planets do not crash together. It is enough for me to have turned over one case to God and to have seen its unfoldment as at Acequia.

But this was not the end, though it might well have been considered enough. I slept that night as sweetly as did my two little children. While I was preparing breakfast, I heard the whirr of an automobile coming to a stop beside the gate used jointly by the Meads and me. Glancing up, I noticed Larson seated in his car, waiting, while Jensen, who owned no car, was leaving the automobile. He crossed the yard, hailing Gillespie, who was pumping water. "Did you get much sleep last night?"

"I should say not!" answered Gillespie, "I don't believe I slept a wink all night long."

"Neither did I. I don't believe any one in the district slept last night."

That seemed amusing to me, considering my dreamless rest, but I did not think it polite to contradict them, under the circumstances. Jensen was a long time in the Mead house. The children and I had finished breakfast before Larson's car left the gate with Jensen in it. Shortly afterward came a knock on my door. It was Mrs. Mead.

"Mrs. Greenwood, you can't guess what that Larson put Jensen up to doing! Actually, Jensen came this morning to ask me to ask you to resign. He said that he and MacMillan had discussed the matter and had decided that you and Professor Larson could never get along together now, after last night. I said, 'Then why don't you ask Larson to resign, instead of Mrs. Greenwood?' Jensen said, 'Well, Larson is in debt and needs the money.' I said, 'I suppose you think Mrs. Greenwood is teaching for her health. I suppose she doesn't have to support herself and her children.' I said to him, 'If you ask me to request Larson to resign, I will do so, but after the fight that woman put up last night, I'll never ask her to resign. You and MacMillan can do it yourselves. But don't be surprised if she refuses.'"

"Thank you, Mrs. Mead," I said. "I am certainly grateful to you. You are perfectly right. Since I know that nearly every parent wishes me to remain, the trustees could have no power whatever to compel my resignation. I would refuse to resign."

That set me thinking. Jensen had held the scales of justice so equitably the night before, yet at the instigation of a man whose character had been proved reprehensible, he was willing to bring pressure on me to resign. You cannot tell when the influence of an unworthy man will cease. If God had not inspired me to send those invitations, how might I have fared "in the presence of mine enemies"? Surely He had set a table before me as unmistakably as any David could boast. But had He not whispered that the invitations be sent—a list of *bona-fide* taxpayers; four complaining parents; the Principal supporting them; two trustees against me, the third wavering; the big, cold, drafty room with no ears or eyes to compel justice—can you believe for a minute I would have been spared defeat?

I CONDUCTED the singing as usual the next morning. The pupils watched narrowly both Larson and me. Those who had not been present the night before had listened with the intensest interest to a recital of the petition trial while they ate their breakfasts. Larson had delegated unto himself the office of reading *Ten Nights in a Bar Room* each morning—I think you may be able to judge the man's mentality in his choice of *Ten Nights in a Bar-Room* to read to a high school in modern United States. The quiver of his voice at the touching parts, touching parts which no longer had any touch with actual life, brought only the answering quiver of a smile to those young faces before him.

I thought they showed admirable self-control. Had I been a student under the same circumstances, I fear I should have ventured one tiny protesting groan. It is not a matter of drinking. I have never felt the need of getting exhilaration from a bottle. I was born intoxicated. The liveliness of my spirit needs no increase. And I scorn the cowardice that must seek false reinforcement to meet the buffets of fate. But the lack of intelligence that imagined anything could

237

be gained for prohibition by reading an obsolete, poorly written, maudlin piece of fiction was a challenge to my sense of humor. I could feel the eyes of the high school resting on my face, ready to reflect my slightest reaction. As Larson had regarded the cracks in the flooring the night before, so now I studied one of the window-blinds with expressionless countenance.

I cannot imagine why newspapers were instituted—unless it be to provide jobs for cub reporters, such as once was I. And perhaps to kill the monster that all Americans fear—the Monster Time. And to cultivate the American sense of cruel and stupid humor by means of the Sunday supplement, undoubtedly a valuable contribution to the character-building of an American child. Yet, like other citizens of Columbia, I am fascinated by the press. Particularly the little town papers, which have no reason whatever for existing except to thrill the inhabitants with the sight of their own names in public type, for only news that concerns any community travels on wings that are more swift than radio. Who would have expected a report of the trial to reach the ears of the County Superintendent of Schools before the following morning?

As I began teaching my first class, through the open door I marked the arrival of the little woman with the gray eyes, indomitable features, and beautifully mild manners. When the period was nearly over, a knock on my door summoned me into the hall, where Mrs. Sullivan said, "I have taken from your shoulders the discipline of the high school, where it has so unjustly rested during this whole year. I have told Professor Larson that henceforth he must have the burden of the high school himself, during the day and during the study period. You will have the room he formerly occupied, and he will have yours. You need have nothing whatever to do with him except in so far as your work is concerned."

That was how I came to have the smaller, sunnier, warmer, and more comfortable room. Larson was forced to take the big, drafty room that he had imposed upon me, with big-bellied, pompous stove which heated only itself. And whereas, before, I had had no leisure whatever during the day on account of the exigencies of disciplining the entire high school, I now had several hours of my own, free from any strain incident to watching rebelliously disposed students.

The changed attitude of the pupils was not the least remarkable metamorphosis. Clarissa, Alberta, Rosa, each of them fairly groveled at my feet in the utmost prostrate respect, and where there had been secret sneering for Larson, now there was open insolence. I who have never run with the herd could not help observing these manifestations with a certain sadness. Had I not been inspired to send those invitations, this insolence might have been mine. But no! I am unjust. For had I been expelled from the school, I know that a certain amount of pity, combined with my own impregnable spirit, would have carried me through with some form of dignity. I am unjust, for how could they have heard of the events of that night and retained any respect for Larson? Still, there creeps across my reverie that the justice of the crowd hangs by a hair, and sometimes it visits its revenge upon those who are innocent but weak in defense resourcefulness. Was it because I had been proved right that I was receiving this abject homage, or was it because I had outwitted four farmers' wives and an illiterate, unprincipled man?

That same morning Larson had met cold and cutting insult from the men in Mead's store, where he went to get his mail, and also at the Acequia Cheese Factory, where he took the milk from his rented cow and where Wendell's brother was an assistant. Filled with indignation at what he considered inexplicable injustice—he was even as stupid and callous as that—he had come to school only to meet the same contemptuous attitude. Curiously enough, his first encounter during the study period was with Alberta Duggan. Upon her continued whispering, he threatened to throw her out of the window, actually pushing up the sash, his eyes bulging with anger. Of course, this only made him appear ridiculous to the students, but it could not lower their respect, for that was already destroyed.

During the morning, when the other pupils were occupied elsewhere, Victor Harper came to my desk. "Mrs. Greenwood, I think you ought to know what Professor Larson used to do with us boys when you sent us to him. You remember that day I ate an apple in class? When you sent me to Professor Larson, I was glad to go. We boys used to try to do things that would make you send us to Larson. When I went to him that day, he said, 'Now, what has that woman been doing? Can't she

get along with you?' I told him I had been eating an apple in class, and showed him the apple. He said, 'Never mind. It's just her bad temper. Just sit down here and wait till it blows over.' And that is the way he always talked to us whenever you sent us to him. He didn't want us to hear him praise you in his paper last night." Victor laughed, showing his beautiful teeth and looking as handsome as possible.

The next day Rosa appeared before me like an April morning. "Mrs. Greenwood," she sobbed, "Professor Larson is sore at me since the petition night, and he says that I am going to fail in your subjects—that you will fail me because Mama was on that petition. He says my card is so low now that I cannot get through. Mama told me she knew you now, since that meeting, and that she knew you would be fair, and to come and ask you, because if I can't get through, she says she will have me stop right now and learn dressmaking."

Now, here was a problem for me. Rosa was likely to make an excellent dressmaker—her mother showed great skill in that line. She would never make a scholar. But if I told Rosa so, Larson would consider that he had triumphed over the poor girl, and also over me. Any opinion he might have about me was of no concern whatever, but, on the other hand, her mother had not asked me to decide Rosa's superior aptitude; she had simply asked whether Rosa could sneak through my courses. I have always considered that the unforgivable sin mentioned in the Bible, but not named, is that of meddling in the destiny of another human life. It was not my province to settle Rosa's fate. How did I know what experiences God considered necessary to form Rosa into the instrument most efficient for His use? I would keep hands off. I would not smooth the way unjustly for her, but neither would I pile unnecessary rocks in her way. God will provide his own impediments. There is no truer passage in the Bible than that which tells, "whom the Lord loveth he chasteneth." I thank God for every mountain he has put across my way, for every stream that seemed like to drown me. Fortunate is he who must fight to attain his ambition. Only so can he be rightly dedicated to his work, and only through such dedication comes worthwhile accomplishment.

"Can you get your card from Professor Larson? We will soon see whether you can make it. So much of the year is gone, it would be a pity to lose what credits you have gained. Get all you can in school, Rosa, but remember that it is a splendid thing to be able to do something useful with your hands. A well-made dress may be a work of art."

Rosa dried her tears and left the room, soon returning with her report card. I inspected it. "As I figure it, from your average so far, if you can make good percentages in your future tests and examinations and keep your class record as high as possible, you ought to get through. Of course, it will all depend on you. I think it is well worth risking. But don't give up all thought of dressmaking. You are the best-dressed girl in the high school. Perhaps you have inherited your mother's taste and gift with the needle. If you have, Rosa, keep your independence by being a dressmaker. There are always dresses to be made, and not enough capable hands to make them."

That was not meddling. That was just sowing a seed, and it was also warming the heart of a woman who had learned to trust me, and who got little enough praise, God knows, being a farmer's wife. Rosa's tears of gratitude made a rainbow through which she smiled. "Oh, Mrs. Greenwood! It's so good of you to say so many nice things. Professor Larson is sore at me because I wouldn't get up a petition against you. That time when you and me had trouble, he told me to get up a petition against you, and when you had trouble with Herbert, he told Herbert to get up a petition against you, and I wouldn't and Herbert wouldn't."

Larson heard a rumor that unless he stopped his activities to send Wendell Troughton to St. Anthony, there would be a lynching bee; consequently his ardor in that direction suddenly cooled. He was having a bitter time with the high-school students. I despised him, but pitied his predicament. The students had never been so unruly. In order to curry favor with the pupils and parents, he graded their report cards extremely high. They had been forced to earn any good marks they received from me. Some of the most inveterate whisperers, who could have been reformed only by the lockjaw, he gave P + in Deportment. They came in laughing groups to me, exhibiting their cards in mock triumph. Not one of them valued any mark Larson might give them.

"What does *P plus* mean, Mrs. Greenwood?" one chuckling student asked, passing me her card.

I smiled. "That means Perfect Plus...and, as the giraffe said when he saw the farmer, 'There ain't no sich animal!'"

WHAT BECAME of Larson? Were I writing fiction for the approval of the usual American public, I would relate how he received his just deserts by being barred from the public educational field forever. Not so. This book is about real life in the United States. Over in Denmark such a man as Larson would never have been allowed to teach at all. I doubt that in any of the more civilized countries of Europe he could have taught.

I speak the truth when I tell you that this reprehensible, illiterate man is today superintendent of schools in one of the most important counties of a Western state. Without education, violent of temper, and unintelligent, by means of politics he is able to retain a position with excellent pay, making him supervisor over a whole countyful of teachers, most of them his superiors, none of them his inferiors. Politics in the schools reveals to all other nations, by means of these United States, to what shameful uses the freedom of a democracy can be brought. The indifference of the able and the ignorance of the masses make the election of such men as Larson to positions of importance an everyday occurrence in our free country—free to the corrupt.

As for me, these Acequia days were almost the last that I spent among the sagebrush farmers. I learned what faith can do at Acequia. I did not learn to keep the faith myself, continually, until after I left the wilderness. When I left Acequia, with the offer of the principal-ship for the next year, which I declined, I did not know that I was on the point of leaving the farm forever.

XI. ECONOMICS

Yes, we lost the farm, thank God! It had become a case of our losing the farm or the farm gobbling us up. It was a Daniel Webster case of sink or swim, and we could not swim. My children are today fighting for their educations, for when you have to work your way through college, most of the time with scarcely any sleep, it is not just a struggle, it is a fight. The four of them, the wonderful four of them, so good to look upon; so good inside—worthy of temptation, but not yielding to it, for virtue is not virtue that is too unattractive to be worth the Devil's time. As for me, cursed before birth with the doom of being a writer, good or bad, success or failure, I whose golden writing years were cooked into pies, hoed into vegetables, hatched into chicks—I have escaped a bed among the little drowned infants, beside the syphilitic babe, on that bleak desert hill overlooking the little town of Hazelton.

We were not alone in our loss of the farm. Scarcely any of the farmers in that sagebrush country have been able to hang on to the land. City and rural farmers alike, nearly all have lost their farms, or are hanging on to them by a mere thread, slipping back, and slipping back, until there is no possible hope of their rescue unless...unless President Roosevelt can find the *right* solution. Even then, it may not be able to save them, but it will save others. If he can find the *right* solution for the ills of agriculture, he will have found the *right* solution for all the ills of the entire economic system. Agriculture is the barometer of the whole national-economics weather. The farmer is the first to go down and the last to rise, but no nation can claim a stable prosperity until the farmer is safe. Why? *Because he feeds the world.* It is a dangerous thing for the dog to leave Old Mother Hubbard lying there so sick in bed, and he not even barking a bark to summon help. Don't you know that a cupboard, of itself, cannot always go on supplying bones?

The Huberts were the only family who ever left us of their own free will. They went only so far as another part of Idaho, as wild as our own. We all loved the sagebrush country with an unexpressed and inexpressible passion. And, in return, our sagebrush farms were vampires which sucked our blood, and the blood is the life. No! It was not the sagebrush farm that visited upon us this gross injustice, but the indifference, greed, and blindness of the public at large, as represented by a Government of the people, for the people...a Government of the politicians for themselves and their friends.

You may recall my telling of the scandal concerning my discrimination against little Willie Hubert at the Fourth of July celebration when Maizie, the city girl, ate three pies in three minutes and even more quickly performed a public regurgitation of the same. It was his mother and her family who left the district first of us all. Mrs. Hubert was a rather wonderful woman. She was the strongest member of that little family, and usually she commanded its destiny in a wise and effective manner. And she liked good music. That fact would inevitably endear her to me, beyond any possible cavil. For that matter, all the sagebrush folks liked good music, strange as that may appear. But it was Mrs. Hubert who so generously thanked me the night that I explained the operas "Aïda," "Carmen," and several others, illustrating the music I described by means of phonograph records. On that night the two school-rooms which could be opened together, Primary and Upper Grades, were crowded with sagebrush farm folks, listening so intently that you could have heard yourself breathe had not the music interfered.

241

The Huberts had bought their farm outright and had then erected on it a good frame farm-house of one large room, one small room, and a lean-to summer kitchen. The heat from the range was needed in the house in the wintertime, when the smaller room was used for a living-dining-kitchen room. The Huberts were the most successful farm family in our part of the project, not because of their crops, which were no better than those of any one else, nor because of any other circumstance that occurred during their life with us. They had simply not saddled themselves with debt to begin with, to add to it the cost of water and the taxes on the land. The rest of us were trying to buy our farms, as well as get out of them the expenses of farming and livings for our families. It could not be done. It is criminal to advise people to try to own land unless they have capital with which to make the start.

Practically all we sagebrush folks were in the position of the young bride who learns to cook at the expense of her husband's stomach and pocketbook. Yet our own losses from this cause were not so great as might have been expected. It did no good that you were an experienced farmer in Illinois, Nebraska, Oklahoma, Missouri, Arkansas, Texas, South Carolina, or Canada. The farmers from Utah became prosperous ahead of all others. X stands for the unknown quantity, *irrigation.*

Charley knew as well as any of them how to farm in Idaho because he had sent for government bulletins and had followed every suggestion put forth by the Government, a thing which the dyed-in-the-wool farmer almost never does, one of the reasons being that nobody can tell him anything—he thinks he knows already better than the agricultural experts; and for another thing, he is not a reader, and all the government bulletins in the world cannot change his methods, for he never looks at them. As for irrigation, there was not a farmer in the whole sagebrush country who could beat Charley at that. It takes brains to make water run uphill; to make it go over a hill; to get the most out of the least water; to handle it so that the crops needing it most can have it when it is most needed it takes brains, and Charley had the brains. He was an authority, among those sagebrush farmers, on irrigation.

When the Huberts decided to buy a farm in another part of Idaho, they staged our first farm sale, and it was the last for many years. We were all a good deal excited over it. Charley and I went to the Hubert farm in our Mormon white-top, behind two beautiful, almost black farm horses, Bonny and Bess. Our Kansas team were dead, as well as Old Buttons, but we had now also Star, a beautiful, vicious thoroughbred. Along the Lincoln Highway east we rode, then climbed a gentle hill north, passing the place where one day would live my good friend Gramma Poole, who once said to me, "You got no call to grum, Mrs. Greenwood, if folks don't come to see you, for you never go to see no one." And she further philosophized, "We women pomper the men too much."

Gramma Poole, so strong and sagacious, was not yet up from Texas when we rode toward Hubert's. But next to the place where she would live was the tar-paper shack of Simon Heminway, housing, strange to relate, the only piano in the district, the only piano for many, many years. The wagon was gone from their doorway, so we practically knew that the Heminways were at the sale.

From the top of the hill we could see the Hubert place, a tidy gray house, with a few young trees and a beginning row of fruit-bushes. The farm lay on the edge of the desert, barbed wire marking a line between green alfalfa and gray sagebrush. Somehow Hubert had been able to keep the rabbits from devouring his crop, which they generally do on farms located as his was. But I have an idea the fight made him leave us. We could see that the yard was filled with farm folks, their horses tied to the cedar fence-posts to the east of the house.

All the household goods had been assembled in the back yard of the farm-house, and they were polished until they looked better than new. I hurriedly clambered over the wagon-wheel, while Charley was tying our horses so they would not bite Old Man Babcock's mare Damyou—at least I suppose that was her name, for whenever he drove into our farmyard to borrow the seed-cleaner, or the hay-rake, or what-not, we could hear him shouting as he came, "Git up, Damyou!...If you don't git a move on you, I'll lick the daylights outen you, Damyou!...Git up, Damyou!...Damyou, git up!"

I know I am writing on *economics*, in a rambling sort of way, but I have to pause to tell

242

you how Old Bab got the best of Hen Turner, the Woodman of the World Grange Overseer of whom I once told you. Hen and the Baron were the only ones in our part of the country having hand seed-cleaners. The hand cleaner, of course, was used only when a farmer wanted to clean a small amount of seed, too trifling to bother putting through the threshing-machine. Bab came to borrow ours and found Charley busy with it, so he went on to Hen Turner's in his white-top—one just like ours, except that it had no U.S. Mail stenciled on it in big letters, and Bab usually went about without the back seat in his, using it as a little wagon.

He asked Hen if he could take Hen's seed-cleaner home for a week or ten days. Hen was not using it and would not be using it, but he replied, "You're welcome t' use muh seed-cleaner, Bab, but yuh'll hev to use it here, on muh own place."

It was not more than two weeks afterward that Hen's wife was taken suddenly very sick, and Hen rode like mad over to Bab's to borrow his white-top to take her to Dr. Berry in Hazelton. Bab eyed him a minute, and then he said, "You're welcome t' use muh white top, Hen, but yuh'll hev to use it here, on muh own place."

Hen thought that was terrible. He came over to borrow our white-top, and that's how the story got out.

As I approached the Hubert house, I could see Mrs. Hubert and Mrs. Hatch fussing around a gasoline stove, out in the yard. They were heating a wash-boiler filled with water, and on an unpainted kitchen table nearby were several salt-sack bags of coffee, long strings attached for drawing them out of the water, in which they would presently be immersed. Beside the bags of ground coffee were two big dish-pans—I surmised they might belong to the two women and these were filled with thinly buttered buns, ordered from Twin Falls, a town which had not been alive very long, but which had been lively from the first gasp. We were to have lunch, and no matter of what, the fact was cheering. Especially cheering to a farm woman, who never gets to eat after any other woman, as we express it in the brush.

Grouped together in the yard, as I have said, were all the house hold articles. I am a little mad about antiques. I am a little mad about most things. But my greedy eye goes looking this way and that—once I found a lyre-backed chair; once I found a lovely antique lamp. Mark Twain might have taken his own words from my mouth: "The very 'marks' on the bottom of a piece of rare crockery are able to throw me into a gibbering ecstasy....I am content to be a *bric-a-bracker* and a Keramiker."

It took me but a second to see that my only hope was among the odds and ends of dishes, all scattered about in black dripping-pans. I am a champion maker of odds and ends myself, having a kind of poltergeist gift which causes the dishes to fall out at me when I open the cupboard doors. The only time I was ever mad at Hib was when I broke a saucer after this manner, and over my shoulder he remarked, "Do you know, Mrs. Greenwood, I don't know when I ever broke a dish." He had that very morning broken the expensive spring-tooth harrow, and I want to tell you I bit a sore place on my tongue to keep from saying, "Do you know, Hib, I don't know when I ever broke a spring-tooth harrow."

Of course, I could not just pick up whatever china I fancied. There was to be an auctioneer, and I should have to bid my bid against all comers. I saw a treasure that I meant to have: it was a fish platter, with a goggle-eyed fish sprawling on it, in red and yellow, and twelve little fish plates for bones, each with a little yellow and red fish painted on it. It was so ugly that I could see how Mrs. Hubert could bear to part with it. Maybe somebody she did not like gave it to her. I could just fancy how fascinating it would be to watch a tableful of folks fishing fish bones out of their mouths to lay on those little dishes. Those plates would not hold an entire skeleton, unless the dish were used for the head and the tail end allowed to trail over the table-cloth in a kind of fernlike decoration. I resolved I must have that fish set.

There were straight chairs, rocking-chairs, an old couch, a wash-stand, home-cobbled, and various other articles, among them a clumsy, big, old-fashioned coal-oil stove. I breathed a sigh of relief when I saw the Baron desert the home-cobbled wash-stand, after several lingering,

affectionate glances. I knew it would be like him to fill up the kitchen with home-cobbled wash-stands for the comfort and convenience of helping farmers, though he was willing they should share one comb. I was so absorbed in the fish dishes that I barely noticed him circling the big, clumsy coal-oil stove, closing in on it as though it were a maverick at a round-up. We had a gasoline stove we could not use because we could not afford the fuel, and we certainly could not afford coal-oil any more than gasoline. So I never dreamed he could have designs on that stove.

The auctioneer was from Twin Falls, like the buns, and he began by grabbing up two articles at a time, holding them in his hands—he was standing on a wash-bench—and talking so fast that we sagebrush folks were thrown into a flutter, sort of hypnotized, as the fakirs play on their flutes to hypnotize the cobra or something. We all began to breathe hard and fidget about, casting suspicious, avaricious glances at each other. I suspected every one there of having a mind for those fish dishes, and I feel sure that each one of us had segregated something to be fought and bled for with those farm neighbors of ours. The contagion of it, that's all. If the auctioneer had been as slow as our brains, we could have kept a thought ahead of him; but he was a high-pressure salesman, and he knew wherein his power lay. He had no mercy on us.

"Now, folks, here's a rockin' cheer as fine as ever you see, just see how easy...to sit down on when you come in tired from milkin'...or from cookin' for thrashers...and cheap...cheap...at any price. How much am I offered...what do I hear? Who'll make it twenty-five cents...twenty-five cents...who'll make it twenty-five cents? Twenty-five cents did I hear? Twenty-five cents it is! Who'll make it fifty cents?...make it fifty...fifty...who'll make it fifty...thirty-five do I hear? Who'll make it fifty...fifty...That's right! fifty it is. Who'll make it seventy-five...why, you couldn't get a cheer like that less'n five dollars...who'll make it seventy-five...seventy-five...strong back, look at them rockers, last a life time...who'll make it seventy-five? Seventy-five it is! Who'll make it a dollar...a dollar...who'll make it a dollar?..."

We are all dead still, staring at the rocker as though we had never seen one before. It is rather a miserable little rocker; most of us would not feel flattered to have it given to us, but somebody is going to buy it in a minute...somebody is going to get it away from us...the chance of our lifetime, and somebody will get it away from us....

The auctioneer is perspiring, his iron-gray hair falling from under his peaked cloth cap into expressionless wide eyes, mustache waggling. "A dollar...a dollar...a dollar...How 'bout you, brother? Ain't you gonna bid a dollar on this here fine rockin' cheer?...A dollar it is!..."

The auctioneer wears a red and black mackinaw and overalls. He has big overshoes pulled over the bottoms of the legs, for the ground around the barn may be soggy with cow and horse manure. He was a farmer's son on a farm out in Ioway, and he learned auctioneering when a lad. All over the sagebrush country he is in demand at sales. This being our first sale, he has not been among us before. He is not overanxious about the sale. We look like a pretty poor bunch of future customers.

"A dollar...a dollar...Won't someone gimme more than a dollar? *Once* a dollar!...*twice* a dollar!...*you!*...Can't you bid moren' a dollar? No? Three *times* a dollar!...and sold to this man over here with the ear-muffs on his cap!"

As the sale is getting nearer and nearer to the fish dishes, my heart begins to throb. I cannot lose them. I know they must be antique something or other. Of course, with my poltergeist gift I shall have them all broken inside of a month, but I shall enjoy the feeling of passing them on to my grandchildren as heirlooms, even if it never happens. The sewing-machine is sold, the couch is sold, the coal-oil stove is sold, and all without my consciousness. There I stand with eyes riveted on those goggle-eyed red-and-yellow fish dishes. And now they are up. I must keep control of myself. If I appear anxious, every one of these frightfully greedy creatures close around me will bid them out of sight.

The auctioneer begs for bids on the fish dishes. Begs almost with tears in his flat, expressionless eyes. Begs with disgust in his voice. I bid. Ah, that makes Mrs. Hatch chirp up. I might have known she would try to get those fish dishes away from me. I brace myself. If we have

to, the Baron must pawn the crown jewels. Or maybe a calf. But Mrs. Hatch dares not falter another chirp. Perhaps she does not like fish. And then again, it may be that those fish dishes do not look to her like antiques. Besides, I cannot imagine her going mad over antiques. Oh, I do love folks who go mad over antiques!

The fish dishes are mine, and for a fish's song, which I think everyone will agree is about the smallest song there is. I carry them joyfully to the white-top and come back to trail the men to the corral, where the auctioneer is already shouting, "What am I bid for this here fine heifer, bred from a bull whose mother gave twelve pounds of butter a week...."

Only a city greenhorn would laugh at a cow giving butter. We all knows what he means, and not a smile changes a face. We are all intent and serious. The other women gather in little groups apart, far enough removed from the men folks not to seem to be listening. But Old Lady Babcock, wearing one of her husband's coats and one of his old felt hats, is as close to the auctioneer as possible. He is on the other side of the pole fence around a small corral just outside the shed barn, and Mrs. Greenwood is hanging over the top of the pole fence—as she would be! Oh, me! the trial that woman has been to me! Especially since the Baron is a little conscious of the fact and would have her go over where the other women are, and she knows it and never stirs. Why should she care? She is rich in antique fish dishes, bought for a fish's song, and she doesn't give a damn what any one thinks about her hanging over the pole corral fence and listening to the fascinating auctioneer. She means to write a book sometime and put him in it, and she must remember how he looks and sounds. And...oh, yes! He pauses for a moment so the men can feel the heifer with their hands, and look in its mouth, and maybe in its ears, and he takes out a plug of tobacco and bites off a big chaw. That is the signal for all hands to reach into all hind pockets and all teeth to bite off big chaws. The mother of the calf is standing near, and she and the farmers all begin to chaw together. No wonder Mrs. Greenwood hangs over the pole fence, watching, fairly mesmerized by all those moving jaws. The Baron is not chewing, but he cannot fool me. I know. I would never have married...And if he had known how crazy I am about writing...

I look out beyond the corral, beyond the pole fence, beyond the barbed-wire fence, and there as far as I can see lies the sagebrush desert, the horizon a line of white tents, the peaks of the Sawtooth Range. I can see jack-rabbits leaping among the clumps of sagebrush all along the line where in a short time will be laid the track for the Sage-hen, Gallopin' Goose, Hootin' Nanny, Gasoline Split-the-wind, or whatever other name the sagebrush farmers exercise their humor inventing for the important, puffing little train of one engine, one caboose, one car, that will ply from Bliss to Minidoka and back. Nothing is there now, the auctioneer's voice being the loudest sound on that desert air, except when the mother of the heifer lets out a long, melancholy Mo-o-o-o!" in the faces of those tobacco-chawing males, or when the hog Old Bab is buying, in spite of Old Lady Bab's emphatic protests, expresses a disgusted bass "Awnk! Awnk! Awnk!" waddling impatiently from under Bab's thumping fingers.

I know that Old Lady Babcock is not the only woman watching her man with anxious distrust. Not one of us farm folks has any business to be buying anything—no, not even extraordinarily valuable fish dishes, even for a fish's song. Yet everything is sold at last, and we are all herded around the gasoline stove, with Mrs. Hubert and Mrs. Hatch passing dozens of tin cups, rented from Daddy Ayres, the hardware man in Hazelton, and handing out the two dishpanfuls of thinly buttered buns. If any one had offered us such a meal at one of the farm-houses, we should have gone on a hibernating sulk, but to get it for nothing, out here in the open air, coming only miles to do so, standing first on one foot and then the other, there being no seats, scalding our throats with chicory—I wonder about the Baron, who has to have the best brand of coffee on the market—why, just to get it for nothing, with a cold bun thrown in—or down, if you mean throats—who could resist such a bait?

Being through first, for I cannot drink much coffee and was not sure about chicory, I went out to the white-top to gloat over my fish dishes, and as I was in the midst of my gloating, I happened to lift my eyes to see Charley coming toward the white-top, carrying in his arms that

245

atrocious old coal-oil stove. What could I say? Nothing. Since we could not afford the kerosene, it never came down from upstairs. Charley had paid two dollars and seventy-five cents for that old stove, and I used to go upstairs and glare two dollars and seventy-five cents worth of glares at it. But every time I looked at the fish dishes I felt humbled. We didn't need them either, even if I did get them for a fish's song. I could not use them for fruit. There is something sickening about seeing a fish's goggle-eyed head peering up at you through your stewed peaches.

I never went to another sale, but Charley attended them all, bringing home various pieces of outdoor equipment; but since I did not know how much these things cost, or how the Baron was ever going to pay for them, all sales being on time, it did not worry me. I was a pretty good woman about keeping my place—if you call being a good woman spending most of my life cooking myself over the kitchen range. I was the ideal woman signified by the old German proverb, "A woman is to be from her house three times; when she is christened, married, and buried."

In the course of time, there was a sale at Simon Heminway's, one at Old Bab's, and one at Eb Hall's, among many others. These were years after the Hubert sale. It took years for Eb Hall finally to give up his farm—have it taken away from him. His was the farm on which, a long time after he left, I sat eating three ice-cream cones, my back to a tree, at the conclusion of that rabbit-drive described earlier in these pages. His good wife had planted old-fashioned flags and lilac-trees around the place, and the reason I could lean my back against a big tree was because it was one of the first trees ever planted in that desert, and it had been Eb Hall's hands that had planted it.

The Hubert sale really caused the loss of Eb Hall's farm. Eb had come into the district at the same time as the Huberts. That was about three years before the Greenwoods settled on the hill above the school-house. The Huberts had come with capital; the Halls had come with nothing but a wagon, a team of horses, a cow, and a hog. They had managed to get trusted for what they absolutely needed, and Eb told me that for months that little family had lived on lumpy Dick, bread, butter, and milk. A sack of flour and a cow—with a very little sugar and some salt. That was all. When I asked about lumpy Dick, Eb explained that it was made by stirring white flour into boiling salted water. This made a kind of mush, impossible to keep from having some lumps in it. That brave little family made a joke of it. "Lumpy Dick for breakfast!" "Come, sit up; lumpy Dick for dinner!" "Gosh, I'm hungry! Where's the baby? Lumpy Dick for supper! Lots of folks is starving tonight, children, but we got good old lumpy Dick!"

The whole district had seen the Huberts drive proudly away in their new car—the very first car ever owned by any of us. They had money enough to buy a new farm in another part of the state, for Miss Butterworth and her brother had bought the farm from them. We envied them their prosperity, but we would not have left our farms, not any of us, and every one of us expected, in a short time, to be driving on the Lincoln Highway in our own shining new cars.

One day I was startled by the approach toward the toothpick-pillared porch of a great Studebaker car. We still had the driveway past the very front of the house, before it was moved beyond the top of the orchard fence. At the whirring of the big machine I ran out on the porch, and there...there...was my good Mormon friend Eb Hall and his quiet, efficient wife, with their five little children fairly boiling over the sides of that car!

Charley came from the granary, looking as amazed as I felt. This was Eb's explanation: "Well, yuh see, Charley, it's jes' this-a-way. I come t' this country the same time George Hubert come here...me and him was a-buildin' our houses at the same time. And when I see him with his auto, I figgered if he could do it, so could I! Ain't she a bird?"

Yes, she was a bird—an albatross, hanging around the neck of poor Eb Hall. The very next day after Eb brought her in for us to see, he ran head-on into another car, and the damage to both cars cost Eb three hundred dollars, and he did not have even one hundred dollars in the world. That meant a mortgage plastered on his farm and stock, a mortgage to pay interest on while he paid for his car, his taxes, his water, and his land. What Eb had overlooked was that Hubert had begun without debts and had concluded without debts.

There was a long, heart-breaking strain to keep the Hall place, and every day Charley and I saw cheerful, fine Eb at our farm, for he always called on his way to the mail-box, or from it, bringing our mail also up the hill. It was no use. The Halls finally lost the farm, their stock, and the car. All they had left was the wagon and a team, with which they left the country, to go down to Utah, where they might farm among their own relations, getting a little financial help as needed. I was sorry to have Eb go. We used to have such grand times talking about what God must be thinking. And I still wonder. But maybe Eb knows. I heard that he died two years after the little family left us.

Old Bab and Old Lady Babcock could not make a go of it, either. All they were able to call their own in the end was a little stock, and this, sold, just helped them to reach the Oklahoma oil-fields, where some one had written Bab there was a fortune to be picked up. If there were any gushers there that could beat Old Bab when he had one of his mads on, I'd like to see it.

Simon Heminway gave up farming some time before he left. Simply could not make any money at it. So he went with the truck he was buying on time to Twin Falls, peddling vegetables which he bought from wholesale produce-dealers in the town. When he had the truck paid for, he let his land go back to the Water Company, sold what little stock he had, made the truck into a house, and started off for the orange-ranches of California. The family would live in the truck until, by some miracle of God, they could own an orange-orchard.

SAID MARK TWAIN about the farming of Henry Ward Beecher, "He was a very inferior farmer when he first began...and now he is fast rising from affluence to poverty." City farmers, city dreamers—Old Bab and Simon Heminway, the Greenwoods, Hib the baker, all city dreamers. But there was Eb Hall, and all the other real-farmer dreamers. It may possibly take dreams to *make* money, although usually the money does not go to the dreamers. What is certain is that it takes money to *fulfil* dreams. My sister-in-law had a dream of my raising white peacocks, though what for, heaven only knows. To a farmer they would have seemed a horrible waste of meat and feathers, and no one else would ever see them, however they paraded in that sagebrush wilderness. And she wrote to the Baron about sometime having a grilled iron gateway to our farm with the name in large letters above: GREENWOOD. Well, I never punctured her pride in the supposition that our rural district had its name from her brother. Until I wrote this book, I never told any one but Charley of Mrs. Sullivan's letter.

It is just as foolish and dangerous for a city man to take his family out in the sagebrush to farm as it would be for the local barber to attempt an operation for gall-stones with a razor and a shaving-mug. And yet, we city farmers did very well alongside the born farmers, and we might have succeeded entirely were not the world of agriculture ruled by the middlemen who know no law but that of profit to themselves. I cannot understand why we think we have reached the perihelion of civilization when the state of national economics is in the dark ages.

After we lost our farm, I watched from the living-room windows the sale of the stock. It was all that belonged to us, except our shabby household goods. I saw Florry led out for inspection, beside the octagonal barn-red granary. She was now a big gray mare, turned that way from a bay colt, but I do not think she turned gray from being on the farm, as I have heard this is the habit of bay colts. She was sold, to whom I did not notice and did not want to know; I felt a pang that I had ever been cross with her about chewing the sheets off the line.

Napoleon Bonaparte, or Bony, as we generally called him, with noble head and ridiculously small body, had been sold some time before the farm sale. But there were led out to the auction-block our other faithful slaves, Abe, Bess and Bonny, and the thoroughbred Star, most beautiful and brilliant and unmanageable of all. Sold!...sold!...sold!...Strange faces, strange hands, strange stalls, strange fields. They would not like it. How could they?

All the cats and dogs had been given away, carried off with questioning, reproachful, backward looks at their mother, and that was I. "How can you do this?" they seemed to say, "and how do you know that we will be treated considerately?" I did not know. I had to shut out the thought of my poor animal children.

It was not right that we should fail, Charley and I, and yet it was right. It was not our just reward, but it was our best reward. There is a saying among the sagebrush farmers that the first settlers clear and plow the land for those who are to own it. Not only did we fail from lack of capital, but we had pioneering problems such as no other frontiersmen ever had.

My young mother and father had been Western pioneers, but every one in the whole West was a pioneer then, and the East was a foreign country. We in the sagebrush were surrounded by civilization, touched elbows with it at every turn, yet we lived under conditions much more primitive than those my mother and father endured. For grandfather and his brother were men with money; their wives, who were sisters, had never done any manual labor in their lives. They were both musicians, and their melodeons came to Utah with them by ox-team across the wide plains. Grandfather at once built a comfortable house, so comfortable that it could compare favorably with houses of today. My father, a young pioneer physician, took my mother to a home almost, if not quite, as comfortable, not long afterward building her a mansion, the home in which my childhood and early youth were spent. Pioneers! I was the one who knew what pioneering means!

My father was a pioneer physician, and we were just farmers. Even the farmers of my father's day were more fortunate than we, because their market was where they were—their own homes and the town near them. We planted for a mythical market, which rose or fell as the middlemen dictated, practically all the time to our disadvantage.

The early pioneer farmers raised their sheep to supply meat for their tables and wool for their spinning-wheels. We had a flock of sheep which was sold at a loss, the best part for us, and the only profit, being some wool Charley clipped from their backs, which the good old Russian-German beet-thinning mother lye-cleaned for half of it to keep for herself. Out of my share I made four splendid quilts—but not until I was teaching and could get the money to buy material for covers.

During the World War, while most of the people of the earth were suffering privation, if not actual famine, three-fourths of Idaho's potatoes were left unharvested, to rot in the field or freeze in the ground, the price being too low to pay for the labor of handling. At that time Idaho had a law requiring farmers to grade potatoes so as to exclude all but the big bakers, such as you see on the menus of railroad dining-cars. These potatoes brought forty-five cents for a hundred-pound sack, and they were sold wholesale at Chicago for six dollars and fifty cents a hundred-pound sack.

I am rendered speechless with indignation when I think of the waste of food, and the waste of human labor, which means human life, and the starving people in the cities, who would have been glad of those smaller potatoes which the farmers were forced to leave to freeze in the ground or to rot in cellars, in cases where they had not enough hogs to consume them. How we can call this a civilized nation and allow such a criminal waste of food and life, I cannot see.

The year we went into the war, we sagebrush folks sold our hay for fifteen dollars a ton.

During the war, sheepmen, who were making big profits from wool and meat, refused to pay more than twelve dollars a ton, measured their own way, which, according to the Government, meant only ten dollars a ton. Yet wages were twenty per cent higher than before the war, when we raised fifteen-dollar hay at a scant profit. Charley refused to sell, and so there our haystack stood, four great monuments commemorating agricultural injustice.

During the war, while we were all eating corn-meal and oat-meal and barley and rye and what-not, refraining from using wheat flour in order that the soldiers Over There might have it, the price of wheat was so depressed that Eb Hall remarked to me, "Mrs. Greenwood, I see by the paper that wheat is a drudge on the market." His expression seemed to suit the situation. If the law of supply and demand had been left to operate, as it was in every other business during the war, even though we American farmers had refrained from using the wheat flour ourselves, we might have had a profit that would have helped us to pay off our mortgages. There was scarcely a farmer on the whole project without a mortgage, and the war just made the mortgages grow, instead of lightening them. We farm folks in the sagebrush were drafted to shed our life's blood just as surely as were the soldiers on the field of battle. When you steal a man's labor, you steal his life. The Government saw to it that the farmer could have no profit on the foodstuffs he raised, but did nothing about lowering the cost of the things the farmer had to buy and the labor he had to hire. Who paid highest for the World War, and had to live on and on, and pay and pay, and still pays? The American farmer! There is no other great nation with the degree of ignorance and indifference toward its farming class that we have. The Government, during the war, was careful to fix an arbitrary price for wheat, governed by what those who bought thought they ought to pay, and not by the actual cost of production. Are we going to commit such an unintelligent folly again?

Success on the farm is a sad kind of failure, for it means the acceptance of injustice for your portion and conforming to the sacrifice with resignation. What did our Government do for us sagebrush farmers—and all other farmers—while I was on the farm? Besides setting a price on wheat to our disadvantage, it sent county agents to tell our husbands how to poison jack-rabbits, so they would not eat our crops—a valuable service if the crops had been worth anything to the farmer in profits. How much more practical and valuable to the whole country those agricultural experts would have been had the Government instructed them to market the farmer's crops by means of food zones! Good Old Grandma Government sent home-economics experts to teach us women how to make underwear and aprons out of flour sacks, when we were already making everything possible out of them, from table-cloths to sheets. The salaries those women earned would have been put to better account had they been paid to assist the county agents in translating the farmers' crops to the poor city folks at a reasonable profit. The poor fed at a reasonable cost, the farmer given a reasonable profit.

The Government also spent a large sum of money having experts make diagrams of iceless refrigerators and home-made screens (in competition with legitimate business), and spent more money having these diagrams printed, and spent more money sending them broadcast to poor, overworked farm women, who were expected to be tickled to get something more from the hands of the Government that would make them content with their unjust poverty. Spent to take the farmer's crop off his hands and market it, without selfish designs on his labor and life, that same money, with the rest that was similarly wasted, would have enabled the farmer to buy efficient manufactured refrigerators and screens for his windows, would have given more time to the farmer's wife, and would have put more money in the pocket of business. Were the manufacturers of screens and refrigerators asleep that they let the Government pull one on them like that?

Those window-screen diagrams fascinated me, probably because I had only two window screens in my whole house and wanted some more so badly. I carefully read the directions, and the following is all the overworked farm woman would have to do to equip her home with screens. In the first place, she would have to get some money to buy the screening. There being little or no market for the sagebrush woman's butter and eggs, and whatever there was being needed at once to

answer the immediate necessities of the family, we shall have to assume a special act of God in the getting of the raw screening. Next, all the farm woman has to do is to wangle the wire cutting shears from her husband, read the bulletin carefully, and cut the screen according to directions. She must also work big buttonholes in a strip of cloth cut from beet-seed sacking, that being the strongest on hand. Then she must bind the screening all around with the sacking, sewing the buttonhole strip to all four sides. Next she must drive hooked screws, also provided by the special act of God, into the window-frames. On these hooked screws she now buttons her screen. This same operation must be repeated for every window. The result—hours of the overworked woman's life turned into screens which cannot compare with the manufactured articles. The Government has spent large sums of money to keep the farmer contented without legitimate profit and to rob the business man of a customer. Talk about the Government going into business! Why are the farmer and his wife and children to be degraded to such poverty? *Because they feed the world!*

Our Government, whose basic shibboleth is that all men are equal, has spent untold millions of dollars to degrade one class of its citizens. It has wasted good tax-money, some of it coming from the farmers themselves, to maintain county agents and home-economics experts and others in their jobs of showing farm families how to endure failure, rather than helping them to make a success by assisting in the disinterested marketing of their crops. Farming is one business, and marketing is another, and no man has time for both. It has been proved by the experience of thousands of years that self-interested men are not to be trusted in the marketing of farm crops. If a correct value were placed upon the crop as it left the farm, and there were no means by which this could be meddled with, all might be well; but that would require the omniscience of God to operate. Honesty is the rarest attribute of the human animal, and it is the foundation of character. Deliver the middlemen from temptation by making it impossible. Middlemen should be abolished from the marketing of farm crops. Surely, if anything is legitimate government work, it is the distribution of the food-supply. A thousand years from now, people such as you and I—they will be like us—will be amazed that anything of such universal and vital importance as the distribution and marketing of the food-supply of a nation was ever left to chance and graft.

It is not right for men to endure failure. A fine rebellion is evidence of the godlike spark in man. The Government of the United States of America, from the beginning of its history until the present day, without malice aforethought and with the kindliest feeling toward all, has been occupied in the deadly business of pauperizing, and allowing any one sufficiently predatory enough to pauperize, its agricultural class. *Credit is not what agriculture needs, but justice.*

NOTHING WHATEVER that is vital has so far been done to relieve agriculture. Credit is simply legalized charity which must be paid back, with interest; those who accept it are thereby rendered just as poor after its receipt as they were before. Nay, poorer, for with a false sense of security they go on, getting deeper and deeper into debt. Too much credit for everybody was the first step toward the present financial depression, say what they will about the gold standard or any other concomitant factor.

The Government cannot set the price of wheat arbitrarily without making conditions worse than they are, and that is hard to conceive. The actual cost of a sack of wheat is at the heart of the cost of everything. It should be reckoned by the average cost of operation among the farmers who produce wheat. It must take into account the cost of the seed, plus the taxes on the land where it is grown, plus the cost of water (in the West), plus the cost of the farmer's labor, plus that of his farm hand, plus that of his sons, plus that of his wife and daughter at threshing or other special boarding times, plus board for threshers, etc., plus wear and upkeep of machinery and horses (they must be replaced some time), plus feed for horses, plus threshing bill, plus sacks and binder-twine, plus wages of help and teams in hauling to elevators, plus a reasonable profit. Of course it is easier to set the price by guess and by gosh, but it is more expensive, in the end, to paralyze a whole country with financial need, and that is the actual result of not paying the farmer what is coming to him.

Because this is not justice just to one enterprise in the United States, but to all, it must be

a government project, in co-operation with men who know from all industries. The cost of wheat would be but the beginning. The costs of all commodities are affected by the cost of wheat, and it should, therefore, be the business of the Government to watch all along the line. What should the sacks and binder-twine cost? And then we must go on estimating for the cotton farmers, beginning again with the seed and working outward. And so on throughout agriculture.

When we find the real instead of the speculative values of all commodities, it is not going to matter whether we have a dollar of silver or of tin, or whether we have an ounce of gold in the Treasury. I see monetary experts throwing fits at this statement. If I carefully compute the cost to me of a piece of embroidery, from the flaxseed to the finished article, and my neighbor does the same with a wool muffler, she having raised the sheep and spun the wool, we can trade with some certainty that our market is right. There are many factors, of course, unmentioned here, to be dealt with in the same spirit of intelligence. But the basis of everything is what the average producer can produce in a certain time for a certain cost—fluctuations of money can mean nothing: the cost is the cost. If the cost is high, the price of wheat is high. It is self-stabilizing, being price based upon actual cost, low or high. We should need no money at all, except as a matter of convenience. A sack of wheat would have an actual value which could be exchanged for other products at a fair profit, because their values also had been rendered actual.

Such real values must be re-estimated every year. This should be the regular business of the Government, beyond the chance of politics, just as it is the business of every self-respecting individual to get up in the morning and prepare himself to meet the public, or just to be with himself, in a cleanly, decent manner. Until such a course of yearly establishing of actual values occurs, there will be nothing but fluctuating guess-prices, at the mercy of speculators and an eternally seesawing dollar. As long as we continue to pay guess-prices, we shall be paying either too little or too much, and both these courses must lead to recurring periods of depression, a confession of failure on the part of the citizens of the world. *Let's look at this thing straight!* Everything costs something in human life and natural materials. *What is that cost?*

I here quote from an article I casually picked up just now, attracted by the title. It is by Bernard M. Baruch. I read only what I shall quote, it seeming to leap to my eye, and I do not know how Mr. Baruch applied it to his topic, but I do know that it speaks the truth for agriculture: "The human factor is of enormous importance in the consideration of any economic problem. This human factor, with its wide variations, keeps economics from ever becoming an exact science. It must always be empiric—that is, guided by experience, rather than by hard, impersonal science."

Farmers would gladly keep books on their wheat crops if they thought that thereby they could lift the mortgages, but no farmer likes to keep track of how far he is going into the hole. When real prices are set, there will no longer be any farm mortgages. Farm families are not extravagant. Far from it. They almost never have debts of folly.

The farmer has been given the credit which he does not want, and has been refused the justice which he so needs. It rankles in his heart that his government loan is to cover what he is having stolen from him by the marketers of his crops, if not with the sanction of the Government, yet without its prohibition. The farm woman's salary is as yet a thing undreamed, but can you doubt its justice when you see your pretty daughter, dressed in her fur coat, go to her few hours of work, while the farm woman and her daughter work from dawn to dark *to keep you and your family from starving?* If jobs must be underpaid, or paid not at all, let them be those without which we could sustain existence. The cost of wheat, to be just, must take into consideration the world's greatest, as yet unfreed slave, the farm woman.

It is a crime of no small proportions to restrict crops while there are any hungry people left in the world. There must be no consideration as to who will pay for the food those people need. If the Government cannot open the way for them to pay themselves, by means of training and, perhaps, supplying jobs, then it should be the business of an enlightened Government to invite those poor people to its table as its guests.

A century ago, the Owenists, in England, first proposed political representation according

to industrial interests. Mussolini and Soviet Russia are now putting similar principles into practice. I declare that it is a step toward enlightened government. It is always the new-born governments that must point the way to change, crude though their methods may seem to the older nations, sunk in the ruts of custom. What I advocate in the way of accurate estimation of the real values of crops goes one step further toward prosperity for the people.

When we can make our politicians and lawmakers really represent the industries of the United States instead of the businesses that prey upon those industries, we shall have solved the economic question that confronts us, and in no other way can it be done. What a senseless thing it is to keep juggling the dollar and the tariff, winning enemies at home and abroad, when the simple plan of finding out what a tiling is worth and paying for it accordingly would win friends and antagonize nobody but commercial racketeers. The new tariff would be the required submission of the actual cost value of the article that desired admission to the United States. It is absurd to encourage any home industry to manufacture something at a loss to the consumer if he can obtain it at lower cost from abroad. Let us have the practical international brotherhood of exchange. Give the other nations a chance to earn a living, too.

Where ever did we get the idea that the United States of America has to manufacture within its confines everything that is manufactured anywhere else in the world, at a loss to the great consuming public? Why should I be allowed to set my heart on the making of caviar from cat's whiskers to the loss of every one else in my home town, Russian caviar having a tariff on it too high for the town folks to enjoy? Let me go out and scrub steps, like other honest women! There are too many American industries trying to fill the rôle of God's little pet lambs.

If we cannot grow tiddle-de-winks as economically as can the Republic of Nosuchplace, then let Nosuchplace have a chance at a living wage by supplying us, while we, because of a more favorable rainy season, raise door-knobs to supply the folks of Nosuchplace, who are able to buy from us because we are buying tiddle-de-winks from them. For heaven's sake, let the nations grow up and quit squabbling like a lot of naughty boys playing marbles for keeps! Don't they know that there is a brutal schoolmaster about to pounce on them and lick the life out of them? His name is WAR. Did it never occur to our statesmen that one of the surest causes of war is unintelligent and dishonest economics?

Now I hear some of those university-professor economics experts asking me, "What unit of exchange will you use in your utopian plan, if you have no gold standard, or what-not?"

(I have taken some dirty whacks at professors, ministers, and what-nots in this book, and I want to say right here that one of my best friends...two of my best friends were a splendid minister and his splendid wife. Also, I look hopefully toward economics experts of whatever stripe. They are at least thinking, while the rest of us United Staters are mostly vegetating.)

While I was writing that parenthetic paragraph, I was thinking up my answer to the professors. Every plan that has advanced the world in justice and humanitarianism has been condemned by folks in high places. There is no unchangeable unit of value for exchange, and never has been, and never can be. Certainly not silver and gold. Bryan was righter than he was thinking when he startled that convention with, his glorious voice chilling every one's bones, "*You shall not crucify mankind upon a cross of gold!*"

There is a deeper thought behind that perfectly splendiferous outburst than William Jennings Bryan was thinking. Now that the Democrats are in, I dast to tell, and maybe brag, about the time Bryan called on my father at the Territorial Insane Asylum, where we had our luxurious suite of rooms. The Insane Asylum was the show place in Provo, and if a man were notable enough, he was always taken out to see the institution run by Dr. Pike. Bryan's visit was a source of lifelong grief to me. I wanted to sit on his knees, and he did not ask me. I mean one of his knees. My sister Hattie, who was always smiling, was sitting on one of them, but I, who was always staring solemnly, could only stand as near as possible, just yearning. It was a great day in my father's life. He was among the two or three most prominent Democrats in the State of Utah, and I can see the serious faces of the two men as they sat there, like farmers, settling the Government. Not a word of

253

that historic dialogue do I recall—only my yearning to sit upon Bryan's other knee.

All the time I was writing that paragraph, I was doing some more thinking—or reacting, if you believe Watson. I say, *You shall not crucify mankind upon a cross of gold, nor upon a cross of silver, nor a cross of platinum, nor a cross of any other metal, nor a cross of any kind!* There was a Man who died upon a cross of wood, but what good did it do? Those who profess to follow what he died to impress, are still slaughtering each other. One crucified Man is *enough!* What, in God's name, has any metal to do with the actuality of living, except as it affects the working hours of the men who mine it?

No, the sack of wheat is not the unit of value, although the unit of value must be translated into wheat, or into all the farmer's crop, of whatever sort. The wheat or the crop is the translated unit for the farmer. Must there be a different unit of value for every industry? No. The same unit for all, but translated into the terms of each industry. *For the unit of value is the worth of an hour's work in any field of endeavor.* It is not stable. It is a thing which must be re-estimated by disinterested experts from year to year. Any other course is lazy and destructive. Some of our most penetrating scientists say that there is no such thing as stability throughout the universe. Einstein has proved relativity. The unit of value must have its material manifestation re-estimated year by year, even as Nature "tries if the earth be in tune" and continues in her efforts to keep the blamed thing in tune with cosmic harmony. Continual tuning is the only way to keep a piano and a government's economic system in working order.

An hour of the life of every man is not of the same value, even to himself, though more than once I have suspected that no executive's hour is worth what some Captains of Industry receive. Even so, when that famous executive Mr. Insull, at several thousand dollars an hour, sat down to eat a meal, the continued absence of which would have caused his insulation underground, the man who kept him and his like from starving ought to have had a working hour worth more than minus a hundred cents. The working hour of any man is worth more than minus anything. The reason the farmer is today in desperate distress is because the world has always valued his work as a minus quantity.

How much is a working hour of the farmer's life worth? A person might work very hard trying to keep a ball from rolling down a sloping cellar door, but the work would be worth nothing. If the farmer's work is worth nothing, we want to know, so that we can tell him to give up farming. Tell all the farmers in the world to give up farming. It is a case of relativity.

The farmer's case must be considered by a board of disinterested industrial experts from all industries. We must all rise together, or we shall fall together. And the agricultural industry is the keystone of the entire arch. Are you going to reckon the farmer's working hour in silver or gold? No. They have no relation to his work. You will reckon it in terms of wheat, or the whole estimated crop, just as you are going to reckon the working hour's value of a pants-maker by the number of pants he can make in an hour and the quality of his skill. Valued in money? Not primarily. Valued in what it takes to grow pants from the lamb to the label.

If we really do not need to eat, then let's force the farmer to the city by continuing economics as they are at present. Do not expect him to solve his problem. He is like a reporter. Nearly all reporters are born writers. They gravitate to newspapers because there they are allowed to write all day and get paid for doing it. Not what they are worth—by no means. But publishers never have to think of reporters going on strike for the wages they deserve: they are too glad of a chance to write. They rarely get what is coming to them, unless their wrongs get mixed up with those of linotype operators—and then, look out! What the reporters would never do for themselves is done for them by the Typographical Union.

Farmers are the same. The born farmers would die of nostalgia away from the land. And there are folks, like the Baron and God's little pet lamb, who love the growing acres so much, and the great outdoors, and the quiet, and the serenity, that they are willing to bear almost anything not to leave the farm. Some one must see that all these lovers of the soil receive a just wage for a just working hour, or the world may be starving worse than it is. Some union may appear to take the

farmer's battle out of his hands.

Of course, there would have to be money. You cannot go around jingling two or three sacks of wheat in your pocket to impress folks, and you cannot buy anything with a bunch of keys. But the money can be made out of lead, if you desire. The Government would have to be clever in reproducing some design calculated to defeat the counterfeiters. The best way to dispose of counterfeiters is to place such skilful, enterprising men where they can do something skilful and enterprising for the Government. In other words, citizens with jobs are not doing much counterfeiting.

Money might be like street-car tokens. Nobody ever counterfeits them, yet they stand for good money. I do not say that base-metal money would wipe out counterfeiters. Some folks are born wrong, and some folks get that way by envying the display of folks who get their money by law-safe robbing. Emulation is the only means of educating the ambitions and habits of a people. The rest is simply search for knowledge, usually forgotten as soon as obtained. Were there no thieves in high places, displaying their lavish gains won through speculating or grafting, there would have been no racketeers and kidnappers in low places. We can never wipe out the racketeers and kidnappers until we wipe out the speculators and grafters.

Eph Farmer is a sick man, and has been so always. He is making feeble attempts to open his own home door, but cannot do it. Mr. Inflated Dollar says, "I will dress you in this inflated suit, and you can pass through the transom without hurting you, padded so nicely as you are." But Eph Farmer gets stuck in the transom, the suit bursts, and he falls to the ground. What can an inflated dollar buy in a market that automatically deflates it?

Mr. Tariff says, "I will dig a hole under the door, and you can crawl under." The wood is dug away, the farmer tries to crawl through, gets caught, and is stripped naked by a pack of middlemen. What good is the tariff when it is the middleman who depresses the home market?

Next comes Mr. Government Credit. He bursts in the door, and grateful Eph Farmer tumbles in. But over him tumbles immediately the Big Bad Wolf, and he is not sick at all; so before the farmer can get over being grateful and realize what is happening, the Big Bad Wolf has gobbled up not only the three little pigs, but the farm as well. And Mr. Government Credit was just the Big Bad Wolf in sheep's clothes.

So *what?* sez you. Sez I: Did nobody think of looking straight at the keyhole, which is the working hour of the farmer's life? (And his son's, and his daughter's, and his wife's.) The key is already in the lock, and nobody has thought to turn it. The key is the sack of wheat; how many working hours of an average farmer's life did it take to produce that wheat? So many hours throughout the summer (help of everybody included) for so many sacks of wheat. Divide the sacks of wheat by the hours, and you have so much wheat per hour. What is the cost of that wheat from the seed? The result will be the worth of a farmer's working hour. Now, how much is that wheat worth as compared with the products of other industries? Remember, if worse came to worse, we could make the whole United States a nudist colony, but we should not be successful in making it a never-ending-fast colony. You would find folks dying of that. Is food worth anything? What is the farmer's food-producing hour worth, as compared with the importance of other industries? No, not holding you up. Don't you think it ought to be worth a slight profit? Not just mortgages?

Every living man has a working hour or an idling hour. We should not be compelled to pay for the idling hour, though we are at present. But that is another problem. The working hour of different industries is worth different amounts in this base-metal money we are using for convenience—it might be pins or street-car tokens. And that is where our industrial board of disinterested experts comes in. There they sit, ready to make comparisons, by actual vital values, of every man's working hour, be he farmer or pants-maker. I do not believe the farmer's hour would be valued by such men as meriting bankruptcy. No middlemen would be seated at that table. I believe the other industries, so represented, would give the farmer a square deal. He will never be able to turn the key in the door himself. He has not learned, and may not learn, the power of brotherhood. Slaves do not unite against their masters. Some one else must free them. A real, loyal

union of all farmers could wag the world.

WHAT is a working hour of your life worth? If you were a farmer, slaving from dawn till dark, would you say your working hours were worth nothing? If you were his wife, slaving from before dawn until after dark, would you say your time was worth nothing? Would you be content to see your children drudge through the years and have nothing for it?

If the churches would only stop taking up the Lord's time, pleading with him to save their little peanut souls, they might do something so wonderful here at home. And there must be among the hymn-singers enough intelligent, willing folks who are able to forget their selfish personal salvation in order to save some one else. Let the churches join together to free the slaves of the United States, the farm families. The political parties have failed. Come alive, churches! "Inasmuch as ye have done it unto the least of these..."

Charley and I succeeded as well as the majority of the farmers where we were. Nearly all those who tried to own their own farms lost them, and only the tenant farmers, shifting about from farm to farm, were able to survive adverse conditions, and that at the expense of the city owners. If the actual value of farm products had been paid while the Baron and I were on the farm, we would still be there. I loved it then; I love it now; but I am not sorry to be gone. Though, of course, I must have moments of yearning for that poverty-poor hilltop home, with my darlings running underfoot, at which times the city, where I now live, seems a pale and hollow substitute.

One of our Texas neighbors, when a lad, worked for two years on a farm and received at the end of that time, as his entire wages, five dollars. He was supposed to have slept out and eaten up the rest of his reward. Bewildered by so much money as five dollars, he went to town to spend some of it. He had been so long without money that he could think of nothing to buy but ten cents worth of gunpowder. This purchase was bruited around the countryside with the swiftness of a tumbleweed flying before a strong wind. "Hev yuh heerd the news 'bout Buddy Hanks? He done bought hisself rich with a dime's worth o' gunpowder!"

Walter

Charles

Joe

Rhoda

THE GREENWOODS GROWN

The farmer is reaching the place where he will no longer sell himself poor by throwing in,

for nothing, two thousand dollars' worth of his labor, and the combined labor of his entire family, in order to buy himself rich with a dime's worth of specious independence. I am glad we have an intelligent, practical, calm, clear-sighted extrovert in the White House. I did not vote for him, and thank God that the fate of the nation did not depend on me, for if ever there was a man of destiny, time is proving that man to be Franklin D. Roosevelt.

Yet even he might be blinded by so much cry about the tariff, inflated money, farm credit, and arbitrary price-fixing. (And I left out Mr. Arbitrary Price-Fixing because all he tried to do for Eph Farmer was to attempt to squeeze him through the crack between the door and the jamb, and it could not be done. Any price that does not represent actual value plus a reasonable profit is worse than useless.) I hope President Roosevelt will not be misled by any of the gentlemen who tried to help poor Eph Farmer through the door. If he is, he will miss the opportunity to revolutionize the whole United States economic system, by neglecting to give agriculture simple justice for the first time in the history of the world. Three thousand years before Christ they threw the farmer into the canal to drown if he could not pay his rent, and his wife and children were sold into slavery. Well...today we do not drown the farmer.

I AM MINDED at this point to tell you of the last hired hand we had on that farm. He was a sort of derelict, drifted to us from foreign lands, having been a young farming serf in Russia. His name was a mouthful of consonants, ending in *vitch*, or *kov*, or *sov*, or *rov*, but Charley always called him Mike.

After he had spent the winter on our farm, one night he was moved to tell us the story of a Chinese idol and its reputed heart of gold. This idol was worshiped in a temple just over the border from the part of Russia where Mike and others like him slaved for a nobleman.

It was known that at a certain hour after midnight the clay idol was left alone, though how the priests were then occupied, Mike did not say. No Chinese slave would have dared approach the altar, on which flares lighted up the hideous visage of the idol, in spite of the temptation of that heart of gold.

A Russian who had once been a serf on the very land that Mike plowed returned from America on a visit. From that time Mike could think of nothing but the Promised Land. He must go...he must go...But how?...how?

He and two other young men decided to steal the Chinese idol for its heart of gold. They slipped into the temple like shadows and as noiselessly, with their great muscles, lifted the ugly, squat image from its platform above the flickering altar.

Then began a journey which even in memory cast a look of agony across Mike's wild features. Elation at first made the burden light; but after miles of torturing struggle, through deep, turbulent streams and through thick, pathless underbrush, one of the three gave up and sank exhausted. On went the other two, afraid to rest for fear of pursuit, realizing that discovery meant death. But after more miles of torture the second man lay down, refusing longer to help.

Mike said: "I go on. I go on alone. I think I cannot do...but I go on. The god, he heavy, like I cannot carry him. My arms, they hurt like knives; I cannot breathe; but I must go. This far that idol I carry him. If I not get him home, I no go to that America. So I get him there."

His voice hoarse from exhaustion, he called to his wife for his sledge-hammer. With his last gasp of strength he split the idol open, and the heart rolled out. It was made of iron.

How Mike reached America I do not know. That story to me meant something so personal that Mike and his fate became blotted out as I constantly reviewed it in after years. For always I could not help thinking: "That is I...I who have been forced to drag the clay idol of heavy, thankless toil across all the hard years of my young womanhood, through the deep waters of despair, through the dragging, tearing underbrush of dreadful hopelessness."

Ah, but here is where I know now that Mike's story and mine differ! With the last gasp of strength of my spirit I have split open that terrible idol of clay, and I see...I see...yes, I see at last that it is good—all good. Is not this that I see a heart of gold?

And now, while President Roosevelt is beginning to write an order to start economic justice for the whole world by inaugurating it for the farmer—a large order for one man, but I can see him doing it; while President Roosevelt is attaching to his signature that firm straight line hooked on the *t*—no monkey-business nor posing there—I will take this chance to say good-by to you, dear reader, in the good old-fashioned way of the day when they always had the double book-tides so fascinating to me.

I am not old-fashioned when I say that I wish you were here to eat some of my pie with me, only I have no time to make any just now, though my pitchfork-handle rolling-pin is only a few steps away from my typewriter, in the little kitchenette. I hope when you finish reading this book, my very first book to be published, you will not feel like blaming Daisy in any way, even though it is true that the book would never have been written had it not been for a cow named Daisy, who died on a handkerchief of land on the outskirts of Columbus, Ohio, of indigestion in one of her five stomachs—or was it seven? So this is the end of my rambling record concerning us sagebrush folks, the Baron, God's little pet lamb, *et al.*

CPSIA information can be obtained
at www.ICGtesting.com
Printed in the USA
LVHW041648090122
708144LV00003B/183